The Fertile Crescent
Gender, Art, and Society

The Fertile Crescent
Gender, Art, and Society

Judith K. Brodsky & Ferris Olin

With essays by Judith K. Brodsky and Ferris Olin,

Margot Badran, Kelly Baum, and Gilane Tawadros

Published by
The Rutgers University Institute for Women and Art
New Brunswick, New Jersey

Distributed by
D.A.P. / Distributed Art Publishers, Inc.
New York, New York

d·a·p

Contents

Preamble

It has been an honor and a pleasure to collaborate with Judith K. Brodsky and Ferris Olin of Rutgers University on *The Fertile Crescent: Gender, Art, and Society*. As this catalogue will make clear, the range and quality of women's art currently being produced in the Middle East are superb, and it is my hope that both the catalogue and the exhibitions upon which it is based will draw attention to this formidably diverse group of artists.

Readers may not be aware of one aspect of this exciting project that particularly pleases me—its broadly collaborative and cooperative approach to the exhibition of art. The project was conceived at the Rutgers University Institute for Women and Art, but Brodsky and Olin early on decided that it would become more powerful if it could embrace cultural institutions across central New Jersey. The two have done an amazing job of reaching out to both New Brunswick and Princeton. The loose grouping of sponsoring institutions includes the campus galleries at both Rutgers and Princeton; academic centers (like those directed by Brodsky, Olin, and myself) at both universities; public libraries in East Brunswick, New Brunswick, and Princeton; the Princeton and West Windsor Arts Councils; the College of New Jersey; several different schools and departments at Rutgers University; the Lewis Center for the Arts at Princeton University; and the Institute for Advanced Study, among others. This collaborative approach will produce many wonderful exhibitions and programs for the residents of our region, but it is also producing an unprecedented level of intellectual and cultural collaboration across both public and private cultural institutions in the region. It is a great model of public cultural production.

And in culture, it is content that matters. *The Fertile Crescent* highlights artists who reside in, or come from, a highly conflicted part of the world that is usually characterized by the religious beliefs of its inhabitants. As the works of art reproduced in this publication indicate, religion is a central aspect of perception in the region, but it is not the only aspect, nor is it a unitary perspective, even within particular religious cultures. The works also display, importantly, the similarities of outlook that pervade the region, and that may in the long run even provide a basis for the sort of peace based on understanding that most of us so ardently desire. And, not least, the works display the energy and originality of women artists who surely have not received the admiration and attention that they deserve. Judith K. Brodsky and Ferris Olin have brought to our attention a group of artists with whom most of us in the United States are not familiar, and have shown us that women artists everywhere, including those from the Middle East, are vibrant, inquiring, and courageous. They are making major intellectual and aesthetic contributions to world culture.

My Center and I have been delighted to participate in this highly creative collaboration, which is proving important to building sympathetic understanding among the leading cultural institutions in New Brunswick and Princeton—and which I hope will prove important in promoting understanding in many cultures through art.

Stanley N. Katz
Director, Center for Arts and Cultural Policy Studies, Woodrow Wilson School of Public and International Affairs, Princeton University

Preface and Acknowledgments

Judith K. Brodsky and Ferris Olin

The Fertile Crescent: Gender, Art, and Society recognizes and celebrates women artists from the Middle East. This exhibition validates the relevance and importance of their work in shaping the intellectual and aesthetic concepts emerging from that region. It demonstrates the breadth of women's cultural expression as inspired by their birthright heritages and the cultures of their countries of residence (often different from their countries of family origin), and presents their analysis of the underlying social, theological, and historical issues that have shaped, and are shaping, the status of Middle East women and their societies today. In addition, their work addresses global issues of transnationalism, the environment, sexuality, and the economy. This project also presents an alternative perspective on an area of the world that since 9/11 has been under suspicion and prejudice in both Europe and the United States.

The Fertile Crescent is a project of the Rutgers University Institute for Women and Art (IWA). We established the Institute in 2006. Both of us have been workers in the feminist art field since the 1970s. As feminist women faculty members at Rutgers University, we were among a cohort of feminist academics and artists who, thirty years ago, catalyzed the state university into becoming a leading feminist studies institution. We counted as our pioneer colleagues in the Art History and Visual Arts Departments the feminist art historian Joan Marter and the feminist artists Martha Rosler, Joan Semmel, and Emma Amos. In 1977, Brodsky had been the first artist and third president of the Women's Caucus for Art, which originated within the College Art Association, but had become a separate organization. Under her leadership, it became the largest organization of female visual arts and art history professionals in the country. In 1985, Olin became the Executive Officer of the Rutgers Institute for Research on Women; she worked with its Director, Catharine Stimpson, who came to Rutgers University from Barnard, where she had launched the major feminist periodical *Signs: Journal of Women in Culture and Society.*

Rutgers feminist scholars, not only in Art History and Visual Arts, but across the disciplines, won hard-fought battles to secure a place for feminist studies at the university. Today, the Women's and Gender Studies Department has over four thousand students taking courses in any one semester; offers an MA and PhD in Women's and Gender Studies; and, with the entrepreneurial involvement of Brodsky and Olin, is a pioneer in establishing online courses in the field. Over three hundred faculty members at Rutgers describe their research as directed toward women's and gender studies. In addition, Rutgers is home to a unique constellation of women-oriented research centers in various fields under the umbrella of the Institute for Women's Leadership. Along with the Women's and Gender Studies Department and the Institute for Women and Art, these include the Center for American Women and Politics; Center for Women and Work; Center for Women's Global Leadership; Center on Violence Against Women and Children; Douglass Residential College; Institute for Research on Women; and the Office for the Promotion of Women in Science, Engineering, and Mathematics.

In 2005–06, on the principle that the whole is greater than the sum of its parts, we felt that the climate was right for an institute focused on feminist art. In addition to the now-substantial number of feminists in the Visual Arts Department at the Mason Gross School of the Arts and in Art History, Martin Rosenberg, a male art historian whose field is feminist art, became Chair of the Art Department at Rutgers University's Camden, New Jersey, campus while at the Newark campus, Daniel Veneziano, another male feminist (later succeeded by Anonda Bell), was directing the Paul Robeson Galleries. By pooling such resources, the envisioned larger enterprise could gain greater visibility than any of these entities on their own. Furthermore, we would be breaking new ground: the Institute for Women and Art would be, and still is, the only one of its kind at any United States university.

We framed the following mission statement for the newly founded organization:

The mission of the Institute for Women and Art (IWA) at Rutgers is to transform values, policies, and institutions, and to ensure that the intellectual and aesthetic contributions of diverse communities of women in the visual arts are included in the cultural mainstream and acknowledged in the historical record. To accomplish this goal, the Rutgers Institute for Women and Art invents, implements, and conducts live and virtual education, research, documentation, public programs, and exhibitions focused on women artists and feminist art.

The IWA strives to establish equality and visibility for all women artists who are underrepresented and unrecognized in art history, the art market, and the contemporary art world, and to address their professional development needs. The IWA endeavors to serve all women in the visual arts, and diverse global, national, regional, state, and university audiences.

In fulfillment of these objectives, we have mounted numerous exhibitions; sponsored scholars-in-residence; created programs to help women artists with their careers; developed online resources to assist scholars in their research on women artists; and established an archive called the Miriam Schapiro Archives on Women Artists at the Rutgers University Libraries, devoted to the personal papers of women artists and the records of feminist art organizations. In addition to Schapiro's papers, the holdings of the Miriam Schapiro Archives include, for example, the papers of the artist Faith Ringgold; the records of the Heresies Collective, one of the most important entities of the American feminist art movement; and the records of the Women's Caucus for Art. The IWA is also responsible for the Mary H. Dana Women Artists Series, the nation's longest continuously running space for showing established and emerging contemporary women artists. The Dana Women Artists Series, which celebrated its fortieth anniversary in 2011, was the brainchild of Joan Snyder, the distinguished feminist artist and MacArthur "genius award" recipient, who is an alumna of Douglass College with an MFA from Rutgers.

In 2005, as we were developing the IWA, we were approached by the artist Judy Chicago, the late critic Arlene Raven, the art historian Anne Swartz, and the curator Susan Fisher Sterling, now Director of the National Museum of Women in the Arts, to see if we might partner with them on an endeavor that would sustain the energy and impetus in feminist art that was developing as a result of the planning for two major exhibitions: *WACK! Art and the Feminist Revolution,* which addressed the history of the feminist art movement internationally and which would be shown at the Los Angeles Museum of Contemporary Art and the National Museum of Women in the Arts in 2007, and MoMA PS1, New York, and the Vancouver Art Gallery in 2008; and *Global Feminisms,* an exhibition of younger feminist artists around the world, held at the Brooklyn Museum's Elizabeth A. Sackler Center in 2007, in conjunction with the launching of the Center. Elizabeth Sackler had enabled the Brooklyn Museum to acquire Judy Chicago's *Dinner Party,* the installation of which also opened in 2007. Additionally, the National Museum of Women in the Arts was about to celebrate its twentieth anniversary, and the thirtieth anniversary of the founding of the Feminist Art Program at the California Institute of the Arts was also about to take place in 2007. In response to the ideas outlined by Judy Chicago and the others in the group, we agreed to take on what came to be known as The Feminist Art Project (TFAP). In 2005, to inaugurate TFAP, we mounted *How American Women Artists Invented Postmodernism, 1970–75,* giving credit to twenty women artists of the early 1970s, including Chicago and

Schapiro, who introduced new elements into artistic practice that continue to this day—the use of pattern and decoration, explicit female sexual imagery, and autobiography as material for artmaking, among others. Today, TFAP has forty regional coordinators around the world, and its web site lists over fifteen hundred exhibitions, publications, and programs worldwide that focus on feminist art. In addition, through its *Feminist Art Resources in Education,* TFAP provides valuable online information on women artists for educators that includes, along with bibliographies and other aids, model curricula that can be downloaded for free and adapted for classroom use.

The Fertile Crescent is not our first venture into global feminism. Three years ago, we mounted two exhibitions of work by women artists from India. The first, devoted to art by women who live in India, was a traveling exhibition called *Tiger by the Tail! Women Artists of India.* The second, dedicated to Indian women artists of the diaspora living in the United States, was entitled *Passage to New Jersey: Women Artists of the South Asian Diaspora in Our Midst.* Given the significance of the Middle East in contemporary world affairs, we decided to make the focus of our next international undertaking women artists from the Middle East.

The Fertile Crescent quickly developed into a major endeavor. After selecting the artists whose work we wanted to highlight in the show, we realized that the number of artists was more than we had room for at Rutgers. Because we both live in Princeton, we decided to approach Princeton University, the Arts Council of Princeton, and the Princeton Public Library (and

later, the Institute for Advanced Study) to see if they would be interested in our expanding the exhibition and related programming to Princeton, in addition to the already-slated New Brunswick venues. The two towns, both with major universities, are only fifteen miles apart. Furthermore, the corridor between them is a site for recent Muslim and Middle East immigration. It is also the location of a large Jewish community. To our delight, all three Princeton institutions were interested in *The Fertile Crescent*. The project also moved beyond solely an art exhibition to encompass other creative fields, such as film, literature, and music. We had already received funding support from the New Jersey Council for the Humanities for a symposium and artist's lecture, as well as a film series featuring women directors from Middle East countries, which would take place in New Brunswick.

As with any project of such scope and magnitude, *The Fertile Crescent* would not have been possible without the vital support of many individuals along the way. We cannot express our gratitude enough to Stanley N. Katz, Professor, Woodrow Wilson School of Public and International Affairs, Princeton University; Director, Center for Arts and Cultural Policy Studies, Woodrow Wilson School, Princeton University; recipient of the 2010 National Humanities Medal; and former longtime Executive Director of the American Council of Learned Societies, for convening a meeting of Princeton University and community leaders at which we presented our ideas. We truly feel that it is due to Professor Katz's endorsement of our project that we received such a welcoming reception in Princeton. Kate Somers, Curator of the

Bernstein Gallery at the Woodrow Wilson School, was also instrumental in the realization of the project.

There are many additional people at both Rutgers and Princeton, and in the broader community, whom we wish to thank. At Rutgers University, we want to express our gratitude to LaToya Ruby Frazier, Director of the Mason Gross Galleries; George Stauffer, Dean of the Mason Gross School of the Arts; and Diane Neumaier, Chair of the Visual Arts Department, for welcoming us to the Mason Gross Galleries as one of the venues for the core exhibition. Ousseina Alidou, Professor, Department of African, Middle Eastern, and South Asian Languages and Literatures, and Director of the Center for African Studies; Alamin Mazrui, Chair of the Department of African, Middle Eastern, and South Asian Languages and Literatures; and Nida Sajid and Fakhri Haghani, also faculty members in that department, organized amazing public programs and courses related to the Middle East diaspora. Lynn Shanko, Associate Director of the Rutgers Center for Historical Analysis, worked with Professor Haghani to develop the Middle East curriculum for the course offered by the Rutgers Institute for High School Teachers. Alison Bernstein, Director of the Institute for Women's Leadership (IWL); Lisa Hetfield, Associate Director of the IWL; and Jackie Litt, Dean of Douglass Residential College, along with her staff, were helpful in so many ways. Abena Busia, Chair of the Women's and Gender Studies Department; Carolyn Williams, Chair of the English Department; Elin Diamond, a faculty member in the English and Comparative Literature Departments; Yael Zerubavel and Karen Small, Director and Associate Director,

respectively, of the Allen and Joan Bildner Center for the Study of Jewish Life; Karen Alexander, at the time, the coordinator of the *Knowledge and Power* course at Douglass Residential College; Jane Sloan, Media Librarian, Rutgers University Libraries; and Albert Gabriel Nigrin, Director of the New Jersey Film Festival, also enthusiastically participated in program planning. We also want to express our gratitude to Dorothea Berkhout, Associate Dean at the Edward J. Bloustein School of Planning and Public Policy, for facilitating sponsorship of Sigalit Landau's lecture. In addition, we thank Suzanne Delehanty, Director of the Jane Voorhees Zimmerli Art Museum, for hosting the inaugural symposium and reception for *The Fertile Crescent.* Rutgers–Camden colleagues Nancy Maguire and Cyril Reade, and Anonda Bell, Paul Robeson Galleries, Rutgers–Newark, mounted complementary exhibitions. Michael Joseph structured the Annual Book Arts Symposium to focus on Middle East artists who make books. We also want to thank the Art History Department, particularly Catherine Puglisi and Susan Sidlauskas, and Triveni Kuchi, Director of the South Asian Studies Program, for their early support. Barry Qualls, Vice President for Undergraduate Education, made it possible for Rutgers students to travel gratis to Princeton to see the exhibitions there and to attend events. Isabel Nazario, Associate Vice President for Academic and Public Partnerships in the Arts and Humanities, under whose umbrella the Institute for Women and Art is situated, was a source of encouragement, support, and very useful advice throughout the planning process. Casandra Burrows and Glenda Daniel helped immeasurably with grant applications and administration, as did Kelly Welch, Building Administrator for the Mabel Smith Douglass Library.

At Princeton University, we are very grateful to James Steward, Director of the Princeton University Art Museum, one of the venues for the exhibition, and Kelly Baum, Haskell Curator of Modern and Contemporary Art, along with Maureen McCormick, Registrar, and Caroline Harris, Education Curator, for their enthusiastic embrace of the exhibition and accompanying programming. Paul Muldoon, Director of the Lewis Center for the Arts at Princeton University, came to the first meeting we had with Princeton University and Princeton community leaders and immediately offered the Center as a venue for literary and performance events. He went on leave shortly thereafter, and Professor Michael Cadden took over the Center in his absence, assuring us of continuation and even dedicating part of the Center's budget to *Fertile Crescent* programming. As a result, several programs took place, including performances by Fawzia Afzal-Khan, Chair of the Women's and Gender Studies Program at Montclair State University, who is an expert on the history of Pakistani music as well as a performer, and the Turkish artist Nezaket Ekici (among the artists featured in *The Fertile Crescent*); a symposium with several women authors of Middle East descent; and assorted lectures, including a conversation between the journalist Yasmine El Rashidi, 2012 Hodder Fellow at the Lewis Center for the Arts, Princeton University, who covered the Egyptian uprising in Tahrir Square, and Margot Badran, Senior Scholar, Woodrow Wilson International Center for Scholars, and Senior Fellow, Prince Alwaleed ibn Talal

Center for Muslim-Christian Understanding, Georgetown University, a leading expert in the study of gender in the Middle East; as well as an evening with Najla Said, the daughter of Edward Said. Steven Runk, former Director of the New Jersey State Council on the Arts, came on board as the Lewis Center Director of Communications in the middle of our planning, and, along with his Lewis Center colleague, Mary O'Connor, assisted with the development of programs. Jill Dolan, Annan Professor in English, Professor of Theater in the Lewis Center for the Arts, and Director, Program in Gender and Sexuality Studies at Princeton University, became a program participant as well as advisor.

At Princeton's Institute for Advanced Study, we met with Professor Joan Scott and artist-in-residence Derek Bermel. That meeting resulted in a concert sponsored by the Institute and organized by the composer Andreia Pinto-Correia. The concert included the world premiere of arias from *Territories,* a new opera composed by Correia with a libretto by the Palestinian American playwright Betty Shamieh, based on her play of the same name.

In addition, we want to thank Jeff Nathanson, Executive Director of the Arts Council of Princeton, for welcoming us to the gallery and for his sage advice throughout the planning process; we are also grateful for the assistance provided by his colleague, curator Maria Evans. Leslie Burger and Janie Hermann, respectively, the Director and Program Coordinator of the Princeton Public Library, responded immediately to the invitation to participate, committing the library to exhibitions, a community read of three books by Middle East women authors, and lectures. Melanie Clark and the Princeton Symphony Orchestra performed two concerts of music about the Middle East and its diaspora. E. Kim Adams of the New Brunswick Public Library deserves particular mention for organizing an exhibition of local artists from the Middle East and its diaspora and a film viewing and filmmaking program for New Brunswick teenagers, expanding their horizons to include cultures other than their own. Susan Kaspin from the East Brunswick Public Library used her library's resources for a lecture by the political scientist Michael Curtis and an exhibition curated by Anne McKeown, master paper-maker, Brodsky Center for Innovative Editions, Rutgers University. Ilene Dube, board member of the West Windsor Arts Council, arranged for an exhibition to take place in the Arts Council Gallery, which Anne McKeown also agreed to curate. Emily Croll and Deborah Hutton at The College of New Jersey also mounted a complementary exhibition.

We want to express our appreciation to the New Jersey Arab American Heritage Commission; the American Arab Forum, particularly Dr. Aref Assaf; Dr. Mohammad Ali Chaudry of the Center for Understanding Islam; Rabbi Julie Roth of the Princeton Hillel and her colleague Sohaib N. Sultan, Muslim Life Coordinator and Chaplain at Princeton University; Rabbi Esther Reed of the Rutgers Hillel; Shaykha Reima Yosif at the Al-Rawiya Foundation; and many other individuals from statewide organizations for their assistance and enthusiastic endorsement of the project.

We must give special thanks to Fawzia Afzal-Khan; Fulya Erdemci, Curator of the 2013 Istanbul Biennal; and Farideh Tehrani of the Rutgers University Libraries, for their excellent recommendations as we shaped *The Fertile Crescent*. They introduced us to background that was essential in creating programs that were pertinent and relevant; suggested artists, speakers, and performers; and were generously available whenever we had questions.

We carried out research for several years to select the artists who are in the exhibition, and we are delighted that they all agreed to participate. We want to thank them, as well. We won't name them here, since they are the subject of this catalogue. We also want to thank their gallerists, who have been so helpful, particularly Ted Bonin of the Alexander and Bonin Gallery; Karen Polack at the Cheim & Read Gallery; Molly Epstein at the Barbara Gladstone Gallery; Leila Heller and Lauren Pollock at the Leila Heller Gallery; Rebecca Heidenberg and Anna Nearberg at the RH Gallery; Andrea Meislin at the eponymous gallery; and Claire Oliver, also at the eponymous gallery, along with Mariclare Hall, all in New York. We are also grateful to Dina Ibrahim at the Third Line Gallery, Dubai, for her help in securing Hayv Kahraman's work; Melanie Wagner at Galerie Hubert Winter, Vienna, for loaning Nil Yalter's installation *AmbassaDRESS;* and Sasha Ayoub at Proaction Film, Damascus, for arranging for Diana El Jeiroudi's film *Dolls* to be shown.

The lenders to the exhibition are: Negar Ahkami; Jananne Al-Ani; Fatima Al Qadiri; Monira Al Qadiri; Alexander and Bonin Gallery; Zeina Barakeh; Binta-Zarah Studios; Jasanna and John Britton; Cheim & Read Gallery; Ofri Cnaani; Edition Block, Berlin; Parastou Forouhar; Michael and Lindsey Fournie; Ayana Friedman; Shadi Ghadirian; Barbara Gladstone Gallery; Leila Heller Gallery; Rose Issa Projects; Efrat Kedem; Sigalit Landau; Ariane Littman; Maryam Massoudi; Andrea Meislin Gallery; Howard and Maryam Newman; Claire Oliver Gallery; Ebru Özseçen; Fred Perlberg; RH Gallery; Laila Shawa; Shahzia Sikander; Shvo Art Ltd.; the Tourism Development & Investment Company (TDIC); Fatimah Tuggar; Galerie Hubert Winter; and Nil Yalter.

We are also very pleased that outstanding scholars, Margot Badran, Kelly Baum, and Gilane Tawadros, agreed to write essays for the catalogue.

Isabella Palowitch not only designed the catalogue and identified the appropriate printers, she provided us with the expertise to negotiate the publishing world, introducing us to the literary agents Lyn Delli Quadri and Jane Lahr, who, in turn, presented the catalogue to D.A.P. / Distributed Art Publishers, Inc., which acquired it for distribution. Jane Friedman, with her writing abilities, provided expert copy editing; Margaret Trejo, elegant typesetting; and Stephen Stinehour of Capital Offset was an essential advisor, ensuring a beautiful printing. Michele Benjamin, who designed the *Fertile Crescent* web site, was as imaginative and knowledgeable as one would like a web designer to be. Ilana Rose Cloud worked endless hours entering the final texts and images accurately and ingeniously into Michele's architectural infrastructure. We are grateful as well to Andrea Smith for her effective work as publicist for *The Fertile Crescent*.

Without the funding provided by the National Endowment for the Arts; the Andy Warhol Foundation for the Visual Arts; the Artis Foundation, which helped fund the participation of the five Israeli artists in the exhibition, Ofri Cnaani, Ayana Friedman, Efrat Kedem, Sigalit Landau, and Ariane Littman; the New Jersey Council for the Humanities, a state partner of the National Endowment for the Humanities; the Violet Jabara Charitable Trust; the Harris Finch Foundation; Rutgers and Princeton Universities; the Institute for Advanced Study; the Arts Councils of Princeton and West Windsor; and support from the additional partner institutions listed above and from individuals, particularly Basem and Muna Hishmeh, this project would not have taken place.

We acknowledge from the bottom of our hearts the staff of the Institute for Women and Art, who were indispensable to the realization of *The Fertile Crescent*. Connie Tell, Deputy Director and Manager, The Feminist Art Project, set up grant accounts and managed the financial aspects of the project. Nicole Ianuzelli, Director of Operations and Manager, Dana Women Artists Series, installed the portions of the exhibition held in the Rutgers venues and facilitated the transportation and mounting of the exhibitions at the Princeton locations. With grace and patience, Leigh-Ayna Passamano, Curatorial Assistant, accomplished the mammoth task of developing the checklist of works; collecting the images, biographies, statements, and captions for the catalogue; and acting as liaison among the curators, the copy editor, and the artists. Rubab Hassan, student intern, researched the bibliography, identified and developed lists of student organizations at Princeton and Rutgers and statewide community groups and their representatives, thus providing a means to reach out to participants, potential audiences, and co-sponsors for events. In addition to her work on the *Fertile Crescent* web site, Ilana Rose Cloud, along with Nicole Sardone, both recent graduates of the Visual Arts Department at the Mason Gross School of the Arts, assisted in so many ways to make this project happen. We also thank Yulia Tikhonova, who was Assistant Curator during part of our exhibition development period, and Nicole Plett, who helped secure the funding from the National Endowment for the Arts.

Judith would like to append an additional thank you to her husband, Michael Curtis, one of whose specialty fields is the politics of countries in the Middle East, for his wise counsel and enthusiastic support throughout the years of development that this undertaking required.

Judith K. Brodsky and Ferris Olin
Co-directors, *The Fertile Crescent: Gender, Art, and Society* project; Co-curators, *The Fertile Crescent: Gender, Art, and Society* exhibition; and Co-directors, Rutgers University Institute for Women and Art

Essays

The Fertile Crescent: Gender, Art, and Society
Unavailable Intersections

By Judith K. Brodsky and Ferris Olin

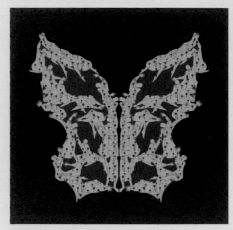

PARASTOU FOROUHAR
Ashura Butterfly, 2010

In this essay, we want to describe the concepts that led us to organize this exhibition of works by women artists who address their complex legacies from the various countries of the Middle East, and who, in the words of Afsaneh Najmabadi, present us with "unavailable intersections."[1]

In founding the Rutgers University Institute for Women and Art, we determined that an integral aspect of our mission would be to spotlight women artists from around the globe. Our goal is to bring these artists to visibility in the American university community as well as the American general public. Five years ago, we mounted two exhibitions on women artists from Southeast Asia. In conceiving our next exhibition of artists identified with cultures that originated in parts of the world other than Western Europe, and, aware of the need for more education on and familiarity with the arts of the countries in the Middle East, we decided to initiate this show. This has been a long and complicated journey. The work of the artists has changed throughout this time, as has the world itself. Five years ago, 9/11 was one of the defining events of the period. As of the publication of this catalogue, the critical event for this era may be the Arab Spring revolutions of 2011.

A word about the title of the exhibition, which is meant to be interpreted as a pun on the essentialist concept of women. Both of us are of a generation when United States schoolteachers introduced ancient history to their third- or fourth-graders by referring to the Middle East as "The Fertile Crescent"— the part of the world where agriculture originated. As we began planning this show, we remembered that

phrase and thought it might catch people's attention and provoke reflection. Our objective is to create an environment in which women are not essentialized, and in which diversity and individuality of cultures are not subsumed under a single umbrella. We anticipated that people would understand that the reference was ironic and that, on seeing the exhibition, they would realize that we were aware of its double meaning and colonialist associations when used in conjunction with women from the region active in the cultural sphere.

The University of Chicago archaeologist James Henry Breasted coined the term "Fertile Crescent." As Kelly Baum explains in her essay in this volume, Breasted's work paralleled the swelling imperialist aspirations of the European countries and the United States to control the Middle East. Yet it was largely due to Breasted's *Ancient Records of Egypt*, published in 1906, that the early world of the Middle East and North Africa became familiar in the United States to both scholars and the general public, who, up until then, had thought of Greece and Rome as the primary antecedents to the development of European culture. The popularity of Breasted's writings resulted in Americans' widespread recognition of the crucial role played by the people and countries of the Middle East in the development of language, agriculture, law, art, and the other aspects of what we call civilization, despite their simultaneous acceptance of Orientalist stereotypes that posited a view of the Middle East as inferior to the West. American museums began to display artifacts of this world as prominently as they did Greek and Roman art;

DI GHADIRIAN
m the series *Miss Butterfly*, 2011

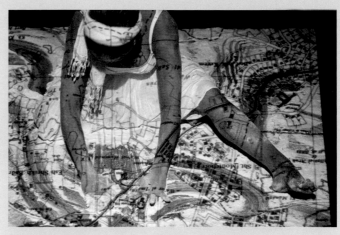

ARIANE LITTMAN
Still from *Mehika/Erasure*, 2006

colleges and universities included units on ancient Mesopotamia and other ancient Eastern Mediterranean cultures in their curricula, and, as noted above, even schoolchildren like us came to know about "The Fertile Crescent."

Our curatorial journey began with our research on women artists from the various countries of the Middle East. Ferris Olin had attended the Istanbul Biennal in 2007 and came home excited about the artists she had observed. She brought them to the attention of Judith Brodsky, and it was at that point that the concept of this exhibition was born.

Identifying which artists to feature in the show was the next step; we did so by several means, largely by examining printed catalogues and resources available on the Internet. Faced with a multitude of artists from a dozen different countries, the handling of a wide range of themes, and a broad scope of artistic approaches and perspectives, we realized that we would not be able to include all the artists, nor all of the topics we had encountered. We therefore decided that the exhibition should focus on illustrating the heterogeneity of countries, cultures, and individualities of each artist. We realize that our overview may be simplistic, but we hope that it will rouse interest and reflection. We came to understand that the Middle East is not a unified culture, any more so than the countries of North America—the United States, Canada, and Mexico. Artists have different heritages, different languages, different contemporary situations, but, at the same time, like the North American countries, they also share certain histories and cultural aspects. In fact, if there is any one

theme that runs through *The Fertile Crescent*, it is this concept of "unavailable intersections." The world as presented by these artists is one of unfixed identities and fluctuating social contexts. They present critically insightful explorations into the complexities of the intersections of contemporary culture, history, gender, and power, revealing that these considerations result in "unavailable intersections."

The initial idea was to limit the show to artists who deal with gender and sexuality. We were familiar with the exhibitions mounted over the last decade presenting artists whose work is concerned with deconstructing Western stereotypes of Middle East women. But even that category became complicated, as each artist approaches this issue from her individual perspective.

We ultimately selected several artists who contend with deconstructing Orientalist stereotypes of the female body. The most sexually explicit works are those by Ghada Amer and her collaborator, Reza Farkhondeh. In their drawings of women derived from pornographic publications, the sexually engaged figures contrast with images of Middle East women wearing hijabs, chadors, and burkas—the types of representations that usually appear in the Western media. Their images are ambiguous. Fulfilling the concept of unavailable intersections, they can be interpreted as critiquing Orientalist stereotypes, questioning religiously inspired Muslim restrictions on women's dress, or perhaps flouting the separation between high art and pornography. Amer's collaborator, Reza Farkhondeh, is a male. We visited her studio and met with both. Amer told us that their

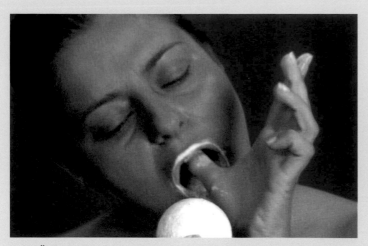

EBRU ÖZSEÇEN
Still from *Jawbreaker*, 2008

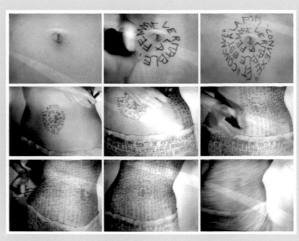

NIL YALTER
Stills from *The Headless Woman (Belly Dance)*, 1974

collaboration was "post-feminist," in that neither dominates the other: another unavailable intersection. The two artists work on canvases and drawings simultaneously. Amer sets down the female figures; Farkhondeh covers them with lush flowers and foliage; Amer then embroiders over the layers to finish off the work. It did occur to us that their way of working was a sexual act in itself.

Ebru Özseçen's *Şerbet* (1999–2010) shows pastries kept moist by syrup poured, scooped up, and repoured, echoed by film passing from projector to floor to ceiling and back to the projector: "a Love Elixir . . . romantic experiences humanizing the dessert, as if it were a living being." In *Jawbreaker* (2008), a woman sucks a candy. Özseçen explains, "The sound is important in the transformation of . . . the jawbreaker into a submissive fetish . . . I love to watch the members of the audience and see how they move to the sound and . . . respond when they realize the source."

Hayv Kahraman paints in a style derived from Persian miniatures, although on a much larger scale. Her elegant, sinuous depictions of women's bodies often show women in harem-like situations. Kahraman may be critiquing the Orientalist view of Middle East women as sexual objects readying themselves for the male gaze—they are all pictured grooming themselves with combs or other grooming implements— but they can also be viewed as pleasuring each other through their sensual grooming activities.

Nil Yalter, who describes herself as Turkish/French, is a feminist pioneer who participated in some of the earliest feminist actions by women artists living in Paris in the 1970s. Her video *The Headless Woman*

(Belly Dance) (1974) is a take on Orientalist illusions surrounding the female body. The dancer's gyrating abdomen fills the screen, cutting off a view of her head. The text of a feminist manifesto demanding sexual rights for women is written over the dancer's body and becomes legible as she twists.

Negar Ahkami upends the Orientalist trope of the nineteenth century by painting Iranian women as they are today in the real world—very different from the odalisques of Ingres or Delacroix. Although mostly nude, they engage in everyday activities: painting their fingernails, reading magazines, gossiping, petting a cat that sits on one of their laps. Ahkami situates them in a setting of couches, which form a prison-like enclosure, not unlike a metaphor for a harem; but in this case, the prison is that of perception, in which they are not seen for the real women that they are. At the same time that she critiques Western attitudes toward the Fertile Crescent countries, Ahkami also critiques the Iranian class structure and the way in which wealthy Iranians have succumbed to Western consumerism and ostentation. The sofas in her paintings and in her installation *Suffocating Loveseat Sectional* (2007) are eighteenth-century French in style; she sees them as a metaphor for the pretentious taste displayed by many Iranians, now wealthy through oil, both those who live in Iran and those who are transnational.

Five years ago, when we began planning this exhibition, many women artists from Middle East countries were challenging Western hegemony and Orientalism through the image of the veil, pointing out the complexities of interpretation. The West sees the veil

...A FARKHONDEH AND GHADA AMER
...nge Dream, 2007

PARASTOU FOROUHAR
Freitag (Friday) (detail), 2003

PARASTOU FOROUHAR
Swan Rider IV, from the four-part series *Swan Rider*, 2004

as a universally oppressive garment, but in the various regions that make up Islamic culture, the veil has many meanings. Parastou Forouhar's *Freitag* (Friday) (2003) is one such example. The chador becomes a wall curtain extending over a large, flat surface. In the middle of the curtain, a hand emerges from the folds of the fabric. Depending on the political and intellectual context in which the image is viewed, the hand can signify the presence of the body underneath the chador, thus disrupting the Orientalist conflation of the woman with her garment. It also can be a sign of her sexuality, given the position and shape of the hand.

Throughout the course of the five years of working on the exhibition, we saw changes in the work of artists who are dealing with gender issues. While they continued to work with gender, they began to use a variety of images and narratives besides the veil. The vulnerability of women emerges as a central theme in Shadi Ghadirian's *Miss Butterfly* series (2011), consisting of fifteen photographs of a single woman in interior settings in which the woman is isolated. Ghadirian aims the camera shots high, to emphasize the prison-like walls of the rooms in which the woman is enclosed. Webs are visible in most of the photographs. In her description of the series, Ghadirian tells the story of a butterfly who is caught in a spider's web. Impressed by the butterfly's beauty, the spider tells her that if she brings him other insects, he will help her escape. The butterfly doesn't want to betray the other insects and offers herself, instead. The spider is so moved by her courage that he ultimately allows her to escape.

The butterfly is also a thematic element in Parastou Forouhar's work. In a series of images, Forouhar uses outline figures of subjugated nude women, pinned like a collection of insects, in a repetitive wallpaper design, to create patterns on the wings of butterflies. The butterflies fill the space of the paper surface in confrontation with the viewer, like a shield protecting the women who make up their bodies. The identification of woman as butterfly suggests a fragility that is simultaneously heroic. Forouhar's parents were assassinated in 1998. As Forouhar explains in her statement in this catalogue, *parvaneh* is both the Farsi word for "butterfly" and her mother's first name.

In another set of works, titled *Swan Rider* (2004), Forouhar based a series of photographs on the narrative of Leda and the swan. Women in black chadors are travelling on the backs of white swans that are actually not real swans, but swan boats. Forouhar lives in Berlin, and these images are partly satires on Wagner's opera *Lohengrin* and German folktales, as well as commentaries on Orientalism. In Forouhar's iconography, the story is transformed. The women are not being overpowered or controlled by the swans. Rather, it looks as if the women have tamed the swans and are riding them like horses. Like so much in this exhibition, these images can be read on many levels depending on the context of the viewer.

The exhibition includes another group of works in which artists critique the status of women in their own countries. In the performance *Lifting a Secret* (2009), the Turkish artist Nezaket Ekici reads aloud

NIL YALTER
The AmbassaDRESS, 1978

LAILA SHAWA
Refraction of Paradise, from the twenty-nine part series
Sarab, 2008

ARIANE LITTMAN
Still from *The Olive Tree*, 2011

from her adolescent diary, in which she expresses her feelings about the marriage that her father has arranged for her. As she describes the situation, she becomes more and more angry. While she has been speaking, she has also been drinking a cup of coffee. Her anger erupts violently when she flings the liquid in her cup at the wall. As the coffee drips down the wall, it reveals words from her diary that she wrote on the wall in petroleum jelly before beginning the performance. She refills her cup over and over again, slapping the coffee against the walls until her words have emerged across the entire surface. Shirin Neshat's series of photographs *Women of Allah* (1993–97) is an early feminist intervention into the social/political construction of Iranian women from the perspective of an Iranian woman living in exile. The photographs consist of various parts of Neshat's own body in a chador, with Farsi text inscribed across her face, hands, or feet, often with a gun barrel placed across the image.

Diana El Jeiroudi critiques the status of women in Syria by comparing the Fulla doll (the Syrian version of the American Barbie), and the marketing statements that accompany it, with a young middle-class wife/mother in Damascus and the social/religious values that shape her life. El Jeiroudi says that the Fulla doll, which comes in a box wrapped in cellophane, is a metaphor for this young woman's restricted life.

The significance of women's dress in relation to the construction of gender is not confined to the consideration of the veil. Ayana Friedman's video *Red Freedom* (2008) illustrates this point. A woman is

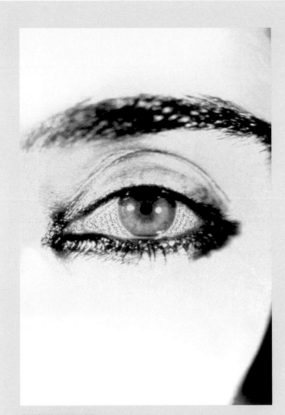

SHIRIN NESHAT
Offered Eyes, 1993, from the eleven part series
Women of Allah, 1993–97

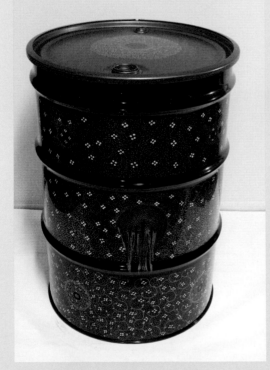

SHIVA AHMADI
Oil Barrel #9, 2011

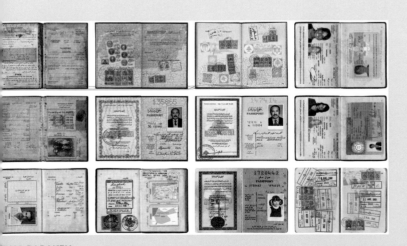

EINA BARAKEH
assport details from the series *Third-Half Passport Collection: M.E. Transit*, 2012

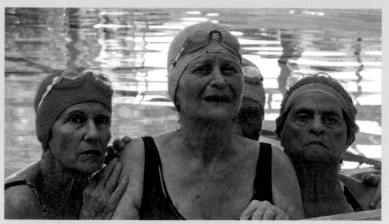

OFRI CNAANI
Still from *The Sota Project*, 2011

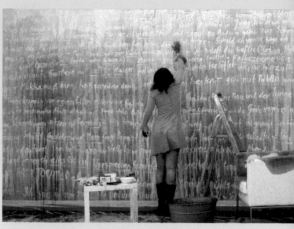

NEZAKET EKICI
Still from *Lifting a Secret*, 2009

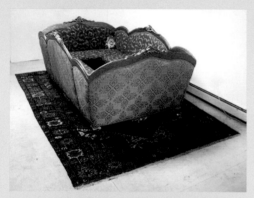

NEGAR AHKAMI
Suffocating Loveseat Sectional, 2007

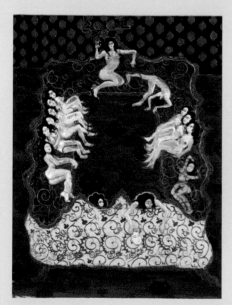

NEGAR AHKAMI
Hamam Harem Louis Quatorze Chaise, 2005
(Not in the exhibition)

clothed in an immense red dress. Its hem extends far beyond her feet and forms a train. The swirls of fabric become part of the action as she moves about. The dress becomes a signifier for women's lives, complicated by social constructs. Women's clothing also figures as the central element in the installation by Nil Yalter entitled *The AmbassaDRESS* (1978). The focus of the installation is a white satin evening gown from the 1920s by the French designer Jeanne Lanvin. Yalter counteracts the symbolically empty dress through an installation consisting of drawings, photographs, and a video that provide a more expansive view of the life of the woman who might have worn the dress. In her multifaceted works mimicking Byzantine icons, Monira Al Qadiri challenges the patriarchal dominance of heterosexuality as the norm in both East and West, as well as art-historical narratives and narratives of dress, through self-portraits in which she assumes the role of a man, moustached and wearing garb that can simultaneously be interpreted as a chador or a monk's robe.

In *Mehika/Erasure* (2006), Ariane Littman's performance and video work about contested territory, a map is screened over the artist, inscribing itself on her white dress and thereby showing how gender and other themes are commingled. We were ourselves aware of this commingling, and, as time went on, the focus of the exhibition became as intricate as the group of artists we had selected. We therefore decided to include examples of artists who were investigating contemporary geopolitics and natural and economic resources, alongside their intersection with gender. In a style based on Persian miniatures, Shiva Ahmadi

AYANA FRIEDMAN
Still from *Red Freedom*, 2008

MONIRA AL QADIRI
Still from *Wa Waila* (Oh Torment), 2008

paints on oil barrel drums. She references Iranian cultural history in an ironic commentary on the oil that underlies the economies and politics not just of Iran, but of the world. Littman's *Olive Tree* (2011) focuses on an olive tree, dead because it exists at an Israeli checkpoint. The video follows her as she wraps the tree in bandages. She then wraps her own feet in bandages as well, caring for the wounds in both the land and on herself. In a reference to contested borders, Sigalit Landau's video *Dancing for Maya* (2005) shows two women on the beach drawing a line in the sand, a visual representation of the adage about the impermanence of drawing lines in shifting sands. *Third-Half Passport Collection* (2012), Zeina Barakeh's installation of archival inkjet prints of the passports of three generations of her Palestinian family, shows how the conflict and conditions under which the Palestinians have lived for several generations have resulted in a displaced population. The passport is a document that stands for mobility and escape. At the same time, it is an expression of borders, gatekeeping, restrictions, and bureaucracy: elements of political and territorial power.

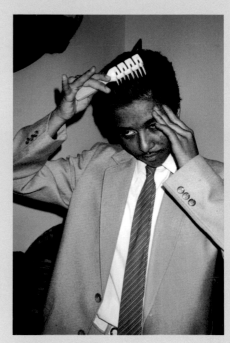

FATIMA AL QADIRI
Bored (detail), 1997, 2008

Although frequently working in video and sculpture, Laila Shawa returned to painting several years ago in response to the expansion of Dubai in recent decades. At first glance, these paintings, removed from the specific Middle East context, look like contemporary versions of Arab decorative patterns. But Shawa has another goal in mind. She introduces elements, such as floral or jagged abstract shapes, that have no resolution into a formal design, and coloration that also contrasts with the traditional Arab aesthetic. Shawa characterizes her work as a critique of the large-scale construction of Dubai. She believes that the city has been erected under the influence of Western consumerism, and has no roots in Arab culture.

Ofri Cnaani's *Sota Project* (2011), derived from the Talmud, narrates the story of Sota, a wife accused of adultery, who is required to undergo a trial in which she must drink a poison. If she is pure, she will survive. But if she is guilty, her abdomen will explode, cast out the resulting fetus, and she will

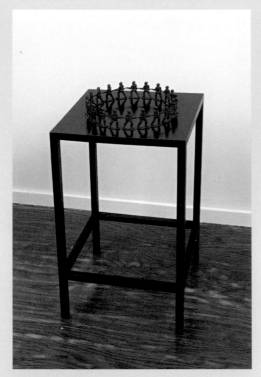

MONA HATOUM
Round and round, 2007

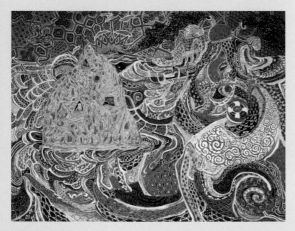

NEGAR AHKAMI
Hot and Crusty, 2011

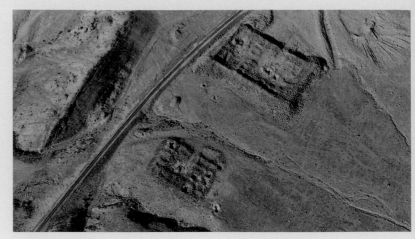

JANANNE AL-ANI
Still from *Shadow Sites I*, 2010

and the influence of Western consumer standards on Kuwaiti values through the video *Mendeel Um A7mad (NxIxSxM)* (2012), in which four young transvestite men impersonate wealthy Kuwaiti matrons. The four men/women sit in an elaborate ballroom, parodying the Kuwaiti equivalent of the "McMansions" built in the United States during the economic boom of the last years of the twentieth century and the first years of the twenty-first. They are participating in the daily ritual of drinking tea before lunch, separate from the men, who have their own ritual space. Reminiscent of reality television, they gossip about family, friends, and their daily activities. Every now and then, they rise from their chairs to take a tissue from a giant tissue box in the middle of the ballroom, mocking the Kuwaiti middle-class obsession with cleanliness.

Foucault famously exposed the power of surveillance in *Discipline and Punish: The Birth of the Prison*. Using a Foucaultian tactic, Jananne Al-Ani displaces the Orientalist paradigm of the lifeless desert in her video *Shadow Sites I* (2010). Through aerial photography, the patterns of ancient cities that lie beneath the sand become visible, revealing the rich history of the desert as holding the remains of great ancient civilizations, rather than the barren wasteland equated in the Western imagination with a belittling view of the Middle East. Efrat Kedem also interrogates surveillance in *The Reality Show* (2012), her installation of cameras at various street corners throughout the town of Princeton, New Jersey. Visitors to the Taplin Gallery could view the activity taking place on those street corners, through monitors placed at that gallery. When one considers the fact that Kedem

die. She goes to her sister, who takes her place and survives. But in the end, Sota does die when her sister kisses her—the poison is still on her lips. Sota dies from sisterly love. Her sister then commits adultery, herself—with Sota's husband. As we considered this story from outside the region, it seemed to reflect the ambiguity surrounding Israel itself, another example of unavailable intersections.

Fatima Al Qadiri satirizes Kuwaiti gender attitudes

AT KEDEM
from *The Reality Show*, 2012

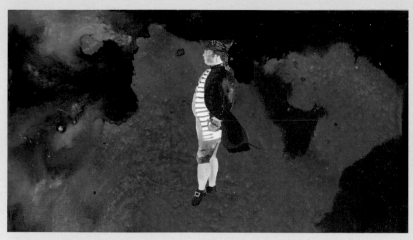

SHAHZIA SIKANDER
Still from *The Last Post*, 2010

is Israeli, her transfer of surveillance, which is a daily occurrence in Israel, to the placid university town of Princeton, becomes subtly ominous.

We were also made aware by colleagues at Rutgers in the fields of African and South Asian studies of how much the histories and cultures of Middle East countries are interwoven with countries in Africa and Asia, and we thus felt that it was essential to reference those countries while still keeping the primary focus on countries actually in the Middle East. As a case in point, we decided to include two artists from countries in Africa and Asia: Fatimah Tuggar and Shahzia Sikander. Tuggar's birth country, Nigeria, is the African nation with the highest percentage of Muslims. She now lives in the United States, adding another dimension to her life and work. Tuggar's method of working reflects her multi-faceted identity. Through her art, she deconstructs the concept of a homogeneous Africa and the nostalgia associated with it. She creates collages, for instance, from photographs of black women in Muslim or tribal dress, contrasted with images of white middle-class women. Sikander has used the Middle East legacy extensively. The work with which she first became well known was based on the style of Persian miniatures. Sikander was trained as a traditional miniaturist at the National College of Arts, Lahore, Pakistan. She recontextualizes the tradition of Indo-Persian miniature painting by using a contemporary iconography in which she combines Hindu and Muslim images along with aspects of contemporary life.

Besides "unavailable intersections," another rubric that might apply to the artists in this exhibition is that of transnationalism. Many of these artists live outside their countries of origin, in New York, Berlin, Paris, London, and other cities of the world. Some were even born elsewhere and identify with (or are sometimes torn between) their countries of origin and their birth countries. Such is the case of Negar Ahkami, who explains that her paintings are narratives based on the conflict she experiences between her Iranian heritage and her transnational geographic existence. She was born in Baltimore, but is assumed by everyone she meets to have an Iranian identity. Her paintings include references to Persian culture, both historical and contemporary; to the condition of women; and to the transnational experience. They are often set in a metaphorical sea. Her edifices melt into the sea, and her skies are filled with Islamic patterns. Her human figures are small in the immensity of the sea, which becomes a signifier for the shifting culture that occurs in the transnationalism that exists today. Another aspect of Ahkami's work that she talks about, is her disengagement from religion. Mosques sink into the ocean and disintegrate, perhaps a visual image for the loosening of religious restrictions in a secular world.

In his attempt to assemble an overall theory, Homi Bhabba used the term "hybridity" to describe post-modern, postcolonialist cultural production in non-European and non-United States countries. To return to an indigenous culture would mean defining societies by supposedly innate traditions. Those cultures would then perpetuate the second-class status they had endured under colonial rule. For Bhabha, the only answer is to recognize that a new culture emerges from

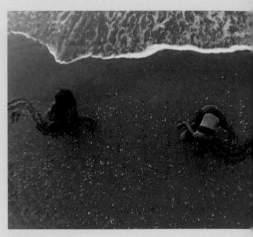

DIANA EL JEIROUDI
Still from *Dolls: A Woman from Damascus*, 2007–08

SIGALIT LANDAU
Still from *Dancing for Maya*, 2005

the interaction and conflict between colonial powers and colonized societies, a culture that, in itself, is a form of resistance since it refuses to be defined as either essentialist or colonial. Feminist theorists like Meyda Yeğenoğlu, Deniz Kandivoti, Chandra Talpade Mohanty, and Afsaneh Najmabadi critique Bhabha's theory for assuming a universal subject—one who has been colonized—instead of multiple subjects: women from a plethora of cultures, some never having been colonized, some religious, some secular, and in various stages of modernization; and living in their countries of origin, born or residing in other countries of the Middle East, or in Europe or the United States.

The Middle East has had many complex identities in the imagination of Western Europe and the United States. It is the source of the Judeo-Christian paradigm that began to shape European thought even before the end of the Roman Empire. But beyond the academic world, little acknowledgment is made that what survived of the Greco-Roman world is the product of Hellenistic culture as a whole, rather than that solely identified with Athens or Rome; and that Hellenistic culture is the modification of the precepts of classicism through the concepts and aesthetics of the indigenous cultures of the Eastern Mediterranean rim.

How the European imagination was affected by the Middle East can be seen in so many random manifestations from the last several centuries—Mozart writing an opera called *The Abduction from the Seraglio;* Montesquieu using concepts of government in the Orient to criticize the ancien régime in France; the turban as a symbol of intellectual prowess in Dutch and Flemish portraiture; and the harem paintings of

Ingres and Delacroix, cited above. These are trivial examples, perhaps, but their very inconsequentiality and casual acceptance reveal the impact of the Middle East and the absorption of its history and culture into the Western mindset. As the political scientist Michael Curtis has observed, a number of European thinkers, ranging from Montesquieu and Burke to Marx and Weber, were fascinated by the Middle East and wrote about systems of government, social structure, and economic organization in Middle East countries even though they had never been there.

The artists featured in *The Fertile Crescent* transcend the stereotypes that have arisen about Muslim and Middle East women in Euro-American culture. Some critics have lamented the fact that the Muslim and Middle East women artists, writers, and filmmakers who have become the most popular in translation, in the galleries, or in movie theaters, are those whose cultural expressions fulfill those stereotypes—that Muslim and Middle East women are completely oppressed, that they are the sexual property of men, that their bodies have disappeared under the veil, and that all are compelled to undergo genital mutilation, to name a few. At the same time, there are social and theological restrictions on women that should be and are being explored, as well. The artists in this show investigate the reasons that some Muslim and Middle East women leave their homelands and come to live in Europe or the United States to pursue their creative endeavors.

Like that of so many of the artists in this exhibition, there are multiple readings of Mona Hatoum's work. Hatoum was born in Beirut to Palestinian

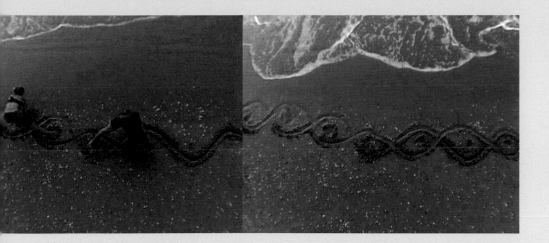

HAYV KAHRAMAN
Leveled Leisure, 2010

parents who were exiled in Lebanon. She identifies herself as a Palestinian. Her work is about the body; ordinary objects that relate to daily life; language; and how the violent power struggle in the outside world transforms beds, chairs, tables, and light bulbs into implements of pain, torture, and isolation. The particular artworks in this exhibition illustrate that impact on each facet. *Projection* (2006), a map in cotton and abaca, uses the Peters projection of the world, which is an unfamiliar view to a Western audience. In this world map, instead of the placement of North and South America in the middle of the image, with Asia and Africa pushed to the edges, the African-Asian landmass occupies the center, while the American continents are off to one side and Europe off to the other. The image in *Projection* presents a positive-negative reversal, where the continents appear like fissures or gaps, as if they have been etched or corroded away. The pair of etchings entitled *Hair and there* (2004) are made using human hair, which has been placed onto the ground of the etching plate in a manner that appears both random and controlled. While one's first reaction to the work is of the pleasure gained from looking at the delicate and beautiful pattern this organic material naturally makes, one is also aware of the etchings as images derived from the debris of the body. Hatoum seems to be using the aesthetic beauty of hair alongside its abject aspect, as something that, when removed from the body, becomes unpleasant, a reminder of the body itself as vulnerable and ultimately discarded in death. That dual quality may be what gives the work its intensity. *Round and round* (2007) is a small table, the sort of occasional table one

puts in a living room next to a sofa. But on the table is a circle of soldiers who are interlocked, as if in a constant march or never-ending battle, permanently connected to one another by the barrels of their guns.

The artists in the exhibition are representative of a complicated state of affairs. They consider themselves inheritors of the culture, values, and beliefs of their individual countries while often living elsewhere, and they deem themselves as also belonging to the nations in which they reside. They represent a new agency, shattering the binary oppositions of colonizer versus colonized, center versus periphery, or global versus local. They are not defined by nation, nor is this exhibition one based on the political divides in the Fertile Crescent. Rather, it is based on a group of meaningful artworks by a diverse group of artists. What is perhaps most striking is the fact that these artists point to the future. They transcend current politics to comment on issues that are global as well as regional and individual. Their points of view look to a complex new cultural entity in the world that at the moment may be, to again invoke Afsaneh Najmabadi's term, an "unavailable intersection."

Notes

1 Afsaneh Najmabadi, "Teaching and Research in Unavailable Intersections," in Joan Scott, ed., *Women's Studies on the Edge* (Durham: Duke University Press, 2008).

Judith K. Brodsky and Ferris Olin are Co-directors, The Fertile Crescent: Gender, Art, and Society project; Co-curators, The Fertile Crescent: Gender, Art, and Society exhibition; and Co-directors, Rutgers University Institute for Women and Art.

The Art of Revolution in Egypt
Brushes with Women[1]

By Margot Badran

Can we speak of a revolution? If so, does this imply that "the revolution" is finished? How do we think about revolution? Define revolution? "The art of revolution" evokes the making of revolution and the making of art. The revolution many want in Egypt extends beyond regime change (yet to be achieved) and political overhaul. It involves broad societal and cultural transformation, including gender and sexual transformation. Using a term that transmits multiple meanings and is picked up differently by different people's antennas is perhaps the best way to keep the dynamics of revolution alive, to keep the art of revolution alive. It is contentious to speak of art in and of the revolution, although provocation can lead to reflection and itself be part of the process of change. More contentious still is to speak of women and revolution. The phrase "brushes with women" alludes to encounters with women who *act,* and to tools women artists use in promoting political and social transformation.

Revolutionary time and space in Egypt is what artists, like others, fill and mark, define and expand. We enter the Egyptian revolution in its zone of possibility and peril, its wondrous porosity, and its arc of uncertainty through the work of women artists, acting as Egyptians, citizens, and, most fundamentally, human beings. The artists visually and verbally narrate the open time and space of the revolution.

The revolution in Egypt is often called a "youth revolution." It is that, for youth spearheaded the uprisings launched in January 2011, and have remained steadfast in the struggles thereafter. It is also more, for Egyptians of all generations, both women and men, are makers of the revolution. In considering the art of revolution, this essay mainly focuses on artists of the youth generation—women artists who were born in the 1970s and came of age in the 1990s—while also considering women artists of earlier generations.[2]

The *silsila,* or chain, of Egyptian women artists goes back to the beginnings of modern art in Egypt, starting with Effat Nagui (1904–1994) and Marguerite Nakhla (1908–1977), who were among the pioneers. The next generation includes Gazbia Sirry (born 1925), a student of Nakhla, and Inji Aflatun (1924–1989), both of whom were born in the aftermath of the 1919 revolution, when first-wave feminism was making its public debut, and who became practicing artists in the middle of the century.

Aflatun combined the roles of artist, leftist activist, and feminist, connecting a staunch anti-imperialist leftist politics with an unwavering feminist politics. She declared in her 1949 book *Nahnu al-Nisa'iyyat* (We Egyptian Women), "The enemies of woman are the enemies of democracy." In her earlier book *Thamanun Milyun Imra'a Ma`na* (Eight Million Women are With Us, 1947), Aflatun, challenging those who raised the specter of religion to put women down, insisted that women's liberation and Islam are compatible. Jailed by the Nasser regime for her political work, she poured out her anguish in paint while in prison. Aflatun retained a lifelong commitment to feminism; following her release from prison, she expressed this commitment in the language of art, which now became her primary means of activism. However, the activist artist also engaged in direct action, conducting consciousness-raising among

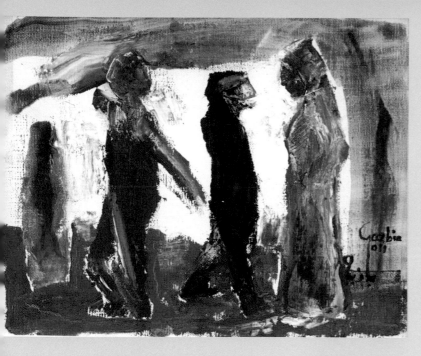

GAZBIA SIRRY
About the January 25, 2011, Revolution, Egypt, 2011
Oil on canvas
13 x 16 1/8 in. (33 x 41 cm)
Courtesy of the Zamalek Art Gallery, Cairo

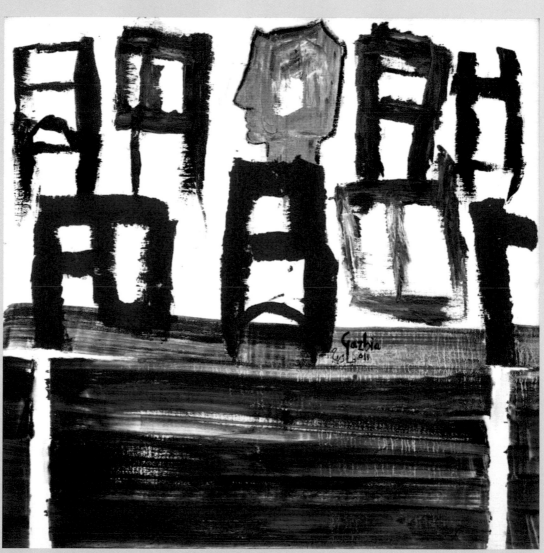

GAZBIA SIRRY
About the January 25, 2011, Revolution, Egypt, 2011
Oil on canvas
31 1/2 x 31 1/2 in. (80 x 80 cm)
Courtesy of the Zamalek Art Gallery, Cairo

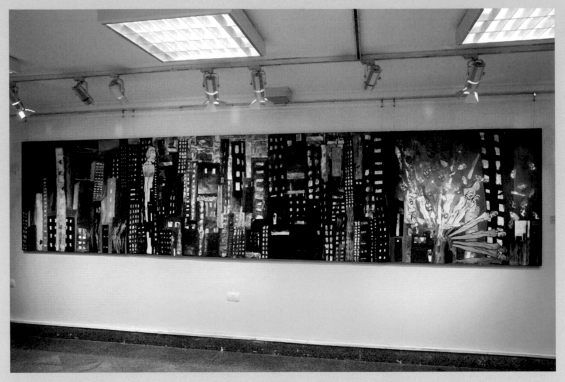

NERMINE EL ANSARI
Black City, 2010–11
Collage and mixed media
47 1/4 x 196 7/8 in. (120 x 500 cm)
Courtesy of the artist

women factory workers with the first-wave feminist Saiza Nabarawi and marching to demand the end of the British occupation of the Canal Zone.[3] Were she still alive today, we can only imagine the anxiety she would experience about the fate of democracy and women in Egypt after the initial revolutionary euphoria.

Sirry, a practicing painter for over half a century, who taught at the Higher Institute for Art Education for Girls and later at Helwan University, training generation upon generation of artists in Egypt, is now an octogenarian.[4] Witness to the revolution underway, Sirry completed a body of work that was recently shown in the exhibition *Time and Place 2012*, at the Zamalek Gallery, Cairo. These paintings express the sense of release, freedom, and joy that were leitmotifs of the early days of the revolution, as well as the anguish that later set in.

The 1970s, when most of the women artists addressed in this essay were born, was a moment of hope and, so it was thought, possibility. Independent voices silenced during the Nasser regime were allowed public expression after Sadat succeeded to the presidency in 1970 following Nasser's death. Students and women were among the first to rush to the fore. A democratic movement spread in the universities, and a resurgent feminism of the second wave was looming on the horizon. In 1972, the physician and writer Nawal Al-Saadawi, who would become a leading figure of second-wave feminism, published *Al-Mar'a wa al-Jins* (Woman and Sex), exposing to public glare what was being done to the female body, but not openly discussed. Al-Saadawi confronted the physical and psychological traumas resulting from incest, rape, genital cutting (which was then called "female circumcision"), and the obsession with women's virginity. The Sadat government rewarded Al-Saadawi for her efforts by expelling her from her position in the Ministry of Health. *Woman and Sex*, meanwhile, gained wide readership in the universities, as Egyptian youth began to articulate the connections between multiple forms of exploitation and abuse of power. Ahmed Abdalla, the student activist leader of the democratic movement, writes of the systematic suppression of the movement, which carries valuable lessons for the present.[5]

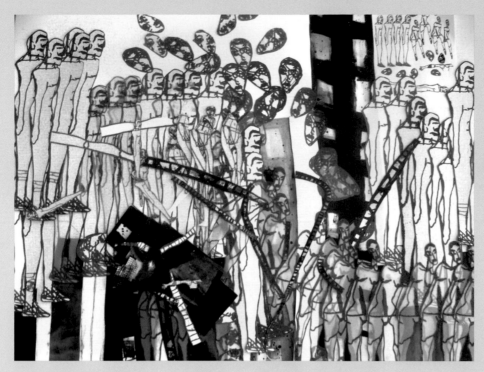

NERMINE EL ANSARI
Collage materials for *Black City*, 2010
Courtesy of the artist

While feminists and Islamists, also muzzled under the previous regime, were allowed public space by the Sadat regime, with its new opening toward the West and reorientation away from socialism to capitalism, the state played these forces off against one another in the interest of maintaining its power. During Sadat's rule, the state, under pressure from Sadat's wife, Jehan, made some modifications to the Muslim Personal Status Code in favor of women (feminists since the first wave had been assiduously calling for reforms). Later, the Mubarak regime, with outside pressures added to the long-term feminist agitation at home going back to the 1920s and coming more recently from women like Mona Zulficar—a prominent lawyer and legal activist steadfastly pressing for reform—granted some concessions to women. Women willing to relinquish all financial claims on their husbands now had the ability to initiate a court divorce through a mechanism known as *khul'*; women no longer needed their husbands' permissions to travel abroad; and women were finally able to become judges. But at the same time, the state, through ever tightening NGO laws regulating the funding and monitoring of projects, kept women's collective activism contained.

Women born in Egypt in the 1970s grew up amid conditions of illusory freedom, marked by red lines that were often like invisible electric fences. Their elders had learned the arts of survival, understanding and internalizing the limits of free action. Those who did not, or would not, most notably Al-Saadawi, paid for their defiance. In such a context, in the absence of any semblance of democracy it was impossible for a feminist movement—like any other liberation movement—to effect change. As the years passed, people coped as best they could, while the corruption, arrogance, and oppression of citizens by the powerful state, with its multiple layers of security, blanketed the country. This created both a sense of resignation and built forms of resistance, as seen in the work of some, especially young, writers in the 1990s,[6] and in the political activism of the April 6 and *Keyafa* (Enough) movements emerging in the early 2000s.

After years of building tensions and simmering anger, a sudden spark blew the lid off the pressure cooker. On January 25, 2011, thousands of citizens poured forth into the streets and converged in Midan Tahrir, unleashing a revolution. If the revolution has yet to bring about fundamental political transformation and basic social and economic demands

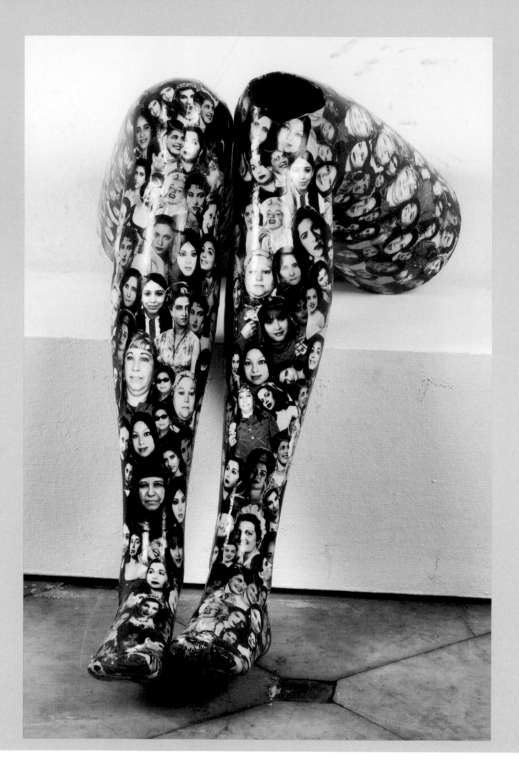

HUDA LUTFI
House Bound, 2008
Mixed media, photo collage,
and mannequin legs
25 x 15 1/2 x 6 1/4 in.
(63.5 x 39.5 x 16 cm)
Courtesy of the artist

have thus far not been realized, the revolution has clearly changed the way people regard themselves, how they want to be governed, what they are willing to live and die for, and what they are not able to tolerate. There is a new context in which Egyptians place themselves, ask their questions, answer back, and understand both the limits of their endurance and their most basic, un-negotiable needs. With special sensitivity and intensity, women artists bring us into the fluid time and space of the ongoing revolution.

Women as visual artists in Egypt today often work in multiple media: drawing and painting, installation, film, photography, and graffiti. Graffiti art in particular has come into its own. It is one of the revolution's most stunning scripts and certainly, along with photography, the most immediate. After

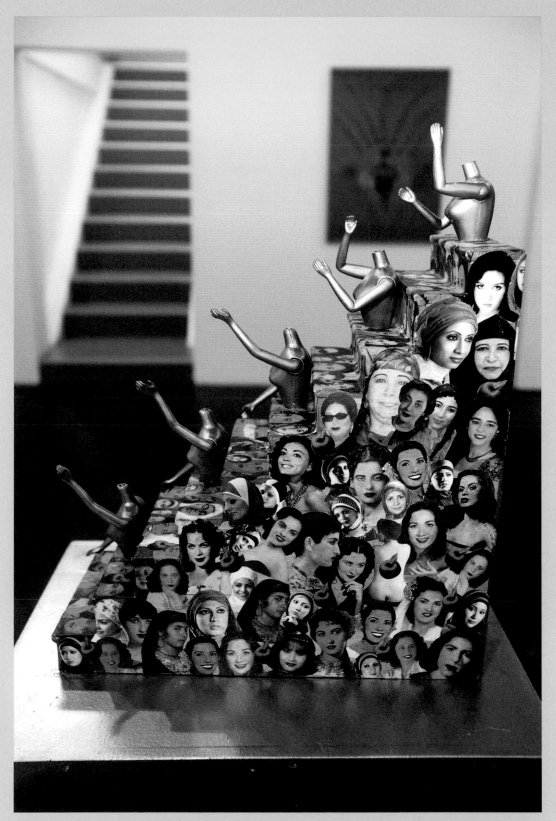

HUDA LUTFI
Going up? Going down?, 2008
Mixed media, painted photo collage, wood, and plastic dolls
17 3/4 x 10 5/8 x 8 5/8 in. (45 x 27 x 22 cm)
Courtesy of the artist

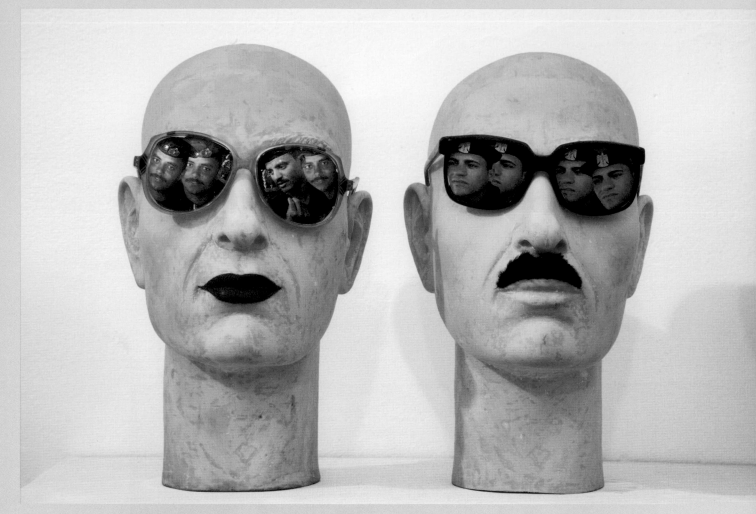

HUDA LUTFI
Lipstick and Moustache, 2010
Mixed media, collage, synthetic resin
sculpture, and plastic eyeglasses
Each 13 3/4 x 6 1/4 x 5 1/2 in. (35 x 16 x 14 cm)
Courtesy of the artist

decades of public expression fettered under the watchful eyes of state surveillance, women and men are quick to spray images and words on walls. When the military and police erect a concrete wall to cordon off citizens, artists paint back the obliterated scene. When security forces brutalize citizens, graffiti artists paint the brutality. The Alexandrian Aya Tarek (born 1989), now legendary in the world of wall art, distills strong messages in her graffiti.[7] In an act of both exposure and answering-back, she spray paints a revolutionary with a microphone head assaulted from behind by a shadowy armed figure. As women and men in Egypt become martyrs to the revolutionary cause, graffitists record their images on walls and buildings near where they fall and multiply their likenesses around the city, creating a commingling of the living and the dead in an intense present.

Scrolling Past and Present

Art in the moment of revolution scrolls past and present in a slippery, fluid temporal and spatial continuum. Film is an especially powerful vehicle for projecting the flow of past into present and its reversal. In her haunting film *In Search of a City (In the Papers of Sein)* (2011) and her intriguing installation at the Townhouse Gallery in downtown Cairo, entitled *Al Khawaga and Johnny Stories* (2011), the painter,

MAY EL HOSSAMY
Two Faces
Courtesy of the artist

AYA TAREK
Mural poster for the film
Microphone, 2010, by
Ahmed Abdalla
Graffiti by Aya Tarek
Courtesy of Tareky Hefny

photographer, and filmmaker Hala Elkoussy (born 1974) creates works that speak to each other as they unite past, present, and future longings.[8] The projects begun before the outbreak of the revolution and continuing afterward capture the fluidity of experience and reflection in this liquid temporal continuum. In *In Search of a City,* the artist-narrator creates the character of Sein (which means "X") and lets her loose in Cairo, with memory serving as her GPS. Sein weaves back and forth between past and present, "looking for what is lost, what is missing." The Townhouse Gallery installation displayed the visual and textual sources from which *In Search of a City* was made; the artifacts were hung on painted walls and laid out on a long wooden table, making the gallery visitor feel as if she had entered a study *(not illustrated).* In my recent interview with the artist, Elkoussy explained:

Archiving is the product itself . . . It is my way of telling you I have read the materials you see

in a particular way. It is one way of opening up the subject. There is no single history or one way of reading. I leave it to you to engage even as I present my views. . . . I find this, in hindsight, a reaction to the state and how it was functioning.

In that same interview, Elkoussy reflected on her generation, the generation which came of age in the 1990s in a stalled society, when in many ways the screw of state control was at its tightest.

We were living in a state of suspense. We were conscious of waiting. But waiting for what, it was not clear. Your whole life could have continued this way because you were not waiting for anything, really. The break came with the revolution. You are still waiting, but now you know what you are waiting for. You know it very clearly.

NADINE HAMMAM
Tank Girl, 2012
Acrylic on canvas and mixed media
66 7/8 x 74 3/4 in. (170 x 190 cm)
Courtesy of the artist

She confessed,

It is extremely difficult now. All the skills you accumulated over the first half while you were waiting are of no use to you now. The waiting before the revolution was not consuming me. I was doing my art. I found my own space where I could circulate. It is not comfortable to wait any longer. What is going on is so assaulting to your senses.

Even as the revolution opens up new space and new visibility, the change of consciousness that comes with the revolution, experienced with

NADINE HAMMAM
Got Love, 2011
Acrylic on canvas and mixed media
65 x 45 1/4 in. (165 x 115 cm)
Courtesy of the artist

particular intensity by the members of the younger generation, but not only them, elicits its own anxieties. The revolution brings out a certain anger and defiance. It also gives rise to the opportunity to bring back into renewed public scrutiny ideas about the body, gender, and sexuality. Such issues are reflected in Egyptian art of this moment. Is some of the art too raw, too explicit, too political? Says who, and why? However these questions may be answered, this is undeniably a volatile and expressive time.

During the initial uprisings of the Egyptian revolution and for months afterward, women artists, like others, were consumed by their activism. The pause

button was pushed on their art. After such a moratorium, women began returning to their art, each in her own time and way, resuming previous projects and embarking on new ones.

City and Revolution in Fluid Time

The city is both site and stage of the Egyptian revolution. Its *midans* and streets have been captured in myriads of photographs for the world to see. Midan Tahrir, in the center of Cairo, is emblematic of the revolution. Maspero, Muhammad Mahmud Street, and Parliament Street are etched in our visual memories as sites of protest and close-up brutality. A young

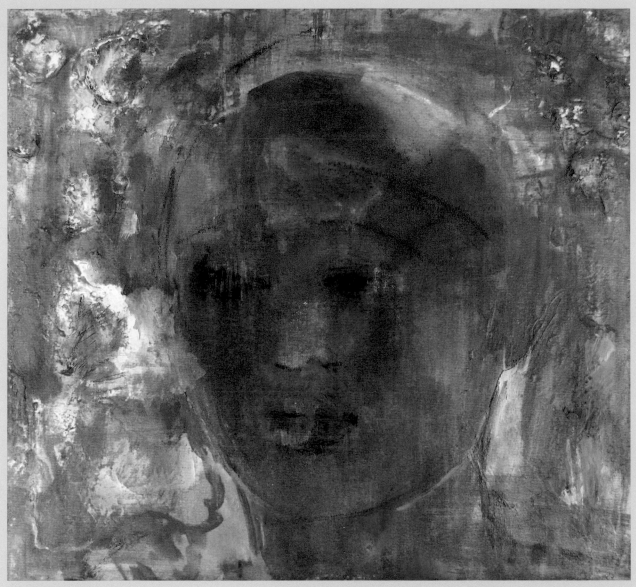

NAZLI MADKOUR
Woman, 2011
Mixed media on canvas
16 1/8 x 17 3/4 in. (41 x 45 cm)
Courtesy of the artist

woman thrown on the asphalt in front of the Parlia-ment, her black *abaya* pulled up, exposing her torso and blue bra, lying prone under the kicking boot of a military policeman, is caught in a photograph that went viral—since known as "The Woman with the Blue Bra." This searing image will not detach itself from the retina of our recent memory.

Nermine El Ansari (born 1975) began painting the densely packed cityscape of teetering towers that make up *Black City* in November 2010, in that taut moment before January 25. Amal Kenawy (born 1974) captures the mounting pressure and stifling suffocation of that time when the lid was heavier than the steam in her 2010 multimedia installation, *The Silent Multitudes,* a rectangular stack of butane gas cylinders. The stack looks like a fortress. It is still. Yet everything is about to explode.[9]

El Ansari completed her *Black City* triptych after the igniting of the revolution.[10] In the first panel, done before the revolution, the specter of a man

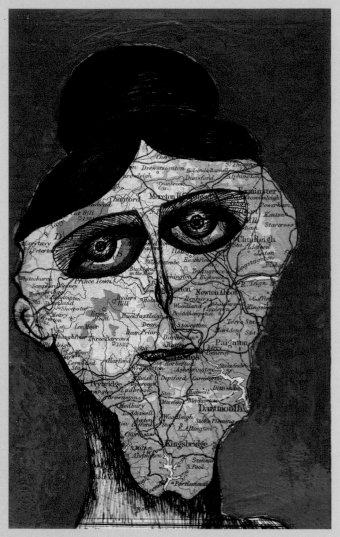

SOUAD ABDEL RASOUL
From the exhibition *Maps Miracle*, Mashrabia
Gallery, Cairo, 2012
Courtesy of the artist

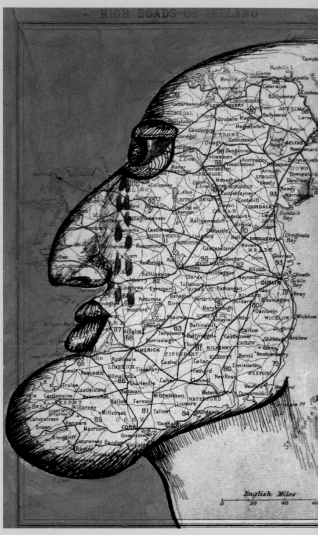

SOUAD ABDEL RASOUL
From the exhibition *Maps Miracle*, Mashrabia
Gallery, Cairo, 2012
Courtesy of the artist

hovers vaporously amid the dark buildings. The artist observed, "The man is like a ghost crossing the black city. At the same time, he is very tall and very real. There are women, also like ghosts crossing the city, but they are far from him, passing as though they are hiding behind the buildings." Recalling the 2010 exhibition *The Invisible Presence: Looking at the Body in Contemporary Egypt,* held at the Mashrabia Gallery, Cairo, El Ansari explains that the theme of this panel

grew out of the notion that we are living in a city where we are not aware of our body. There is this idea that we have no body. We hide our body,

walking in the street as if we have no body. We are conditioned as women to hide our body even if we are not veiled. There are a lot of taboos about the body, about the woman's body.

In the third panel of *Black City,* created after the outbreak of the uprising, the artist paints an explosion of bodies flying and heads tossed about, helter-skelter.

The Body in Question
Who owns the female body? Who portrays the female body? These are questions posed by critics of

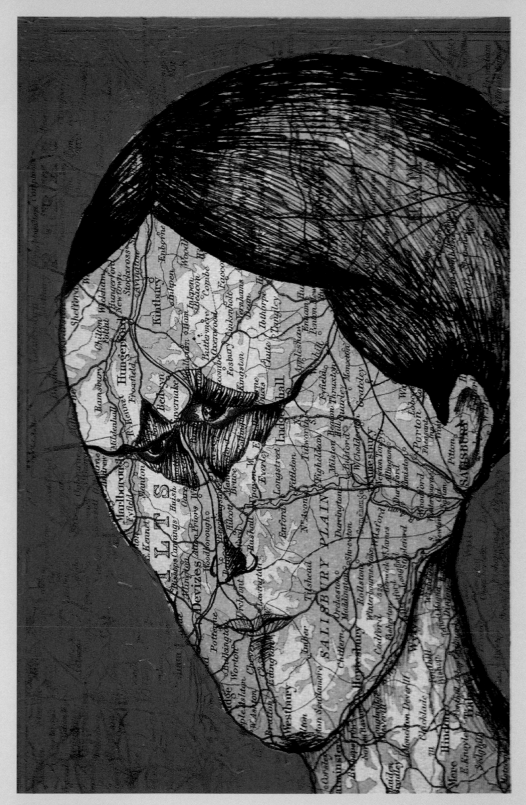

SOUAD ABDEL RASOUL
From the exhibition *Maps Miracle*, Mashrabia
Gallery, Cairo, 2012
Courtesy of the artist

HUDA LUTFI
Crossing the Red Line, 2011
Mixed media, photomontage,
collage, and acrylic
33 1/2 x 74 3/4 in. (85 x 190 cm)
Courtesy of the artist

patriarchy. As elsewhere, the female body was long portrayed by male artists in Egypt. Back in the 1930s, when feminists campaigned for women's admittance to the Cairo School of Fine Arts (est. 1908), they were rebuffed. They were told that art instruction involved studying the nude—a practice deemed culturally scandalous, yet permissible for men—and that the notion of women and men drawing nudes together in the same class was unacceptable.[11] Art instruction in the School of Fine Arts was thus the sole province of men, who then alone were free to depict women's bodies. At mid-century, when the Higher Institute of Art Education for Girls was established, women were able to study the female body. In 1981, under pressure from Islamists, drawing from nudes was banned in state art schools. Gazbia Sirry told me that this occasioned her resignation as a professor of art. However, Egyptian women artists today are freely portraying women's bodies, their own bodies.

The ways men look at women's bodies, or women *as* bodies, concerns Nadine Hammam (born 1974).[12] Hammam observes that men do not see women as multi-dimensional human beings, but instead separate "the woman" out into different persons with different roles—most notably, as mother, wife, and whore—and in different ways, they want to possess them all. Hammam puts the manmade fragments back together. The female figures she renders in graceful, flowing forms in the series *Got Love,* which

she started before the revolution and finished in March 2011, are all the same woman. In her *Heartless* series, done after the outbreak of the revolution, Hammam explores the fraught intersections between love, sex, and desire. These two series, along with the painting *Tank Girl,* discussed below, were exhibited in dynamic juxtaposition in the artist's fall 2011 solo show at the recently opened Gallery Misr, Cairo. The assemblage provided a powerful exposé of the harsh consequences of male constructions and modes of domination of the female body and control of sexuality that are part of the larger regime of suffocating political and social domination.

Gender and sexuality as social constructions are visually rendered with stunning clarity by Huda Lutfi (born 1948), who embraces multiple artistic practices: painting, photography, collage, and installation.[13] Lutfi was trained in the 1980s as a cultural historian, specializing in pre-modern Middle East and Islamic history, and was simultaneously exposed to gender theory as it was evolving alongside the rise of women's studies during the heyday of second-wave feminism. Lutfi was among the earliest excavators of women's past in Egypt and the region. This historical work, as Lutfi told me two decades ago, was both an act of retrieval and an assertion that "we have had a feminism of our own." It served as a clear rejoinder to allegations that feminism is a product of the West.[14]

HUDA LUTFI
Marching on Crutches, 2012
Mixed media, photo collage,
and acrylic
25 5/8 x 78 3/4 in. (65 x 200 cm)
Courtesy of the artist

Lutfi's visual narration of the social construction of gender and of its constraining effects on women, bring viewers to abrupt attention. Take the 2008 installation *House Bound,* displaying a mannequin-like pair of women's legs, upon which the artist pasted pictures of women's heads in the manner of funky hosiery and which she cemented to a white cube. Are these legs that ran free in the marches and demonstrations of 2011? In *Lipstick and Moustache* (2010), another installation representing a playback of gender construction, Lutfi juxtaposes two identical mannequin heads: one face with a red lipstick-painted mouth and the other with a black-painted moustache. Seeing this stunning display reminded me of the words of the first-wave feminist Nabawiyya Musa, who, scoffing at the hyperbole of artificial differences between women and men, wrote in 1922,

"Men have spoken so much of the differences between the man and the woman that they would seem to be two different species."[15]

Also in a deconstructive move, May El Hossamy painted a pair of look-alike male and female faces. In *Two Faces,* the tie hanging beneath the chin of the one with the slightly receding face marks it as male.[16] The artist insists that women are stronger and more responsible than men. "No man wants a woman stronger than himself, but in the end he lets her do the work . . . What does the man do? He is lost." As El Hossamy spoke, I thought how women were so visibly powerful in Tahrir Square during the first eighteen days of protests, as well as afterward. Not invisibly strong inside the house. Was the deep resentment and violence against women manifested in the weeks and months following "the eighteen

days"—including the imposition of so-called virginity tests on female protesters at the hands of the military—triggered by unease at women's powerful public militancy, and politically exploited in the power games that ensued?

A series of images of women's faces appearing to be the same face, with a haunting sense of melancholy and deep-set eyes like black shadows producing the effect of a distant gaze, is the creation of Nazli Madkour (born 1949).[17] Created during the time of the revolution, these canvases were displayed in the artist's solo exhibition *Homage to Women,* in the Safar Khan Gallery, Cairo, April 2012. In my interview with Madkour at the time, she explained that with these works, she wanted to honor women,

> because now [a year and a half into the revolution], women stand to lose whatever little they gained in the past several years. During the revolution, men grabbed women in the streets and asked why they went out in the first place instead of standing by them. The faces painted after the start of the revolution express injustice—centuries of injustice.

In preparation for a Cairo exhibition scheduled for February 2011, Madkour had assembled a large collection of foliage canvases she had been working on for two years. With the outbreak of the revolution, the show was cancelled. Entitled *Heralding Spring* (a more literal translation of the Arabic original—and a more exuberant translation catching the spirit of the moment—would be "And the Spring Came"), her exhibition of floral abstracts, bursting with color, energy, and joy, opened in May 2011 at the Mahmoud Khalil Museum. Madkour later displayed some of the foliage paintings alongside her female heads in her *Homage to Women* exhibition. The juxtaposition formed a tension between exuberance and *tristesse,* mirroring what so many, following the initial euphoria, have come to feel about the revolution, a feeling experienced with particular intensity by women, as seen in the work of Gazbia Sirry.

Madkour also discussed her portraiture in our recent interview. "I paint women in general, not particular women. I do not portray women in the abstract. The work is figurative. I want to reveal the inner feeling of women in Egypt." As Madkour was speaking, I thought of the well-known sculptor Mahmoud Mukhtar, who emerged on the scene after the 1919 revolution, and who used the *fallaha,* or peasant woman, as both the symbol of Egypt and a symbol of modernity. Madkour remarked that, unlike Mukhtar, she is interested in portraying women's inner

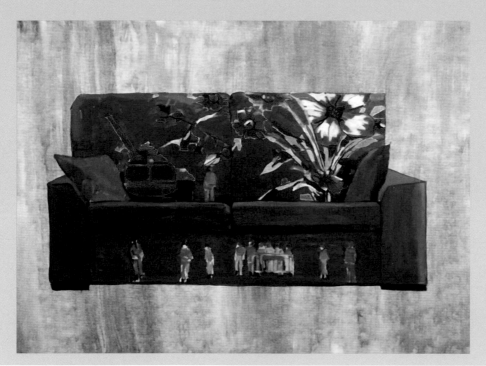

EMAN ABDOU
The Couch, 2012
Acrylic, ink, and oil on canvas
39 3/8 x 59 in. (100 x 150 cm)
Courtesy of the artist

emotions. "Mukhtar was very much caught up with what was going on then: encounters with modernity and the creation of an independent nation. I see Mukhtar's women as figures of power that stand in for something else. My women stand for themselves, for inner life and balance." She stressed, "The issue now is justice."[18]

Souad Abdel Rasoul (born 1974) offers a different approach to portraiture in work also done after January 25, some of which was on display in *Maps Miracle,* her May 2012 exhibition at the Mashrabia Gallery with the Sudanese painter Salah El Mur.[19] With the exception of one of her portraits in the show, Abdel Rasoul's stylized women, with tight, red-rimmed eyes and painted on pages torn from old atlases, gaze sideways or downward. Unlike the others, this one figure possesses a long chin, large eyes, and, wearing an enigmatic expression, stares straight ahead. The artist challenges us, the viewers, to discern what these images are about from clues in their visages.

Abdel Rasoul's men are strikingly different. If her women are "eyes" that we must fathom, her men are "chins" protruding with assertive exaggeration. She paints her women full-face and her men in profile. Two male portraits are particularly arresting, and perhaps tell us something of the still-young story of the Egyptian revolution. One "chin man," with a tracery of map lines visible under transparent skin, sprouts a cascade of red tears falling in two neat lines from a bloodshot eye, his protruding chin serving

as a base for this waterfall. The jutting chin of the other man seems to be a badge of power and superiority, reflected in his smug lips and outward gaze emanating from the dark pits that are eyes. Only the merest trace of the map paper appears on this otherwise smooth, unrevealing façade that is his face *(not illustrated)*. Abdel Rasoul affirms that she uses distortion to bring people to abrupt attention in this fragile moment. "Now, everything is under the control of the men: the army, the Muslim Brothers, the Salafis. They want to shove women aside, to keep them far removed from real life."

Patriarchy and Uniformed Masculinities

During the period comprising the final years of the former police state to the emergence of the SCAF-controlled state following the deposition of Mubarak, Egyptian artists began to confront securitized patriarchy and uniformed masculinity. They did and are doing so through reversals of patriarchal gender prescriptions or "feminizing" as a form of ridicule of hyper-masculinity, unmasking gendered fraud and weakness, and displays of new modes of behavior and action. Masculinity, especially uniformed masculinity—the military and police—is a subject that Huda Lutfi took up both before and after January 25. In the mixed-media piece *Crossing the Red Line,* completed in April 2011, Lutfi superimposes photographs of the heads of women and men in Tahrir Square—including a photograph of the legendary singer and

national icon Umm Kalthum—on the white-uniformed bodies of policemen pacing back and forth over a red line, "as if they are guards protecting the revolution, but they are not armed. Their only implement is the mobile (a ubiquitous tool of the revolutionaries). Their caps carry the logo of the white dove, the symbol of peaceful resistance, and on their arm bands is written *silmiyya* (peaceful)." In this work, the revolutionaries appropriate the state's "red line"—*they* decide when it is crossed. In the massive women's demonstration of December 20, 2011, protesting the military brutality in the incident of "the woman with the blue bra," women carried signs asserting, "Army: our daughters are the red line." In another mixed-media piece that resembles a frieze, Lutfi strings out cropped photographs of the legs of soldiers chasing protestors—and mounts them on crutches.

Tanks have become ubiquitous in the Egyptian uprisings. They appeared all over the streets on February 11, 2011, the day Mubarak stepped down, as "saviors" and "safe-guarders." The military intoned that "the army and the people were one hand." But it soon became apparent that they were not. On the day after the first women's march in honor of International Women's Day on March 9, young female protestors were picked up and physically and sexually roughed up by soldiers in what became known as the infamous "virginity tests." The women were openly subjected to crude "virginity tests" at the hands of the Egyptian military, as an extreme form of humiliation and intimidation. The military claimed, in twisted logic, it acted thus to protect soldiers from accusations of rape.

Hammam's 2012 solo exhibition at Gallery Misr featured the artist's *Tank Girl*. Naked except for a red bra, the eponymous tank girl sits with legs splayed astride a pink tank, whose massive gun juts out in an upward thrust, spewing out rats. Explains Hammam, "The army is using vulgar tactics to discourage women from participating and to humiliate us, virginity tests, etc. The 'blue bra girl' becomes the 'tank girl.' You can beat us, strip us, gas us, arrest, and virginity test us, but in the end we will prevail." Evoking the army's penetration even into the private precincts of home and family, the artist Eman Abdou (born 1975), who teaches at Helwan University, painted a domestic scene in which a tank sits on a couch, accompanied by a tiny soldier standing on the seat of the couch beside the tank, while several other soldiers appear on the skirt below.

It is striking that Egyptian artists at this time have portrayed patriarchy and masculinity in "secularized" form. In a work shown in the 2012 exhibition at the Mashrabia Gallery entitled *A, B...Cartoons,* the silhouettes of a man with a helmet and a woman fully covered *niqabi*-style stand shoulder to shoulder. The words *amna markazi* (central security) are written in blood red on the black male figure, and *amna* (security) is inscribed in the same blood red on the black figure of the woman—both rendered as dark shadows. In this powerful and disturbing piece, Shayma Kamel (born 1980) condenses patriarchy in a militarized/Islamized form as the state "protecting" and "securitizing" the country and citizenry along with women, intent upon keeping the structure and power of (secular and religious) patriarchy intact, and the revolution at bay.

Notes

1 I offer special thanks to the artists discussed in this essay for making time for conversations about their art, the revolution, and other subjects. I thank Stefania Angarano, Director of the Mashrabia Galley of Contemporary Art, Cairo; Mia Jankowicz, Artistic Director of the Contemporary Image Collective, Cairo; Mohammad Talaat, Director of Gallery Misr, Cairo; and William Wells, Director of the Townhouse Gallery, Cairo, for discussions about art in the time of revolution and the Egyptian art scene, and for important leads on these topics. I thank the filmmaker Tania Kamal Eldin for videotaping two of my interviews with artists as part of the film we are making on Egyptian women artists in the time of the revolution.
2 Liliane Karnouk, *Modern Egyptian Art, 1919–2003* (Cairo: American University in Cairo Press, 2005); and Jessica Winegar, *Creative Reckonings: The Politics of Art and Culture in Contemporary Egypt* (Stanford: Stanford University Press, 2006).
3 Author's interview with Inji Aflatun, Cairo, September 17, 1975, and March 1988.
4 Mursi Saad El-Din, ed., *Gazbia Sirry: Lust for Color* (Cairo: American University in Cairo Press, 1998).
5 Ahmed Abdalla, *On the Student Movement and National Politics in Egypt* (London: Saqi Books, 1985).
6 Samia Mehrez, *Egypt's Cultural Wars: Politics and Practice* (Cairo: American University in Cairo Press, 2008); and Caroline Seymour-Jorn, *Cultural Criticism in Egyptian Women's Writing* (Syracuse: Syracuse University Press, 2011).
7 Author's interview with Aya Tarek in Alexandria via Skype from Cairo, May 13, 2012.
8 Author's interview with Hala Elkoussy, Cairo, May 8, 2012; www.halaelkoussy.com.
9 Author's interview with Amal Kenawy, Cairo, May 8, 2012.
10 Author's interview with Nermine El Ansari, Cairo, February 13, 2012.
11 See Margot Badran, *Feminists, Islam, and Nation: Gender and the Making of Modern Egypt* (Princeton: Princeton University Press, 1995), 156–57. First-wave feminists campaigned unsuccessfully for women to be admitted into the School of Fine Arts. This only happened years later.
12 Author's interview with Nadine Hammam, Cairo, May 4, 2012.

13 Author's interview with Huda Lutfi, Cairo, May 2012. A monograph on Lutfi and her work has just been published: *Huda Lutfi* (Dubai: Third Line Gallery, 2012).

14 Margot Badran, *Feminism in Islam* (Oxford: Oneworld Publications, 2009); see chapter 6, "Gender Activism: Feminists and Islamists in Egypt," 160. Information from the author's interview conducted with Huda Lutfi in Cairo, May 22, 1990.

15 From Nabawiyya Musa, *Al-Mar'a wa al `Amal* (Woman and Work) (Alexandria: Al-Matba al Qawmi, 1921).

16 Author's interview with May El Hossamy, Cairo, February 12, 2012.

17 Author's interview with Nazli Madkour, Cairo, April 25, 2012.

18 Following Mukhtar's death in 1934, the pioneering first-wave Egyptian feminist Huda Sha'rawi created a group called "The Friends of Mukhtar," which sponsored annual competitions for young women and men artists. See Margot Badran, *Feminists, Islam, and Nation,* 158.

19 Author's interview with Souad Abdel Rasoul, Cairo, May 19, 2012.

Margot Badran is Senior Scholar, Woodrow Wilson International Center for Scholars, and Senior Fellow, Prince Alwaleed ibn Talal Center for Muslim-Christian Understanding, Georgetown University.

Artists Featured in This Essay

Eman Abdou (born 1974, Cairo) is a visual artist whose work addresses the complex relationship of the state to the domestic realm. She graduated first in her class from the Faculty of Fine Arts, Helwan University, in 2001. Since then, painting has been her primary medium, although she also experiments with, and exhibits in, other media, as well. In 2009, she completed her master's degree from Helwan, writing her thesis on "The Effects of Conceptual Art on Contemporary Art." She is currently an Assistant Lecturer and pursuing her PhD at that university; her doctoral dissertation is entitled "Egyptian Art and its Relation to Politics from 1990 till now." She was in residence at Loughborough College in England in 2004–07, and also participated in the Independent Study Program at the Townhouse Gallery, Cairo, where she studied modern and contemporary art in the Middle East. In 2011, she contributed to the best-selling volume *Egyptian Rights and Duties,* which uses caricatures and humorous colloquial Egyptian language to ironically depict *The International Declaration of Human Rights* and *The Proposal of the International Declaration of Human Responsibilities* as they pertain to the political situation in Egypt.

Nermine El Ansari (born 1975, Suresnes, France) is a painter who also works with graphics, photography, and installation, using photomontage and sound. Her fine arts education began at the School of Fine Arts, Cairo, and continued in France, where she received a painting diploma from the School of Fine Arts, Versailles, in 1998, and a fine arts diploma from the Ecole des Beaux-Arts, Paris, in 2002. She is known for her urban landscapes, while also exploring the architectural design of the media apparatus. Her solo exhibitions include *Ghost City,* Espace Karim Francis, Cairo, 2003; *Exercise,* video installation, KunstrumB Gallery, Kiel, 2006, and Mashrabia Gallery, Cairo, 2007; *Olympic Stadium 2945,* Werkhof, Kiel, 2008; *Transit,* video installation in collaboration with Sherif El Azma, Museo Madre, Naples, and Townhouse Gallery, Cairo, 2009; *Dream and Inverse Dream,* video installation, Artellewa Art Space, Cairo, 2011–12. Significant group exhibitions in which her work has appeared include *Art Protects,* Galerie Yvon Lambert, Paris, 2007, 2009, 2011; *Cairospace,* Kunstlerhaus Bethanian, Berlin, 2008; *Maspero,* Darb 1718, Cairo, 2011; and *Le Corps decouvert,* Institut du Monde Arabe, Paris, 2012. She has been awarded several residencies including the Hweilan International Artists' Workshop, Taiwan, 2005; Kunstlerhaus Bethanien, Berlin, 2008; and a residency for lithography and engraving, Salzau, 2008.

May El Hossamy (born 1974, Cairo) is an artist and photographer. She graduated from the Faculty of Fine Arts at Helwan University and also went on to complete a PhD in fine arts in France. She was among the artists featured in the high-profile exhibition *Maspero,* Darb 1718, Cairo, 2011. In this exhibition, devoted to the Maspero Building, the headquarters of the government-run media during the Mubarak regime, Egyptian artists explored the government's propaganda machine and the ways in which state-run media spins the truth. El Hossamy's work in the exhibition consisted of a grave entitled *Maspero 1960–2011.* Another work by El Hossamy is devoted to the devastating 2010 fire that occurred in one of Cairo's biggest markets, Souq al-Goma'a, leaving many residents of the area homeless. The artist began taking photographs of the Cairo market before the fire, and then continued photographing it afterward, as well as interviewing people about the tragedy. The piece that resulted is a 12-minute video documenting El Hossamy's relationship to the market and showing people talking about their lives since the fire. Her exhibition

of this piece was accompanied by an installation made up of the burnt objects collected from the remains of the Souq al-Goma'a.

Hala Elkoussy (born 1974, Giza) is a painter, photographer, and filmmaker. She studied at the American University in Cairo in 1992–96, and completed an MA in image and communication at Goldsmith College, London, in 2010. In 2004, she co-founded the Contemporary Image Collective, an artist-run, Cairo-based initiative dedicated to the visual image and the promotion of a contemporary visual language. Her many solo exhibitions include *Magda & Nevine: Two Women from Egypt,* Sakakini Centre, Ramallah, 2003; *Peripheral (and Other Stories),* Townhouse Gallery, Cairo, 2005, and Stedelijk Museum Bureau Amsterdam, 2006; and *First Story: The Mount of Forgetfulness,* Göteborgs Konsthall, 2009, and Townhouse Gallery, Cairo, 2010–11. In 2006, she completed a two-year residency at the Rijksakademie van beeldende kunsten, Amsterdam. In 2010, Elkoussy was a recipient of the Abraaj Capital Art Prize. Most recently, her feature film treatment, *Cactus Flower,* was awarded development funding by the Hubert Bals Fund, Rotterdam Film Festival.

Nadine Hammam (born 1974, Cairo) received her BA from the American University in Cairo in English and comparative literature and her MFA from Central St. Martin's School, London. Working in a variety of media, ranging from video installation to oil on canvas, she uses the female nude, often in subtle and suggestive poses, to explore the role and perception of women in society. Her first solo exhibition, *Akl Aish,* was held at the Townhouse Gallery, Cairo, in 2008. Her second solo exhibition, *I'm For Sale,* was held at the Safarkhan Gallery, Cairo, in 2010; featuring multi-layered canvases appearing almost like photographic silkscreens, the work in the show explored the notion of the male gaze and created controversy because of the artist's nude figures. Hammam's work was shown at Art Dubai, 2011, where it was a sensation, as well.

Shayma Kamel (born 1980, Giza) received a BA in psychology from Ain Shams University, Cairo, 2002. In 2006–09, she was Gallery Assistant and Coordinator at the Falaki and Sharjah Art Galleries, American University in Cairo. Her numerous solo shows include *Shayma Kamel,* Saad Zaghloul Cultural Centre, Cairo, 2008; *Intimacy,* Kunst Gallery, Cairo, 2009; *Faces in Time,* Knauer Gallery, West Chester University,

Pennsylvania, 2010; and *A, B...Cartoons,* Mashrabia Gallery, Cairo, 2012. Her many group exhibitions include *Window Women (Shayma Kamel and Marisa diPaola),* Ewart Gallery, American University in Cairo, 2006; *A Mediterranean Trilogy of Contemporary Art,* Athens Centre, 2007; and *Dream,* Ahmad Shawky Museum, Cairo, 2008. She has participated in various artist residencies and workshops, at places such as the Townhouse Gallery, Cairo, 2004; Goethe Institute, Cairo, 2005; and Atlantis Books, Santorini, 2007. Kamel has conducted many art workshops for children both in Egypt and other locales, including St. Croix, Sudan, and Sri Lanka.

Amal Kenawy (born 1974, Cairo) works in various media, including installation, video animation, and painting. She studied at the Academy of Fine Arts, Cinema Institute, Cairo, in 1997–99, and received her BA from the Faculty of Fine Arts, Helwan University, in 1999. She considers her brother, the artist Abd Ed Kenawy, her mentor. She exhibited her first work, a sculptural piece she created with him, at the Youth Salon of 1997, where it received first prize. The two exhibited their collaborative piece *Transformation* at the 1998 Cairo Biennale, where it was awarded the UNESCO Grand Prize. Kenawy's first independent work, the video installation *The Room,* was exhibited in 2002 at the Townhouse Gallery, Cairo. Her video installation *Fighter Fish* was featured in the exhibition *Why not?,* Palace of Arts, Cairo, 2010. That same year, her video installation *My Lord Is Eating His Tail* was exhibited at the Sydney Biennale, installed at the convict precinct of Cockatoo Island. In the piece, based on a short story written by Kenawy herself, the artist interrogates the social stagnation brought on by miscommunication. Kenawy is the recipient of prestigious awards, such as the Global Crossing Prize, Leonardo International Society for the Arts, Los Angeles, 2005; and the Golden Prize, Alexandria Biennale, 2011.

Huda Lutfi (born 1948, Cairo) received a PhD in Arab-Muslim cultural history from McGill University in 1983, and went on to teach at the American University in Cairo. With her second career as a visual artist, Lutfi emerged in the 1990s as one of Egypt's most important contemporary image makers. She has had many solo exhibitions, including *Making a Man Out of Him,* Townhouse Gallery, Cairo, 2010; *Zan'it al-Sittat,* Third Line Gallery, Dubai, 2010; and *Huda Lutfi: Twenty Years of Art,* Tache Art, Cairo, 2011. She has participated in major international group exhibitions, among them *Contemporary Egyptian Art,*

Kunstmuseum, Bonn, 2007; *Trilogy,* Palais des Arts, Marseille, 2008; *Umm Kulthum,* Arab World Festival, Paris, 2008; *Icons Reloaded,* Elysée Arts Gallery, Liège, 2009; *My World Images,* Festival for Contemporary Art, Copenhagen, 2010; and the Frieze Art Fair, New York, 2012. In 2012, the Third Line Gallery, Dubai, published a monograph on the artist.

Nazli Madkour (born 1949, Cairo) holds a master's degree in political economy from the American University in Cairo. Her works fall between abstraction and figuration, exploring an inner world inspired by the Egyptian landscape and often haunted by the women of Egypt. Since 1982, she has had over thirty-five solo shows and has taken part in numerous group exhibitions all over the world, in locations that include Egypt, Sharjah, Bahrain, Kuwait, Lebanon, Germany, France, Italy, Portugal, Holland, Greece, the United Kingdom, the United States, Canada, Ecuador, Japan, and China. Her works can be found in many private and public collections both in Egypt and abroad. Madkour is the author of the book *Women and Art in Egypt* (Arabic, 1989; English, 1993). She illustrated a deluxe edition of the Nobel Laureate Naguib Mahfouz's *Arabian Days and Nights,* published by the Limited Editions Club, New York, in 2005; the book and the original illustrations were first exhibited at the Corcoran Gallery, Washington, D.C., and subsequently shown in Egypt, Holland, Japan, Italy, Switzerland, Canada, and Sweden.

Souad Abdel Rasoul (born 1974, Cairo) received her undergraduate degree in fine arts from the University of El Minya in 1998 and her master's degree in art history from Helwan University in 2005. She has participated in numerous exhibitions, in shows and venues that include the Salon of Small Works, Museum of Modern Egyptian Art, Cairo, 1998; Goethe Institute, Cairo, 2007; Spring Salon, Sakia El Sawy, Cairo, 2007; Gallery Grant, Cairo, 2008; and Misr Gallery, Cairo, 2012.

Gazbia Sirry (born 1925, Cairo) is considered one of the preeminent Egyptian artists, her career spanning more than fifty years. She received her diploma in fine arts from the Higher Institute of Art Education for Girls in Cairo, 1949, and completed postgraduate studies in Paris, 1951; Rome, 1952; and the Slade School of Fine Art, London, 1954–55. She taught in Egyptian high schools in 1949–55, and subsequently at Helwan University, 1955–81, and the American University in Cairo, 1980–81. Since 1950, she has had over seventy-one solo exhibitions in Egypt, other Arab countries, Europe, and North America, and participated in group exhibitions both in Egypt and abroad. She has been the recipient of major accolades such as the Rome Prize, 1952; Honorary Prize, Venice Biennale, 1956; first prize from the Cairo Salon, 1960; first prize for painting at the Alexandria Biennale, 1963; and the Egyptian State Merit Prize, 1999. Her works can be found in museums in Egypt and around the world, including the Institut du Monde Arabe, Paris; Mathaf: Arab Museum of Modern Art, Doha; Metropolitan Museum of Art, New York; Musée d'Art Vivant, Tunis; Museums of Modern Art in Cairo and Alexandria; and National Museum for Women in the Arts, Washington, D.C. A monograph on the artist and her work, *Gazbia Sirry: Lust for Color,* was published by the American University in Cairo in 1998.

Aya Tarek (born 1989, Alexandria) is a graffiti artist, painter, typographer, and designer. She is the founder of the first graffiti artists group in Alexandria, and she also works with advanced design initiatives and illustration. Tarek was featured in *Microphone,* a 2010 Egyptian independent film by Ahmad Abdalla about the underground art scene of Alexandria. The film received the Best Arabic-Language Film Award from the Cairo International Film Festival and the Tanit d'Or from *Journées cinématographiques de Carthage.* In the film, Tarek, twenty-one years old at the time, asserts. "The country is ours again. Public space is ours."

Art, Precarity, Biopolitics[1]

By Kelly Baum

t is all too easy to caricature an exhibition such as *The Fertile Crescent,* organized as it is around "gender" and "regional identity." On the surface, it would seem to posit a shared sensibility, a common aesthetic project, based on biology and geography. From this assumption follow three more, each of them deeply problematic: first, that the meaning of an artist's work is determined primarily by her gender and her regional identity; second, that because they share a gender and hail from the same region, women artists of Middle Eastern descent speak with a uniform voice; and, third, that their unanimity of perspective translates into formal and thematic affinities, all of them transparent and all of them intrinsic to the art in question. Together these assumptions constitute a narrative of exceptionalism, and if they provide the basis on which we are supposed to isolate the joint enterprise of the artists seen here, then we are surely in trouble.[2] First and foremost, neither gender nor regional identity can any longer be understood as secure ontological categories.[3] While feminism and post-structuralism have reframed subjectivity as plural, provisional, and performative, globalization has destabilized regional affiliations, making it harder for citizens to coalesce around a fixed set of beliefs.[4] Working at cross-purposes with these forces are the institutions of war and patriarchy. Via means both material and ideological, the latter "militarize" relations, establishing rigid distinctions between "friends and enemies" and reducing otherwise disparate groups to singular, often odious stereotypes—none more so than "Arabs," "Persians," "Muslims," "Jews," and "women" (to name just some of the constituencies represented in *The Fertile Crescent).*[5] Anyone writing on women artists of Middle Eastern descent, therefore, must take two divergent phenomena into account: first, the deterritorialization of identity in the wake of feminism, post-structuralism, and globalization, and, second, the reification of identity under the conditions of war and patriarchy.

Accounting for the disparate phenomena cited above turns out to be less difficult than one might imagine, since they are the conditions of possibility for the art presented in *The Fertile Crescent.* Indeed, as long as we understand gender and identity as the artists do—as highly contingent formations imperiled by theory and history alike—neither is superfluous to the videos, photographs, sculptures, and paintings seen here. Using different means and reflecting a variety of perspectives, many of these works serve as sophisticated, often poignant meditations on the vagaries of "attachment" in the twenty-first century. Some scrutinize the spurious coherence of gender and regional identity, while others dissect tenacious stereotypes about femininity and the Middle East. Others still pose provocative questions about community and commonality. What, if anything, links people from "The Fertile Crescent"? What does it mean to be a woman in (or from) the Middle East? How are identifications at the level of gender and region complicated, even contradicted, by those of class, sexuality, ethnicity, and nationality?

Precarity

Cognizant of the tendency to frame art by women and non-whites exclusively in terms of gender and

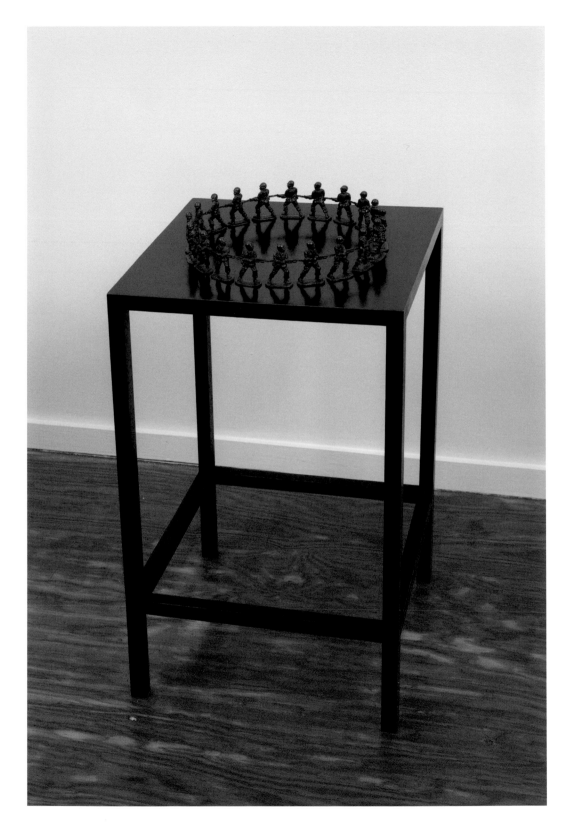

MONA HATOUM
Round and round, 2007
Bronze
24 x 13 x 13 in. (61 x 33 x 33 cm)
Photo credit: Bill Orcutt
Courtesy of Alexander and Bonin, New York

HAYV KAHRAMAN
Mass Assembly (Sliding Puzzle), 2010
Oil on wooden panels
17 1/2 x 17 1/2 x 1 5/8 in. (44.5 x 44.5 x 4 cm)
Courtesy of Michael and Lindsey Fournie;
The Third Line, Dubai; and the artist

ethnicity, I would like to suggest another lens through which to view the videos, photographs, paintings, and sculptures in *The Fertile Crescent:* precarity.[6] Precariousness is universal, of course, no more so than today, when people the world over grapple with social, political, environmental, and economic uncertainty, but it is inflected differently for different populations. Thanks to the institutionalization of misogyny and the ubiquity of conflict, ethnophobia, American imperialism, and state-sponsored oppression, precarity is a daily experience for women and Middle Easterners. This is especially true for Middle Eastern women and women of Middle Eastern descent, whose gender, religion, and ethnicity compound the prejudices to which they are exposed. Many of the videos, photographs, sculptures, and paintings I will discuss demonstrate heightened sensitivity to the biopolitical conditions of life in the twenty-first century; many more address the unequal distribution of precarity among women and Middle Easterners. As an interpretive device, then, precarity does not so much replace as attenuate gender and regional identity. Adopting it also represents an

NEGAR AHKAMI
Hamam Harem Louis Quatorze Chaise, 2005
Acrylic and nail polish on gessoed panel
32 x 24 in. (81.3 x 61 cm)
Courtesy of the artist
(Not in the exhibition)

effort on my part to institute what Darby English has called "a practice of critical and interpretive integration," one that seeks to expand the meaning of art by women and non-whites.[7]

In order to understand precarity as the artists in this exhibition do, we first have to explore the history of precarity in the Middle East. The sources of regional precarity are many, but the two most relevant for our purposes are Orientalism and imperialism. The curators of *The Fertile Crescent* acknowledged as much when they chose none other than James Henry Breasted as their project's namesake. Breasted was the founding director of the Oriental Institute at the University of Chicago, and his rise as an Oriental scholar proceeded apace with the expansion of Western interests throughout the Middle East. The phrase "Fertile Crescent," from his 1916 book *Ancient Times,* reflects the disparities and contradictions that fueled Breasted's career. At its most innocuous, "Fertile Crescent" refers to the fecund strip of land between the Mediterranean and Red Seas that Breasted considered the cradle of civilization.[8] At its most ominous, however,

the term implies a highly gendered set of beliefs that worked in concert with weapons and soldiers to secure the submission of an entire region.

Orientalism

According to Edward Said, whose magisterial book *Orientalism* was published in 1978, Orientalism is a discourse produced in the West and exported to the Near East along with European missionaries, diplomats, businessmen, and soldiers.[9] Orientalism is premised on the inherent inferiority as well as the radical alterity of "Orientals," a group that includes North Africans, Middle Easterners, and Asians.[10] Moreover, even though Orientalism insists on the absolute difference between East and West, it makes no allowance for internal variations among Orientals. The Oriental's alterity is therefore not only categorical, but also singular.[11] In these ways and others, Said argues, Orientalism *produces* the Oriental subject.[12] The latter is an invention of the West, in other words, a phantasmatic projection of European desires and experiences. Even though there is an actual territory in the Near East, it has no ontological relationship to the designation "Orient."[13] In this regard, we might think of Orientalism as a process or operation that results in the Orientalization, in the systematic reification and deformation, of the Near East.[14]

The attitudes that underlie Orientalism—attitudes that Orientalism, in turn, catalyzes—are distinguished by their consistency and tenacity: once Orientalism was codified, it proved nearly impervious to change.[15] Orientalism's durability stemmed from Europe's considerable material investment in the Near East:[16] indeed, imperialism and Orientalism emerged around the same time, in the middle of the eighteenth century, and each provided fuel for the other's fire.[17] Insofar as it dehumanized Oriental populations, the Orientalist belief system worked to justify European expansion overseas; the seizure of territory and people, in turn, provided Orientalism with "resources" on which to reflect and fantasize. Violence and power were very much at stake in the marriage of Orientalism and imperialism.[18] The first was an instrument, the second an effect. With the unequal distribution of violence and power, moreover, came precarity: Said does not name it as such, but he clearly has precarity in mind when he describes the reduction of Orientals—Arabs specifically—to "mere biological beings." Defined by his irrationality as well as his "sexual drive," and confined to narrow interpretations of race and ethnicity, the Oriental as portrayed in this caricatural depiction is, Said writes, "nil, or next to nil."[19] Insofar

as he counts for nothing, no law protects him, and insofar as no law protects him, he is vulnerability incarnate. There is no better definition of precarity than this.

When Said's book first appeared in 1978, Orientalism was more commonly known as a field of study. The province of academics first in Europe and later in the United States, this iteration of Orientalism emerged in the fourteenth century, and it, too, benefitted from Western expansion into the Near East. Indeed, territorial accumulation was the condition of possibility for the discipline of Orientalism.[20] The acquisition of knowledge that accompanied the acquisition of land was, in turn, put to good use by imperials: the facts and statistics collected by scientists allowed governments to better understand and, by extension, better manage, control, and dominate the Orient.[21]

James Henry Breasted

In the United States, no scholar exemplifies the mutual imbrication of Orientalism and Western imperialism more than Breasted. Breasted began his career in the late nineteenth century, a turning point in the history of Orientalism. Over the course of that century, Orientalism evolved from an informal network of scholars and enthusiasts into "an imperial institution"[22]—that is, into a field of study supported by universities, braced by scientific techniques and methodologies, and enabled by European expansion overseas.[23] (The modernization and professionalization of Orientalism did little to divest the discipline of prejudice, but more on that later.) One of the earliest Americans to specialize in Orientalism, a discipline previously monopolized by the British and French, Breasted received his PhD in Egyptology (the first American to do so) from the University of Berlin in 1894, and started teaching at the University of Chicago later that same year. Breasted is recognized today for his research on early civilization, the origins of which he located not in Greece or Rome, but in Egypt and the Fertile Crescent.[24] As we might expect, Breasted was a prolific writer. Among his most influential texts are his study of ancient Egypt and his anthology of ancient Egyptian documents, published in 1905 and 1906, respectively.[25] In 1916, he wrote a high school textbook entitled *Ancient Times: A History of the Early World;* a companion volume for adults, *The Conquest of Civilization,* appeared a decade later, in 1926, guaranteeing his insights a wide audience. We might say that Orientalism, in the United States at

least, reached the general public in large part through Breasted's writing.

Breasted's area of specialty, Egypt, was in many ways the "primal scene" for European Orientalism. Indeed, Said dates the beginning of modern Orientalism to the Napoleonic invasion of Egypt in 1798, which harnessed both military and scientific power.[26] Breasted himself did not visit Egypt until 1894, twelve years after the British suppressed a nationalist uprising and occupied the country. This invasion had material and phantasmatic consequences for Breasted: his trip was only possible because the British had secured the country, and because they had secured the country, the Egypt Breasted visited was as much a land of archaeological treasures as it was a "realm of political will . . . management . . . [and] definition."[27] In ways both real and imaginative, imperialism also facilitated the expedition he mounted in 1919, shortly after founding the Oriental Institute.[28] Breasted's timing was auspicious: after the fall of the Ottoman Empire, at the end of World War I, the Middle East was divided between France and Britain, making countries previously closed to scholars accessible once again.[29] No one recognized the importance of these geopolitical shifts more than Breasted, and he moved quickly to exploit them.[30] Between 1919 and 1921, he traveled through several newly minted European mandates (Egypt as well as present-day Iraq, Syria, Lebanon, and Palestine) in search of antiquities to acquire, contacts to make, and excavations to plan.[31] In the process, he received vital material support (transportation, supplies, accommodation, permits, and security) from both the British and the French.[32] Breasted even availed himself of the Royal Air Force, taking aerial photographs of archaeological sites in planes generally used for military reconnaissance.[33] Moreover, while traveling, he consorted with some of the highest ranking diplomats, government officials, and military officers in the area.[34] If he was able to secure the aid and access he did, it was due to his standing as one of America's foremost Orientalists. During his trip, Breasted not only traded his

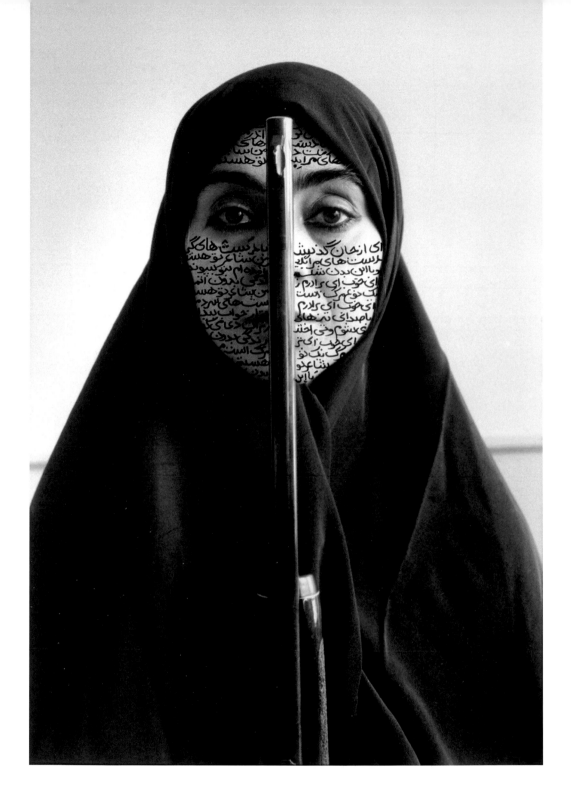

knowledge for favors and offered his expertise to generals and foreign ministers—individuals with whom he clearly sympathized—he routinely wielded his books like currency, as well.[35]

As Said reiterates on numerous occasions, the scholar is by no means exempt from the prejudices that underlie Orientalism. Insofar as Orientalism is a "political vision of reality" more so than a collection of empirical data, a philologist is just as likely to fall victim to the fantasy of Oriental aberrance and fallibility as a poet or novelist.[36] This was most certainly true of Breasted, whose belief in the inherent superiority of West over East manifested itself in numerous ways. First and foremost, Orientals were *subjects* to him, never *citizens*.[37] Thinking citizenship to be the right of Westerners alone, it was impossible for him to truly understand, much less endorse, the nationalist and anti-colonial uprisings he witnessed during his trip. Like so many other Orientalists, moreover, Breasted made a fetish of the Near East's

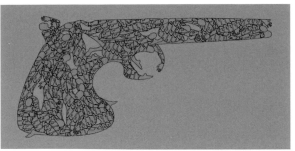 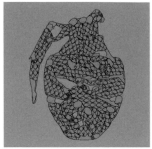 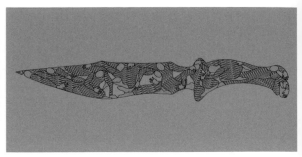

past. Having forsaken modernity, the Fertile Crescent was a kind of fossil to him, inert and stagnant, and whatever its contributions to progress and enlightenment, the region was now nothing more than a Western satellite.[38] Its past was literally and figuratively the *property* of Europe, since only Europe had proven able to exploit the promise of Eastern antiquity.[39] In other words, Breasted may have identified Egypt and the Fertile Crescent as the cradle of civilization, but this did little to either contradict the ideology of Orientalism or mitigate the essential inequity between West and East.[40] Indeed, denying "contemporaneity" to the Middle East only exacerbated that disparity.[41] The result of Breasted's writing, however insightful and groundbreaking it might have been, is thus to dramatize over and over the supremacy of West over East.

Or is it? In a curious twist of historical fate, one of Breasted's most popular books, *Ancient Times,* was used to promote an agenda for which Breasted himself had nothing but antipathy: Arab nationalism. According to Orit Bashkin, *Ancient Times* was translated into Arabic in 1926 and taught in high schools in Palestine, Transjordan, and Iraq. Nationalist leaders, many of them wealthy and (paradoxically) sympathetic to Western values, seized upon it as a symbol of regional accomplishment. They also appreciated something else about Breasted's book, namely the importance it placed on cross-cultural exchange.[42] In contradistinction to orthodox Orientalism—which insists on the absolute alterity of the East, an alterity understood as geographical as well as intellectual—Breasted emphasized the role of transmission in spreading civilization from both within and without the Fertile Crescent. For Breasted, encounters, whether violent or felicitous, were always productive. He describes the Fertile Crescent in his 1916 book, for instance, as a site not just for multi-ethnic conflict but multi-ethnic cooperation as well.[43] "Mixing" may have been anathema to him, then, but he nonetheless established the

conditions of possibility for just this when he prioritized hybridity and reciprocity in his writing.

The Fertile Crescent
This long detour into Orientalism and imperialism is the backdrop to the videos, photographs, sculptures, and paintings featured in *The Fertile Crescent*. Many of the artists seen here are sensitive to the history of these two phenomena and their lingering effects on the region. They are equally sensitive to current manifestations of Orientalism and imperialism—that is, to American militarism and Islamophobia. In general, the artists in *The Fertile Crescent* frame the impact of Orientalism and imperialism, whether past or present, in terms of precarity, by which I mean the precarious circumstances under which people of the region live by virtue of their gender, ethnicity, or a combination thereof. Their disparate bodies of work thus constitute sophisticated meditations on the material and immaterial, economic and social, institutional and ideological incarnations of the new biopolitical regime.

Precarity in its most naked form, as the ground upon which bare life emerges, is represented explicitly in the work of Sigalit Landau and Mona Hatoum. In videos and installations such as *Resident Alien I* (1996–97), *Dead Sea* (2005), *The Endless Solution* (2005), and *The Dining Hall* (2007), all by Landau, references to wounds and wounding proliferate.[44] (Landau's three-channel video *Dancing for Maya* [2005], documents a different iteration of precarity—precarity as ephemerality. In this case, two women "draw" on a Mediterranean beach. The fragility of their intervention is underscored by the waves that threaten and eventually erase their every mark. Here, precarity is understood as both a material state and a temporal condition.) The twin themes of vulnerability and brutalization are also at stake in some of Hatoum's sculptures, including *Light Sentence* (1992), *Entrails (Carpet)* (1995), *Slicer* (1999), *Round and round* (2007), and *Interior Landscape*

PARASTOU FOROUHAR
Triptych, 2010
Digital prints on photo paper
Left and right:
Each 13 3/4 x 27 5/8 in.
(35.1 x 70.1 cm); center: 13 3/4 x 13 3/4 in.
(35.1 x 35.1 cm)
Courtesy of the RH Gallery, New York, and the artist

PARASTOU FOROUHAR
Ashura Butterfly, from the seven-part series *Butterfly,* 2010
Digital print on photo paper
Each 39 3/8 x 39 3/8 in. (100 x 100 cm)
Courtesy of the RH Gallery, New York, and the artist

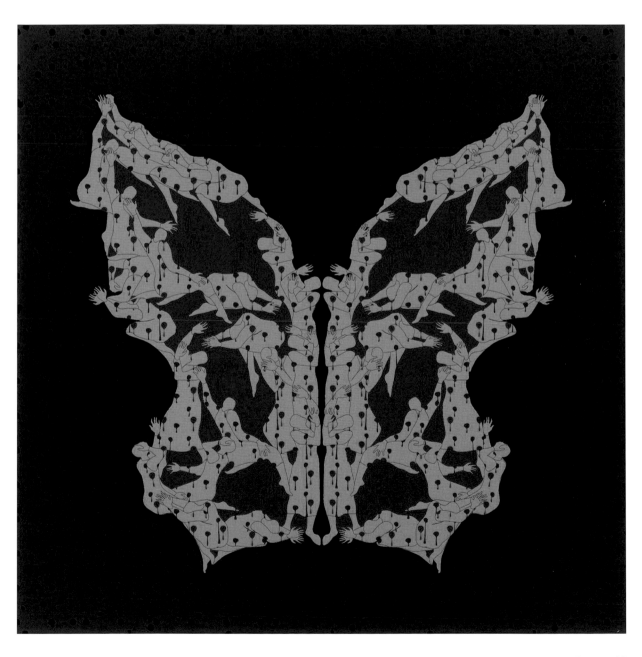

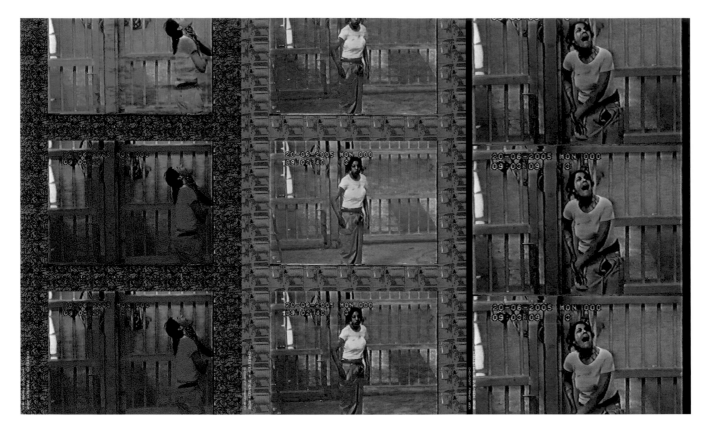

LAILA SHAWA
Stills from *Gaza Fashion Week*, 2012
(revised from *Trapped*, 2011), from the installation *The Other Side of Paradise*, 2011–12
DVD continuous loop
Courtesy of the artist

(2008). Both Landau and Hatoum tend to historicize precarity: for them, it is a function of such concrete events as exile, migration, the Holocaust, and the Israeli-Palestinian conflict. At the same time, each recognizes precarity as a universal condition.[45] In other words, precarity might manifest itself in particular ways for particular populations, it might affect some groups more than others, but no one is impervious to it. Sadly, at a moment when the world is being divided into ever smaller parcels of friends and enemies, only precarity seems to link us any longer.[46] Thus, the importance of empathy to Landau's and Hatoum's work: considering a video such as *Barbed Hula* (2000), by Landau, or *Prayer Mat* (1995), by Hatoum, we are driven to identify, compelled to imagine the physical and emotional state of another who is not us but who is nonetheless like us—that is, another who is exposed to the common threat of precarity.

Negar Ahkami takes a more oblique approach to biopolitics. Concerned with the reduction of Arab women to erotic and highly corporeal objects, she rehearses a range of Orientalist tropes, in particular the odalisque and the harem.[47] Underlying both of these fantasies of Western masculinity is a belief system that associates the Near East with exotic femininity on the one hand and unchecked libidinality on the other. For her part, Ahkami indulges in what we might call "mimetic exacerbation," a phrase coined by Hal Foster. According to Foster, whose case study is Dada, mimetic exacerbation involves inflating the "dire conditions" of one's time "through hyperbole or 'hypertrophy.'"[48] In the Dadaists' hands, it served primarily as a compensatory technique disguised as parody. In Ahkami's hands, it is first and foremost a critical operation.[49] Take *Suffocating Loveseat Sectional* (2007) or *Hamam Harem Louis Quatorze Chaise* (2005), for instance. In the latter work, the artist exaggerates a female stereotype—the highly sexed yet perennially submissive odalisque—to the point of absurdity. Here, women function as little more than opportunities for visual stimulation: doubly, even triply objectified, they read as figments of the imagination, as

copies with no original. Ahkami also likens them to decoration. Arrayed along a highly patterned background meant to represent a Persian carpet, the voluptuous nudes are the literal and symbolic "ground" to (Western) male privilege and (Western) male desire.[50]

If Ahkami explores the stereotypes that enable highly gendered belief systems like Orientalism, Hayv Kahraman investigates the taxes these stereotypes ultimately levy on women. In oil-on-panel paintings such as *I Love My Pink Comb* (2010) and *Leveled Leisure* (2010), Kahraman represents women engaged in collective beautification rituals. The activities she inventories seem benign enough—brushing, shaving, waxing, and the like—but considered as a whole, they read as something far more ominous. Indeed, together they comprise a narrative that arcs inexorably toward Botox, plastic surgery, and, eventually, self-mutilation, as seen in *String Figures* and *Migrant 3,* both from 2010. *Migrant 3* is especially disquieting. As the title implies, Kahraman's female protagonist is an immigrant (perhaps an Iraqi immigrant like the artist herself) whose relocation to the West and ensuing confrontation with Western ideals of feminine desirability has triggered an acute psychological crisis. Under pressure to conform, the woman's ego splits. This division is expressed physically, as a doubling of her torso, one half of which hangs placidly from the bottom of the painting, while the other half proceeds to cut out her own tongue. Both halves are equally "flat," drained of both depth and individuality. As imagined by Kahraman, then, self-alienation is worn on and borne by women's bodies, with terrible consequences for their voice and agency.[51]

While Ahkami and Kahraman address the biopolitical stakes of Orientalism, immigration, and the beauty industry, Shirin Neshat and Parastou Forouhar, both Iranian, explore the threat that authoritarian regimes and religious fundamentalism pose to women and dissidents. Indeed, Neshat's and Forouhar's work reflects poignantly and incisively on the unequal distribution of uncertainty among Iranians. Importantly, each artist was a victim of state-sponsored violence, Neshat in 1979 and 1990 and Forouhar in 1998.[52] These experiences inform much of the work they create.

Neshat's *Women of Allah* series (1993–97) evokes the active role women played in the Iranian Revolution of 1977–79.[53] Assuming their rightful place in the public sphere, women distributed leaflets, provided aid, and demonstrated often, protesting an oppressive state apparatus enslaved to Western interests and Western economies. By early 1979, women were even beginning to organize "for women." These gains were short-lived, however, as Khomeini announced a series of laws designed to restrict women's rights in March of that year.[54] The contradictions of female Islamic militancy are given free rein in Neshat's striking photographs. Wielding a long-barrel rifle, the model in *Rebellious Silence* (Neshat herself), a work dating to 1994, returns our gaze with ferocity, threatening the male subject's monopoly on desire, visuality, and the means of violence. The chador she wears is a study in incongruity: although typically associated with female submission and Orientalist fantasy, here it serves to enhance, not dampen, her political (and even sexual) authority. Moreover, insofar as the veil conceals and exposes simultaneously, it also lends the photograph a delicate erotic charge.[55] Neshat's icons of female empowerment are not unequivocal, however. The framing of *Rebellious Silence* is tight, almost carceral, and the four sides of the print bear down on its subject, as if threatening bodily harm. There is also the matter of the Farsi calligraphy inscribed over the women's flesh. Excerpted from the poems of the contemporary female Iranian writer Tahereh Saffarzadeh, whose work addresses the relationship between women, martyrdom, and political devotion, the script evokes decoration and body art as much as it does punishment, branding, and disfigurement.[56] It also symbolizes the precarity of women's place in Iranian society—specifically, the uncertain circumstances under which they speak and the uncertain existence that speech leads once uttered, vulnerable as it is to censorship.

Forouhar's digital print *Ashura Butterfly* (2010) is an act of both protest and commemoration. Conceived in the aftermath of her parents' assassination in 1998, its title pays tribute to her mother (whose first name, Parvaneh, is Farsi for "butterfly"), while its content evokes violence and death. Upon first glance, *Ashura Butterfly* reads like an elegant study in decoration, one inspired by Persian ornamentation or the wings of a butterfly. A closer look quickly dampens whatever visual pleasure we might experience, as the composition dissolves into a pile of naked bodies, each one riddled with bloody wounds. Some of the victims raise their hands to the sky, signaling pain, supplication, or defeat, while others bring their chest to the ground, either begging or praying. The victims are also identical and anonymous: in much the same way that violence turns individuals into objects, so, too, has the artist taken from these men and women anything that might make them human. *Triptych,* also from 2010, is a companion piece to *Ashura Butterfly:*

the three compositions therein are built from the same sorts of brutalized bodies as *Ashura Butterfly,* but here they comprise an arsenal of weapons: a gun, grenade, and knife. Together, Forouhar's digital prints constitute a kind of biopolitical meditation on contemporary Iran, that is, on the conditions of bare life and the mechanisms of sovereign power therein.[57]

The Gaza-born artist Laila Shawa addresses similar issues in relationship to Palestine.[58] Precarity, both economic and geopolitical, is endemic to Palestine, thanks to an ongoing conflict with Israel, whose roots can be traced to the Six-Day War of 1967 and the ensuing occupation of Gaza and the West Bank (and, further still, to the Nakba of 1948 and the Balfour Declaration of 1917). For decades, Shawa has explored the repercussions of these and other events on Palestinian health, education, employment, happiness, and freedom. The mixed-media canvas *Gaza Sky* (2011), for instance, combines references to Persian miniatures, comic books, and Pop Art with scenes inspired by the 2008 aerial bombardment of Gaza. Violence is often met with violence, and repression with rebellion, a subject Shawa explores in a group of sculptures and mixed-media canvases from the same year. Much like the photographs from Neshat's *Women of Allah* cycle, moreover, these works address militant Islamic femininity, would-be martyrs such as Samir Ibrahim al-Biss, who, in 2005, was caught crossing the border between Gaza and Israel wearing a suicide belt. In *Trapped* (revised as *Gaza Fashion Week* by the artist), Shawa superimposes ribbons of Arabic calligraphy made illegible through cropping and magnification on stills from a video documenting al-Biss's incarceration. Al-Biss screams in frustration, but we can no more hear what she says than we can read the text. In these works, communication is thwarted—strangled—under conditions of generalized violence.[59]

By way of a conclusion, I would like to recall those Arab nationalists in the early twentieth century who repurposed Breasted's *Ancient Times* for the cause of liberty and self-determination. That Arab nationalists could have found something appealing in the work of an Orientalist like Breasted—particularly his commitment, however reluctant and however circumscribed, to cross-cultural dialogue—strikes me as revealing and not incidental. It also has bearing on the work of several artists in *The Fertile Crescent,* including Jananne Al-Ani, Sigalit Landau, and Shahzia Sikander.[60] The latter not only endorse Breasted's notion of cross-cultural reciprocity, they take it one step further, engaging the far more radical

notion of intersubjectivity. Rather than a project of the individual, subjectivity for these artists is a performance involving the cooperation of others (other cultures, other histories, other people), a performance that results in a flexible, contingent self that acknowledges one's ethical responsibility to others, or so we might imagine. It is important to keep Al-Ani's, Landau's, and Sikander's aesthetic experiments in mind as we consider ways to counteract the increasing militarization of human relations in the twenty-first century.

Notes

1 Katy Dammers, 2011–12 McCrindle Intern at the Princeton University Art Museum, provided invaluable research assistance on this essay.

2 I want to make it clear that I am *not* suggesting that the curators of *The Fertile Crescent* endorse such a narrative of exceptionalism. In this introductory paragraph, I deliberately misrepresent their position in order to create a foil for what I believe is a more accurate portrayal of their perspective.

3 Besides the difficulty of locating the subject position "woman" or "Middle Easterner" with any certainty, we must also contend with the expectations and obligations that seem to hound both women and non-white artists. These encumbrances (from which white male artists are always exempt) operate at the level of both reception and production. While critics are all too inclined to generalize the work of women and non-white artists—to frame that work solely in terms of the artists' gender, race, or ethnicity—artists themselves are often pressured to address their gender, race, or ethnicity in particular ways and to the exclusion of other issues. Yet no matter how problematic they might be, no matter how much they might circumscribe the creative possibilities for objects, artists, and even viewers, claims for an internally consistent, identity-specific aesthetic—an aesthetic that is not only common to a particular group or based on the shared biology and experiences of that group, but that also distills and reflects that group's essence—are always historically motivated. Indeed, most such claims are the artistic complements of political movements that seek to secure recognition, legitimacy, freedom, and empowerment for their constituencies. In grappling with these issues, I have found Darby English's excellent book *How to See a Work of Art in Total Darkness* (Cambridge: MIT Press, 2007) to be extremely helpful. For an insightful perspective on the framing of contemporary film in terms of "the Muslim world" and the political benefits and repercussions thereof, see Ali Nobil Ahmad, "Introduction: Is There a Muslim World," *Third Text* 24 (January 2010): 1–10. For discussion of the concept of "feminine aesthetics" and its relationship to the feminist movement, see Gisela Ecker, ed., *Feminist Aesthetics* (Boston: Beacon Press, 1985).

4 On the reframing of subjectivity by feminism, post-structuralism, and globalization, see Judith Butler, "Bodily Inscriptions, Performative Subversions [1990]," in Sara Salih, ed., *The Judith Butler Reader* (Malden, Mass.: Blackwell Publishing, 2004); Jonathan Rutherford, "The Third Space: Interview with Homi Bhabha," in *Identity: Community, Culture, Difference* (London: Lawrence & Wishart, 1990); Rosi Braidotti, "Introduction: By Way of Woman," in *Nomadic Subjects: Embodiment and Sexual Difference in Contemporary Feminist Theory* (New York: Columbia University Press, 1994); Stuart Hall, "New Ethnicities," in Bill Ashcroft, Gareth Griffiths, and Helen Tiffin, eds., *The Post-Colonial Studies*

Reader (London: Routledge, 1995); Arjun Appadurai, *Modernity at Large: Cultural Dimensions of Globalization* (Minneapolis: University of Minnesota Press, 1996); Denise Riley, *The Words of Selves: Identification, Solidarity, Irony* (Stanford: Stanford University Press, 2000); Benedict Anderson, *Imagined Communities: Reflections on the Origin and Spread of Nationalism* (London / New York: Verso, 2006); and Judith Butler and Gayatri Chakravorty Spivak, *Who Sings the Nation-State? Language, Politics, Belonging* (London: Seagull Books, 2007).

5 "Friends and enemies" is a reference to the German philosopher Carl Schmitt (1888–1985), whose writing from the 1920s and 1930s has received renewed attention in the last twelve years, pertaining as it does to the increasing polarization of identity along national, religious, ethnic, and sectarian lines. According to Schmitt, the political world is organized around "the dualism of 'enemy and friend.' What constitutes politics for Schmitt might be described as an inverted alterity—an antagonism toward the Other so strenuously expressed, an enmity so implacable, that politics itself is a matter of life and death." As a result, "One's status as a political subject . . . demands the *existential negation* of the enemy' " (Pamela M. Lee, "My Enemy/My Friend,' *Grey Room* 24 [Summer 2006]: 103–104). It goes without saying that this sort of rhetoric and the resulting disavowal of empathy and identification have serious consequences, as witnessed by the wars in Iraq and Afghanistan and the ongoing conflict between Israel and Palestine. As a counterpoint to Schmitt, we might consider Judith Butler, who has addressed the constitutive role "others" play in the formation of subjectivity. For Butler, subjectivity is a common project insofar as our relations with others are the stage upon which the self is constituted. According to Butler, the self is structurally and therefore ethically bound to the Other. See her two books *Precarious Life: The Powers of Mourning and Violence* (London: Verso, 2004) and *Giving an Account of Oneself* (New York: Fordham University Press, 2005). See also Adriana Cavarero, "The Necessary Other," in *Relating Narratives: Storytelling and Selfhood,* trans. Paul A. Kottman (New York: Routledge, 2000) and Jacques Derrida, *On Cosmopolitanism and Forgiveness,* trans. Mark Dooley and Michael Hughes (New York: Routledge, 2001).

6 The French word for "precarity" is *précarité,* and it "indicates a socioeconomic insecurity that is not as evident" in English, according to Hal Foster. "Indeed, *précarité,*" he writes, "is now used to describe the condition of vast numbers of labourers in neoliberal capitalism for whom employment (let alone health care, insurance or a pension) is anything but guaranteed. This 'precariat' is seen as a product of the post-Fordist economy" (Hal Foster, "Towards a Grammar of Emergency," *New Left Review* 68 [March–April 2011]: 106). Precarity is by no means limited to economic uncertainty, however, just as the sources of precarity are far wider than neoliberalism. The latter include occupation, forced migration, war, civil conflict, and environmental disaster.

7 English, *How to See a Work of Art in Total Darkness,* 67. According to English, who is writing about African American art, such a practice involves understanding how the work of black artists is "in excess of racial culture" (68).

8 Breasted describes it thus: "The Westernmost extension of Asia is an irregular region roughly included within the circuit of waters marked out by the Caspian and Black Seas on the north, by the Mediterranean and Red Seas on the west, and by the Indian Ocean and Persian Gulf on the south and east. It is a region consisting chiefly of mountains in the north and desert in the south. The earliest home of men in this great arena of Western Asia is a borderland between the desert and the mountains, a kind of cultivable fringe on the desert, a fertile crescent . . . This fertile crescent is approximately a semi-circle, with the open side toward the south . . . This great semi-circle, for lack of a name [in the West, at least], may be called the fertile crescent" (James Henry Breasted, *Ancient Times: A History of the Early World* [Boston: Ginn and Company, 1916], 100–101).

9 By "Near East," Said means primarily the Middle East, the region at issue in *The Fertile Crescent.* In its initial phase, in the medieval and Renaissance periods, "Islam was the essential Orient," but during the eighteenth century, as Europeans expanded farther East, the Orient was understood to encompass far more areas of the globe. Edward Said, *Orientalism,* 2nd ed. (New York: Vintage Books Edition, 1979), 116. That said, "Islam [has] remained forever the Orientalist's idea (or type) of original cultural effrontery, aggravated naturally by the fear that Islamic civilization originally (as well as contemporaneously) continued to stand somehow opposed to the Christian West" (Said, *Orientalism,* 260). Said is writing in 1978, of course, but his comments continue to hold true today. For Said's more summary statements on Orientalism, see chapter 1 and part 1 of chapter 3 of *Orientalism.* It is important to note that Europe's encounter with both Islam and the Near East was essentially an encounter with the very powerful Ottoman Empire, which had expansionist ambitions of its own, ambitions that Europe became more successful at thwarting by the end of the seventeenth century.

10 Throughout this section, I use the term "Oriental" not only because that is the term Orientalists employed, but also because I want to convey through language how Orientalism reduces and simplifies a vast and internally differentiated region.

11 Said, *Orientalism,* 205.

12 Ibid., 322.

13 Ibid., 5, 21–22.

14 Ibid., 273.

15 Ibid., 5.

16 Ibid., 6.

17 Although the United States did not begin to truly exercise its military, political, and economic interests in the Middle East until after World War II, imperialist sentiment nonetheless inflected some of the earliest manifestations of American Orientalism, as witnessed in the founding document of the American Oriental Society (1842). See Said, *Orientalism,* 294.

18 Ibid., 5.

19 Ibid., 312. Said is more than likely referencing Michel Foucault's notion of biopower, introduced in his 1976 book *La Volenté de savoir* (published in English in 1978 under the title *The History of Sexuality*). The concept of biopower, or biopolitics, has had far-reaching implications for our understanding of how power operates in the modern world. In contradistinction to ancient times, when power was exercised solely through the taking of a life or, alternately, through the rescuing of a life from death, power now establishes its dominion primarily by administering, regulating, and managing both the "performances of the body" (its usefulness, efficiency, and docility) as well as the "processes of life" (births, mortality, health, longevity, and life expectancy). As Foucault writes, "This great bipolar technology . . . characterized a power whose highest function was perhaps no longer to kill but to invest life through and through" (Michel Foucault, *The History of Sexuality, Vol. 1: An Introduction,* trans. Robert Hurley [New York: Vintage Books, 1978], 139). "For the first time in history," he continues, "biological existence was reflected in political existence; the fact of living . . . passed into knowledge's field of control and power's sphere of intervention" (142). As for the beneficiaries of biopower, Foucault mentions both the state and capitalism (141), but Said clearly saw the relevance of biopolitics to colonialism. In the process of invoking biopower, moreover, Said also alludes to a concept Giorgio Agamben would popularize several years later: bare life. When power (specifically, sovereign power) concerns itself with life, it addresses human beings as matter, as flesh, and in so doing, reduces them to the mere fact of their biological existence. Under the conditions of biopolitics, in order words, the exemplary political

subject is not "bios politikos," but "zoe," not a citizen, but a kind of beast. Moreover, insofar as this beastly citizen is subject to, but never protected by, or from, the force of law, she is exposed to manifold forms of violence. See Giorgio Agamben, *Homo Sacer: Sovereign Power and Bare Life,* trans. Daniel Heller-Roazen (Stanford: Stanford University Press, 1998). Both biopower and zoe are inextricably related to precarity, of course. On the interest among contemporary theorists in bare or "creaturely" life, see Hal Foster, "I am the decider," *London Review of Books* 33 (March 17, 2011): 31–32. On the relationship between art, precarity, and bare life, see T. J. Demos, "Life Full of Holes," *Grey Room* 24 (Summer 2006): 72–87.

20 Said, *Orientalism,* 123. As he writes elsewhere, "The period of immense advance in the institutions and content of Orientalism coincides exactly with the period of unparalleled European expansion; from 1815 to 1914 European direct colonial domination expanded from about 35 percent of the earth's surface to about 85 percent of it. Every continent was affected, none more so than Africa and Asia. . . . But it was in the Near Orient, the lands of the Arab Near East, where Islam was supposed to define cultural and racial characteristics, that the British and the French encountered each other and 'the Orient' with the greatest intensity" (41).

21 Ibid., 36.

22 Ibid., 95.

23 Ibid., 42–43, 49–51, 104.

24 See Breasted, *Ancient Times,* iii. Breasted credited Egypt and the Fertile Crescent with having invented the technologies and sciences as well as the various forms of sociability, government, time-keeping, and communication on which Western civilization was built. As he writes, the ancient Orient "gave the world the first highly developed practical arts, like metal work, weaving, glassmaking, [and] paper-making . . . To distribute the products of these industries among other peoples and carry on commerce, it built the earliest seagoing ships. It first was able to move great weights and undertake large building enterprises. . . . The Orient gave us the earliest architecture in stone masonry, the colonnade, the arch and the tower . . . It produced the earliest refined sculpture . . . It gave us writing and the earliest alphabet. In literature it brought forth the earliest known tales in narrative prose, poems, historical works, social discussions, and even drama. It gave us the calendar we still use today. It made a beginning in mathematics, astronomy, and medicine. It first produced government on a large scale . . . Finally, in religion the East developed the earliest belief in a sole God and his fatherly care for all men, and it laid the foundations of a religious life from which came forth the founder of the leading religion of the civilized world to-day [by which he means, of course, Christianity, not Islam]. For these things, accomplished—most of them—while Europe was still undeveloped, our debt to the Orient is enormous" (217–18). Ironically, Breasted lists among the East's failures democracy, freedom, citizenship, and liberty, the very values Europe was in the process of stripping from the Near East (218). Breasted reiterates many of his claims about the origins of civilization made in his earlier book *A History of Egypt* (New York: C. Scribner's Sons, 1905), vii, 3, 13.

25 For more on Breasted's accomplishments, see William Murnane, "James Henry Breasted," in Clyde Norman Wilson, ed., *American Historians, 1866–1912: Dictionary of Literary Biography Series* (Detroit: Gale Research, 1986), 57.

26 Said, *Orientalism,* 42, 80–88.

27 Ibid., 169.

28 The Institute was funded in part by a grant from John D. Rockefeller, a long-time supporter of Breasted (Breasted often provided advice to Rockefeller in return). For a transcript of Breasted's proposal to Rockefeller, see Geoff Emberling, ed., *Pioneers of the Past: American Archaeologists in the Middle East, 1919–1920,* Oriental Institute Museum Publications 30 (Chicago: Oriental Institute of the University of Chicago, 2010), 115–18. Unfortunately, I had neither the time nor the space to investigate Breasted's relationship with Rockefeller and the latter's personal, artistic, historical, and economic interest in the Fertile Crescent.

29 Article 22 of the founding charter of the League of Nations justifies the parcelization of the Middle East by making recourse to several Orientalist tropes, in particular the fallibility and inferiority of Orientals, whose incompetence necessitates the benevolent guiding hand of more advanced nations. See Emberling, ed., *Pioneers of the Past,* 24. It is important to note that British and French control over the Near East during this period was by no means complete. In fact, Breasted traveled through the region during a period of considerable turmoil. Catalyzed by the mandate system instituted after World War I, nationalist movements were springing up around the Middle East, and they posed a serious challenge to imperial authority, which reacted with characteristic brutality. Breasted recognized as much: his letters home during the period 1919–20 include references to the unrest in the area. On occasion he faults the British and French, particularly with regard to the settlement of Palestine, but he generally dismisses or demonizes oppositional movements.

30 See Breasted's February 16, 1919, letter to Rockefeller in Emberling, ed., *Pioneers of the Past,* 32. Around the same time, Breasted began to insinuate himself into the American political process, wielding his influence to try to shape foreign policy, especially with regard to Western control of Middle Eastern archaeological sites. See Emberling, ed., *Pioneers of the Past,* 32.

31 Ibid., 9. The establishment of the mandate for Palestine was preceded by the 1917 Balfour Declaration, penned by the British Foreign Secretary Arthur James Balfour. The Declaration expressed British support for the creation of a Jewish homeland in Palestine and facilitated Jewish settlement in the area.

32 On the material support he received while traveling, see ibid., 22, 25–26, 39, 55, 62, 66.

33 Ibid., 52. Interestingly, since 2007, the artist Jananne Al-Ani has been working on a series of videos titled *The Aesthetics of Disappearance: A Land Without People,* which explore the structural, historical, and geopolitical aspects of aerial photography. See Rachel Withers, "Conversation with Jananne Al-Ani," *Res* 7 (June 2011): 36–44.

34 Emberling, ed., *Pioneers of the Past,* 35, 39.

35 Ibid., 12, 35, 40. In this, Breasted was following in the footsteps of Orientalists before him, who often advised governments on the East. "Here the role of the specially trained and equipped expert took on an added dimension: the Orientalist could be regarded as the special agent of Western power as it attempted policy vis-à-vis the Orient" (Said, *Orientalism,* 223). Breasted thereby represents the shift in Orientalism from an "academic to an *instrumental* attitude," a shift that involves the weaponization of thought (246). See also Said, *Orientalism,* 275–76.

36 Ibid., 43.

37 Ibid., 207.

38 See, for instance, Breasted, *Ancient Times,* 95–96, 169, 436, 714, as well as *A History of Egypt,* 595.

39 As Breasted writes in a 1919 letter, "the number of educated Egyptians who can appreciate [ancient Egyptian artifacts] is an insignificant handful, while on the other hand, as our birthright and inheritance from the past, Egypt can be a wonderful educational influence in civilized lands" (Emberling, ed., *Pioneers of the Past,* 11). Interestingly, Breasted made this claim around the same time that nationalist movements in the Middle East were seizing on antiquities as symbols of collective identity (Emberling, ed., *Pioneers of the Past,* 12).

40 Said, *Orientalism,* 40.

41 Ibid., 108.

42 Orit Bashkin, "The Arab Revival, Archaeology, and Ancient Middle Eastern History," in Emberling, ed., *Pioneers of the Past,* 92.

43 Breasted, *Ancient Times,* 102, 104, 172, 241. On the notion of exchange and reciprocity, see, too, Breasted's *A History of Egypt,* 13.

44 For more information on Landau, see Gabriele Horn and Ruth Ronen, ed., *Sigalit Landau* (Berlin: KW Institute for Contemporary Art, 2008); and Jean de Loisy and Ilan Wizgan, *Sigalit Landau: One Man's Floor is Another Man's Feelings* (Paris: Kamel Mennour; Dijon: Les Presses du Réel, 2011).

45 For a brilliant reading of Hatoum's negotiation of the universal and the particular as framed by her use of the grid, see Jaleh Mansoor, "A Spectral Universality: Mona Hatoum's Biopolitics of Abstraction," *October* 133 (Summer 2010): 49–74.

46 For more on this notion, see Butler, *Precarious Life.*

47 Jananne Al-Ani also addresses the Orientalist stereotype as it was represented in ethnographic photography in works such as *Veil* (1997) and *Untitled I* and *II* (both 1998). For an incisive discussion of the stereotype, see Homi Bhabha, "The Other Question," *Screen* 24, no. 6 (1984): 18–36. According to Bhabha, the stereotype is "an ideological construction of otherness" that vacillates between desire and derision. Even though it strives to arrest and secure racial difference, the stereotype is an inherently contradictory, ambivalent, even anxious form of representation. This essay is important for having brought psychoanalysis to bear on the question of the stereotype, and for having shifted the discussion away from the content of images (specifically, their identification as either positive or negative) toward the efficacy of images (that is, the role they play in creating subjects and either maintaining or disputing unequal relations of power).

48 Hal Foster, "Dada Mime," *October* 105 (Summer 2003): 166–76.

49 For more on this strategy in relationship to feminists artists such as Ana Mendieta, see my essay "Shapely Shapelessness: Ana Mendieta's *Untitled (Glass on Body Imprints-Face), 1972,*" in Joel Smith, ed., *More than One: Photographs in Sequence* (Princeton: Princeton University Art Museum; New Haven: Yale University Press, 2008).

50 Ahkami disables stereotypes in other ways as well. In *May The Evil Eye Be Blind* (2006), she represents what appears to be a group of modern, possibly Persian women who flaunt their power and their sexuality, exacting revenge on a turbaned male figure, possibly a reference to the oppression of women under Islamic fundamentalism.

51 Ahkami's and Kahraman's work can both be fruitfully compared to Ghada Amer's, insofar as all three investigate desire (both male and female), sexuality, pleasure, and female stereotypes. For more on Amer, see Laura Auricchio, "Works in Translation: Ghada Amer's Hybrid Pleasures," *Art Journal* 60 (Winter 2001): 26–37; Valerie Cassel, *Ghada Amer: Pleasure* (Houston: Contemporary Arts Museum, 2001); and Olu Oguibe, "Love and Desire: The Art of Ghada Amer," *Third Text* 55 (Summer 2001): 63–74.

52 Neshat left Iran to study art in Los Angeles in 1974. During the Islamic Revolution of 1979, her family's farm was confiscated and a friend killed. During a 1996 visit to Iran, she was detained and interrogated before being allowed to leave. See Tyler Green, "MoMA Keeps the Walls Clean: Islamic Show Sans Politics," *New York Observer,* April 3, 2006 [downloaded from ProQuest on April 13, 2012]. Forouhar, who has lived in Frankfurt since 1991, suffered as well; her parents, who had supported democratic reform in Iran, were murdered in their home in 1998.

53 According to Amei Wallach, the series was inspired by Neshat's 1990 trip to Iran, her first since the 1979 revolution, during which she was struck by the sight of women covered in (compulsory) black chadors. Amei Wallach, "Shirin Neshat: Islamic Counterpoints," *Art in America* 89 (October 2001): 137.

54 Nayereh Tohidi, "Gender and Islamic Fundamentalism," in Chandra Talpade Mohanty, Ann Russo, and Lourdes Torres, eds., *Third World Women and the Politics of Feminism* (Bloomington: Indiana University Press, 1991), 252. See, too, Farzaneh Milani, "The Visual Poetry of Shirin Neshat," in *Shirin Neshat* (Milan: Charta, 2001).

55 The veil had contradictory associations during the Islamic Revolution. See Tohidi, "Gender and Islamic Fundamentalism," 251–52. On the evolution of feminism in Iran over the course of the twentieth century, see Parvin Paidar, "Feminism and Islam in Iran," in Deniz Kandiyoti, ed., *Gendering the Middle East: Emerging Perspectives* (Syracuse: Syracuse University Press, 1996).

56 On Saffarzadeh and Neshat's *Women of Allah* series, see Shadi Sheybani, "Women of Allah: A Conversation with Shirin Neshat, *Michigan Quarterly Review* 38 (Spring 1999): 204–16 [hdl.handle.net/2027/spo.act2080.0038.207; downloaded 05/10/2012]. For more on this series, see Hamid Dbashi, "Bordercrossings: Shirin Neshat's Body of Evidence," in Giorgio Verzotti, ed., *Shirin Neshat* (Milan: Edizioni Charta, 2002) and Amna Malik, "Dialogues between 'Orientalism' and Modernism in Shirin Neshat's 'Women of Allah,'" in Celina Jeffrey and Gregory Minissale, eds., *Global and Local Art Histories* (Newcastle: Cambridge Scholars Publishing, 2007).

57 For more on Forouhar, see Rose Issa, ed., *Parastou Forouhar: Art, Life, and Death in Iran* (London / Saint Paul: Saqi Books, 2010) and Sam Bardaouil, *Iran Inside Out: Influences of Homeland and Diaspora on the Artistic Language of Contemporary Iranian Artists* (New York: Chelsea Art Museum, 2009).

58 Ariane Littman, another artist in *The Fertile Crescent,* addresses the Israeli-Palestinian conflict as well. Her more recent work tends to focus on the relationship between power and cartography, and it often involves the performance of activities meant to heal, restore, and ameliorate the effects of conflict and trauma. Relevant projects include *Erasure* (2006), *Wounded Land* (2009–11), and *The Olive Tree* (2011).

59 For more on Shawa, see Fran Lloyd, ed., *Contemporary Arab Women's Art: Dialogues of the Present* (London: WAL, 1999); Venetia Porter, *Word into Art: Artists of the Modern Middle East* (London: British Museum Press, 2006); and Saeb Eigner, *Art of the Middle East: Modern and Contemporary Art of the Arab World and Islam* (London / New York: Merrell, 2010).

60 In the case of Landau, I am thinking specifically of works such as *Three Men Hula* (1999); *Dancing for Maya* (2005); and her project for the 2011 Venice Biennale, *One man's floor is another man's feelings.* In the case of Jananne Al-Ani, I am thinking of *Echo* (1994–2004), *A Loving Man* (1997–99), *She Said* (2000), *Cradle* (2001), and *Reel* (2001). The acts of communication, reciprocity, cooperation, and collective enunciation these artists stage do not always "succeed," nor are they free of conflict and antagonism. Indeed, there is a kind of pragmatism to the way they imagine intersubjectivity, which is wholly in keeping with the way Butler understands it.

Kelly Baum is Haskell Curator of Modern and Contemporary Art, Princeton University Art Museum.

Slipping Away
(or Uncompliant Cartographies)

By Gilane Tawadros

Like clean, sweet-smelling laundry, Mona Hatoum's *Projection* (2006) configures a pure cartography, unsullied by borders or delineations of nation-states. Fabricated from cotton and abaca, Hatoum's world map, based on the Peters projection, registers the traces of depressions and elevations in different continents without the limitation of territories or frontiers. Her hemp-and-linen map collapses borders, erases place-names, and reimagines the globe as a neutral, white, uninscribed configuration of spaces. The artist's choice of media suggests hard work and resilience to both time and change: linen is one of the world's oldest textiles, while abaca, or manila hemp, is prized for its strength, buoyancy, and resistance to saltwater damage. Laborious to extract and fabricate, these organic materials attest to the resilience and creativity of human nature.

Projection is, perhaps above all, an act of creative defiance. It resists the established protocols of cartography, with the latter's measured distances, delineated boundaries, and labels assigned to discrete parcels of space. *Projection* is also a world map evacuated of all color. Gone are the fields of red, yellow, green, and blue that once designated territorial possession by different colonial powers. (By contrast, color-coded colonialism figures prominently in Zeina Barakeh's *Third-Half Passport Collection: M.E. Transit* [2012], as reflected in the official passport stamps and visas that track her family's post-1943 movements through what we now call the Middle East.) All particularities have been erased from Hatoum's map, transformed into abstract patterns onto which we can project our own imaginative geographies.

With *Projection*, Hatoum makes manifest successive efforts to demarcate geographical space according to political contingency, and compels us to reflect on the provisional and contested nature of physical geography. The work confounds our efforts to name, to define, to circumscribe geography, hinting at the difficulty of corralling a multitude of histories and cultures into a single geographical designation: "Middle East," "Orient," "North Africa," "Fertile Crescent," "Near East," "Levant." Subject to the vagaries of history, politics, and chance, the geography of people's lives and experiences eludes us every time we try to fix it or name it, even tentatively. Geography's tendency to slip away from our grasp just as we attempt to describe it comprises the subject of this essay, which presents some provisional thoughts and reflections on artistic practice, geography, and identity.

The Middle East, to deploy the most contemporary designation of this geographical space, is a problematic label that has cultural and political connotations beyond its reference to a specific topography. It is, according to Derek Gregory, following Edward Said, an "imagined geography," subject to cultural and political projections that have their origins in the nineteenth century, but endure into the present.[1] Gregory refers to Juan Cole's book *Napoleon's Egypt*, subtitled "Invading the Middle East," which points to the juncture in European history when the term began to gain currency:

> Later in the nineteenth century, "Middle East" was used by the British Indian Office to refer to Persia and its surrounding areas, which were

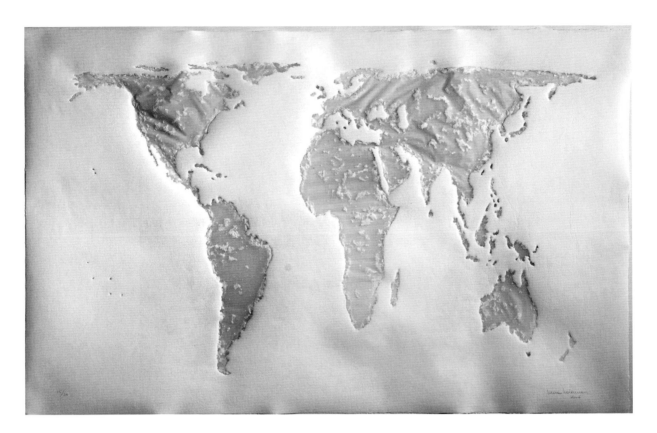

MONA HATOUM
Projection, 2006
Cotton and abaca
35 x 55 in. (89 x 140 cm)
Photo credit: Ela Bialkowska
Courtesy of Alexander and Bonin, New York

considered of strategic importance to the security of the colonies in the Subcontinent. During the First World War, Sir Mark Sykes—intent on "cutting out the cancer" that was the faltering Ottoman Empire and thus release those suffering under the Turkish yoke—advocated the use of "Middle East" . . . this was done to undercut Lloyd George's persistent reference to a "Near East," which implied a continued recognition of Istanbul as a centre of political gravity. Winston Churchill put the region on the map through the abrasive interventions of his recently established "Middle East Department" (within the Colonial Office), which was basically responsible for the political geography we still know today.[2]

In the aftermath of 9/11, with the invasions of Iraq and Afghanistan, through the ongoing conflict between the Palestinians and Israelis and in the wake of the Arab Spring, the region we refer to as the Middle East continues to exercise our political and artistic imaginary, and remains as contested as ever. Our understanding of the Middle East and the contingencies of power and culture persist in what Gregory describes as the "colonial present," and it is this relationship between the politics of space and the artistic imagination that I want to explore further.

As I have noted elsewhere, there is a tendency to regard art exhibitions and artworks as though they were free-floating entities removed from everything else around them, but, of course, exhibitions and artworks are constructions, fabricated from the ideas, materials, and experiences derived from the world in which they circulate. Outside of Hatoum's defiant cartography, there is no blank canvas or pure space unpolluted by the flotsam and jetsam of history and politics.[3] A map, perhaps more than any other projection, reflects the assertion of politics and power over physical space. The mapmaker's spatial constructions

create, as much as reflect, the possession and control of territory. Mapmakers have the power to shape physical geography with their markings and delineations, defining who owns which parcels of land. Without the mapmaker's interventions to fix borders and boundaries, designating ownership and title, geography could not be subordinated to colonial possession and control. Without maps, as the Palestinians discovered in their negotiations with Israel, the balance of power shifts from the dispossessed to those who are able to make cartographic claims. As Edward Said observed of the tactics deployed in the Oslo Process, which ultimately failed to bring about a negotiated settlement between the Palestinians and Israelis:

> The device itself was to redivide and subdivide an already divided Palestinian territory into three subzones, Areas A, B, and C, in ways entirely devised and controlled by the Israeli side since, I have pointed out for several years, the Palestinians until quite recently had neither any maps of their own nor, among the negotiating team, any individuals who were familiar enough with actual geography to contest decisions or to provide alternative plans.[4]

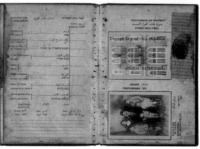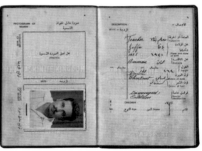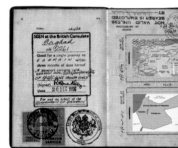

Hatoum's *Projection* recognizes the cartographic convergence of representation and reality, and of past and present colonial realities, which are often separated. By evacuating her map of the cartographer's markings and colorings, Hatoum rejects the colonial impulse to circumscribe, name, and occupy space by force. Here, the artist assumes the power of the cartographer to represent a different reality, in which all boundaries and borders have been erased. In Hatoum's imagined cartography, everyone has been dispossessed of land, nation, and identity, and colonial territories and nation-states unilaterally dissolved.

Hatoum has made other maps as well, returning time and again to mapmaking in different forms as an integral aspect of her artistic practice. In 2008–09, she completed the installation *3-D Cities,* composed of a trio of printed maps of Beirut, Baghdad, and Kabul, mounted on tables linked by wooden trestles. Round craters and mounds cut out of the maps in concentric circles mark out areas of destruction and reconstruction, existing alongside each other in these conflict zones. In some ways, this work could be seen as an attempt to recalibrate the representation of these cities, which invoke seemingly endless images of danger and destruction. Emblematic of the representation of the region as a whole, the maps contest the singular, monotonous narratives that surround the Middle East, focused on conflict, female oppression, Islamic extremism, civil war, and, most recently, protest and revolution. Hatoum's *3-D Cities* also resist the flatness and two-dimensionality of conventional maps. Their elevations and depressions capture the ups and downs of human experience, neither universally positive nor relentlessly negative. Rather, they reflect the nuanced, varied, and changing gradations of a lived geography, as distinct from its mediated, uniform representation.

Edward Said has warned eloquently against the false separation of past and present, of culture and politics, through which "culture is exonerated from any entanglements with power, representations are considered only as apolitical images to be parsed and construed as so many grammars of exchange, and the divorce of the present from the past is assumed to be complete."[5] The 2003 exhibition *Veil: Veiling, Representation, and Contemporary Art,* which I co-curated with the artists Jananne Al-Ani and Zineb Sedira

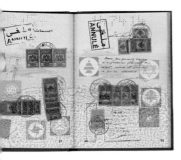

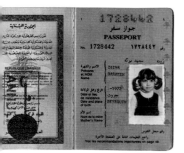
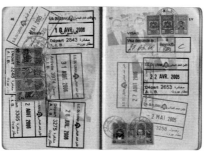

ZEINA BARAKEH
Passport details from the series *Third-Half Passport Collection: M.E. Transit*, 2012
Archival inkjet prints
Installation 67 x 126 in. (170.2 x 320 cm); each 21 x 30 in. (53.3 x 76.2 cm)
Courtesy of the artist

First column, top to bottom: *British Mandate Passport, Bio; British Mandate Passport, Jaffa House; Transjordanian Passport, Bio*

Second column, bottom to top: *Transjordanian Passport, British & French Mandates; Lebanese Passport, Born in Beirut, Bio (Forged); Lebanese Passport, Born in Beirut, Civil War*

Third column, top to bottom: *Lebanese Passport, Born in Jaffa, 1982 Invasion; Lebanese Passport, Born in Jaffa, Bio; Lebanese Passport, Bio*

Fourth column, bottom to top: *Lebanese Passport, 2005 Cedar Revolution; Third-Half Passport, Bio; Palestinian Passport, Bio*

and the curator David A. Bailey, effectively illustrates that point. Conceived before 9/11, *Veil* collided into its political aftermath, attracting the attention of the local authorities in Walsall, England (the site of the first venue of the show), who censored the artworks by the Russian artistic collective AES that were to be included in the show. The two works in question were digitally enhanced images from the group's series *The Witnesses of the Future: Islamic Project* (1996–2003), one featuring New York's iconic Statue of Liberty veiled, and the other depicting an Arab market on the bridge facing London's Houses of Parliament. Although these and other images from AES's *Islamic Project* had been circulating on the Internet for a number of years, they were now deemed "unpatriotic," at a time when British and American forces were preparing to invade Iraq. The imagined geographies of the AES artists thus seemed to transgress a political imaginary that had already decided the outcomes of military invasion and territorial possession and rejected what Gregory might call an "uncompliant cartography." Here, then, a fictional geography collided with the political reconfiguration of the

geography of the Middle East post-9/11. In this context, artistic interventions in the mapping of space and geography could not be separated from political and military intervention in the region.

In development for some years prior to the events of September 11, *Veil* emerged out of the concerns of a number of contemporary visual artists, most notably Jananne Al-Ani and Zineb Sedira, the project's initiators. In conceiving the exhibition, Al-Ani and Sedira sought to bring together artworks that went against the grain of didactic and unambiguous representations. According to Al-Ani, the works in *Veil* were

> generated, often with wonderful humour, by artists with an intimate knowledge of both Western and Eastern cultures and some of whom operating under the codes of Islamic law. Through their work, the artists have helped to broaden the debate on representation and the veil in a complex and provocative way and to sow doubts about the facts of the past, by looking at something we think we know and understand.[6]

Both Al-Ani and Sedira had been exploring the concept of the veil in their respective artistic practices. Sedira deployed the veil as both visual motif as well as referent for the "less visible effects of veiling," which she describes as "veiling-the-mind." Sedira explains,

> I refer to veiling-the-mind in order to explore the multiple forms of veiling in both Western and Muslim cultures. I find myself asking how to "represent the unrepresentable" and my artistic interventions reveal my desire to open up the paradoxes, ambiguities and symbolism of the veil.[7]

It is this desire to move away from fixed assumptions, unambiguous certainties, and the conviction that certain cultures are both "knowable" and "representable" in a literal sense, that prompted Al-Ani and Sedira to investigate questions of identity and representation through the concept of the veil.

In the aftermath of 9/11, *Veil* inevitably became entangled in the struggle among competing, polemical depictions of the Middle East that the project had sought to problematize and critique. Perhaps because of its very insistence on multiple, ambiguous readings and interpretations, no venue in London or New York would even entertain the idea of showing the exhibition. *Veil* ultimately opened in 2003 at the New Art Gallery, Walsall, and the two AES works removed from the show turned up on the front pages of the local newspaper as full-color illustrations. *Veil* became a talking point in Walsall pubs and cafés, attracting 35,000 visitors over the course of its two-and-a-half month run.

Many saw *Veil* as being in some way prescient or prophetic of future events and debates concerning political Islam, religious difference, and the veil and veiling within public and political discourse. Rather than prophetic, however, I would argue that the very process of researching, creating artworks for, and curating the exhibition constituted a means of "reading" the world through the prism of the visual. Furthermore, the conceptual framework of *Veil* was one that amplified paradoxes and ambiguities, emerging as it did from the preoccupations of two artists whose practice resolutely avoids fixity and closure.

Such is not always the case. Indeed, in recent months, in response to the Arab Spring, a plethora of exhibitions both in the Middle East and elsewhere have sought to capture the spirit of upheaval and protest occurring in the region, through "revolutionary"

artworks and presentations. The difficulty with these projects—which the writer Negar Azimi has dubbed "radical bleak"—is that they self-consciously seek to act as the barometer of the times, deploying artworks and exhibitions as figurative and literal representations that aspire to mirror the present conjuncture. As regards the situation in Egypt, where, Azimi notes, "officially sanctioned art events—from the Cairo Biennale to the city's annual Youth Salon—have historically been festooned with bloated political themes from the Palestinian intifada to American imperialism," the language and iconography of revolution has displaced earlier political themes to dominate contemporary curatorial initiatives. Azimi writes:

> In the aftermath of the uprisings, which began on 25 January 2011 and which climaxed with the fall of president-for-life Hosni Mubarak, that relationship to politics has remained largely intact—though the dominant narrative is now concentrated squarely on a singular dramatic mode: the heroism of the revolution. A state that was scrambling to hold on to power has now, predictably, co-opted the very narrative that threatened to dismantle it . . . The revolution, in a sense, has offered itself up as a readymade; it has become an engine for producing artistic flotsam that, for the most part, looks like lobby art for the United Nations and mines the language of consensus (for how can one argue against art that represents such a historic moment?).[8]

Both in the Middle East and internationally, efforts to fix the present by holding up a mirror to current events demand a literal equivalence between artworks and the world around them that inevitably forestalls any possibility of open-endedness in the artistic process. It is my contention that, by contrast, projects like *Veil*—both the exhibition as a whole, and the artworks included in it—invoke the untranslatable, the "resistant remainder," as Stuart Hall terms it: that which is not said, not represented, and which has thus far "escape[d] representation." In this instance, the "untranslatable, resistant remainder" was the ambiguity of the veil as a visual motif, defying efforts to fix it as a metonym for political Islam, female oppression, or as symptomatic of non-Western religious traditions. For years prior to 9/11, the veil had already functioned as a symbolic battleground for divergent and seemingly incommensurate ideologies that the exhibition sought to disrupt. It is this seemingly paradoxical

Veil

Veiling, Representation and Contemporary Art

tension between the visual as a form of representation of the world around us and the world from which it draws that comprises the "displaced zone" that Hall identifies, and that gives rise to representations and hence artworks that go beyond the figurative, the literal, and the present moment.

> Despite the sophistication of our scholarly and critical apparatus in art criticism, history and theory, we are still not that far advanced in finding ways of thinking about the relationship between the [art]work and the world. We either make the connection too brutal and abrupt, destroying that necessary displacement in which the work of making art takes place. Or we protect the work from what Edward Said

Veil: Veiling, Representation, and Contemporary Art, edited by David A. Bailey and Gilane Tawadros (London: InIVA, 2003)
Cover image: Marc Garanger, *Femme Algérienne* (Algerian Woman) (detail), 1960, photograph, 11 3/4 x 15 3/4 in. (30 x 40 cm)
Published on the occasion of the exhibition *Veil: Veiling, Representation, and Contemporary Art*, which traveled to the New Art Gallery, Walsall; Bluecoat Gallery and Open Eye Gallery, Liverpool; and Modern Art, Oxford, United Kingdom, 2003

calls its necessary "worldliness," projecting it into either a pure political space where conviction—political will—is all, or into an inviolate aesthetic space, where only critics, curators, dealers, and connoisseurs are permitted to play. The problem is rather like that of thinking the relationship between the dream and its materials in waking life. We know there is a connection there. But we also know that the two continents cannot be lined up and their correspondences read off directly against one another. Between the work and the world, as between the psychic and the social, the bar of the historical unconscious has fallen. The effect of the unseen "work" which takes place out of consciousness in relationship to deep currents of change whose long-term effects on what can be produced are, literally, tidal, is thereafter always a delicate matter of re-presentation and translation, with all the lapses, elisions, incompleteness of meaning and incommensurability of political goals that these terms imply. What Freud called "the dream-work"—in his lexicon, the tropes of displacement, substitution and condensation—is what enables the materials of the one to be reworked or translated into the forms of the other, and is what enables the latter to "say more" or "go beyond" the willed consciousness of the individual artist. For those who work in the displaced zone of the cultural, the world has somehow to become a text, an image, before it can be "read."[9]

It is in this "displaced zone" between the artwork and the world that meaning is created: a reading of the world that is constructed through the materials of representation that make up the toolkit of the artist. But, unlike the cartographer's constructions, which depend upon (apparently) definitive readings of physical geography, these are not fixed readings or singular interpretations, but, rather, remain open-ended and equivocal. The artistic imaginations of artists like Hatoum, Al-Ani, and Sedira are informed by a postcolonial geography that has shaped their experience and their reading of the world. Moving between one cultural and political space and another, these artists—like the artworks they produce—resist fixity and closure.

Sedira describes eloquently how her postcolonial geography has marked her practice as an artist, with the discontinuities of her own experience prompting her desire to create work that accommodates multiple readings and ways of seeing:

My identity has been formed by at least two seemingly contrasting and sometimes conflicting traditions. On the one hand, I grew up in the Paris of the 1960s and 1970s, partly educated by and socializing in the dominant secular and Catholic tradition of France. Yet simultaneously, my family and immediate community were Arab Muslims. In addition, London has further shaped my identity and, for the last seventeen years, I have lived away from the North African community. The differences between England and France, particularly their contrasting attitudes to cultural difference, have also contributed significantly to my rethinking representation and identity.[10]

For Sedira, both identity and representation are distinguished by discontinuities and displacements that resist being filtered through a singular, interpretative schema premised on a fixed, unchanging worldview. Sedira recognizes that identity can often be messy, provisional, and contingent. Yet there persists a stubborn impulse to define and fix identity, particularly in relation to artists from the Middle East and the Middle Eastern diaspora, for whom writers or curators often wish to assign a direct relationship between an artist's identity and her work. But, as Hall observes of the artwork's relationship to the world, despite the undeniable connection between the artist's identity and the work she produces, the two cannot be "lined up and their correspondences read off directly against one another."

Mona Hatoum—variously described as Lebanese-born, Palestinian, the child of Palestinian refugees, and a Briton of Palestinian descent—is frequently asked to characterize the relationship between her identity and her work in an unequivocal manner:

I am often asked the same question: what in your work comes from your own culture? As if I have a recipe and I can actually isolate the Arab ingredient, the woman ingredient, the Palestinian ingredient. People often expect tidy definitions of otherness, as if identity is something fixed and easily definable.[11]

Writing about Hatoum's work in 2000, Edward Said captures eloquently the elusive relationship between identity and representation in her work:

[It] is the presentation of identity as unable to identify with itself, but nevertheless grappling

with the notion (perhaps only the ghost) of identity to itself. Thus is exile figured and plotted in the objects she creates. Her works enact the paradox of dispossession as it takes possession of its place in the world, standing firmly in workaday space for spectators to see and somehow survive what glistens before them. No one has put the Palestinian experience in visual terms so austerely and yet so playfully, so compellingly and at the same moment so allusively.[12]

Hatoum's works defiantly resist fixed identities and compliant cartographies, insisting on a more nuanced, contradictory, and elusive view of the world and human experience. Hatoum's *Projection* exemplifies her resolutely uncompliant cartography. The work draws attention to the human interventions that have drawn and redrawn borders, and assigned different names and ownership to the same contours of land at various junctures in history. At the same time, the artist has defiantly erased these markings, rendering the globe in its constituent natural materials, able to withstand the impact of change and the passage of time, but, simultaneously, left open to imaginative reinterpretation.

Hatoum's maps make manifest Said's insight that, far from being fixed and enduring, geography is shifting and malleable. Another map work—simply entitled *Map* (1999)—is made up of hundreds of glass marbles arranged in clusters on the floor to form a large map of the world. Installed without the usual museum enclosures, visitors inadvertently stumble upon the piece, disturbing the configuration of continents and dispersing South America and Europe into disconnected fragments. As they collide into the contours of Canada and stumble over Siberia, the map's contours disintegrate into new configurations. Hatoum's map is impossible to fix in time and space, vulnerable as it is to the movements of people and their stumblings and collisions with the artwork itself. The installation eloquently underscores the precarious, volatile, and hazardous occupation of mapping, which is always susceptible to unpredictable human intervention. Hatoum has always understood art as a slippery entity that defies fixity, remaining open-ended and ambiguous. Her work reminds us of art's slippery, uncompliant nature. It calls on us to resist the political and cultural contingencies that consistently seek to impress us with singular and seemingly immovable representations of the world and human experience.

Notes

1 Derek Gregory, *The Colonial Present* (Malden, Mass., and Oxford: Blackwell Publishing, 2004), 17–20.
2 Derek Gregory, paraphrased by Carool Kersten, in "Contemporary Art in the Middle East," *Critical Muslims* (January 24, 2009); caroolkersten.blogspot.com/2009/01/infrastructures-ideas-contemporary-art.html.
3 Gilane Tawadros, "Curating from Right to Left," in Sarat Maharaj, ed., *Printed Project 11: "Farewell to Post-Colonialism: Querying the Guangzhou Triennial 2008"* (Visual Arts Ireland) (May 2009).
4 Edward Said, *From Oslo to Iraq and the Roadmap* (London: Bloomsbury, 2004), 12.
5 Edward Said, *Culture and Imperialism* (New York: Knopf, 1993), 57.
6 Jananne Al-Ani, "Acting Out," in David A. Bailey and Gilane Tawadros, eds., *Veil: Veiling, Representation, and Contemporary Art* (London: InIVA, 2003), 106.
7 Zineb Sedira, "Mapping the Illusive," in ibid., 58, 63.
8 Negar Azimi, "Radical Bleak," *Frieze* (January–February 2012), no. 144.
9 Stuart Hall, "Assembling the 1980s: The Deluge and After," in David A. Bailey, Ian Baucom, and Sonia Boyce, eds., *Shades of Black: Assembling Black Arts in 1980s Britain* (Durham, N.C.: Duke University Press, 2005), 19.
10 Sedira, "Mapping the Illusive," 58.
11 Mona Hatoum, interviewed by Janine Antoni, New York, 1998, reprinted in *Mona Hatoum* (Santiago de Compostela: Centro de Arte de Salamanca and Centro Galego de Arte Contemporánea, 2002).
12 Edward Said, "The Art of Displacement: Mona Hatoum's Logic of Irreconcilables," in *Mona Hatoum: The Entire World as a Foreign Land* (London: Tate Gallery, 2000).

Gilane Tawadros is a writer and curator. She was founding Director, Institute of International Visual Arts (InIVA), 1994–2005.

Artists

NEGAR AHKAMI

My paintings draw inspiration from Iran's patterned-art traditions and elaborate blue-tiled mosques. I apply multiple layers of congealed gesso and acrylic mediums, and alternate the use of glossy and matte finishes, pearlescent gold, and glitter. The results are visually dynamic surfaces that evoke Iran's traditions of lusterware ceramics and bas-relief tile work.

There is a richness and complexity in my paintings that reflect my reverence for Persian art. At the same time, my work upends the perfection we expect from Persian-Islamic art. Taking permission from Western expressionism, feminism, and popular culture, I embrace a personally expressive voice and a raw sense of touch. In lieu of poetry and transcendence, my approach to Persian art reflects the neuroses of our time, as well as those of the artist.

My images of mosques double as melting, radioactive power plants. The cartoonish meltdowns satirize the brutal Iranian regime at the same time that they satirize Islamophobic anxieties about a nuclear Iran. In rendering these melting cityscapes as both exquisite and cartoonishly menacing, I have created an aesthetic out of the painfully opposing views of Iran to which I've been exposed.

I embrace the fantastical sensibility of Orientalist art to create psychological spaces that grapple with my own nostalgia and sense of loss for Iran. Yet, in many works, I subvert the exoticism of Orientalism by emphasizing humanity and interconnectedness. My reference to Iranian consumerist fetishes for the West, as in *Suffocating Loveseat Sectional*, 2007 challenges the one-way gaze of Orientalism, and suggests that exotic escapism occurs in both directions.

Negar Ahkami (born 1971, Baltimore) was raised in northern New Jersey. She received a BA in Middle Eastern languages and cultures from Columbia University in 1992, a JD from Georgetown University in 1997, and an MFA from the School of Visual Arts in 2006.

She has had two solo exhibitions in New York, at LMAK Projects, Williamsburg, Brooklyn, 2007, and the Leila Heller Gallery, New York, 2009. Her work was exhibited in a two-person show at the Miki Wick Kim Gallery, Zurich, 2008. Ahkami's work has also been featured in various group exhibitions, including *A Conversation,* Marvelli Gallery, New York, 2004; *Simply Drawn,* Luxe Gallery, New York, 2004; *Do You Think I'm Disco?,* Longwood Art Gallery, Bronx, New York, 2006; *A Delicate Arrangement,* curated by Dan Cameron, David Zwirner Gallery, New York, 2006; *Iconoclasmic,* Longwood Art Gallery, Bronx, New York, 2006; *Pink Polemic,* Kravets|Wehby Gallery, New York, 2007; *How Soon Is Now?:* AIM 28, Bronx Museum of the Arts, New York, 2008; *East West Dialogues,* Leila Heller Gallery, New York, 2008; *Firewalkers,* Stefan Stux Gallery, New York, 2008; *Weaving the Common Thread,* Queens Museum of Art, New York, 2008; *Iran Inside Out,* Chelsea Art Museum, New York, and DePaul University Art Museum, Chicago, 2009, and Farjam Collection, Dubai, United Arab Emirates, 2010; *The Seen and the Hidden: (Dis)Covering the Veil,* Austrian Cultural Forum, New York, 2009; *Selseleh / Zelzeleh: Movers and Shakers in Contemporary Iranian Art,* Leila Heller Gallery, New York, 2009; *Tehran—New York,* Leila Heller Gallery, New York, 2010; *Women Artists at the New Britain Museum,* New Britain Museum of American Art, Connecticut, 2011; and *Dis[Locating] Culture: Contemporary Islamic Art in America,* Michael Berger Gallery, Pittsburgh, 2011.

Her work is included in the collections of the DePaul University Art Museum, Chicago; Farjam Collection, Dubai; New Britain Museum of American Art, Connecticut; and a corporate collection in the United States.

Ahkami has participated in various artist residency programs, among them the Jentel Artist Residency Program, Banner, Wyoming, 2003; the Skowhegan School of Painting and Sculpture, 2004; the Lower Manhattan Cultural Council Workspace Residency, 2006, 2007; and AIM 28, Artist in the Marketplace, Bronx, New York, 2007–08.

Note: The following work is illustrated on page 8.

NEGAR AHKAMI
Suffocating Loveseat Sectional, 2007

The Fertile Crescent

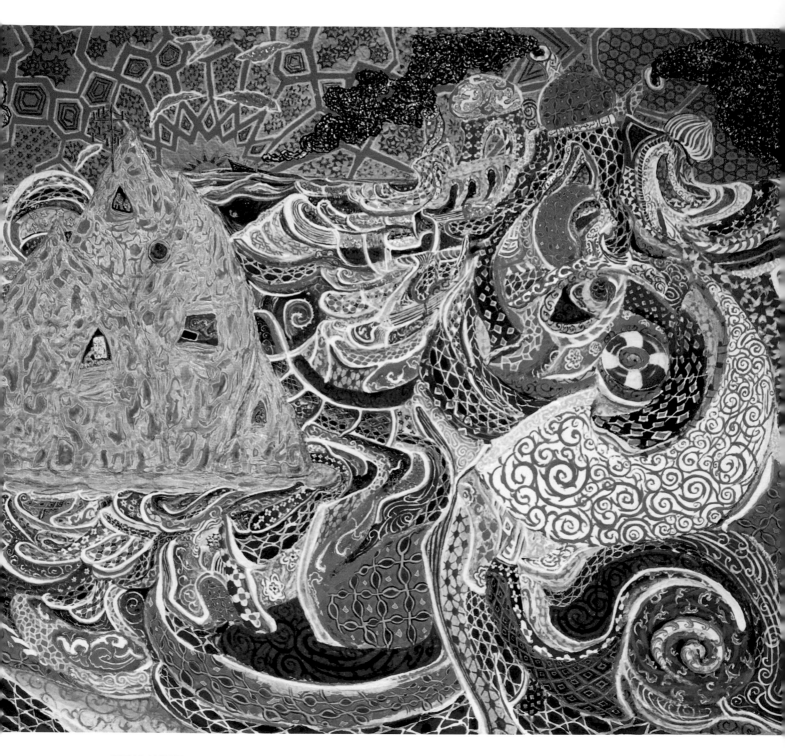

NEGAR AHKAMI
Hot and Crusty, 2011
Acrylic and glitter on gessoed panel
36 x 48 in. (91.4 x 121.9 cm)
Photo credit: Emma Cleary
Courtesy of the Leila Heller Gallery, New York, and the artist

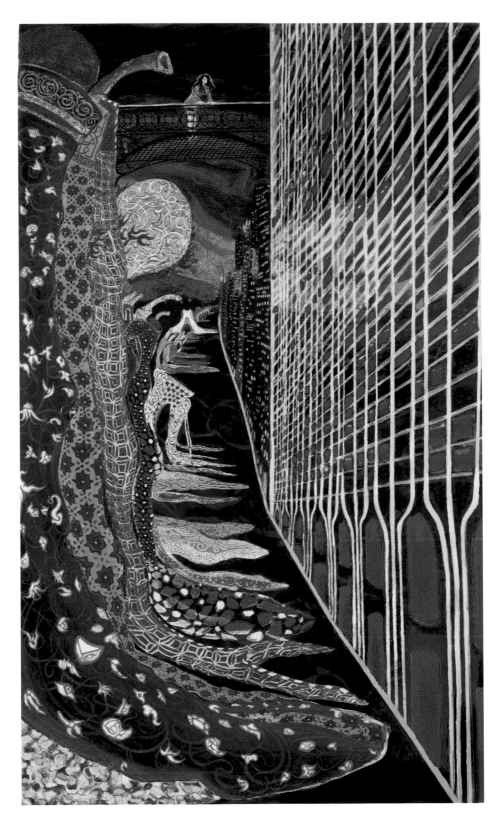

NEGAR AHKAMI
The Bridge, 2007
Acrylic, glitter, and nail polish on gessoed panel
60 x 36 in. (152.4 x 91.4 cm)
Photo credit: Jeff Barnett-Winsby
Courtesy of Fred Perlberg; Leila Heller Gallery,
New York; and the artist

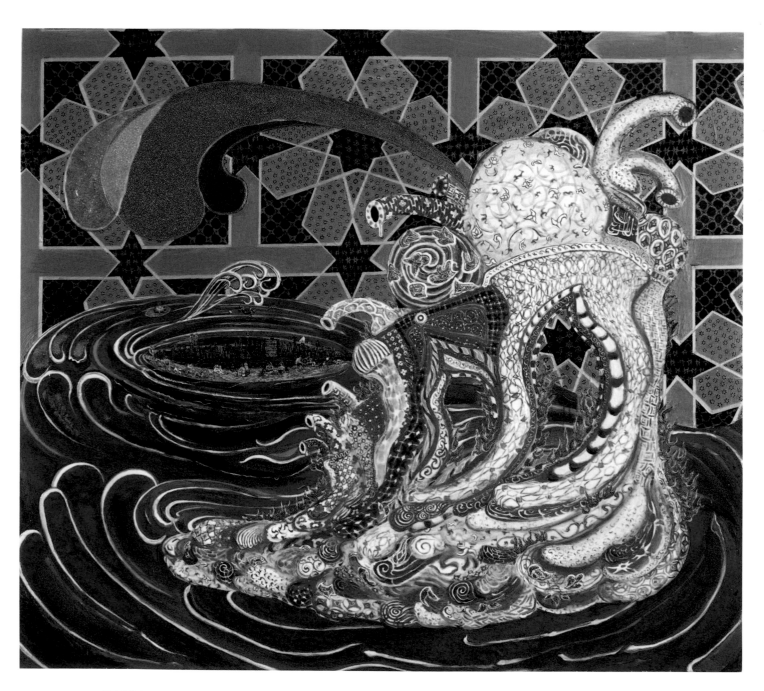

NEGAR AHKAMI
The Source, 2009
Acrylic and glitter on gessoed panel
48 x 54 in. (121.9 x 137.2 cm)
Photo credit: Adam Reich
Courtesy of Jasanna and John Britton;
Leila Heller Gallery, New York; and the artist

SHIVA AHMADI

Shiva Ahmadi's works occupy an uneasy psycho-visual space: at once meticulous and loose, playful and somber, mythical yet very much dealing with the real. They express a sense of instability related to the region: the mounting uncertainty of a tense standoff between two aggressive regimes, Iran and Iraq. But rather than tackle the emotional charges experienced by the civilians of these regimes head-on, Ahmadi has instead chosen an unusual representational detour.

Playfully selective with her referencing of miniature painting, she has created an allegorical realm where faceless tyrants and religious authorities sit on ornate gilded thrones while subservient minions bow to them. Sometimes the tyrants seem messianic, with a veil covering their faces and flames behind their heads; some of them are the guardians of nuclear reactors, which float on clouds. The minions are often festive buffoons, monkeys, and dogs: they kiss feet, juggle grenades, and might even be restrained by leashes. Other animals include elephants and camels floating on candy-like clusters or stomping on highly ornamental carpets, except that the red of the carpet is also a deep pool of blood and the candy clusters are also cluster bombs, bullets, and other projectiles.

Her painterly bag of tricks (loose splatter versus tight rendering, etc.), her intriguing iconography, and the specificity of the geopolitics referenced, make Ahmadi's work at once lush and seductive, but ultimately destabilizing and uneasy. This malaise reflects the artist's inherently critical stance toward power, be it the dictatorial authority of the world she left behind in her native Iran or the more veiled forms of so-called soft and democratic authorities exercised upon her in her current American context.

Shiva Ahmadi (born 1975, Tehran) currently lives in the United States. She received her BFA from Azad University, Tehran, in 1998; MA and MFA degrees from Wayne State University in 2000 and 2003, respectively; and her MFA from Cranbrook Academy of Art in 2005. She is a painter who works not only on two-dimensional surfaces, but also on oil barrels, which function as both content and surface in her work.

Ahmadi's solo exhibitions include *Oil Crisis,* Leila Heller Gallery, New York, 2005; *Shiva Ahmadi: Reinventing the Poetics of Myth,* Leila Heller Gallery, New York, 2010; and one-person shows at Art Dubai, 2010 and 2012. She was featured in the two-person exhibition *Ahmadi and Zhang: Looking Back,* Feldman Gallery, Pacific Northwest College of Art, Portland, Oregon, 2008. Her group exhibitions include the Biennial Art Competition, South Bend Regional Museum of Art, 2003; *Detroit Now,* Meadow Brook Art Gallery, Rochester, Michigan, 2003; Portland Museum of Art Biennial, Maine, 2005; *Three Positions,* Lombard-Freid Projects, New York, 2005; *Figuratively Speaking,* Elga Wimmer Gallery, New York, 2006; *Merging Influences: Eastern Elements in New American Art,* Montserrat Art Gallery, Boston, 2007; *Distant Shores: Cultural Exchange in Contemporary Art,* McIninch Art Gallery, Southern New Hampshire University, Manchester, 2008; Contemporary Istanbul, 2009; *Iran Inside Out,* Chelsea Art Museum, New York, 2009; Abu Dhabi Art, 2011; *Art X Detroit,* Museum of Contemporary Art, Detroit, 2011; *Dis[Locating] Culture,* Michael Berger Gallery, Pittsburgh, 2011; *Jasmin,* Galerie Sabine Knust, Munich, 2011; and three Leila Heller Gallery exhibitions in Abu Dhabi and New York, 2012.

She was nominated for an Altoid Award by the New Museum, New York, in 2008, and received a Kresge Artist Fellowship in 2009. Her work was reviewed in *The Boston Globe,* 2007; *The New York Times,* 2008, 2009, 2010; *Art in America,* 2009; and *The National, UAE News,* 2012. She has taught at the Birmingham Bloomfield Art Center, Birmingham, Michigan; University of Michigan, Ann Arbor; and Wayne State University, Detroit.

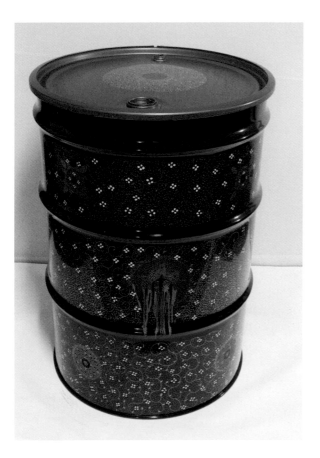

SHIVA AHMADI
Oil Barrel #9, 2009
Oil on steel
34 1/2 x 23 1/2 x 23 1/2 in. (87.6 x 60 x 60 cm)
Courtesy of Howard and Maryam Newman; Leila Heller Gallery, New York; and the artist

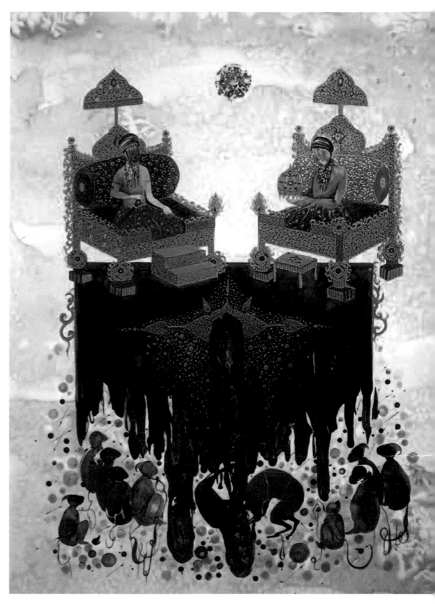

SHIVA AHMADI
Untitled, 2012
Mixed media on aquaboard
45 x 35 in. (114.3 x 89 cm)
Courtesy of the Leila Heller Gallery, New York, and the artist

SHIVA AHMADI
Hades, 2010
Watercolor and gouache on
aquaboard
60 1/2 x 80 1/2 in. (153.7 x 204.5 cm)
Courtesy of Maryam Massoudi;
Leila Heller Gallery, New York; and
the artist

JANANNE AL-ANI

I am an artist working with photography, film, and video. My early work focuses on Orientalist representations of the Middle East in Western visual culture and, in particular, enduring myths and fantasies surrounding the veil.

Starting in the late 1990s, I produced a series of multi-channel video installations including *A Loving Man* (1996–99) and *1001 Nights* (1998), in which a series of complex narratives are carried out by a chorus of female "talking heads." The works address the fallibility of memory, explore the power of testimony, and interrogate the documentary tradition by bringing together intimate recollections of loss and trauma with more official accounts of historic events.

My work has since shifted out of the studio and into the landscape, and in 2004 I completed *The Visit*, the first in a series of ambitious productions to be shot in the Middle East. Since 2007, I have been developing a new body of work titled *The Aesthetics of Disappearance: A Land Without People*, which explores the disappearance of the body in the real and imagined landscapes of the Middle East and includes the single-screen films *Shadow Sites I* (2010) and *Shadow Sites II* (2011).

Jananne Al-Ani (born Kirkuk, 1966) studied at the Byam Shaw School of Art and graduated with an MA in photography from the Royal College of Art in 1997. She is currently Senior Research Fellow at the University of the Arts, London.

Her solo shows include *Jananne Al-Ani*, Imperial War Museum, London, 1999; *The Visit*, Tate Britain, London, 2005; *Jananne Al-Ani*, Darat al Funun, Amman, 2010; and *Shadow Sites: Recent Work by Jananne al-Ani*, Freer and Sackler Galleries, Smithsonian Institution, Washington, D.C., 2012–13. She has participated in major international group exhibitions, among them *Without Boundary: Seventeen Ways of Looking*, Museum of Modern Art, New York, 2006; *The Screen-Eye or the New Image: 100 Videos to Rethink the World*, Casino Luxembourg, 2007; *Closer*, Beirut Art Center, 2009; *The Future of a Promise*, Magazzini del Sale, Venice Biennale, 2011; *Topographies de la guerre*, Le Bal, Paris, 2011; *Women War Artists*, Imperial War Museum, London, 2011; *all our relations*, Sydney Biennale, 2012; and *Arab Express: The Latest Art from the Arab World*, Mori Art Museum, Tokyo, 2012. She has also co-curated touring exhibitions including *Fair Play*, 2001–02, and *Veil*, 2003–04.

Al-Ani's work can be found in numerous major collections, among them the Arts Council England, London; Centre Georges Pompidou, Paris; Darat al Funun, Khalid Shoman Foundation, Amman; Fondation Louis Vuitton pour la Création, Paris; Museum Moderner Kunst, Vienna; Smithsonian Institution, Washington, D.C.; and Tate Gallery, London.

Her work has appeared in various publications, such as Christine Tohme and Mona Abu Rayyan, *Home Works* (Ashkal Alwan, 2003); Rebecca Fortnum, *Contemporary British Women Artists: In their Own Words* (I.B. Tauris, 2007); Glenn Lowry, *Oil and Sugar: Contemporary Art and Islamic Culture* (Royal Ontario Museum, 2009); Sharmini Pereira, *Footnote to a Project** (Abraaj Capital Art Prize, 2011); Jane Rendell, *Site-Writing: The Architecture of Art Criticism* (I.B. Tauris, 2011); and Guy Mannes-Abbott and Samar Martha, *In Ramallah, Running* (Black Dog, 2012). In 2005, Film and Video Umbrella published a monograph focusing on Al-Ani's moving-image work.

She is the recipient of many accolades, including the John Kobal Photographic Portrait Award, 1996; East International Award, 2001; and the Abraaj Capital Art Prize, 2011.

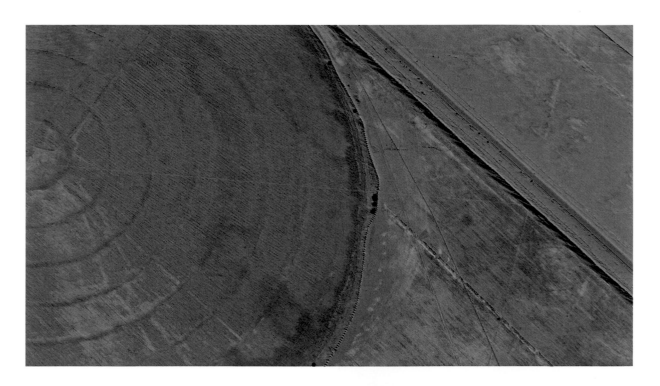

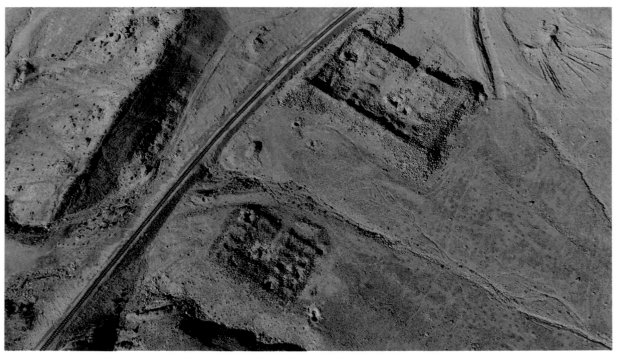

JANANNE AL-ANI
Production stills from *Shadow Sites I*, 2010
Digitized super 16mm film
14:20 minutes
Photo credit: Adrian Warren
Courtesy of Rose Issa Projects, London, and the artist

My visual work examines the interplay among gender, style, and performance by drawing attention to the local context. Sophisticated Google search algorithms allow users to parse information and locate minutiae culled from everyday life, but often neglect significant social rituals that are relegated to the private residential sphere and thus subsequently undocumented. Because of their negligible Google search yield, the Kuwaiti practices and social rituals I address in my work are deemed invisible. Through live performance and video, I create fantasy documentation of said social realities by positing liminal gender identities as the norm, and casting them in a globalized-style setting. My work reveals my fascination with the localized, trickle-down manifestation of global style trends, the reality of consumer culture, and public phenomena. By combining public and private, global and local, the conflation of social barriers reveals the potential manifestations of local identity.

Fatima Al Qadiri (born 1981, Dakar) is a New York–based artist, performance artist, and musician, who produces music under her own name and as Ayshay. She graduated from New York University in 2004 with a degree in linguistics. Through her work in video, photography, and performance, she explores gender stereotypes and the impact of consumerism on contemporary Kuwaiti society.

Selected group exhibitions include *Eb Beiti Ana Geezi,* Sultan Gallery, Kuwait, 2008; *Starship Counterforce,* Aqua Art Miami, Art Basel, 2008; *Goth Gulf Visual Vortex GGVV,* Sultan Gallery, Kuwait, 2009; *No Soul for Sale* (as a member of the collective K48 Kontinuum), X-Initiative, New York, and Tate Modern, London, 2009; *Mahma Kan Althaman ("Whatever The Price"),* Sultan Gallery, Kuwait, 2010; *MOVE!,* MoMA PS1, New York, 2010; *TELFAR SS 2011 ("FORmale"),* White Box Gallery, New York, 2010; *antinormanybody,* Kleio Projects Gallery, New York, 2011; Gwangju Biennale, South Korea, 2011; *Snail Fever,* Third Line Gallery, Dubai, 2011; *The Bravery of Being Out of Range,* Sultan Gallery, Kuwait, 2012; *Global Art Forum,* Art Dubai, Mathaf: Arab Museum of Modern Art, Doha, 2012; *Mendeel Um A7mad (NxIxSxM),* CAP, Kuwait, 2012; *RE-RUN,* Banner Repeater, London, 2012; and *Surrender,* Fourth Edition, Marrakech Biennale, 2012.

Al Qadiri has performed in many countries. Her performances include *CHLDRN* (with Shayne Oliver), The Kitchen, New York, 2009; *Yemenwed, Bedroom w TV and Woman Lays w Aide,* Performa Biennial, New York, 2009, and MoMA PS1, New York, 2010; *Shaytan* (part of *No Soul for Sale*) (as Ayshay), Tate Modern, London, 2010; *SOLILOQUY II,* P.P.O.W., New York, 2010; *Genre-Specific Xperience* (video screening), New Museum, New York, 2011, Nottingham Contemporary, 2012, and Sultan Gallery, Kuwait, 2012; and *Going OVER,* Bidoun Art Park, Art Dubai, 2011.

Al Qadiri has also curated a number of exhibitions, and written and performed film soundtracks. In 2011, she received a visual arts grant from the Arab Fund for Arts and Culture. Al Qadiri is a contributing editor at *DIS* magazine and contributor to *Bidoun* magazine.

FATIMA AL QADIRI AND KHALID AL GHARABALLI
Stills from *Mendeel Um A7mad (NxIxSxM)*, 2012
HD video
15:28 minutes
Courtesy of the artists

FATIMA AL QADIRI
Bored (detail), 1997, 2008
Digital print
64 5/8 x 78 3/4 in. (164 x 200 cm)
Courtesy of the artist

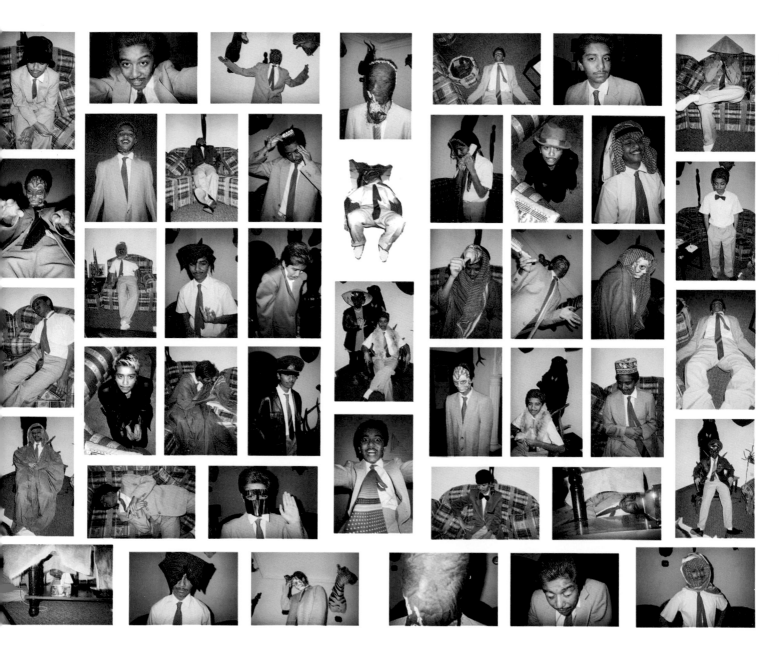

FATIMA AL QADIRI
Bored, 1997, 2008
Digital print
64 5/8 x 78 3/4 in. (164 x 200 cm)
Courtesy of the artist

MONIRA AL QADIRI

A central theme in my work is the exploration of the dysfunctionality of gender roles within Arab society. I experienced this dysfunction personally while growing up in Kuwait. In my youth, I believed that to be someone in the public realm you had to be a man, so I toyed with this idea by repeatedly dressing up in male costumes and attire. This was not about confusion of identity, nor a narcissistic impulse, but, rather, a psychological reaction to a social reality. In my work, I continue to explore the psychological tension of being female in a male-dominated society through the use of self-portraiture and symbols of masculinity.

Another recurring motif in my artistic practice is the dissolution of cultural or religious identity in our time. The ensuing loss of a defined self-image has resulted in a sense of melancholy and an urge to escape, both on an individual and a collective level. I thereby incorporate primitive and historical references into my work to reflect on the slow disappearance of a shared culture. The hyper-communication and mass-migration taking place in today's globalized world produce feelings of estrangement within one's body. I feel we have to come to terms with this fluid loss of identity.

Monira Al Qadiri (born 1983, Dakar) was raised in Kuwait, and has spent most of her adult life in Japan. Her artistic perspective is a cultural hybrid. Having lived through the 1990–91 Gulf War, she became fascinated by Japanese animation as a means of escaping the harsh realities that she had experienced, and at the age of sixteen she moved to Tokyo on an art scholarship from the Kuwaiti government. As soon as she arrived, she realized that the reality of Japan was different from her fantasy of it, and began to incorporate ideas of displacement and dissonance into her work.

In 2005, she completed her first animated film, *Visual Violence*. Since then, she has been conducting research into the relationship between psychology and art, and on the aesthetics of sadness in the Middle East. In 2010, she received her PhD in intermedia art from Tokyo University of the Arts. She has since returned to Kuwait to continue her career as an artist and scholar, and currently divides her time between Kuwait and Beirut.

An emerging artist, she has shown in the following group exhibitions: *Sultana's Dream,* Exit Art, New York, 2007; *In Transition,* National Center for Contemporary Art, Moscow, St. Petersburg, and Kaliningrad, 2008; The Second Annual Gulf Film Festival (GFF), Dubai, 2009 (her film *Wa Waila* [Oh Torment] was screened); *Human Frames,* Kunst im Tunnel, Düsseldorf, 2010; and *Paradisio,* Watermill Center, Southampton, New York, 2010. Her first solo exhibition upon her return to Kuwait was *Tragedy of Self,* Sultan Gallery, Kuwait City, 2011. *Tragedy of Self* was also shown in Japan at the Tokyo Wonder Site and the Harmas De Fare Gallery, Tokyo; in addition, some pieces from the exhibition were shown at the Kleio Projects Gallery, New York, in 2011. Her animation works such as *Visual Violence* and *The Black Moon* have also been screened at such venues as the Gulf Film Festival, Dubai; Rotterdam Arab Film Festival; and the Shanghai International Science and Art Fair.

She was an artist-in-residence at the Watermill Center, Southampton, 2010.

MONIRA AL QADIRI
The Tragedy of Self (series 3), 2009, 2012
Photographs with paint and gold leaf on canvas
47 1/2 x 51 1/8 in. (120 x 130 cm); each 15 3/4 x 13 3/4 in. (40 x 35 cm)
Courtesy of the artist

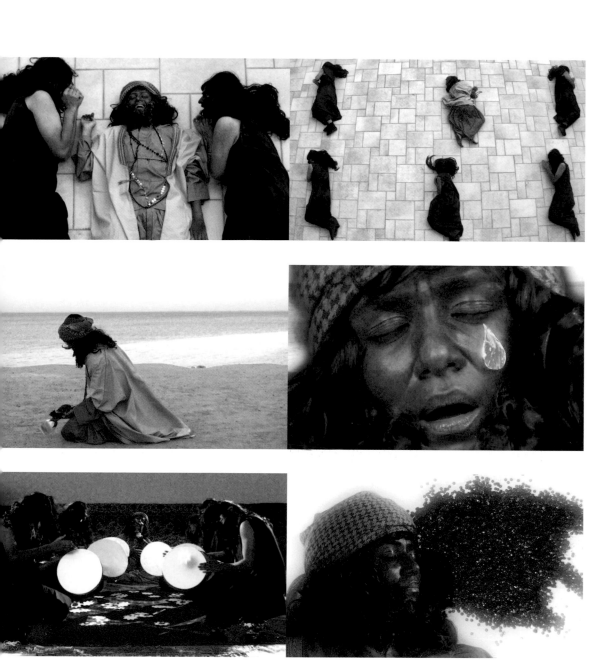

MONIRA AL QADIRI
Stills from *Wa Waila* (Oh Torment), 2008
Short film
10:04 minutes
Courtesy of the artist

GHADA AMER AND REZA FARKHONDEH

hada Amer (born 1963, Cairo) and Reza Farkhondeh met while they were both students at the Villa Arson, Nice, France. There, they received their MFA degrees, Amer for painting, and Farkhondeh for video and short film. Both also studied at the Institut des Hautes Etudes en Arts Plastiques, Paris.

Amer and Farkhondeh reconcile and construct a new formulation of artmaking and gender relationships out of binaries: male/female, painting/embroidery, individual artist/collaboration. Since 1986, the pair have had solo exhibitions at the Stedelijk Museum 's-Hertogenbosch, 2006; Kukje Gallery, Seoul, 2007; Singapore Tyler Print Institute, 2008; Tina Kim Gallery, New York, 2008; Pace Prints, New York, 2009; Galeria Filomena Soares, Lisbon, 2010; Goodman Gallery, Johannesburg, 2011; and the Musée d'art contemporain, Montreal, 2012. Residencies at the Singapore Tyler Institute, 2007; Pace Prints, New York, 2008; the LeRoy Neiman Center for Print Studies, Columbia University, New York, 2009; and OCAD University Faculty of Arts, Toronto, 2012, have helped enable them to pursue their collaborative work.

GHADA: The first question is, how can one "write" painting in the feminine? Then there is the question of beauty: how to convey an emotion and a feeling of beauty when painting.

REZA: The beauty of nature exists outside the domain of art. Do clouds, flowers, and trees have the power to tame artists so that they might be inspired by them?

REZA: I began to paint on canvases that Ghada was preparing for her work. A little later, I began to do watercolors on paper, and this time, Ghada intervened on them.

GHADA: In the beginning, I did not realize that we were collaborating. The first time he left a mark from his vocabulary on my work, that painting became, for me, emblematic of the beginning of our collaboration. I never sold that painting for this very reason.

REZA: Collaboration is a mutant riddle. It is a type of creation that resists control. To be able to continue working, we need to see what the other has done. We reverse roles. That way, we can be both creators and viewers!

GHADA: Perhaps collaboration is a riddle, insofar as we don't speak or communicate with each other a single intention or direction as to what we are doing. Everything evolves in silence.

This statement is based on an interview with the artists conducted by Martine Antle, published in *Ghada Amer and Reza Farkhondeh: The Gardens Next Door*, exh. cat. (Lisbon: Galeria Filomena Soares, 2010).

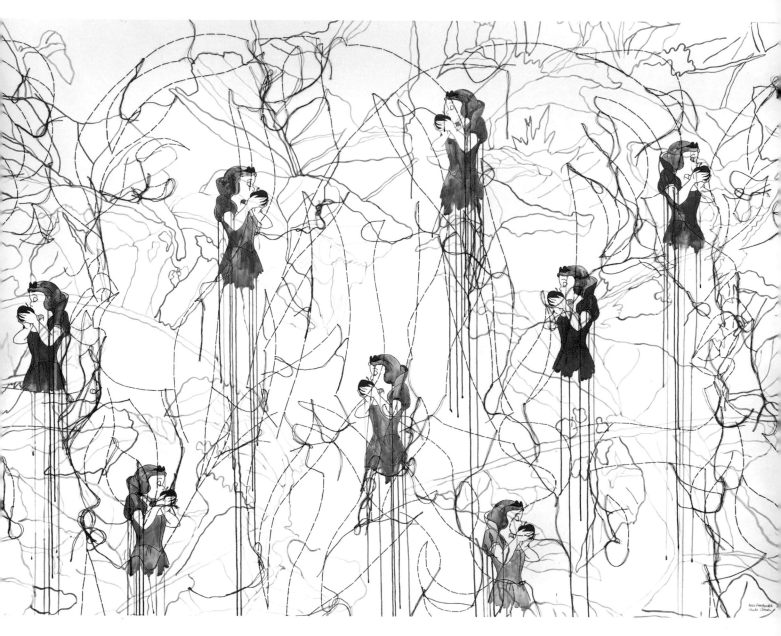

REZA FARKHONDEH AND GHADA AMER
Apples and Petunias, 2011
Watercolor and embroidery on paper
51 1/2 x 82 1/2 in. (130.8 x 209.6 cm)
Courtesy of Cheim & Read, New York, and
the artists

REZA FARKHONDEH AND GHADA AMER
The Gardens Next Door-D, 2010
Mixed media on paper
43 3/4 x 77 1/2 in. (111.1 x 196.9 cm)
Courtesy of Cheim & Read, New York, and the artists

REZA FARKHONDEH AND GHADA AMER
Orange Dream, 2007
Mixed media on STPI handmade cotton paper
57 1/4 x 108 1/4 in. (145.4 x 275 cm)
Courtesy of Cheim & Read, New York, and the artists

ZEINA BARAKEH

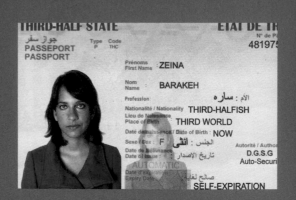

My artwork examines how people and spaces become polarized as a result of binary divisions. During my formative years, Beirut was characterized by perpetual conflict—political alliances shifted regularly, often culminating in armed clashes. Those who shared geographical and socioeconomic markers of identity with political factions were seen as being a part of such alliances, and, consequently, were considered "accomplices" to the perpetuation of civil tensions.

In response to these divisions, I conceptualized a space, the *Third-Half,* in which individuals exist outside of factionalized communities. The *Third-Half* functions as an umbrella under which I produce my work, highlighting divergent narratives of the Middle East, including Western interventions and regional strife.

Identification + Mobility

M.E. Transit (2012) is a digital photograph collection of my family members' passports depicting their mobility since 1943 through a series of official stamps, visas, and signatures of the controlling authorities; a fictive passport permits entry into the *Third-Half.*

Action + Change

And Then . . . (2008–ongoing) is a serialized work of video animation. Chapter 1, *Now,* depicts rival battalions in Beirut as individual cells that merge, disperse, dance, and attack. Chapter 2, *Scenarios of Return,* visits the British Mandate of Palestine. My avatar manifests itself in Jaffa, where my father was born, to fight the British and reverse history.

Media Mobilization

Bring the Money Home (2008) is a multilingual, layered sound piece of a 2008 march in San Francisco against the Iraq War; two Palestinians narrating their escape

Zeina Barakeh (born 1972, Beirut) is a Lebanese-Palestinian artist based in San Francisco. Barakeh obtained her BA in interior design from the Lebanese American University, Beirut, and her MFA from the San Francisco Art Institute. Her artwork examines how people and spaces become polarized as a result of binary divisions. Through animation, digital media, and archival installations, she interrogates constructions of identity, history, memory, and territory.

Selected solo and two-person exhibitions include *Facettes,* Espace SD Gallery, Beirut, 2005; *Passages,* Golden Thread's ReOrient Festival, Theater Artaud, San Francisco, 2009; *The Third-Half,* Anspacher Galleries, The Public Theater, New York, 2011; and *Jaffa Mangoes: History, Memory, and Myth,* Ictus Gallery, San Francisco, 2012. Group exhibitions include *Printemps de la peinture,* Martyrs' Square, Beirut, 1995; *Beyond Tradition,* Illusion Gallery, Kuwait City, 2004; *Journée des peintres,* Deir El-Qamar Festival, Chouf, Lebanon, 2004–05; *Plastic Arts,* Middle East University, Sabtieh, Lebanon, 2006; *Internal Exile: From Palestine to the USA to Mexico,* SOMArts Bay Gallery, San Francisco, 2007; *The Token Woman Show,* Diego Rivera Gallery, San Francisco Art Institute, 2007; and *Proliferations,* Rhodes & Fletcher, LCC/OFF-Space, San Francisco, 2009.

Barakeh's work has been written about in the following Beirut newspapers and journals: *Al-Liwaa, Al-Mustaqbal, Al-Ousbou' Al-Arabi, An-Nahar, The Daily Star/International Herald Tribune, L'Orient-Le Jour,* and *La Revue du Liban.* Her work has been featured on Future TV, Beirut; Heya TV, Arab Woman Channel, Beirut; and on *Arab Talk,* KPOO 89.5 FM, in San Francisco. Barakeh's paintings have appeared in various publications, including the cover of Patricia Sarrafian Ward's novel *The Bullet Collection* (Graywolf Press, 2003) and the Beirut-based arts magazine *L'Agenda Culturel.*

Barakeh received the Sheikh Zayed Fine Arts Award from the Lebanese American University in Beirut, 1994, and two artist residencies from the Vermont Studio Center in Johnson, Vermont, 2001, 2004, among other accolades.

She currently serves as Director of Graduate Administration and Visiting Faculty at the San Francisco Art Institute. In 2012, she initiated the co-curricular arts platform *No Reservations Art,* which links MFA students with professional opportunities in the art world.

from Jaffa to Beirut in 1948; and political speeches from the 2006 Lebanon War. The piece ends at a party with a conversation about mixed marriages.

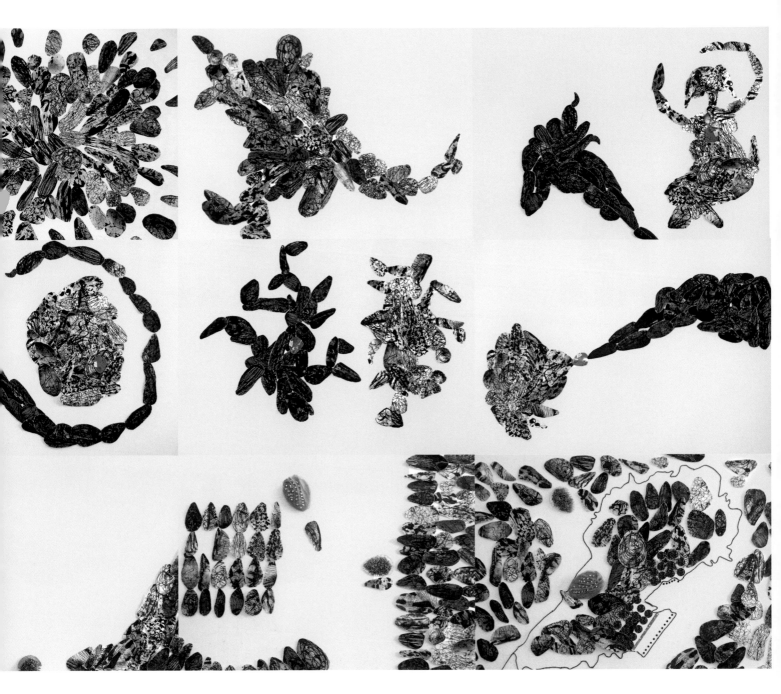

ZEINA BARAKEH
Stills from *Now* (chapter one) (left to right, top to bottom), 2008,
from the series *And Then . . .*, 2008–ongoing
Video animation
Duration variable
Courtesy of the artist

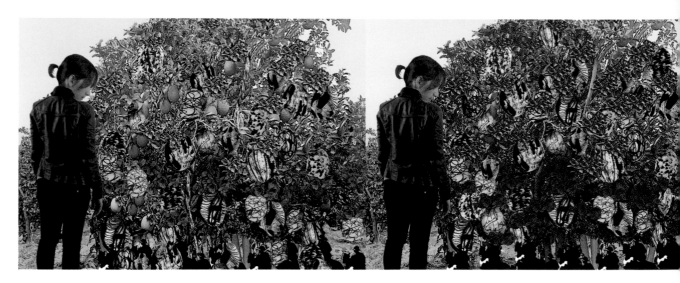

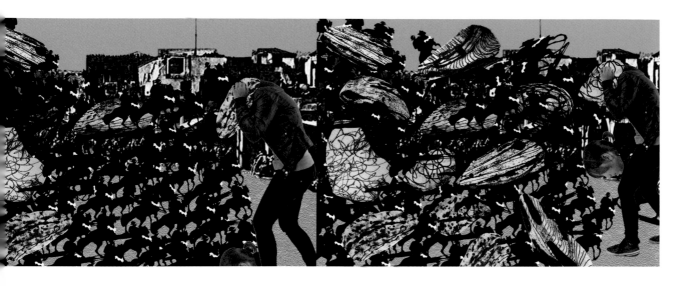

ZEINA BARAKEH
Stills from *Scenarios of Return* (chapter two) (left to right, top to bottom), 2012, from the
series *And Then . . .* , 2008–ongoing
Video animation
Duration variable
Courtesy of the artist

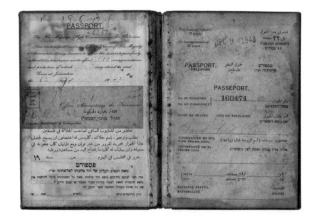
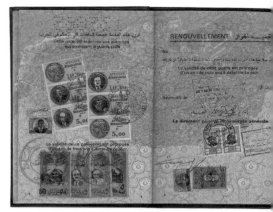
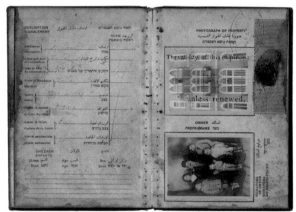
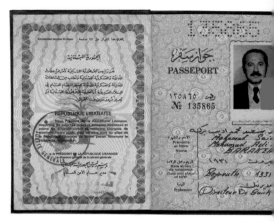
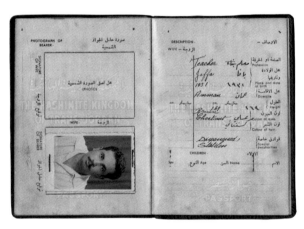
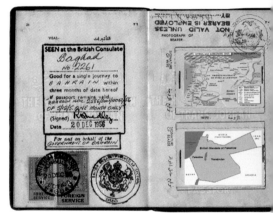

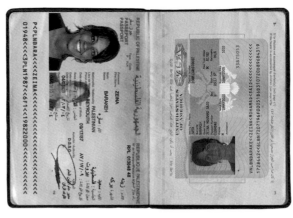
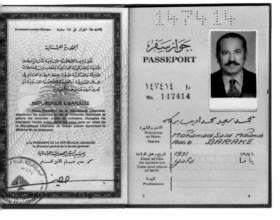
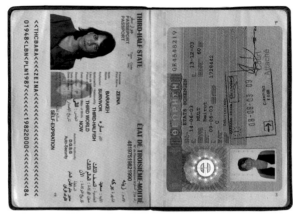
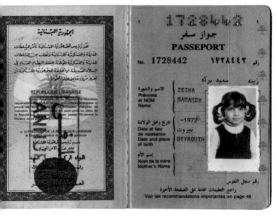
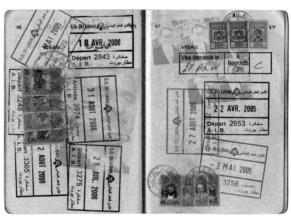

ZEINA BARAKEH
Passport details from the series *Third-Half Passport Collection: M.E. Transit*, 2012
Archival inkjet prints
Installation 67 x 126 in. (170.2 x 320 cm); each 21 x 30 in. (53.3 x 76.2 cm)
Courtesy of the artist

First column, top to bottom: *British Mandate Passport, Bio; British Mandate Passport, Jaffa House; Transjordanian Passport, Bio*

Second column, bottom to top: *Transjordanian Passport, British & French Mandates; Lebanese Passport, Born in Beirut, Bio (Forged); Lebanese Passport, Born in Beirut, Civil War*

Third column, top to bottom: *Lebanese Passport, Born in Jaffa, 1982 Invasion; Lebanese Passport, Born in Jaffa, Bio; Lebanese Passport, Bio*

Fourth column, bottom to top: *Lebanese Passport, 2005 Cedar Revolution; Third-Half Passport, Bio; Palestinian Passport, Bio*

Ofri Cnaani works with time-based media, live-cinema performances, and large-scale installations. Her video installations explore the theatrical potential of the urban space and the relationship between architecture and narrative, seeking to dissolve spatial distinctions between the realms of reality and myth. Her recent works utilize defunct technologies to present her research on the visual memories of the early days of Israeli history, as well as on political and sexual betrayal.

Ofri Cnaani (born 1975, Kibbutz Cabri) lives in New York. She received her MFA in visual arts from Hunter College in 2004. Cnaani's videos and drawings are inspired by the varying perceptions of the land of Palestine—sometimes pictured as a tourist mecca, at other times as a hazardous place—during different periods of the twentieth century. She also bases work on Biblical and Talmudic sources.

Her solo exhibitions and performances include *Patrol,* Herzliya Museum of Art, 2003; *The Blind Scenario,* Galleria Pack, Milan, 2005; *Death Bed,* Haifa Museum of Art, 2006; *Decreation,* Braverman Gallery, Tel Aviv, 2007; *Twister,* Network of Lombardy Contemporary Art Museums, Italy, 2009; *The Vanishing Woman,* MoMA PS1, New York, 2010; *Public Notice: An Exhausted Film* (with Cheryl Kaplan and Kathryn Alexander), BMW Guggenheim Lab, New York, 2011; *The Sota Project,* Kunsthalle Galapagos, Brooklyn, 2011; and *Special Effects,* Andrea Meislin Gallery, New York, 2012. Cnaani has participated in numerous group exhibitions, among them AIM 25, Bronx Museum of the Arts, New York, 2005; *Disengagement,* Tel Aviv Museum, 2006; *Port-City,* Arnolfini Foundation Museum, Bristol, 2007; *Playing with Solitude,* Ursula Blickle Videolounge, Kunsthalle Wien, Vienna, 2007; Moscow Biennale, 2009; Prague Triennale, 2009; and *Rupture and Repair,* Adi Foundation and the Israel Museum, Jerusalem, 2010.

In 2007, Cnaani was the recipient of the Six Points Fellowship, awarded to emerging Jewish artists by the Foundation for Jewish Culture. She received the America-Israel Cultural Foundation Award twice, in 2000–01 and 2003–04.

Artis Foundation grant recipient

OFRI CNAANI
Stills from *The Sota Project,* 2011
Video installation
22 minutes
Courtesy of the artist

OFRI CNAANI
Stills from *The Sota Project*, 2011
Video installation
22 minutes
Courtesy of the artist

OFRI CNAANI
Terre Promise; Land for Youth; Visit; Die Welt Palestina (left to right,
clockwise), from the twenty-part series *Oriental Landscapes*, 2007–08
Ink and spray paint on Mylar
Each 18 x 24 in. (45.7 x 61 cm)
Courtesy of the Andrea Meislin Gallery, New York, and the artist

Note: *Although not illustrated, three other works from the series, Blinding
Sun, Body Drawing, and Symbolic Explosion, were also in the exhibition.*

The idea, the thought, the draft are the bases for my artwork. My ideas come from everyday life situations, social and cultural atmospheres. The idea expresses itself in performances and installations.

I use the body as a means of expression. Sometimes, the artistic idea is expressed using the body alone; at other times, the body is used as part of the installation and within the context of a presentation to an audience.

The subjects I deal with are time, movement, space, material, body, and action/interaction. I try to create works of art that leave for the viewer free space for associations and new possibilities. I take specific situations from everyday life and place them into a new context.

I aim to create an art where all of the elements are interconnected so as to form a total work of art—a *Gesamtkunstwerk*.

Nezaket Ekici (born 1970, Kirsehir) has lived in Berlin and Stuttgart, Germany, since 1973. Many of her performances, installations, and videos are inspired by her dual German-Turkish cultural heritage.

In 1994–2000, she studied art pedagogy, art history, and sculpture at Ludwig Maximilian University and Fine Arts Academy, Munich, and received her MA degree in art pedagogy. In 2001–04, she studied performance art with Marina Abramovic at the Hochschule der Bildenden Künste Braunschweig, from which she received her BFA and MFA.

Her work has been exhibited at major international venues and shows. They include the Fondazione Antonio Ratti, Como, 2000; Haus der Kunst, Munich, 2000; Irish Museum of Modern Art, Dublin, 2001; 25 May Museum, Belgrade, 2001; Museo Centro Galego de Arte Contemporànea, Santiago de Compostela, 2002; PAC, Milan, 2002; Fifth International Women's Art Festival, Aleppo, Syria, 2003; Fiftieth Venice Biennale, 2003; Fourth International Performance Festival, Odense, Denmark, 2003; Art Forum Berlin, 2004; Art Frankfurt, 2004; International Festival of Performance Art, Boston, 2004; MoMA PS1, New York, 2004; Elgiz Museum of Contemporary Art, Istanbul, 2005; Museo Reina Sofía, Madrid, 2005; Van Gogh Museum, Amsterdam, 2005; *The Armory Show,* New York, 2006; Feigen Contemporary, New York, 2006; International Performance Art Event, Singapore, 2006; *Into Me / Out of Me,* Kunst-Werke, Berlin, 2007; Museum of Contemporary Art, Taipei, 2007; Venice Biennale, 2007; Expo Zaragoza, 2008; Triennale, Bovisa Museum, Milan, 2008; Fifth Latin-American Visual Arts Biennial, Vento Sul, Curitiba, Brazil, 2009; Kunstmuseum Heidenheim, 2009; Museum voor Moderne Kunst, Arnhem, Netherlands, 2009; Kunstverein Friedrichshafen, 2010; First Mediterranean Biennale of Contemporary Art, Haifa, 2010; Kunsthalle Exnergasse, Vienna, 2010; Mardin Bienali, Turkey, 2010; Museum Alex Mylona, Athens, 2010; Cobra Museum voor Moderne Kunst, Amsterdam, 2011; Istanbul Modern, 2011; Villa Empain, Boghossian Foundation, Brussels, 2011; Zentrum für Kunst und Medientechnologie, Karlsruhe, 2011; Esbjberg Kunstmuseum, Denmark, 2012; Institute of Contemporary Arts Singapore, 2012; and Museum Boijmans van Beuningen, Rotterdam, 2012.

Selected awards include an artists' and authors' grant, Else-Heiliger-Fonds, Konrad-Adenauer-Stiftung, 2002; artists' residency grant, Künstlerhäuser Worpswede, 2004; GASAG Art Prize, Berlin, 2004; Arbeitsstipendium Stiftung Kunstfonds Bonn, 2005; artists' residency grant, BM Contemporary Art Center, Istanbul, 2005; Arbeitsstipendium Kunststiftung Baden-Württemberg, 2006; U2 Alexanderplatz, Berlin, 2007; artists' residency grant, FADA International, Toronto, 2008; Arbeitsstipendium für Bildende Kunst, Berlin, 2010; Karin Abt-Straubinger Stiftung, 2010. Ekici also received project grants from the Goethe-Institut International to create work in Milan, 2001; Damascus, 2003; Madrid, 2005; Los Angeles, 2006; Amsterdam, 2007; Jakarta, 2007; Istanbul, 2008; Ankara, 2009; Tiflis, 2009; Athens, 2010; Thessaloniki, 2010; Vietnam, 2010; and Ghana, 2012.

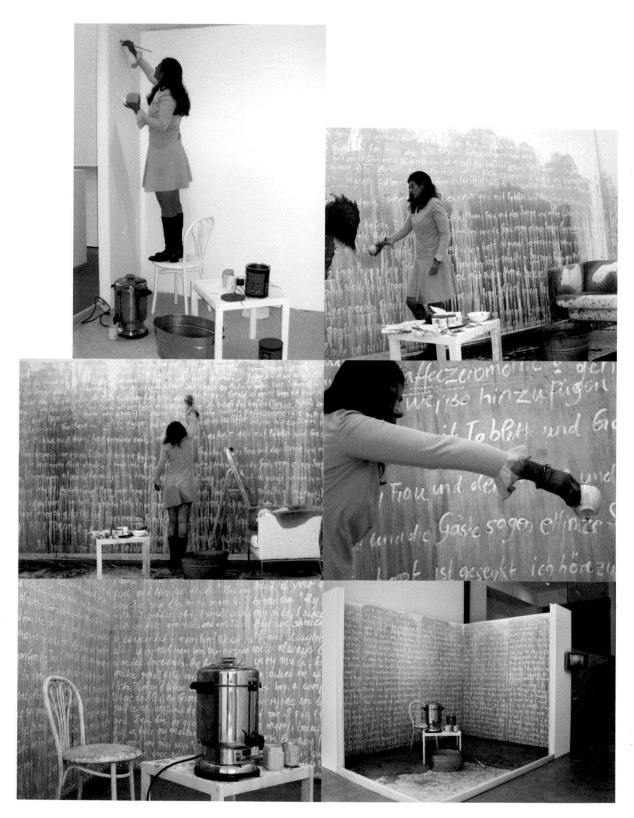

NEZAKET EKICI
Stills from *Lifting a Secret*, 2009
Performance at the Claire Oliver Gallery, New York
Courtesy of the Claire Oliver Gallery, New York, and the artist

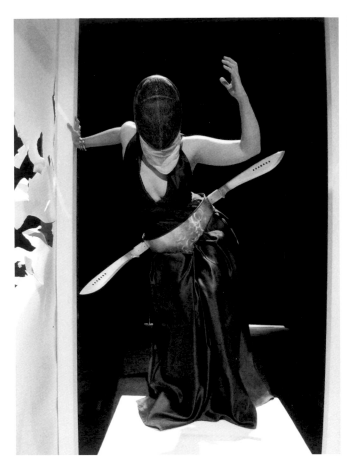

NEZAKET EKICI
Stills from *Oomph*, 2007
Video of performance and installation at *The Erotic Body: Teatro alle Tese* (Theater and Dance), Fifth International Festival of
Contemporary Dance, Fifty-Second Venice Biennale, June 15–17, 2007; and Jahresausstellung der Stipendiaten 2006, Kunststiftung
Baden-Württemberg, E-Werk, Freiburg, July 31–August 12, 2007
Camera by Andreas Dammertz
Photo credit: Andreas Dammertz, Jürgen Bernhard Kuck, and Katarina D. Martin
Courtesy of the Claire Oliver Gallery, New York, and the artist

NEZAKET EKICI
Stills from *Ammo* (left to right, top to bottom), 2007
Video performance
DVD PAL
2:38-minute loop
Camera and video stills by Andreas Dammertz
Courtesy of the Claire Oliver Gallery, New York, and the artist

DIANA EL JEIROUDI

I am struck by the extent to which people have abandoned the act of observing, and are therefore unable to listen to, or see, either "ourselves" or "the other." When I was a young girl, I spent a significant amount of time by myself, so I learned and practiced observation as a means of medilation. Observing people was my favorite form of entertainment. I enjoyed noticing people's reactions and gestures, and reading into them what those external clues told me about their thoughts, fears, illusions, and aspirations. For me, that was what was most human about them, and what most connected them to me. It is always amazing how much one can "see" if one looks carefully and listens attentively. It is exactly what I do today as a filmmaker: I observe.

Whether during the filming process or later in editing, the very experience of "digitizing" human sounds and images, of splitting the two, grants me the ability to be not only positive toward "the other" but also toward "myself."

In my films, I invite people to be consciously open to listening and seeing. I think these are the human skills that we need to value most.

Diana El Jeiroudi (born 1977, Damascus) graduated from Damascus University in 2000. She has been a Syrian filmmaker, producer, distributor, and promoter of creative documentary films since 2002.

Her debut film, *The Pot,* on the experience of pregnancy and its impact on women's relationship to their bodies, premiered at the Yamagata International Documentary Film Festival in 2005. It was followed by the feature-length documentary *Dolls: A Woman from Damascus,* which El Jeiroudi wrote, directed, and co-produced with the Danish production company Final Cut; *Dolls* was introduced at the International Documentary Film Festival Amsterdam, 2006, and premiered at the Silver Wolf competition at the International Documentary Film Festival Amsterdam, 2007. To date, it has played at more than twenty international festivals, including Visions du Réel, Montpellier, and the DOX Copenhagen International Documentary Film Festival; it has also been broadcast on several European TV channels and in Asia.

When not behind the camera or in the editing room, El Jeiroudi works with other creative documentary filmmakers as a producer and distributor through Proaction Film, the company she co-founded in 2002, the only independent film production outfit in Syria operating today. Through Proaction Film, she co-produced three short documentaries and is now in the midst of producing two feature-length documentaries. El Jeiroudi offers consultancies in documentary structure and editing through workshops such as *Storydoc,* Corfu, Greece.

El Jeiroudi is also a co-founder and member of the selection committee of the DOX BOX International Documentary Film Festival, Syria, and since 2007 has headed its Industry and Professional Activities Committee. In 2012, DOX BOX received the European Documentary Network's EDN Award. The award is annually given to an organization, group, or individual making an outstanding contribution to European documentary culture. However, this year the EDN decided to modify its award criteria to recognize DOX BOX's efforts to overcome the extraordinary circumstances facing the Syrian film community. El Jeiroudi and fellow DOX BOX co-founder Diana Orwa Nyrabia received the award the day after DOX BOX Global Day, in which the festival collaborated with film organizations to screen Syrian documentaries in thirty-eight cities around the world.

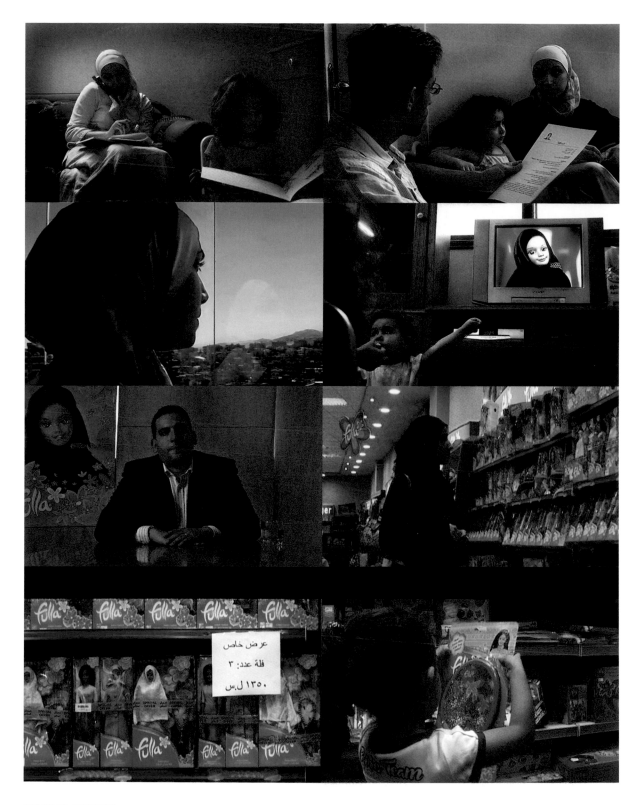

DIANA EL JEIROUDI
Stills from *Dolls: A Woman from Damascus* (left to right, top to bottom), 2007–08
Film
53 minutes
Written and directed by the artist; co-produced with the Danish film company Final Cut
In Arabic and English, with English, French, and Danish subtitles

PARASTOU FOROUHAR

The production of identity, and the repressive mechanisms by which it is reified, comprise the focus of my work. My homeland, Iran, is a constant theme in my artistic practice, but the conception is complex and continuously in flux. Beyond Iran, there is also the collective memory of Germany, where I have lived since 1991. When I arrived there, I was Parastou Forouhar, but I have since become "Iranian." Every space I inhabit is accompanied by a feeling of displacement.

The interaction of contradictory meanings is another central theme in my work. In my series of digital prints and wallpaper entitled *Butterfly* (2010), the delicate form of these insects is contrasted with camouflaged scenes of torture. Only when viewers look at these images a second time, do they notice that the butterfly wings contain wounded and gagged human figures. This series is intensely personal for me, as my mother's name, Parvaneh, is the Farsi word for "butterfly." It has become a kind of memento mori for the political assassination of my parents in 1998 in Iran.

The four-part photographic piece *Freitag* (2003) addresses the reciprocal effect of the veiled and unveiled body. The unveiled skin of the woman's fingers is charged with eroticism, contrasting with the cloth of the veil. This duality invites viewers to challenge their assumptions and gain insight into the complexity of the clichéd trope of Iran as veiled woman.

Parastou Forouhar (born 1962, Tehran) lived in Iran until 1991, when she relocated to Frankfurt, Germany, where she still resides. She studied art at the University of Tehran, joining the first enrolled class in 1984 after a two-year period in which the nation's universities were closed in order to restructure the educational system and implement, in Forouhar's words, "thorough Islamization." In addition to her bachelor's degree from the University of Tehran, Forouhar received a master's degree from the College of Art, Offenbach, Germany. The Islamic Revolution's transformative impact on Iran, paired with the omnipresent collective memory of violence in Germany, has generated a body of work marked by the construction of a complex identity informed by these histories and experiences.

Forouhar's digital drawings are often labyrinths developed out of patterns inspired by classical Persian ornamentation. Forouhar depicts figures trapped inside the borders of Persian ornamental designs—a metaphor for her Iranian homeland and the violence it has witnessed. This violence tragically touched Forouhar's own life when her parents, Dariush and Parvaneh, respected intellectuals who fought for democracy in Iran, were brutally murdered in their home on November 21, 1998. Forouhar has persistently campaigned for a proper investigation into the extra-judicial executions of her parents and other activists murdered in Tehran in fall of 1998. Her commitment to justice provides one of the foundations of her work.

Forouhar has had various solo exhibitions throughout the world. They include *Blind Spot*, Sølvberget, Stavanger Kulturhus, and Golestan Art Gallery, Tehran (banned by the Iranian authorities), 2001; *Thousand and One Days*, Hamburger Bahnhof, Museum für Gegenwart, Berlin, 2003; *Just a Minute*, Fondazione Pastificio Cerere, Rome, 2007; *He Kills Me, He Kills Me Not*, Verso Arte Contemporanea, Turin, 2010; *Parastou Forouhar*, Leighton House Museum, London, 2010; *Parastou Forouhar*, RH Gallery, New York, 2010–11; and *Written Room*, Fondazione Merz, Turin, 2011. Forouhar's art has also been presented in many important group exhibitions including the Second Berlin Biennale, 2001; *Scene Change XIX*, Museum of Modern Art, Frankfurt, 2001; *Bellissima*, Academy of Visual Arts, Leipzig, 2003; *Intersections*, Jewish Museum of Australia, Melbourne, and Jewish Museum, San Francisco, 2005; *Global Feminisms*, Brooklyn Museum, 2007; *Re-Imagining Asia*, Haus der Kulturen der Welt, Berlin, 2008; Incheon Women Artists' Biennale, South Korea, 2009; *Medi(t)ation*, Asian Art Biennale, National Taiwan Museum of Fine Arts, 2011; and *20 Years of Presence*, Museum of Modern Art, Frankfurt, 2011.

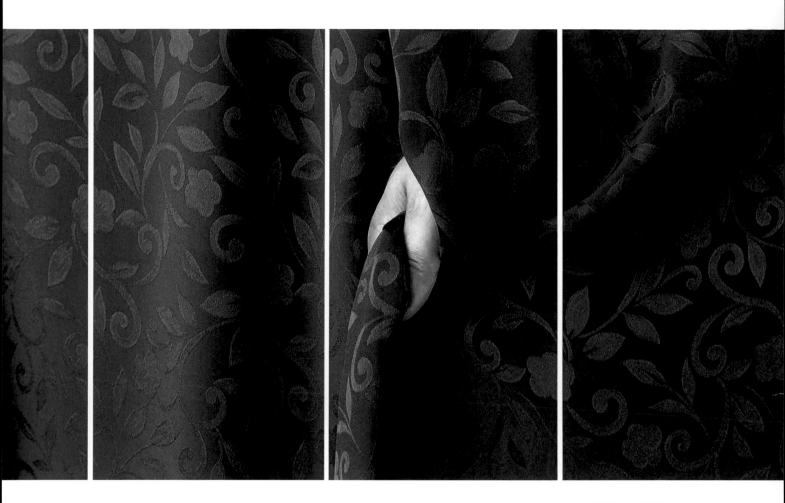

PARASTOU FOROUHAR
Freitag (Friday), 2003
Aludobond
Four panels
Each 66 7/8 x 33 7/8 in. (170 x 86 cm)
Courtesy of the RH Gallery, New York,
and the artist

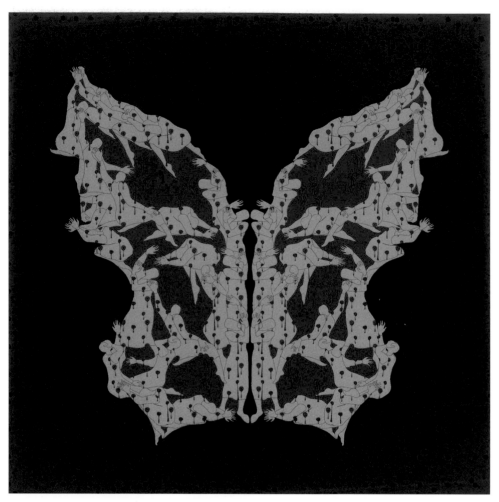

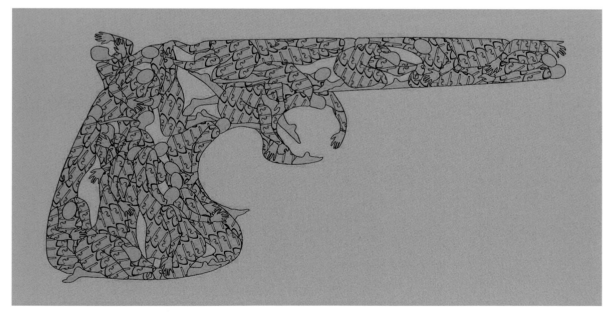

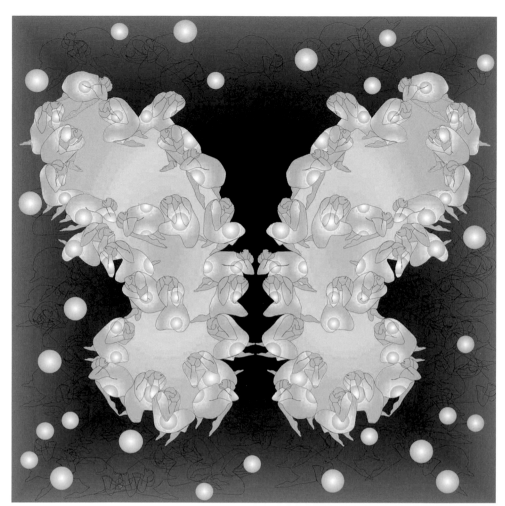

PARASTOU FOROUHAR
Ashura Butterfly (left);
Yakh Bandan Butterfly
(right), from the seven-
part series *Butterfly*,
2010
Digital prints on photo
paper
Each 39 3/8 x 39 3/8 in.
(100 x 100 cm)
Courtesy of the RH
Gallery, New York, and
the artist

PARASTOU FOROUHAR
Triptych, 2010
Digital prints on photo
paper
Left and right:
Each 13 3/4 x 27 5/8 in.
(35.1 x 70.1 cm); center:
13 3/4 x 13 3/4 in.
(35.1 x 35.1 cm)
Courtesy of the RH
Gallery, New York, and
the artist

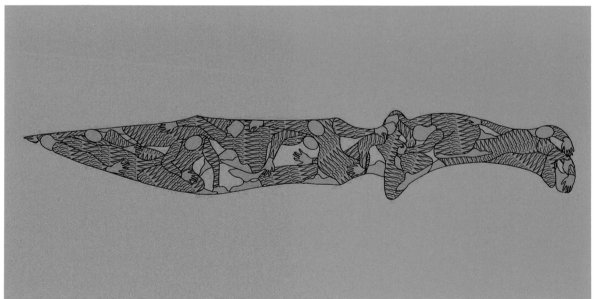

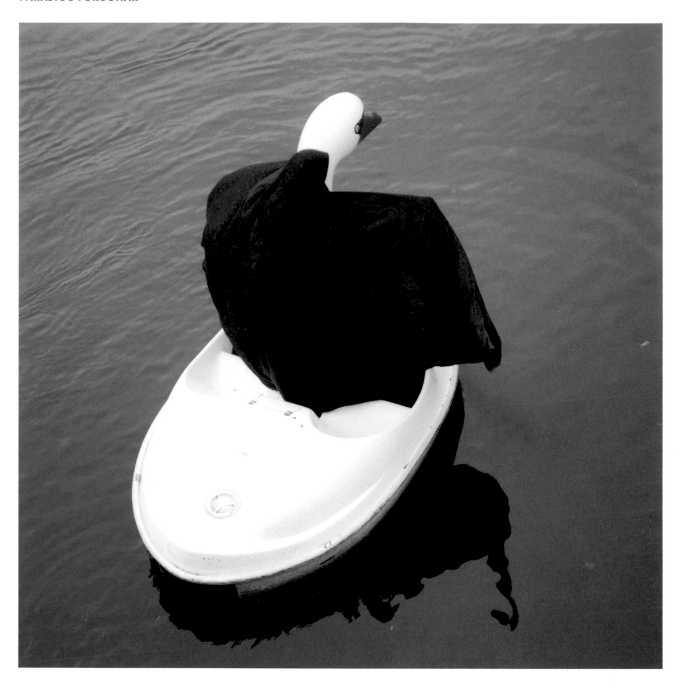

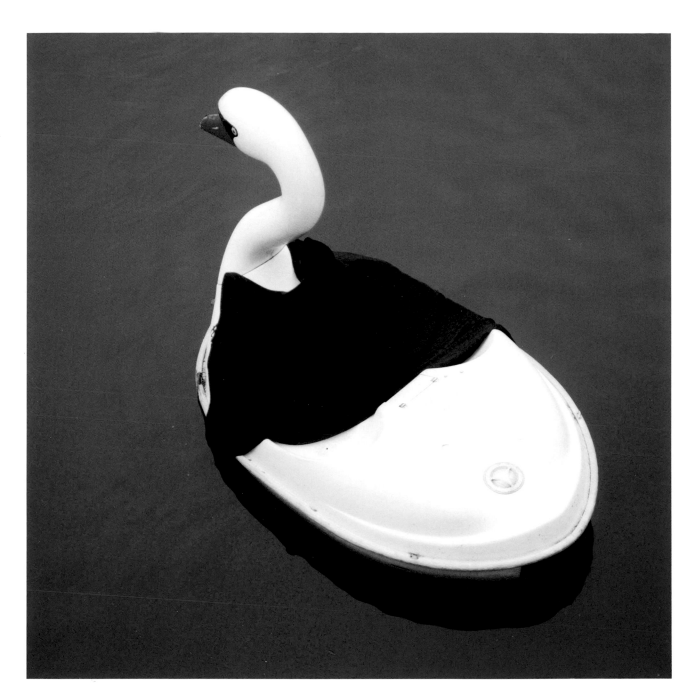

PARASTOU FOROUHAR
Swanrider III (left); *Swanrider IV* (right), from the four-part series *Swan Rider*, 2004
Digital C-print mounted on alubond
31 1/2 x 31 1/2 in. (80 x 80 cm)
Courtesy of the RH Gallery, New York, and the artist

When I focus on women's issues in my artistic practice, I seek to raise awareness about the ways women have been—and still often are—mistreated. Through my work's themes, I challenge society's approach to women—an approach based on historical stereotypes.

I also address women's efforts to fulfill their goals in life, particularly their struggle to pursue a professional career alongside motherhood and family life. I explore these issues by incorporating historically female crafts into my work.

Some of my artworks, particularly my video installations and photographs, were produced in collaboration with female performance artists.

Ayana Friedman (born 1950, Haifa) completed her bachelor's and master's degrees in art history at Hebrew University, and is in the process of finishing her PhD.

Friedman's sculptures, videos, and installations have appeared in numerous exhibitions throughout Israel, Europe, and the United States, among other locales. These include *Oh, Mama: The Representation of Motherhood in Israeli Contemporary Art,* Museum of Israeli Art, Ramat Gan, 1997; *Long Memory / Short Memory,* William Breman Jewish Heritage Museum, Atlanta, and City Gallery of Contemporary Art, Raleigh, 1998; Ninth Triennale, New Delhi, 1998; *Hands,* Israel Museum, Jerusalem, 2002; *Biblical Women in Contemporary Art,* Hebrew Union College, New York, and Jewish Contemporary Center, Washington, D.C., 2003; *Art In the Shadow of the Holocaust,* Manna Gallery, Budapest, 2008; *Maps,* Hebrew Union College, New York, 2008; *Anne Frank in the Artists' Eyes,* Peter Wilhelm Art Project, Budapest, 2009; and *Generations 8,* AIR Gallery, Brooklyn, 2011.

Many of Friedman's works are in private collections and museums, including those of Hadassah Hospital, Jerusalem; Hebrew Union College, New York; Hebrew University, Jerusalem; the Jewish Museum, New York; Museum of Contemporary Art, Ramat Gan; Yad Vashem Holocaust Museum, Jerusalem; and the chambers of the Knesset, Jerusalem.

Friedman has curated several important exhibitions, including *The Art of Aging,* Hebrew Union College, 2004; *Shadows and Silhouettes,* Israel Museum, 2007; and *Evergreen,* Avi Chai Center, Jerusalem, 2010–11.

She has served as a guest lecturer at the Guggenheim Museum, New York; Israel Museum, Jerusalem; Jewish Museum, New York; and Syracuse University, and has taught a course for members of the diplomatic corps at the request of Israel's Ministry of Foreign Affairs.

Friedman writes extensively for Israeli art journals and newspapers. She has been at the forefront of art addressing female subject matter, and promoting artwork created by women and immigrant artists.

Artis Foundation grant recipient

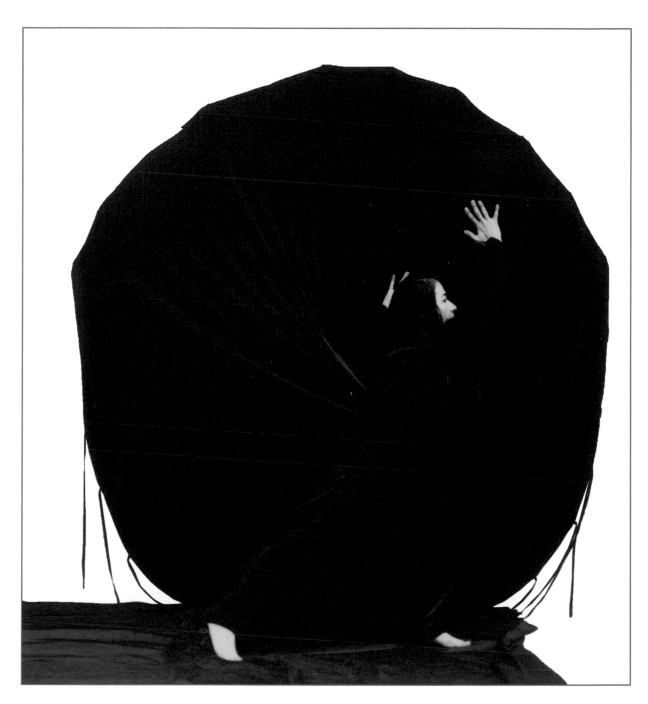

AYANA FRIEDMAN
Staged shot for the
performance *Red
Freedom*, 2008
Courtesy of the artist

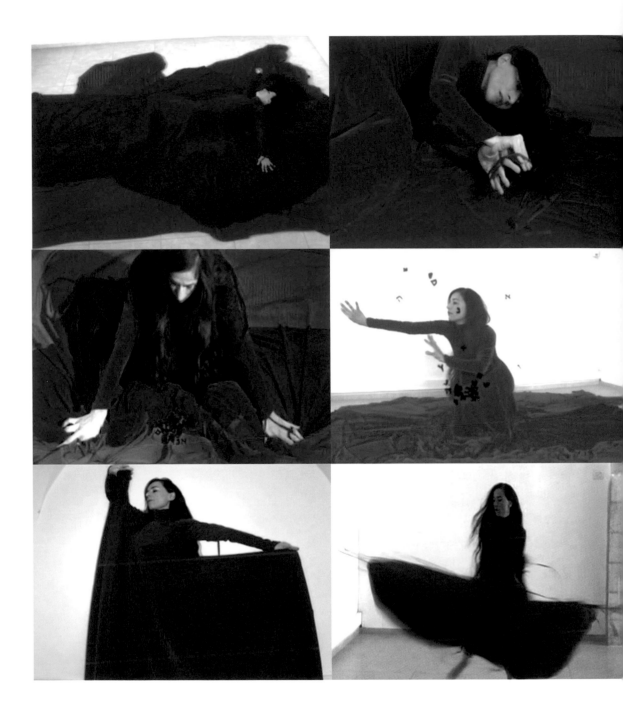

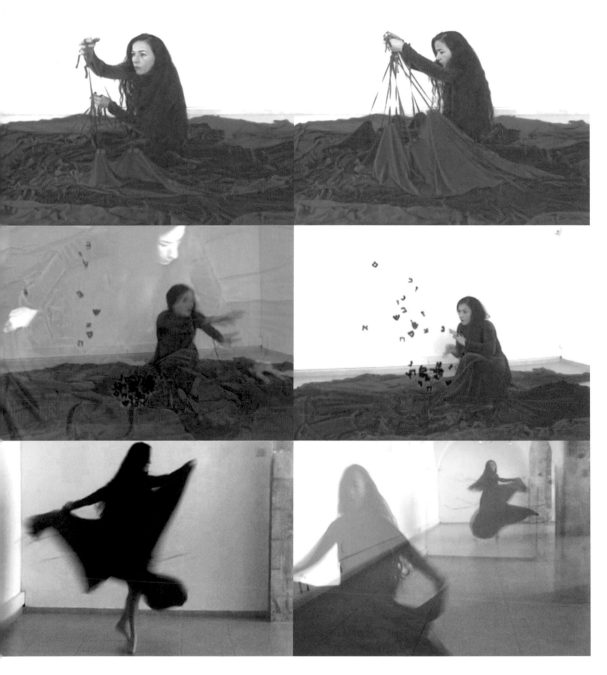

AYANA FRIEDMAN
Stills from *Red Freedom* (left to right,
top to bottom), 2008
Video
5:40 minutes
Courtesy of the artist

AYANA FRIEDMAN
Stills from *Lentils*, 2002
Video
4:45 minutes
Courtesy of the artist

SHADI GHADIRIAN

Miss Butterfly is going to meet the sun; as she is looking for a way out and reaching for the light, she becomes caught in a spider's web. Moved to compassion after observing Miss Butterfly's grace and delicacy, the spider comes to an agreement with her. He tells her to bring one of the insects from the dark cellar and tie it up in the spider's web for him. In turn, the spider will show her the way out and lead her into the light. But after hearing the insects' stories, Miss Butterfly feels pity for them and eventually returns to the spider empty-handed, with injured wings; and she makes herself caught in the web to be the spider's food. Impressed by her courage, the spider sets Miss Butterfly free and shows her the way out to meet the sun. Miss Butterfly calls all the other insects in the cellar to share her freedom with them, but she gets no response. She is so frustrated by their reaction that she opens wide her weary wings and flies toward the sun.

Shadi Ghadirian (born 1974, Tehran) received her BA in photography at Azad University, Tehran. She lives in Tehran, where she works at the Museum of Photography; she also serves as photo editor of the web site *Women in Iran* (www.womeniniran.com), as well as manager of the first Iranian web site devoted to photography (www.fanoosphoto.com).

Ghadirian's photographs epitomize the central dilemma facing Iranian women today: whether to conform to tradition or undertake modernization despite a difficult environment. Yet her work is not only about Iranian women. Ghadirian addresses the issues faced by women around the world—censorship, religious restrictions, the relationship of the individual to the state, and self-fulfillment. Her photographs have been exhibited and recognized on many continents as grasping the challenges experienced by women everywhere.

Since 2000, she has had solo exhibitions at the following venues: Villa Moda, Kuwait, 2002; Al-Ma'mal Foundation, Jerusalem, 2006; French Cultural Center, Damascus, 2006; B21 Gallery, Dubai, 2008; Istanbul Photo Festival, 2008; Los Angeles County Museum of Art, 2008; Tasveer Gallery, Bangalore, 2008; Aeroplastics Contemporary, Brussels, 2009; Boudin Lebon Gallery, Paris, 2009; CO2 Gallery, Rome, 2009; FCG Gallery, Düsseldorf, 2009; Guild Art, Mumbai, 2010; Queen Gallery, Toronto, 2011; and Silk Road Gallery, Tehran, 2011.

Ghadirian's work has been included in many significant group exhibitions, among them *Iranian Contemporary Art*, Barbican Art Center, London, 2001; *Regards Persans*, Espace Electra, Paris, 2001; *Glimpses of Iran*, Thessaloniki Museum of Photography, 2002; *Harem Fantasies and the New Scheherezades*, Centre de Cultura Contemporània de Barcelona, 2003; *Veil*, New Art Gallery, Walsall; Bluecoat Gallery and Open Eye Gallery, Liverpool; and Modern Art, Oxford, all 2003; Moscow Photo Biennale, 2004; Photo Biennale, Luxembourg, 2004; *Word into Art: Artists of the Modern Middle East*, British Museum, London, 2006; *Rebelle: Art and Feminism, 1969–2009*, Museum voor Moderne Kunst Arnhem, 2009; *The Seen and the Hidden*, Austrian Cultural Forum, New York, 2009; *165 Years of Iranian Photography*, Du Quai Branly Museum, Paris, 2009; *Iran: Preview of the Past*, University of Applied Arts, Vienna, 2010; *Idols and Icons*, Yavuz Fine Art, Singapore, 2011; and *Oi Futuro*, Rio de Janeiro, 2011.

Ghadirian's work is represented in numerous major public collections, including the British Museum, London; Centre Georges Pompidou, Paris; Los Angeles County Museum of Art; Museum Moderner Kunst Stiftung Ludwig, Vienna; Sackler Gallery, Smithsonian Institution, Washington, D.C.; and Victoria and Albert Museum, London.

SHADI GHADIRIAN
From the series *Miss Butterfly,* 2011
Photograph
27 1/2 x 39 3/8 in. (70 x 100 cm)
Courtesy of the artist

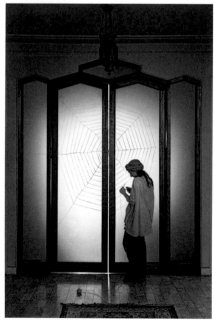
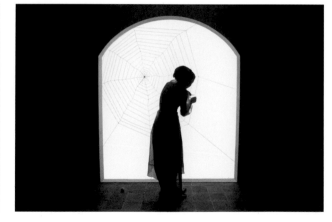

SHADI GHADIRIAN
The series *Butterfly*, 2011
Fourteen photographs out of a total of fifteen;
the fifteenth photograph is on page 113
Each 27 1/2 x 39 3/8 in. (70 x 100 cm);
39 3/8 x 27 1/2 in. (100 x 70 cm)
Courtesy of the artist

When I went to London in 1975 ... I got stranded there because the war broke out in Lebanon, and that created another kind of dislocation. How that manifests itself in my work is as a sense of disjunction. For instance, in a work like *Light Sentence* (1992), the movement of the light bulb causes the shadows of the wire mesh lockers to be in perpetual motion, which creates a very unsettling feeling. When you enter the space you have the impression that the whole room is swaying and you have the disturbing feeling that the ground is shifting under your feet. This is an environment in constant flux—no single point of view, no solid frame of reference.... This is the way in which the work is informed by my background....
I want the work in the first instance to have a strong formal presence, and through the physical experience to activate a psychological and emotional response. In a very general sense I want to create a situation where reality itself becomes a questionable point ...
A kind of self-examination and an examination of the power structures that control us: Am I the jailed or the jailer? The oppressed or the oppressor? Or both. I want the work to complicate these positions and offer an ambiguity and ambivalence rather than concrete and sure answers.

This statement comes from an interview with the artist conducted by Janine Antoni, published in *Bomb* (1998).

Mona Hatoum (born 1952, Beirut), who is Palestinian in origin, grew up in Beirut. While she was visiting London in 1975, civil war broke out in Lebanon, forcing her to stay in England. She studied at the Byam Shaw School of Art and the Slade School of Art, London, in 1975–81.

Hatoum started out as a performance artist, and then moved on to installation and sculpture. Her work addresses violence, the body, politics, gender, and difference. She also works with space, photography, and video as a way of involving the viewer. Hatoum transforms utilitarian objects and furnishings into threatening entities, while deploying physical materials like hair to make the viewer aware of the body's vulnerability.

Hatoum's work has been exhibited internationally. Important selected solo exhibitions include *Mona Hatoum*, Centre Georges Pompidou, Paris, 1994; *Mona Hatoum*, Museum of Contemporary Art, Chicago, 1997, and New Museum, New York, 1998; *Mona Hatoum*, Castello di Rivoli, Museo d'Arte Contemporanea, Turin, 1999; *Mona Hatoum: The Entire World as a Foreign Land*, Tate Britain, London, 2000; *Mona Hatoum: Eine Werküberblick mit Neuen Arbeiten*, Hamburger Kunsthalle, Kunstmuseum Bonn, Magasin 3, Stockholm, 2004, and Museum of Contemporary Art, Sydney, 2005; *Mona Hatoum*, Darat al Funun, Khalid Shoman Foundation, Amman, 2008; *Present Tense*, Parasol Unit Foundation for Contemporary Art, London, 2008; *Interior Landscape*, Fondazione Querini Stampalia, Venice, 2009; *Witness*, Beirut Art Center, 2010; and *Mona Hatoum*, Sammlung Goetz, Munich, 2011–12. She has also participated in many prestigious group exhibitions, including *The Turner Prize*, Tate Gallery, London, 1995; Venice Biennale, 1995, 2005; and the Sydney Biennale, 2006. Her work is exhibited in New York at Alexander and Bonin.

Her work is represented in museums worldwide, including the Centre Georges Pompidou, Paris; Hirshhorn Museum and Sculpture Garden, Washington, D.C.; Israel Museum, Jerusalem; Moderna Museet, Stockholm; Museum of Fine Arts, Boston; Museum of Modern Art, New York; National Gallery of Art, Ottawa; Philadelphia Museum of Art; and San Francisco Museum of Art.

She is the recipient of major awards, including an honorary doctorate, University of Beirut, 2008; the Käthe Kollwitz Prize, Akademie der Künste, 2010; and the Joan Miró Prize, 2011. Just since 2000, eighteen monographs on her work have been published, the most recent being Emre Baykal, *Mona Hatoum: You Are Still Here* (Arter, 2012).

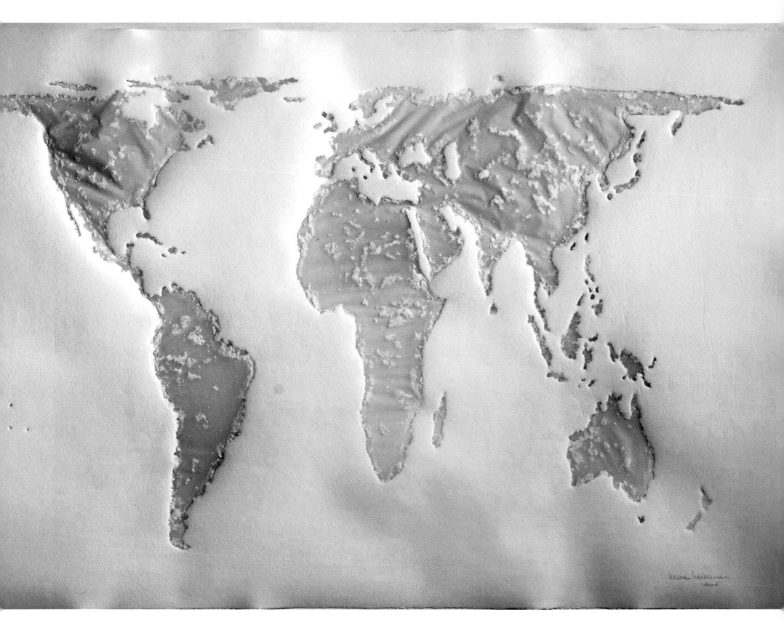

MONA HATOUM
Projection, 2006
Cotton and abaca
35 x 55 in. (89 x 140 cm)
Photo credit: Ela Bialkowska
Courtesy of Alexander and Bonin, New York

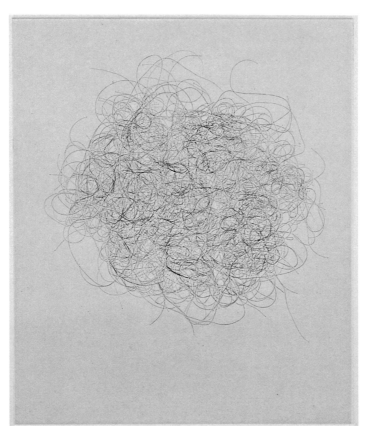

MONA HATOUM
Hair and there (details), 2004
Pair of etchings
Each 18 7/8 x 15 7/8 in. (48.3 x 40.6 cm)
Photo credit: Joerg Lohse
Courtesy of Alexander and Bonin, New York

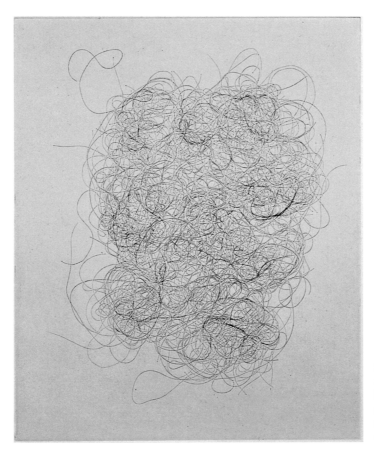

MONA HATOUM
Round and round, 2007
Bronze
24 x 13 x 13 in. (61 x 33 x 33 cm)
Photo credit: Bill Orcutt
Courtesy of Alexander and Bonin, New York

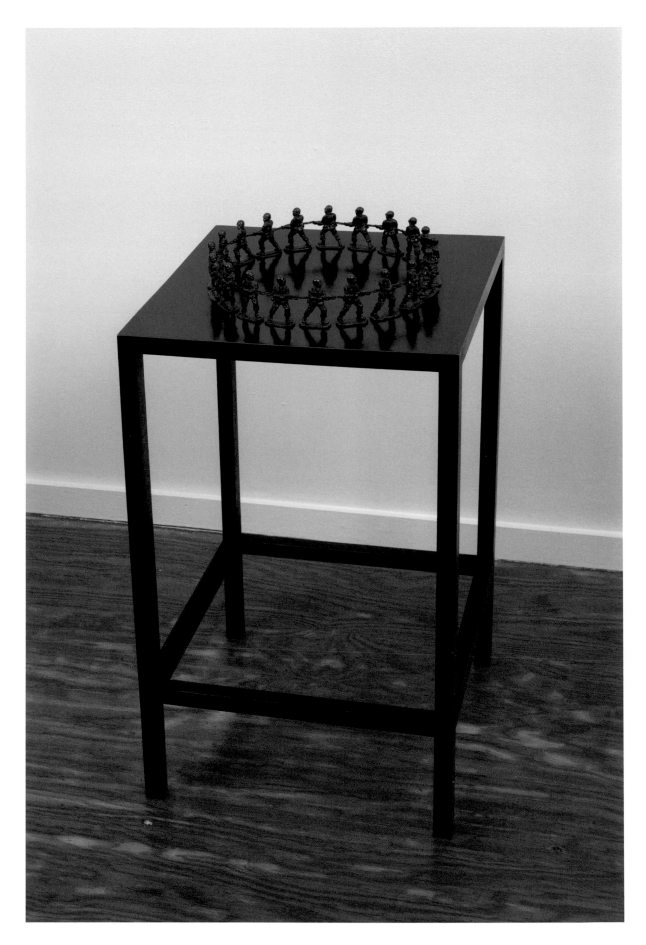

The body as both object and subject has a central place in my work. I regard the body as the site on which culturally dictated concepts of spatiality are produced. Therefore, through an ontological investigation of the human figure I am able to generate a strategy leading to a reconstruction of binary understandings within contemporary thought.

This ongoing exploration of social spatiality, which has occupied my attention throughout the trajectory of my work, includes notions of hybridity, diaspora, and the existence of a third space outside the binary. Exploding concepts of socially coded modes of thought and behavior, challenging traditional attitudes toward gender, and exploring the dynamics of nonfixity and ambivalence found in diasporic cultures are all fundamental aspects of my visual language. They are the product of my experience as an Iraqi immigrant.

Utilizing a vocabulary of narrative investigation, I try to contest and renegotiate boundaries found in social and political space. Whether expressed figuratively in paintings or abstractly in installations, the underlying thread in my work is the attempt to decipher binary concepts of space.

Hayv Kahraman (born 1981, Baghdad) lives and works in California. After studying graphic design at the Academy of Design, Florence, Italy, in 2005, she pursued studies in web design at Sweden's University of Umeå. Kahraman's painting style is based on Persian miniatures. A substantial group of her recent paintings picture women grooming themselves. These women can be seen as either making themselves beautiful for the male gaze or pleasuring each other; in either case, they refer to the Western Orientalist conception of Middle East women as exotic sex objects.

Kahraman has had solo shows in the United States, United Arab Emirates, and Qatar, including *Marionettes,* Third Line Gallery, Doha, 2009; *Pins and Needles,* Third Line Gallery, Dubai, 2010; *Seven Gates,* Green Cardamom Gallery, London, 2010; and *Waraq,* Frey Norris Gallery, San Francisco, 2010. She has participated in international group exhibitions such as the Sharjah Biennial, 2009; *Taswir: Pictorial Mappings of Islam and Modernity,* Martin-Gropius-Bau, Berlin, 2009; *Unveiled: New Art from the Middle East,* Saatchi Gallery, London, 2009; *The Silk Road,* Tri Postal, Lille, 2010; *Women Painters from Five Continents,* Osart Gallery, Milan, 2010; and *Disquieting Muses,* Contemporary Art Center of Thessaloniki, State Museum of Contemporary Art, Greece, 2011. She was shortlisted for the Jameel Prize in 2011, an honor that resulted in her work's inclusion in an exhibition that year at the Victoria and Albert Museum, London; the exhibition subsequently traveled to the Institut du Monde Arabe, Paris, 2011; Casa Arabe, Madrid; Museum of Fine Arts, Houston; and Cantor Arts Center, Stanford University, Palo Alto, all 2012.

Her work is in the permanent collections of the American Embassy, Baghdad; Barjeel Art Foundation, Sharjah; Mathaf: Arab Museum of Modern Art, Doha; Rubell Family Collection, Miami; and Saatchi Gallery, London.

Kahraman's art is documented in the following books: Lisa Farjam, *Unveiled: New Art from the Middle East* (Booth-Clibborn Editions, 2009); and Salwa Mikdadi and Nada Shabout, eds., *New Vision: Arab Art in the Twenty-First Century* (Transglobe Publishing, 2009).

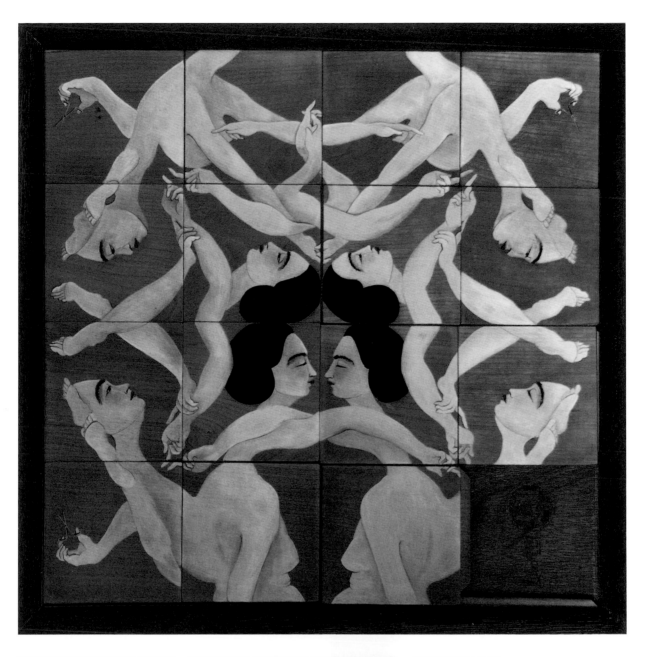

HAYV KAHRAMAN
Leveled Leisure, 2010
Oil on linen
80 3/8 x 60 1/4 in. (204 x 153 cm)
Courtesy of Shvo Art Ltd., New
York; The Third Line, Dubai; and
the artist

HAYV KAHRAMAN
I Love My Pink Comb, 2010
Oil on wooden panel
42 1/8 x 67 3/4 in. (107 x 172 cm)
Courtesy of TDIC, Abu Dhabi; The Third Line,
Dubai; and the artist
© Tourism Development and Investment
Company. All rights reserved.

HAYV KAHRAMAN
Mass Assembly (Sliding Puzzle), 2010
Oil on wooden panels
17 1/2 x 17 1/2 x 1 5/8 in. (44.5 x 44.5 x 4 cm)
Courtesy of Michael and Lindsey Fournie;
The Third Line, Dubai; and the artist

EFRAT KEDEM

I'm curious about the traces left by the temporal flow of everyday life in private and public spaces and the conversions and counter-conversions of objects and materials when they move from one space to another. I mainly work with found objects, an artistic choice I made based on the notion that the world is full of objects and other "stuff." In light of the cultural landscapes of late capitalism, with the world increasingly filling up with stuff, it has become urgent to think of the found object as a raw material. Building on the twentieth-century artistic avant-garde tradition of the *object trouvé*, but going beyond it, my work asks viewers to think of the found object as a starting point, not an end result.

The Reality Show (2012) was an environmental, site-specific installation located throughout the town of Princeton, New Jersey. Surveillance cameras, visible to both viewers and passersby, were deployed across Princeton, broadcasting 24/7 to the Taplin Gallery, Arts Council of Princeton / Paul Robeson Center for the Arts, the visuals of what was happening throughout Princeton in real time. The gallery was the control room, equipped with monitors to receive the images. Visitors to the gallery were recorded in real time while they were viewing the monitors; the visitors' participation comprised the performative aspect of the installation. My idea was to make the gallery space function symbolically like the beating heart of the town. I created an orientation map to help viewers find the cameras located throughout Princeton so that they, too, could broadcast their own "show" in real time if they chose to do so.

Efrat Kedem (born 1980, Jerusalem) currently resides in Princeton, New Jersey. She received her BFA from the Midrasha School of Art in 2005, and her MFA with honors from the Bezalel Academy of Arts and Design in 2008. Kedem is a multidisciplinary artist utilizing installation, photography, and video.

She has had four solo shows in Israel: *Heart,* Dollinger Gallery, Tel Aviv, 2007; *Real Estate,* New & Bad Gallery, Tel Aviv, 2007; *Real Estate Agency,* Dollinger Gallery, Tel Aviv, 2008; and *Beneath Giant Ficus Trees,* Barbur Gallery, Jerusalem, 2009. Since her debut in 2007, she has been featured in many group exhibitions, including *The Roaring Stuffed Animal,* Shturman Museum, Ein Harod, 2008; Art TLV, International Biennial of Contemporary Art, Tel Aviv, 2009; *Standard Deviation,* Center for Contemporary Art, Tel Aviv, 2009; *The Invisible Hand,* Sommer Contemporary Art Project Space, Tel Aviv, 2010; *I just want to be loved,* MAGA Museum Gallery, Milan, 2011; and *Line Made by Walking,* Haifa Museum, 2011. She has had two shows in Taiwan in collaboration with colleagues from the Documenta 12 Openspace Workshop, *Borderline / Mirrorlike,* Huashan Culture Park, Taipei, 2008, and *Power Show,* Kuandu Museum of Fine Arts, Taipei, 2009. Since her recent move to the United States, she has taken part in various group exhibitions in New York, among them *Epitaph,* Clemente Soto Velez Gallery, 2010; *Colored Cactus,* Industry City Gallery, Brooklyn, 2011; and *Signs on the Road,* Winkleman Gallery, 2011. She was included in *New Media: New Forms,* Montclair Art Museum, 2012, part of the New Jersey Arts Annual series.

Kedem has received various accolades, such as the EcoOcean Scholarship, Fresh Paint Art Fair, Israel, 2008; Musya Tulman and Malca Ben Yosef Excellency Award, Bezalel, 2008; and the Givon Prize, awarded in memory of Sam Givon, Tel Aviv Museum of Art, 2011. She participated in Creative Capital's professional development workshop on artists' strategic planning, 2011.

Artis Foundation grant recipient

EFRAT KEDEM
Still from *The Reality Show*, 2012
Closed-circuit live-surveillance feed from live cameras
broadcasting 24/7 from various sites in Princeton, New Jersey,
to the Taplin Gallery, Arts Council of Princeton / Robeson Center
for the Arts
Courtesy of the artist

EFRAT KEDEM
Stills from *The Reality Show*, 2012
Closed-circuit live-surveillance feed from live cameras broadcasting
24/7 from various sites in Princeton, New Jersey, to the Taplin Gallery,
Arts Council of Princeton / Robeson Center for the Arts
Courtesy of the artist

I see my work as being that of a bridge-builder. Both consciously and unconsciously, I am looking for new materials and anchors to connect the past to the future, the West to the East, the private to the collective, the sub-existential to the *Über-profound*, found objects to epic narratives and myths. I do so using scattered, broken words to define the bric-a-brac of our times and transform them into a soft heap of new dream-buds, acting upon the uncertain horizon.

I appear in some of my works, but the body is not mine; I represent the body of any human being. I usually do not show my face. I do not have a face; I do not have an ego. My actions are my portrait.

Politics and poetry fuel my work, which is in essence both political art and poetic art. When I look the ugliness around me "in the eye," I find movements that range from the trivial to the beautiful. This is the force, the coercion, the weight of this country in which I live. As a worker, I am always shoulder-to-shoulder with the people working with me, even though, as an artist, I am very solitary when discovering/creating my universe.

Sigalit Landau (born 1969, Jerusalem) studied at the Bezalel Academy of Arts and Design in Jerusalem from 1990–95. During that time, in 1993, she also participated in a one-semester student exchange program with the Cooper Union School of Art and Design, New York. After spending several years in London, she settled in Tel Aviv, Israel, where she currently lives.

Landau works with a diverse range of media including drawing, sculpture, video, and performance, creating pieces and installations that sometimes stand on their own and at other times form inclusive environments. Her complex artworks touch on a number of social, humanitarian, and ecological issues, exploring topics such as homelessness, banishment, and the relationships between victim and victimizer, and decay and growth. As much of her work is concerned with the human condition, the figure, often her own, is a key motif.

Using salt, sugar, paper, and readymade objects, Landau creates large-scale, on-site installations that transform their given spaces. They do so through such means as the destruction or construction of walls, the excavation and creation of new spaces, the building of bridges over corridors, and the connection of interior with exterior spaces. Her work is recognizable and unique, but, at the same time, refers and pays homage to such artists as Louise Bourgeois, Constantin Brancusi, and Robert Smithson.

Landau has participated in major group showings such as the Art Focus International Contemporary Arts Biennial, Tel Aviv, Jerusalem, and Herzliya, 1994, 1996, 2005; Documenta X, Kassel, 1997; Venice Biennale, 1997, 2011; *Video Zone,* International Video Art Biennial, Herzliya, 2002; *The Armory Show,* New York, 2005; and Art TLV, International Biennial of Contemporary Art, Tel Aviv, 2008, 2009.

She has received numerous awards, including the Ingeborg Bachmann Prize, established by Anselm Kiefer, 1997; Artist-in-Residence, Hoffmann Collection, Berlin, 1999; the ArtAngel/Times Commission, London, 2000; IASPIS Artist-in-Residence, Stockholm, 2003; Nathan Gottesdiener Foundation Israeli Art Award, Tel Aviv Museum of Art, 2004; Beatrice S. Kolliner Award for a Young Israeli Artist, Israel Museum, Jerusalem, 2004; and Sandel Family Foundation for Sculpture Award, Tel Aviv Museum of Art, 2007.

Artis Foundation grant recipient

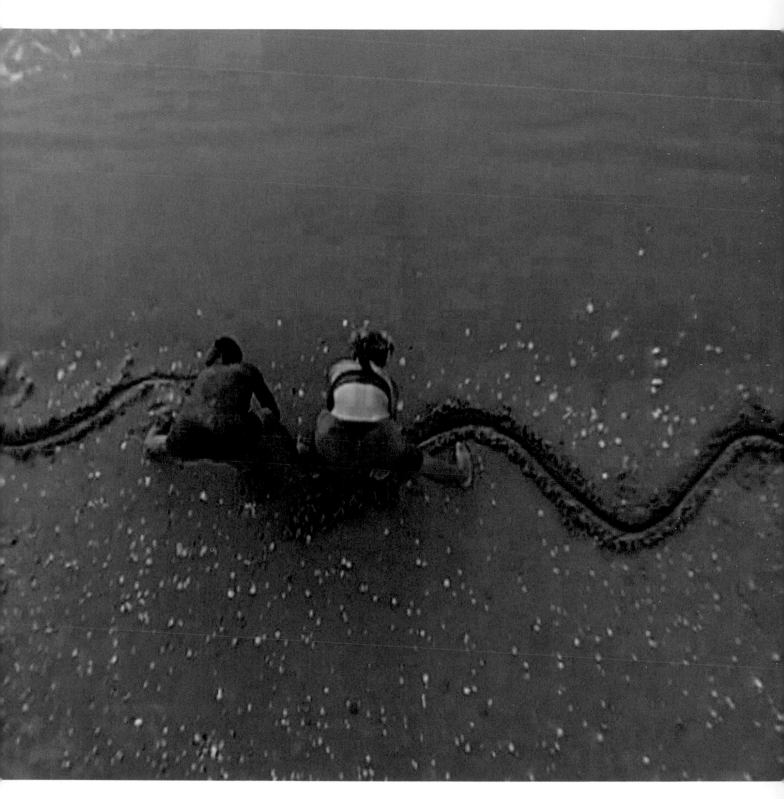

SIGALIT LANDAU
Still from *Dancing for Maya*, 2005
Three-channel video
16:13 minutes
Courtesy of the artist

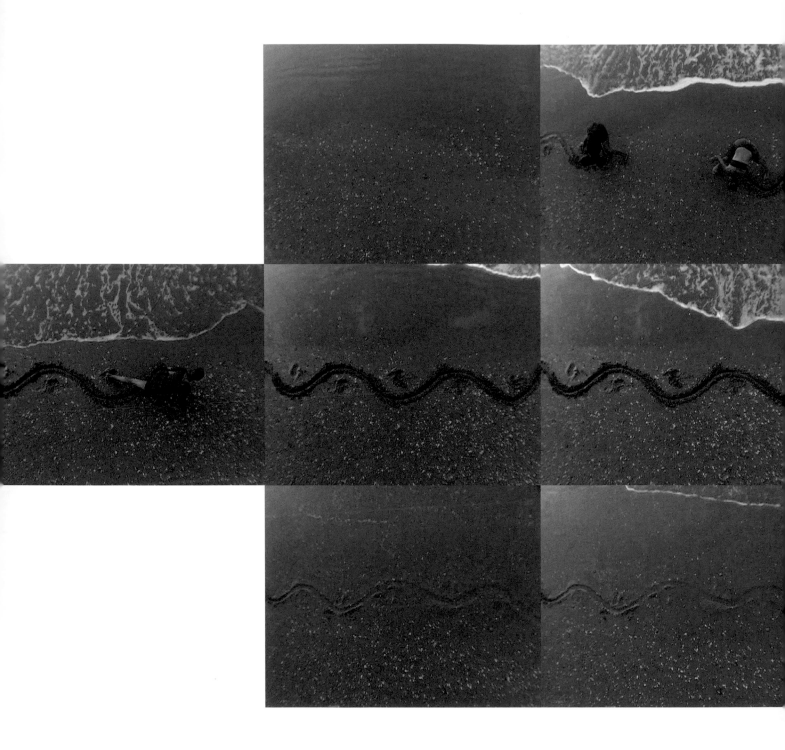

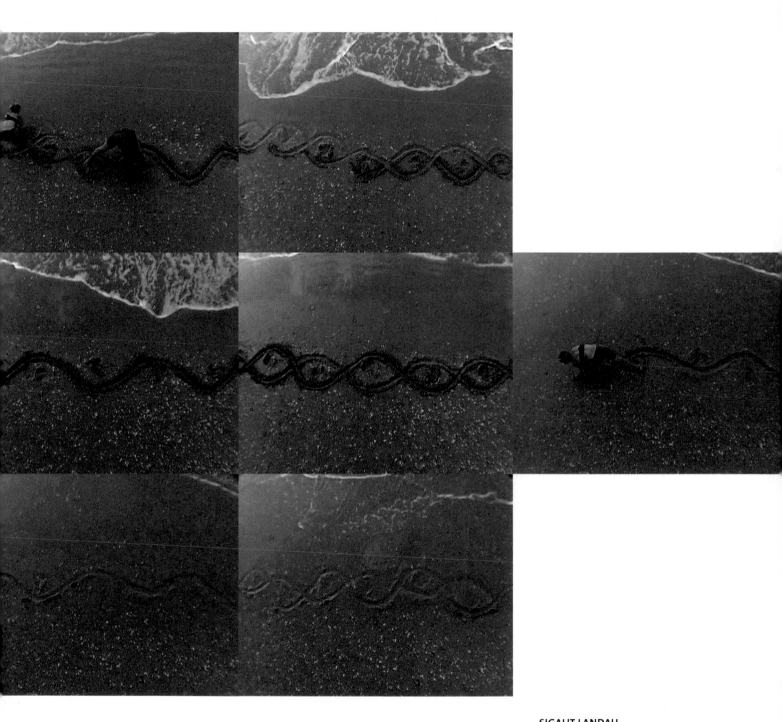

SIGALIT LANDAU
Stills from *Dancing for Maya*
(left to right, top to bottom), 2005
Three-channel video
16:13 minutes
Courtesy of the artist

The *Wounded Land Maps* (2009–12), a series from the *Wounded Land* project, grew out of a cycle of artworks called *Border Land* (2000–07). Witnessing the violence, new walls, and fences erected during the Second Intifada, I used maps to understand the multiple spatial realities of this period. I walked the geography depicted in the maps, crossing borders back and forth as a photojournalist. I then deconstructed the hegemony inscribed on closure maps of Jerusalem and the West Bank by cutting, bandaging, and sewing them together; by performing these absurd and Sisyphean acts of healing a collective wound that marks the landscape as well as the human body and psyche, I succeeded in conveying the existential deadlock of the conflict.

In *Sea of Death* (2010), my bandaged body suggests both the slow death of the Dead Sea and human finitude. In the *Green Thread* (2012), the video of my performance in the Old City of Jerusalem, the green thread that sews the closure maps together also binds the religious quarters of the city together.

The Olive Tree (2011), filmed at a checkpoint, is both a tribute to mothers and a message of hope. On the soundtrack, Ruth Wieder Magan sings Ladino and Hassidic songs and Salam Abu Amneh, traditional Palestinian songs. Both yearn for Jerusalem, the mother of all cities, now a walled city. Their voices soothe me while I bandage the dead olive tree. At sunset, the tree rejoices like a bride as it reunites with Mother Earth.

Ariane Littman (born 1962, Lausanne) is the daughter of a British father and an Egyptian mother. In 1981, she left Switzerland to study international relations and Muslim history at the Hebrew University of Jerusalem. Upon completing her undergraduate studies, she changed direction, receiving her BFA with honors at the Bezalel Academy of Arts and Design in 1991, followed by an MFA, in 1998. In 1991–94, Littman was Assistant Curator in the Department of International Contemporary Art at the Israel Museum. She earned another degree in art and aesthetics at the Hebrew University in 2004, and participated in a Jewish-Arab program at the Musrara School of Photography in Jerusalem. She is currently a Senior Lecturer in the Department of Inclusive Industrial Design at the Hadassah Academic College in Jerusalem.

During several years as a freelance photographer, her work alternated between the studio and the field. She covered major events such as Israel's disengagement from the Gaza Strip in 2005, and in 2006–08 worked as a freelance photographer with Marlene Schnieper, the Middle East correspondent of the Swiss newspaper *Tages-Anzeiger*.

Her solo exhibitions include *Nature Morte,* Bograshov Gallery, Tel Aviv, 1992; *Virgin of Israel and Her Daughters,* Artists' House, Jerusalem, 1995, *A Voyage into the Sublime,* Herzliya Museum, 1997; *White Land,* Artists' House, Jerusalem, 2001; *The Mobile Forest*, part of the multi-site project *LandEscapes: Mysteries of the (holy) Land,* Gershman Y, Philadelphia, 2002; and *Wounded Land,* Artists' House, Tel Aviv, 2011. She has participated in numerous international group shows, among them *Desert Cliché: Israel Now—Local Images,* Arad Museum and Museum of Art, Ein Harod, 1996, Bass Museum, Miami, and Grey Art Gallery, New York, 1997; *After Rabin: New Art from Israel,* Jewish Museum, New York, 1998; *Between Beauty and Destiny,* Cleveland Center for Contemporary Art, 1998; *To the East,* Israel Museum, Jerusalem, 1998; *Love at First Sight,* Israel Museum, Jerusalem, 2001; *Disengagement,* Tel Aviv Museum of Art, 2006; and *Close Up Vallarta,* Second International Festival of Video Creation, Puerta Vallarta, 2012.

She has presented at several important conferences and workshops, including *Border Regions in Transition XI: Mobile Borders,* Universities of Geneva and Grenoble, 2011; and *Cartography & Narratives,* Commission on Art and Cartography of the International Cartographic Association, Concordia University, Montreal, and ETH, Zurich, 2012.

Her work can be found in the collections of such institutions as the Herzliya Museum; Israel Museum, Jerusalem; and Jewish Museum, New York.

Artis Foundation grant recipient

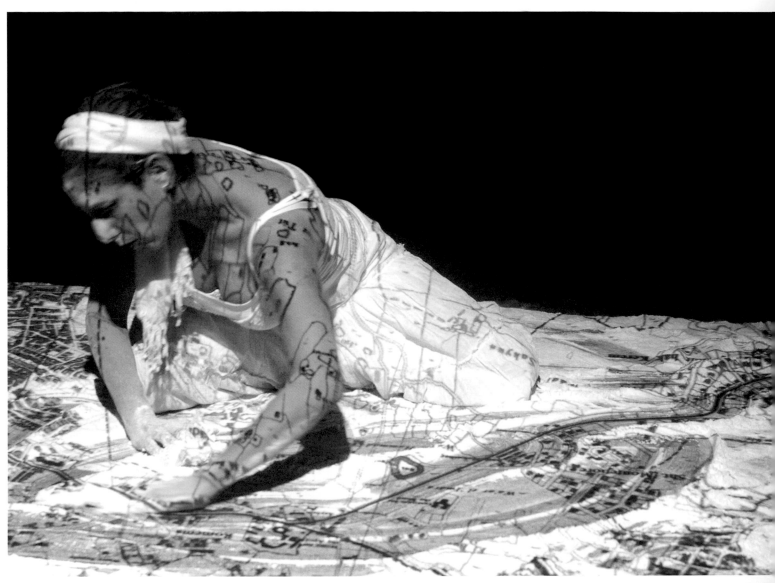

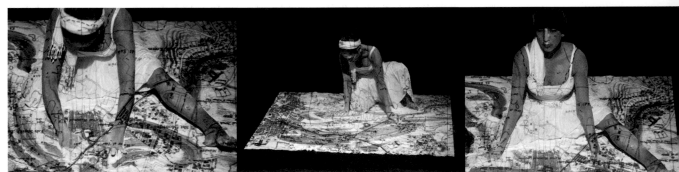

ARIANE LITTMAN
Stills from *Mehika/Erasure*, 2006
Video based on performance by Ariane Littman, Hannan Abu Hussein, and Maya Yogel at
Heara 10: Comments on the Israeli Acropolis, Science Museum, Jerusalem, in which the artist
erases a map of Jerusalem compiled, drawn, and printed by the 1947 Survey of Palestine
(Archives of the Geography Department, Hebrew University, Jerusalem)
Photo credit: Oded Antman
Courtesy of the artist

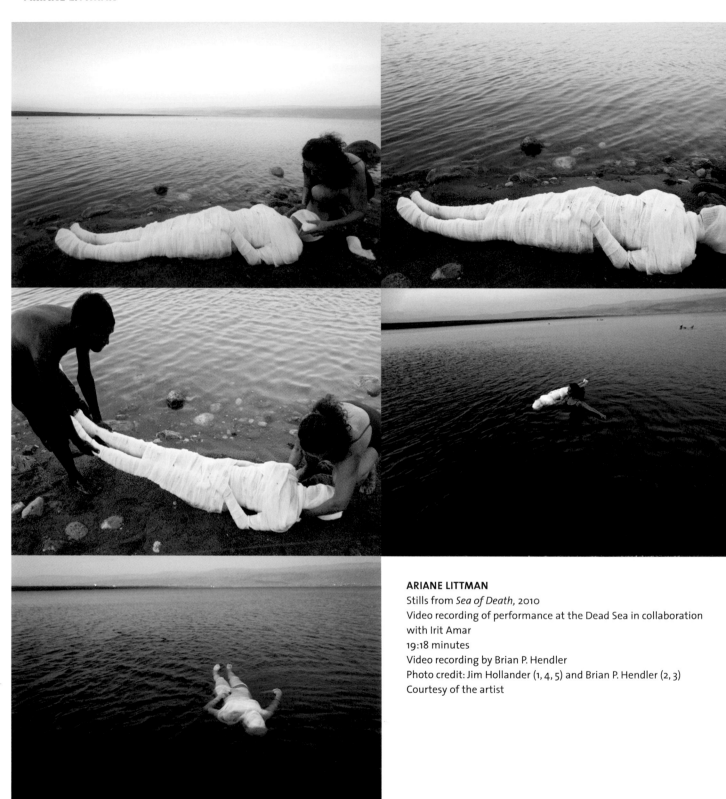

ARIANE LITTMAN
Stills from *Sea of Death*, 2010
Video recording of performance at the Dead Sea in collaboration
with Irit Amar
19:18 minutes
Video recording by Brian P. Hendler
Photo credit: Jim Hollander (1, 4, 5) and Brian P. Hendler (2, 3)
Courtesy of the artist

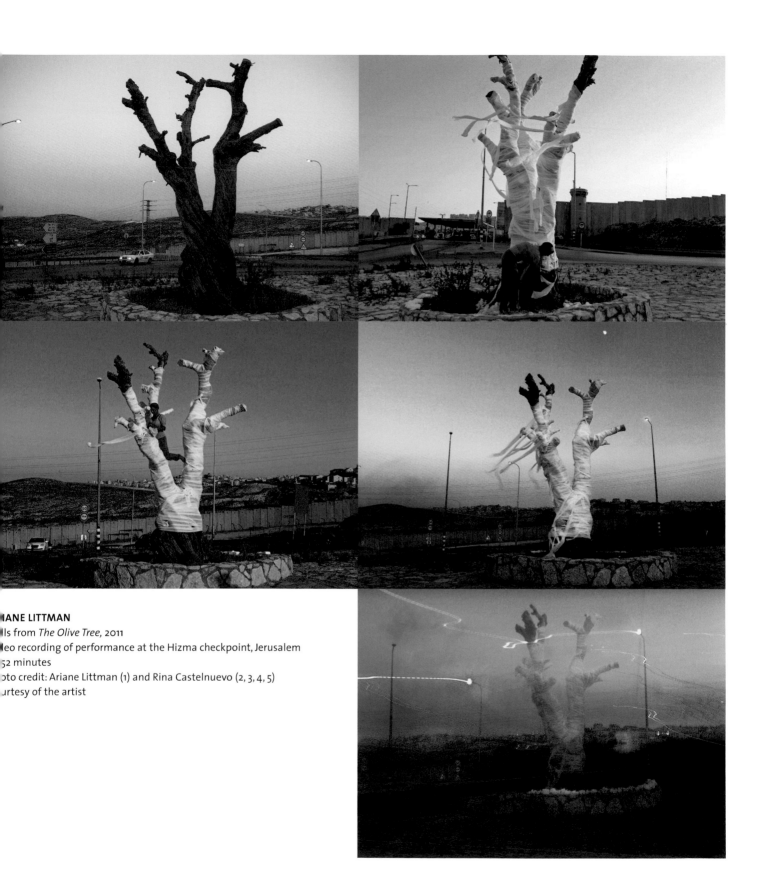

ARIANE LITTMAN
Stills from *The Olive Tree*, 2011
Video recording of performance at the Hizma checkpoint, Jerusalem
52 minutes
Photo credit: Ariane Littman (1) and Rina Castelnuevo (2, 3, 4, 5)
Courtesy of the artist

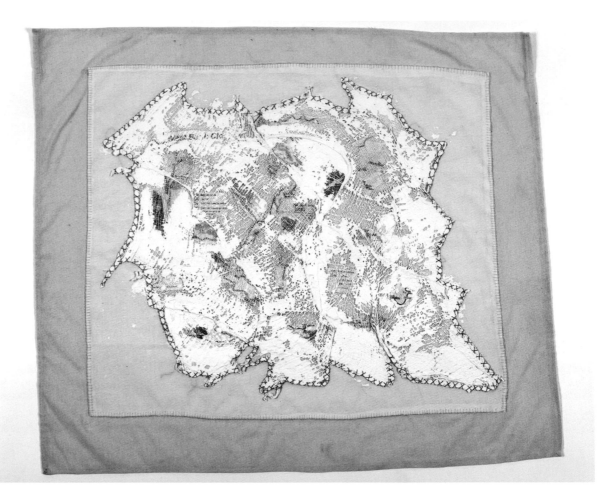

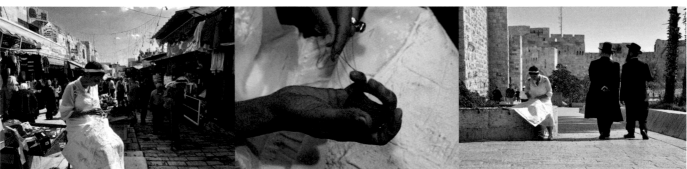

ARIANE LITTMAN (above)
From the eight-part series *Wounded Land Maps* (detail), 2009–12
Map, bandages, plaster, fabric, and green thread
The artist used closure maps printed by the Humanitarian
Information Centre (OCHA) and distributed by the UN Office for
the Coordination of Humanitarian Affairs in East Jerusalem.
Photo credit: Udi Katzman
Courtesy of the artist

ARIANE LITTMAN
Stills from *The Green Thread*, 2012
Video based on performance by the artist, in which she sits in various
locations in the Old City of Jerusalem and sews the *Wounded Land*
maps with thread the color of the "Green Line," the 1949 armistice
line around Jerusalem redrawn in the 1967 War
5:30 minutes
Video recording by Yair Tsriker
Photo credit: Yair Tsriker
Courtesy of the artist

ARIANE LITTMAN
Four maps from the twelve-part series *Shredded Land*, 2010, part of the *Wounded Land* project
Papier maché made from closure maps of the West Bank and Jerusalem (July 2004)
The closure maps were printed by the Humanitarian Information Centre (OCHA) and
distributed by the UN Office for the Coordination of Humanitarian Affairs in East Jerusalem.
Each 21 5/8 x 25 1/4 in. (55 x 64 cm)
Photo credit: Udi Katzman
Courtesy of the artist

In 1993–97, I produced my first body of work, a series of stark black-and-white photographs entitled *Women of Allah*, conceptual narratives on the subject of female warriors during the Iranian Islamic Revolution of 1979. On each photograph, I inscribed calligraphic Farsi text on the female body (eyes, face, hands, feet, and chest); the text is poetry by contemporary Iranian women poets who had written on the subject of martyrdom and the role of women in the Revolution. As the artist, I took on the role of performer, posing for the photographs. These photographs became iconic portraits of willfully armed Muslim women. Yet every image, every woman's submissive gaze, suggests a far more complex and paradoxical reality behind the surface.

Shirin Neshat (born 1957, Qazvin), who lives and works in New York City, left Iran in 1974 to study in Los Angeles. She stayed in California, receiving her BFA and MFA at the University of California, Berkeley. She then moved to New York, where she married the Korean art curator Kyong Park; the two jointly ran the New York exhibition and performance space the Storefront for Art and Architecture. Neshat returned to Iran in 1990, eleven years after the Islamic Revolution, and was shocked by what she saw. That trip led to her first body of work, the photographic series *Women of Allah*, on the subject of female warriors during the Revolution. Neshat works in photography, video, film, and performance, often addressing the theme of the alienation of women in repressed Muslim societies.

Neshat's work is celebrated and shown globally. Since 2000, selected solo exhibitions include *Shirin Neshat*, Serpentine Gallery, London, 2000; *Shirin Neshat: Two Installations*, Wexner Center for the Arts, Columbus, 2000; *Shirin Neshat*, Contemporary Arts Museum, Houston, 2001; *Shirin Neshat*, Walker Art Center, Minneapolis, 2001; *Shirin Neshat*, Castello di Rivoli, Turin, 2002; *Shirin Neshat*, Museo de Arte Moderno, Mexico City, 2003; *Shirin Neshat: The Last Word*, Museo de Arte Contemporáneo, León, 2005; *Earlier and Recent Works*, Hamburger Bahnhof, Museum für Gegenwart, Berlin, 2005; *Shirin Neshat*, Stedelijk Museum CS, Amsterdam, 2006; *Shirin Neshat*, Galeria Filomena Soares, Lisbon, 2007; *Women Without Men*, National Museum of Contemporary Art, Athens, Kulturhuset, Stockholm, 2009, and Palazzo Reale, Milan, 2011; and *Shirin Neshat*, La Fabrica Galería, Madrid and Brussels, 2010. Her work has been included in all the significant international group shows, including the Venice Biennale, 1999; Whitney Biennial, New York, 2000; Documenta XI, Kassel, 2002; and *Prospect 1*, New Orleans Biennial, 2008.

Neshat has been the recipient of accolades worldwide, among them the First International Award at the Venice Biennale, 1999; Grand Prix, Gwangju Biennale, Seoul, 2000; Visual Art Award, Edinburgh International Film Festival, 2000; Infinity Award for Visual Art, International Center for Photography, New York, 2002; Fine Art Prize, Heitland Foundation, Celle, Germany, 2003; honoree at The First Annual Risk Takers in the Arts Celebration, given by the Sundance Institute, New York, 2003; ZeroOne Award, Universität der Künste, Berlin, 2003; Hiroshima Freedom Prize, Hiroshima City Museum of Art, 2005; Lillian Gish Prize, 2006; Creative Excellence Award at the Reykjavik International Film Festival, 2008; Cultural Achievement Award, Asia Society, New York, 2008; Rockefeller Foundation Media Arts Fellowship, New York, 2008. Her first feature-length film, *Women Without Men*, received the Silver Lion Award, Prix La Navicella, and the UNICEF Award at the Sixty-Sixth Venice International Film Festival; and the Cinema for Peace Special Award, Hessischer Filmpreis, Germany, all 2009.

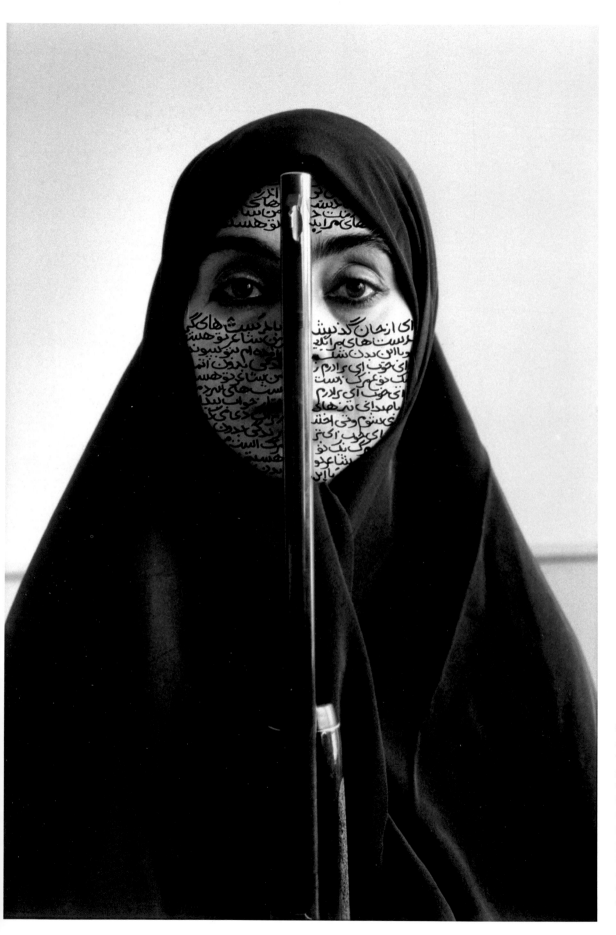

SHIRIN NESHAT
Rebellious Silence, 1994,
from the eleven-part
series *Women of Allah*,
1993–97
Photo credit: Cynthia
Preston
RC black-and-white
print and ink
Framed: 52 x 36 1/2 in.
(132.1 x 92.7 cm)
Courtesy of the
Gladstone Gallery,
New York and Brussels

SHIRIN NESHAT
Offered Eyes, 1993,
from the eleven-part series *Women of Allah*,
1993–97
Photo credit: Plauto
RC black-and-white print and ink
Framed:
52 3/8 x 36 1/4 x 1 1/8 in.
(133 x 92.1 x 2.9 cm)
Courtesy of the Gladstone Gallery,
New York and Brussels

The film shows a stack of Burma Baklava saturated with syrup like a cascading skyscraper. *Şerbet*, "sugared water" in Turkish, is repeatedly re-poured to keep the dessert wet. Each application comes from what remains at the bottom of the tray after each re-pouring …in effect a *Love Elixir* made over and over again. Desire, companionship, falling in love…these are all romantic experiences humanizing the dessert, as if it were a living being. *Şerbet* is a precious portrait of surrender, an example of what a balanced relationship should be. The film runs from the reels on the floor, passes inside of the projector, goes up to the reels in the ceiling and falls …like a metaphor for the syrup taken from the ground again and poured from the top to the bottom in an endless repetition, signifying *Eternal Love*.

Şerbet (1999–2010)

The moment the ball was small enough to fit into her mouth I stopped shooting, but not because her tongue started to bleed. One of the strongest compliments came from a museum director, who said, "I watched your beautiful face all afternoon." I kept my silence. His mind chose to complete the work with me. The blue room could be any background.

The sound is important in the transformation of the round form of the jawbreaker into a submissive fetish. The mouth and the jawbreaker coexist and must move in and out of each other for breathing. As the performance proceeds, the sound becomes more and more intimate. I love to watch the members of the audience and see how they move to the sound and how they respond when they realize the source.

Jawbreaker (2008–10)

Ebru Özseçen (born 1971, Izmir), who lives and works in Munich, Germany, graduated from the Interior Architecture and Environmental Design Department, School of Architecture, Bilkent University, Ankara, in 1994. She received her master's degree from the Department of Fine Arts and the Institute of Economics and Social Sciences, Bilkent University, in 1996.

Her work embraces a range of artistic practices, encompassing urban interventions, sculpture, objects, photography, video, film installations, and drawings. Utilizing her experience in the fields of architecture, design, and contemporary art, Özseçen explores the psychological and sociological relationships between space and the body. Investigating the seemingly mundane, she exposes its magical and unseen aspects, in the process, revealing a space where fantasy and memory hide in plain sight.

Özseçen's work has been shown internationally. Among her solo exhibitions are *City*, Coimbra Science and Technology Museum, 2000; *Sugar Top Girl*, Henry Urbach Architecture, New York, 2001; *Jawbreaker*, Edition Block, Berlin, 2009; *Kısmet*, TANAS, Berlin, 2010; and *True Love Soul Mate*, Rampa, Istanbul, 2012. Selected group exhibitions include *On Life, Beauty, Translation, and Other Difficulties…*, Istanbul Biennial, 1997; *Iskorpit*, Haus der Kulturen Der Welt, Berlin; 1998; *Friends and Neighbours*, Limerick Biennial, Ev+A, 1999; *Passion and Wave*, Istanbul Biennial, 1999; *Arguments*, Atatürk Cultural Center, Istanbul, 2000; *Das Lied von der Erde*, Kunsthalle Fridericianum, Kassel, 2000; *Living the Island*, Busan Biennale, Metropolitan Art Museum, 2000; *Strange Home, Kestner Museum*, Hannover, 2000; Barcelona Triennial, 2001; *The Big Blue*, Tate Modern, London, 2001; *Locus Focus*, Sonsbeek 9, Arnhem, 2001; Whitstable Biennial, 2001; *Works*, De Appel Foundation, Amsterdam, 2001; São Paulo Biennial, 2002; *Fading Lace*, Plantage Kerklaan 30, Amsterdam, 2003; *In den Schluchten des Balkan: Eine Reportage*, Kunsthalle Fridericianum, Kassel, 2003; *o.T. [City IV]*, Leipzig Contemporary Art Center, 2005; *Meisterwerke der Medienkunst aus der ZKM Sammlung*, Karlsruhe Media Art Center-ZKM, 2006; *Modern and Beyond*, santralistanbul, 2007; *Slow Space Fast Pace*, Cork Art Triennial, 2007; *Old News 4*, Midway Contemporary Art, Minneapolis, 2008; *Dream and Reality*, Istanbul Modern, 2011; and *Zwölf im Zwölften*, TANAS, Berlin, 2011.

She has been awarded several artist residencies, including the Amsterdam Rijksakademie, 1997–98; Vienna Medienwerkstatt, 1998; Helsinki Suomenlinna NIFCA (Nordic Institute for Contemporary Art), 1999; and Paris Récollets Institut, 2003.

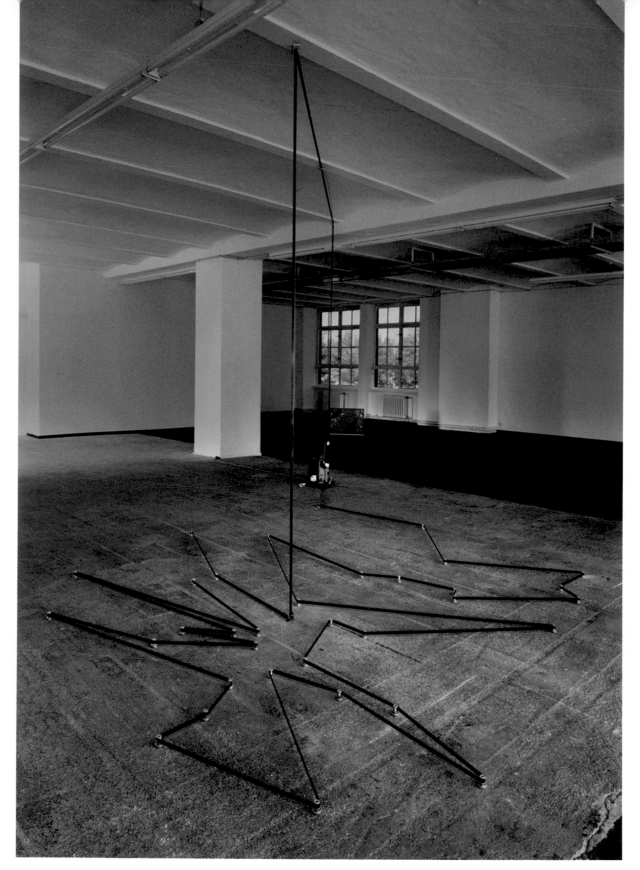

EBRU ÖZSEÇEN
Şerbet, 1999–2010
16 mm film installation
Photo credit: Uwe Walter
Courtesy of TANAS, Berlin

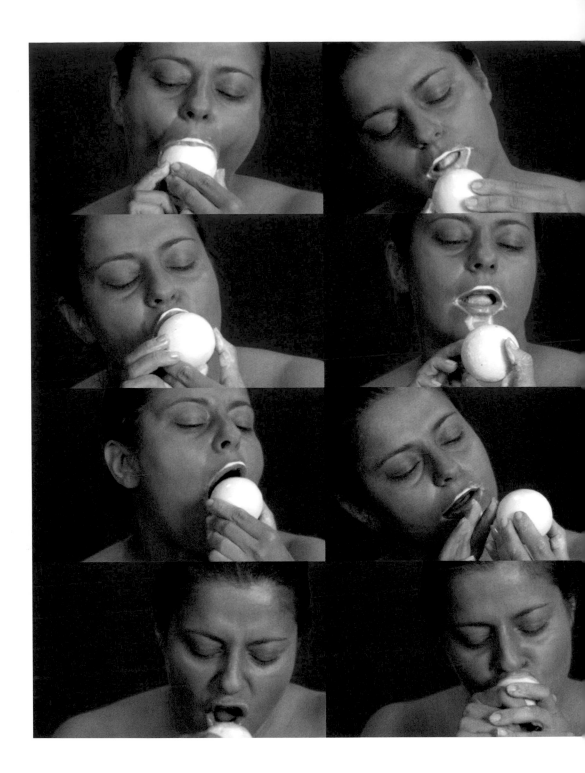

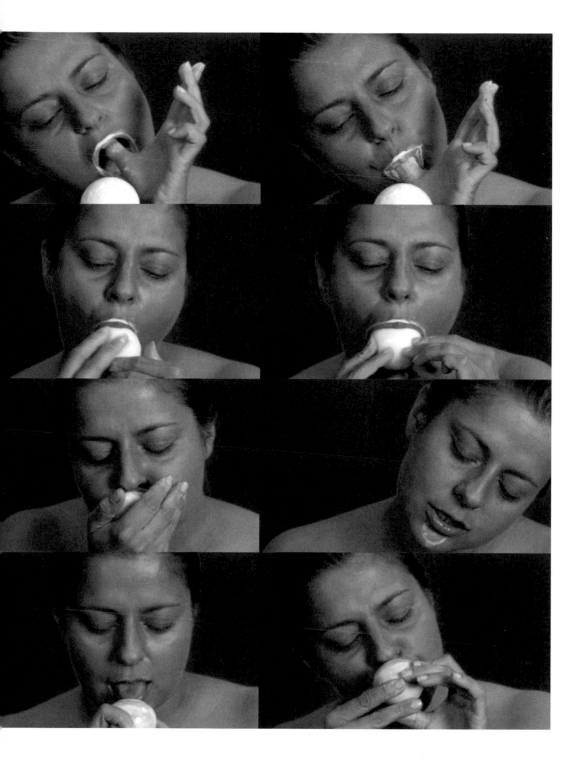

EBRU ÖZSEÇEN
Stills from *Jawbreaker*
(left to right, top to bottom), 2008
Single-channel video projection
Courtesy of Edition Block, Berlin,
and the artist

We are desensitized by media violence. New strategies are needed to overcome people's weariness for compassion. In the painting cycle *Sarab* (2008) (meaning "mirage"), I represent Dubai, a modern city rising from the desert, as a place devoid of cultural identity, through the geometry of Islamic design. Once altered, the laws of Islamic geometry lose their validity, resulting in chaos. The paintings ask what is left of Arab culture when the pattern of the culture itself goes awry.

The inspiration for *The Other Side of Paradise* (2011–12) was a 2007 television documentary showing CCTV footage taken at an IDF checkpoint between Gaza and Israel, of a young Palestinian woman carrying a suicide device, made to undress to reveal the hidden explosives. It was unbearable to watch her anguished progression, from the realization that she was inescapably trapped, to the realization that she was even prevented from ending the situation in death because the device was faulty.

There are two mutually exclusive polarities. To many, Joan of Arc was a heroic "freedom fighter," a martyr and a saint; to others, she was a cross-dressing "terrorist," and a heretic deserving of summary execution. People take stands on these matters without thinking, but I believe that it is my obligation as an artist to reflect on these difficult questions.

I do not wish to pass judgment as to whether these women are freedom fighters, resistance heroines of a harsh occupation, or victims of manipulation by society. I hope that after considering the contrasting arguments of "heroic actors" versus "horrific perpetrators," viewers may actually think for themselves.

Laila Shawa (born 1940, Gaza), a descendant of one of the oldest Palestinian landowning families, lives and works in London and Vermont. She received her first formal training at the Leonardo da Vinci Art Institute in Cairo in 1957–58. In 1958–64, she studied at the Academy of Fine Arts in Rome, spending summers with the artist Oskar Kokoschka at his School of Seeing in Salzburg. After concluding her studies, Shawa returned to Gaza to supervise arts and crafts education in refugee camps for the United Nations Relief and Works Agency, and entered into an informal apprenticeship with the UN war photographer Hrant Nakasian. In 1967, she moved to Beirut, where she stayed for nine years as a full-time painter. With the outbreak of the Lebanese Civil War, she returned to Gaza, where, for the next decade, she collaborated on the design and construction of the Rashad Shawa Cultural Centre.

When Shawa took up residence in London in 1987, she launched the painting series *Women and the Veil*, a sociopolitical critique of its subject. In her next series, *Women and Magic*, she explored the practice of magic and witchcraft in Islamic societies, embodied by *The Hands of Fatima*. In 1992, she began her silkscreen cycle *The Walls of Gaza*, which called attention to the emergence of generations of traumatized Palestinian children.

Shawa's utilization of photography in her paintings, sculptures, and installations has been very influential on contemporary Palestinian art through such works as the artist's installation *Crucifixion 2000: In the Name of God* and her sculpture *Clash,* conveying her immediate reactions to 9/11. With her 2008 series *Sarab,* she returned to painting, executing a cycle of twenty-nine works that assert the role of Islamic geometric patterning as a primary visual identifier of Islamic popular culture. In January 2009, she embarked on two new series, *Gaza III* and a cycle of works entitled *Cast Lead.* The latter focuses on the children killed during Cast Lead—the Israeli name for its three-week-long airstrike operations in Gaza. *The Other Side of Paradise,* from 2011–12, explores the subject of Palestinian female suicide bombers.

Shawa's many solo exhibitions include *In the Name of God: Crucifixion 2000,* Ashmolean Museum, Oxford, 2000; *Sarab,* Atrium Gallery, DIFC, Dubai, 2008; and *The Other Side of Paradise,* October Gallery, London, 2012. Her group shows include Art Dubai, October Gallery, London, and Dubai, 2008, 2009, 2010, 2011; and *Miragens: Contemporary Art in the Islamic World,* Centro Cultural Banco do Brasil, Rio de Janeiro, 2010–11.

Her work is represented in public and private collections throughout the world, including the Ashmolean Museum, Oxford; British Museum, London; National Galleries of Jordan and Malaysia; and the National Museum for Women in the Arts, Washington, D.C.

LAILA SHAWA
Unchain My Heart, from the twenty-nine
part series *Sarab*, 2008
Acrylic on canvas
39 3/8 x 39 3/8 in. (100.1 x 100.1 cm)
Photo credit: Joanna Vestey
Courtesy of the artist

LAILA SHAWA
Night and the City, from the twenty-nine part
series *Sarab*, 2008
Acrylic on canvas
39 3/8 x 78 3/4 in. (100.1 x 199.9 cm)
Photo credit: Joanna Vestey
Courtesy of the artist

LAILA SHAWA
Day and Night, from the twenty-nine part series *Sarab*, 2008
Acrylic with gold and silver leaf on canvas
Diptych
Each 39 3/8 x 78 3/4 in. (100.1 x 199.9 cm)
Courtesy of the artist

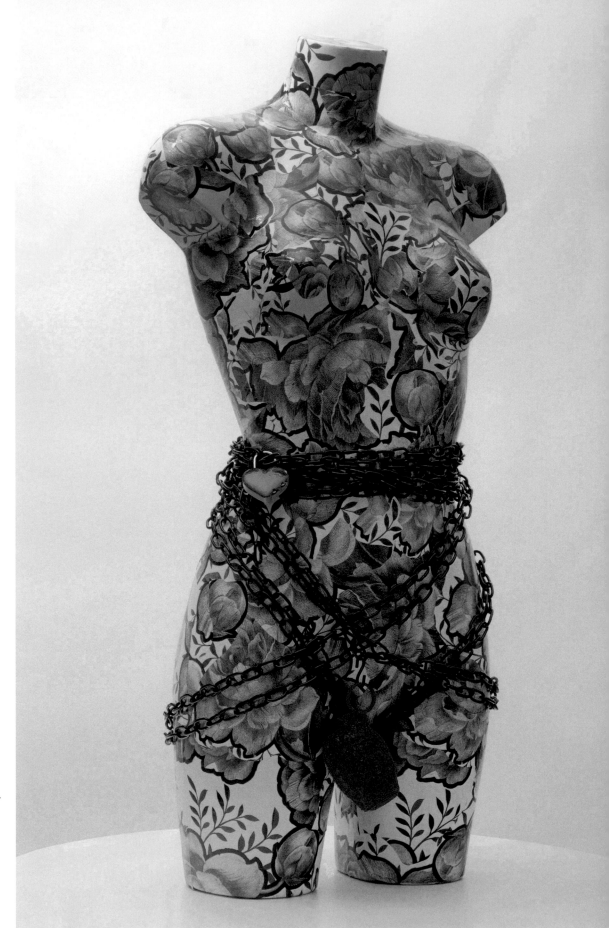

LAILA SHAWA
Disposable Bodies No. 3:
Point of Honor, 2011,
from the installation
The Other Side of
Paradise, 2011–12
Plastic, paper,
steel chain, and
decommissioned hand
grenade and padlock
Approx. 34 5/8 x 17 3/4 in.
(88 x 45 cm)
Photo credit:
Jean-Louis Losi
Courtesy of the artist

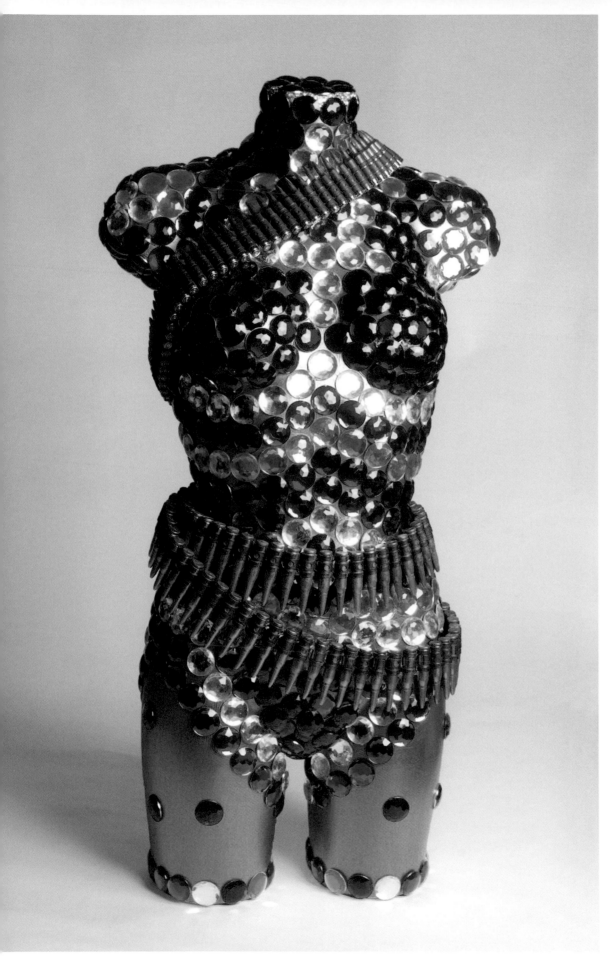

LAILA SHAWA
Disposable Bodies No. 4:
Scheherazade, 2012, from
the installation *The Other*
Side of Paradise, 2011–12
Plastic, rhinestones,
Swarovski crystals,
and decommissioned
bullet belt
Approx. 34 5/8 x 17 3/4 in.
(88 x 45 cm)
Photo credit:
Malcolm Crowthers
Courtesy of the artist

The digital animation *SpiNN* (2003) is a pun on the cable channel CNN. It depicts a mass of spiraling, abstracted forms, hovering like a swarm of angry black crows or bats that coalesce into the image of a Mughal durbar hall (the space where the Indian emperor would meet his ministers or subjects). The hall is incongruously populated by *gopi* women (devotees of Krishna), whose black hairdos comprise the central motif. This "hair bird" is a symbolic representation of feminist agency rather than a direct statement of political resistance.

In the HD video animation *The Last Post* (2010), inspired by the colonial history of the Asian subcontinent and the opium trade, an employee of the British East India Company serves as both metaphor for the collapse of Anglo-Saxon hegemony over China and a lurking threat in the imperial rooms of the Mughal Empire. The piece also makes reference to Company Painting, a European-influenced eighteenth-century style of Indian painting that catered to European tastes by documenting the country's exotic plants, animals, and architecture.

In *Unseen Series* (2011), large-scale HD projections reveal the nighttime landscape, recontextualizing my drawings by shifting their scale and re-rendering them amid foliage and architecture. The projection of the multi-armed female form is a metaphor for Doris Duke herself—mythical, majestic, monumental—looming over Shangri La, her spectacular home overlooking the Pacific, where her ashes were sprinkled. Shangri La's American Orientalism, brilliant craftwork, and collections from Muslim cultures make it both engaging and contradictory.

Shahzia Sikander (born 1969, Lahore) studied the Indo-Persian style of miniature painting at the National College of Arts in Lahore, Pakistan, receiving her BFA in 1992. She also earned an MFA in 1995 from the Rhode Island School of Design. Sikander has developed an original approach, incorporating elements of popular culture and contemporary theory in dialogue with this historical painting style. By referring to the traditional forms of miniatures, she conjures associations with imperialism, storytelling traditions, and popular mythology. Yet by unraveling the conventions of miniaturist painting, she also deconstructs the postcolonial legacy of the Pakistan region. During the 1990s, Sikander's work had a major following at the National College of Arts, inspiring many others to similarly recontextualize the Indo-Persian miniature painting tradition.

Sikander's art confronts and interrogates the perceptual distances between the cultures designated as "East" and "West," a poignant and fraught theme in the current political climate. Working in the mediums of drawing, painting, animation, installation, and video, and employing ideas that are often subversive and polemical in nature, Sikander creates artworks that are physical manifestations of the dynamic of our globalized world. Among Sikander's primary materials are graphite, ink, and gouache, and in 2001 she began working in digital animation, setting her miniatures in motion. Her use of animation, combined with her layering of images and play between figural and abstract forms, destabilizes Sikander's representations and visually embodies her central concerns of transformation, societies in flux, and disruption as means to cultivate new associations.

Sikander has had many solo exhibitions, at venues that include the Renaissance Society, Chicago, 1998; Whitney Museum of American Art, New York, and Hirshhorn Museum and Sculpture Garden, Washington, D.C., 1999; Tang Museum at Skidmore College, Saratoga Springs, and Aldrich Contemporary Art Museum, Ridgefield, 2004; San Diego Art Museum, 2005; Museum of Contemporary Art, Sydney, and Irish Museum of Modern Art, Dublin, 2007; Cooper-Hewitt National Design Museum, New York, and Pilar Corrias Gallery, London, 2009; San Francisco Art Institute, 2010; Massachusetts College of Art and Design, Boston, and Sikkema Jenkins & Co., New York, 2011.

Significant group exhibitions include *Global Vision: New Art from the '90s*, Deste Foundation, Athens, 1998; *The American Century: Art & Culture, 1900–2000*, Whitney Museum of American Art, New York, 2000; *Drawing Now*, Museum of Modern Art, New York, 2002; the Venice Biennale, 2005; *Power of Doubt*, GuangDong Times Museum, Ghangzhou, China, 2011; and many other international venues including the Seville, Shanghai, Johannesburg, Taipei, Istanbul, and Whitney Biennials. She is the recipient of numerous awards and grants including the John D. and Catherine T. MacArthur Foundation Fellowship in 2006.

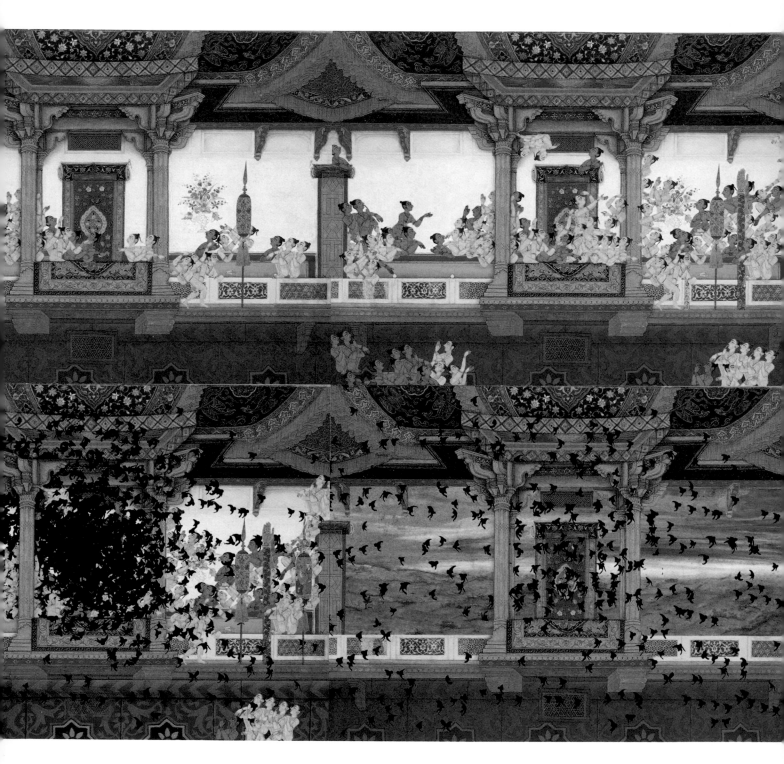

SHAHZIA SIKANDER
Stills from *SpiNN*, 2003
Digital animation
6:38 minutes
Courtesy of the artist

SHAHZIA SIKANDER
Stills from *Unseen Series #1–8*, 2011
On-site HD projection, Shangri La, Doris Duke
Foundation for Islamic Art, Honolulu, Hawaii
Approx. 30–60 feet
Photo credit: David Adams
Courtesy of the artist

SHAHZIA SIKANDER

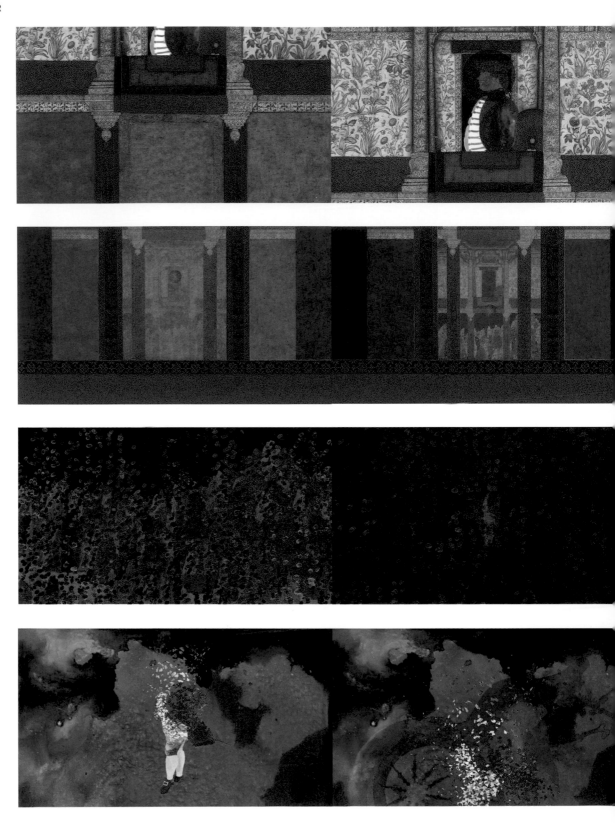

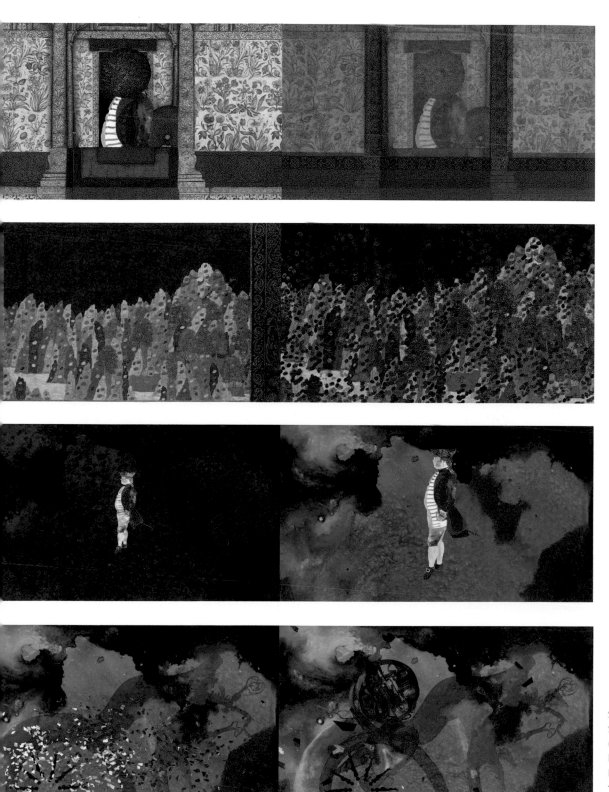

SHAHZIA SIKANDER
Stills from *The Last Post*
(left to right, top to
bottom), 2010
HD video animation
10 minutes
Courtesy of the artist

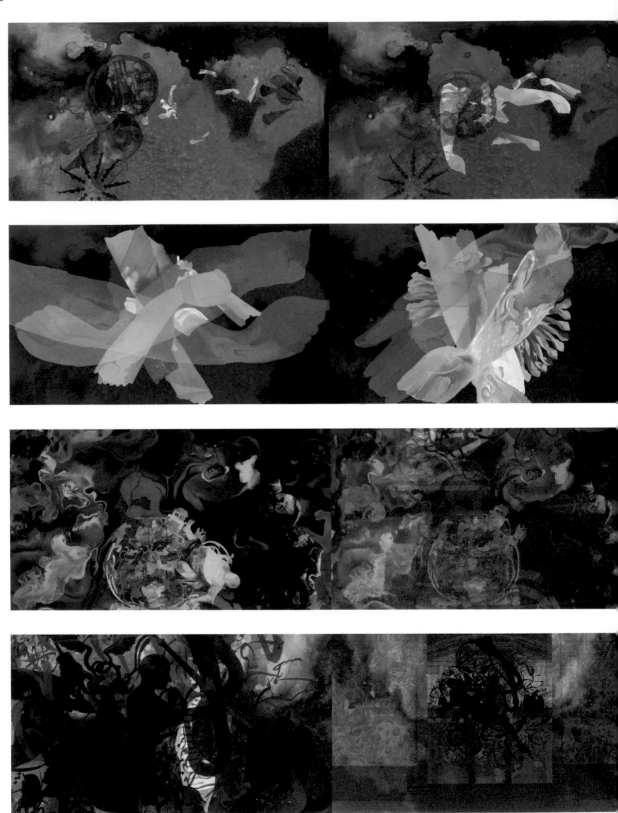

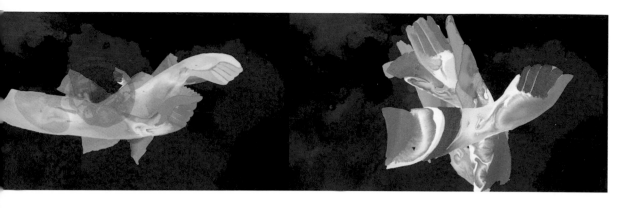

SHAHZIA SIKANDER
Stills from *The Last Post* (left to right,
top to bottom), 2010
HD video animation
10 minutes
Courtesy of the artist

FATIMAH TUGGAR

Borrowing from the realms of advertising, popular entertainment, folklore, and the experiential, I use technology as medium, subject, and metaphor. My goal is to explore the diverse effects of power dynamics on the realities and interdependencies of our lives. Assemblage, collage, and montage are central to my methods of exploration.

In my computer montages and video collages, I bring together a variety of images to examine cultural nuances; the work's meaning lies in the space between these diverse elements. I focus on individuals' internal relationships within the image, tempered by the surrounding power structures.

My web-based interactive works allow participants to create their own collages by selecting backgrounds and animated elements. Participants temporarily facilitate the construction or disruption of non-linear narratives, blending their personal perceptions with set components to produce real-time conversations that can be fluid, resistant, or expansive.

I employ assemblage when working with objects. I combine household implements with varying counterparts, but retaining the objects' functionality so as not to render them mute. In these works, I address the implications of the juggling acts we perform as we adapt, modify, and are, in turn, modified by the devices and power systems that define our environments.

Fatimah Tuggar (born 1967, Kaduna), attended the Blackheath School of Art in London, 1983–85. She went on to receive a BFA from the Kansas City Art Institute, 1992; an MFA from Yale University, 1995; and conducted postgraduate independent study at the Whitney Museum of American Art, 1995–96. She is a member of the art department faculty at the University of Memphis.

Tuggar's work is informed by a broad range of practices, techniques, and materials, among them the artistic traditions of the Middle East, colonial and sub-Saharan Africa, and the European tradition of figure drawing and painting. Her work includes objects, images, videos, and interactive media installations. Her collages and assemblages often combine West African motifs or imagery with their Western equivalents to comment on technology and its impact on both cultures. Her computer montages and video collages blend videos and photographs taken by the artist with found materials drawn from commercials, magazines, and archival footage.

Tuggar's work has been widely exhibited at international venues in over twenty-five countries. Her solo exhibitions include *At the Water Tap,* Greene Naftali Gallery, New York, 2000; *Fusion Cuisine & Tell Me Again,* The Kitchen, New York, 2000; *Celebrations,* Galeria Joao Graça, Lisbon, 2001; *Video Room,* Art & Public, Geneva, 2002; and *Tell Me Again: A Concise Retrospective,* John Hope Franklin Humanities Institute, Duke University, Durham, 2009. She has participated in numerous major group exhibitions, among them *A Work in Progress: Selections from The New Museum Collection,* New Museum, New York, 2001; *Tempo,* Museum of Modern Art, New York, 2002; *Transferts,* Palais des Beaux-Arts, Brussels, 2003; *Africa Remix,* Centre Georges Pompidou, 2005, and Mori Art Museum, Tokyo, 2006; Bamako Biennial, Mali, 2005; Moscow Biennale, 2005; *Street Art, Street Life,* Bronx Museum of the Arts, New York, 2008; *On-Screen: Global Intimacy,* Krannert Art Museum, University of Illinois, Urbana-Champaign, 2009; and *The Record: Contemporary Art and Vinyl,* Nasher Museum of Art, Duke University, 2010.

Tuggar is the recipient of prestigious accolades, such as the Civitella Ranieri Fellowship, 2001; the W. A. Mellon Research Fellowship, awarded by the John Hope Franklin Humanities Institute, 2008; and grants from the Rema Hort Mann Foundation, New York, 1999, and the Wheeler Foundation, Brooklyn, 2000.

FATIMAH TUGGAR
The series *Money & Matter*, 2000
 Riches & Restraint; Currency & Constraints; Assets & Anxiety;
 Funds & Force; Investment & Innocence; Profits & Proficiency;
 Pay & Play; Liability & Liberty; Expense & Explorations
 (each column top to bottom, left to right)
Nine computer montages (inkjet on vinyl)
Each 14 x 30 in. (35.6 x 76.2 x cm)
Courtesy of BintaZarah Studios, New York, and the artist

FATIMAH TUGGAR
At the Meat Market (Small), 2000
Computer montage (inkjet on vinyl)
33 x 96 in. (83.8 x 243.8 cm)
Courtesy of BintaZarah Studios, New York, and the artist

FATIMAH TUGGAR
At the Water Tap, 2000
Computer montage (inkjet on vinyl)
32 x 96 in. (81.3 x 243.8 cm)
Courtesy of BintaZarah Studios, New York, and the artist

FATIMAH TUGGAR
Robo Makes Dinner, 2000
Computer montage (inkjet on vinyl)
45 x 108 in. (114.3 x 274.3 cm)
Courtesy of BintaZarah Studios, New York, and the artist

FATIMAH TUGGAR
Big Lorry, 2001
Computer montage (inkjet on vinyl)
48 x 75 in. (121.9 x 190.5 cm)
Courtesy of BintaZarah Studios, New York, and the artist

FATIMAH TUGGAR
Minor Control, 2005
Computer montage (inkjet on vinyl)
38 x 96 in. (96.5 x 243.8 cm)
Courtesy of BintaZarah Studios, New York, and the artist

FATIMAH TUGGAR
Nebulous Wait, 2005
Computer montage (inkjet on vinyl)
40 x 96 in. (101.6 x 243.8 cm)
Courtesy of BintaZarah Studios, New York, and the artist

FATIMAH TUGGAR
Coverfield, 2008
Computer montage (inkjet on vinyl)
28 x 43 in. (71.1 x 109.2 cm)
Courtesy of BintaZarah Studios, New York, and the artist

FATIMAH TUGGAR
Hot Water for Tea, 2001
Computer montage (inkjet on vinyl)
48 x 72 in. (121.9 x 182.9 cm)
Courtesy of BintaZarah Studios, New York, and the artist

Nil Yalter (born 1938, Cairo), who is of Turkish descent and has lived in Paris since 1965, was educated at Robert College, Istanbul. She participated in the French counterculture and revolutionary movements of the late 1960s, immersing herself in the debates on gender, the status of Turkish migrant workers, and other sociopolitical issues of the time. A pioneer in the French feminist art movement of the 1970s, Yalter experimented with different media including drawing, photography, video, and performance art. She was a member of Collectif Femmes/Art, a Paris-based group of women artists active from 1976 to 1980.

Yalter's multimedia installation *A Nomad's Tent: A Study of Private, Public, and Feminine Spaces* (1973) represents the culmination of her work on Turkish immigrants, revealing her documentary findings on the nomads living around Niğde. The following year, she created the early feminist art classic *The Headless Woman (Belly Dance)*; in this video, the eponymous belly dancer is seen only by her abdomen, on which a feminist statement in script is superimposed. As part of Collectif Femmes/Art's 1978 "Day of Actions," organized to explore the subject of confinement, Yalter mounted a performance and installation in which she acted out everyday life in a harem using utensils and a few items of furniture.

Yalter has created several works on the subject of shamanism, including the videos *Lord Byron Meets the Shaman Woman* (2009) and *Shaman* (1979). Featuring shamanic masks from Paris's Musée de l'Homme, the latter piece embodies the artist's resistance to the appropriation of "primitive" cultures in Western ethnographic museums.

Yalter has had many solo exhibitions, starting in 1973 and continuing to the present. Recent solo shows include *Nil Yalter: Fragments of Memory,* Galerie Hubert Winter, Vienna, 2011; *20th Century / 21st Century,* Galerist, Istanbul, 2011; and *Nil Yalter: 1970–1980,* Galería Visor, Valencia, 2012. Her work has been featured in major group exhibitions, among them *A batalla dos xéneros,* Centro Galego de Arte Contemporánea, Santiago de Compostela, 2007; *WACK! Art and the Feminist Revolution,* Los Angeles Museum of Contemporary Art; National Museum of Women in the Arts, Washington, D.C.; MoMA PS1, New York; and the Contemporary Art Center, Vancouver, 2007–08; Bovisa Triennale, Milan, 2008; *re.act. feminism: performancekunst der 1960er und 70er Jahre heute,* Akademie der Künste, Berlin, 2008; *Türkische Wirklichkeiten,* Fotografie Forum international, Frankfurt/Main, 2008; *elles@ centrepompidou: artistes femmes dans les collections du Centre Pompidou, Centre Pompidou,* Musée National d´Art Moderne, Paris, 2009; *Donna: Avanguardia femminista negli anni 1970s,* Galleria Nazionale d'Arte Moderna, Rome, 2010; *Dream and Reality,* Istanbul Modern, 2011; and *dress/id: the language of the self / le langage du Moi,* Centre d'Art Passerelle, Brest, 2012.

Her sculptures, videos, and installations are in the permanent collections of such institutions as the Centre Georges Pompidou, Paris; Fonds national d'art contemporain, Puteaux; Istanbul Modern; and Tate Modern, London.

Witnessing with an artist's sensitivity the history of intellectual and spatial changes, Nil Yalter, from the 1960s on, redefined political, ideological, aesthetic, and patriarchal narratives from a unique feminine [viewpoint] into a [personal] context to form an original artistic field of activity, creating new meanings . . . between past-present-future, I-other, reality-fiction, imagination-memory. . . constructed memories appear as spaces of immigration, exile, displacement, interfusion and interaction, and the notion of "culture" as an allegedly well-established body is questioned.

This is an excerpt from Derya Yücel, "Nil Yalter: Fragments of Memory" (Istanbul, 2011).

The true woman is simultaneously both "convex" and "concave" . . . nonetheless, it is necessary that she not be deprived, neither in a moral nor a physical sense, of the central principal of her convexity: her clitoris. This hatred of the clitoris in fact corresponds to an age-old horror that man has always had for this "virile"—and also natural—component of a woman; the very part that is responsible for her orgasm in the absolute sense. Every possible step has been taken in order to impede this orgasm, including physical and moral mutilation. From such a starting point it is hardly surprising that, having liberated herself from the "shame of having a clitoris" and the "sin of pleasure," women have subsequently recuperated not only their personal equilibrium—the equilibrium of a dual polarity—but also all the available recourses of their sexuality, a sexuality that is both concave and convex.

This text is inscribed on the abdomen of the belly dancer in Yalter's *Headless Woman (Belly Dance)* (see page 167). It is an excerpt from René Nelli, *Erotique et civilisation* (Paris: Weber, 1972).

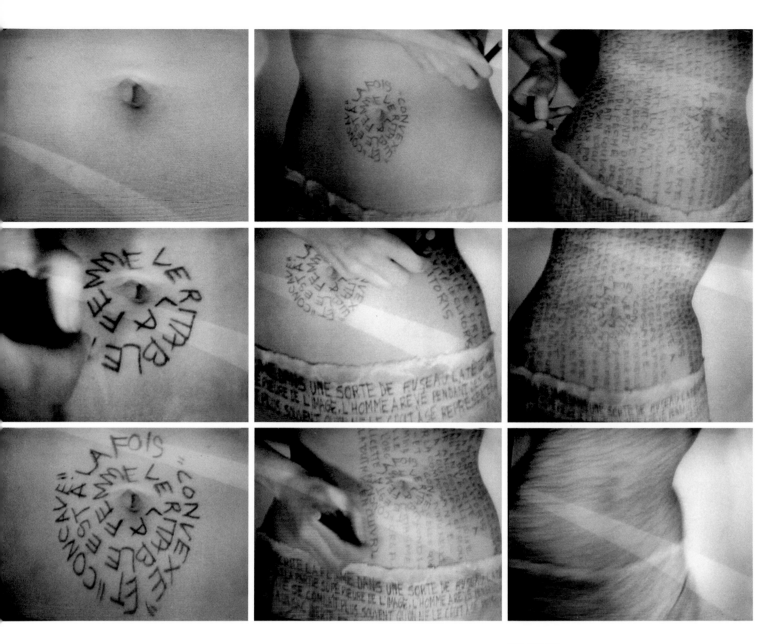

NIL YALTER
Stills from *The Headless Woman*
(Belly Dance), 1974
Black-and-white video
24 minutes
Courtesy of the artist

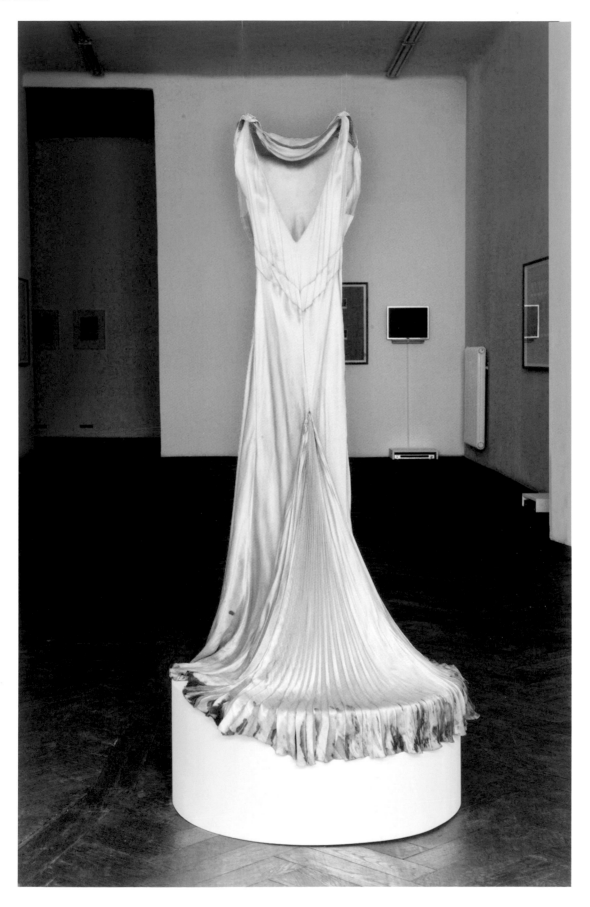

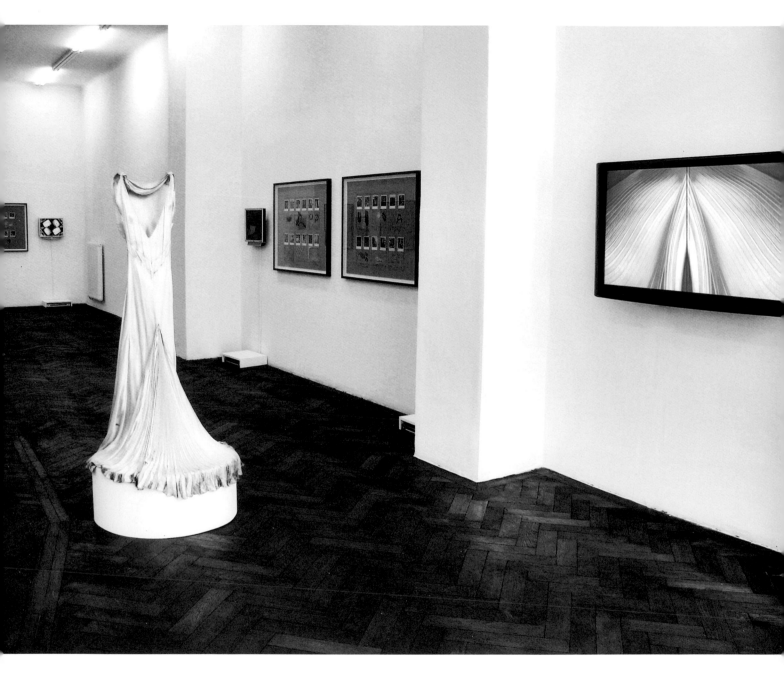

NIL YALTER
The AmbassaDRESS, 1978
Installation (Lanvin dress, video, sixteen gelatin silver
prints, thirteen drawings, one monotype)
Courtesy of the Galerie Hubert Winter, Vienna, and
the artist

NIL YALTER
The AmbassaDRESS (detail), 1978
Installation (Lanvin dress)
Courtesy of the Galerie Hubert Winter, Vienna,
and the artist

NIL YALTER
Video stills from *The AmbassaDRESS*, 1978
Courtesy of the Galerie Hubert Winter, Vienna,
and the artist

Exhibitions and Events

Exhibitions and Events

THE FERTILE CRESCENT EXHIBITION

Arts Council of Princeton / Paul Robeson Center for the Arts
Shiva Ahmadi, Monira Al Qadiri, Nezaket Ekici,
Hayv Kahraman, Efrat Kedem

**Bernstein Gallery, Woodrow Wilson School of Public and
International Affairs, Princeton University**
*Negar Ahkami, Ghada Amer and Reza Farkhondeh, Zeina
Barakeh, Ofri Cnaani, Parastou Forouhar, Shadi Ghadirian*

**Mary H. Dana Women Artists Series Galleries,
Rutgers University**
Ariane Littman, Shahzia Sikander, Fatimah Tuggar

Mason Gross Galleries, Rutgers University
*Jananne Al-Ani, Fatima Al Qadiri, Monira Al Qadiri,
Ofri Cnaani, Diana El Jeiroudi, Ayana Friedman,
Ariane Littman, Ebru Özseçen, Laila Shawa, Nil Yalter*

Princeton University Art Museum
*Parastou Forouhar, Mona Hatoum, Sigalit Landau,
Shirin Neshat, Laila Shawa*

COMPLEMENTARY EXHIBITIONS

Borderlands
New Brunswick Public Library
*Sheetal Bagewadi, Linda Bock-Hinger, Reem Hussein,
Natalia Kadish, Mediha Sandhu, Ela Shah,
Tamara Woronczuk*

Mary Cross: Photos of Egypt **and** *Ifat Shatzky:
Soil-Adama*
Princeton Public Library

*The El Nafeza Papermaking Project: A Collaboration
Between Art and the Environment*
East Brunswick Public Library

Fertile Crescent exhibition
Stedman Gallery, Rutgers–Camden Center for the Arts

*Goddess, Lion, Peasant, Priest: Modern and Contemporary
Indian Art from the Shelley and Donald Rubin Private
Collection*
The College of New Jersey Galleries
*Chandrima Bhattacharyya, Sakti Burman, Arpana Caur,
Shanti Dave, M. F. Husain, Krishen Khanna, Seema Kohli,
K. S. Kulkarni, Bari Kumar, Mahjabin Majumdar, Nalini
Malani, Kamal Mitra, Gogi Saroj Pal, Shyamal Dutta Ray,
Sadequain, G. R. Santosh, Arpita Singh, F. N. Souza,
K. G. Subramanyan*

*Memory of Here, Memory of There: Fertile Crescent
Dialogues*
West Windsor Arts Council Galleries
*Samira Abbassy, Nadia Ayari, Milcah Bassel, Dahlia Elsayed,
Armita Raafat, Emna Zghal*

Farah Ossouli: Ars Poetica
Orbit I Gallery, Paul Robeson Galleries
Rutgers University, Newark

LECTURES, SYMPOSIA, AND WORKSHOPS

Conversation on Female Suicide Bombers
Rutgers University
Julie Rajan, Rutgers University, and Laila Shawa, artist

Conversation on Women and the Revolution in Egypt
Lewis Center for the Arts, Princeton University
Margot Badran, Senior Scholar, Woodrow Wilson International Center for Scholars, and Senior Fellow, Prince Alwaleed ibn Talal Center for Muslim-Christian Understanding, Georgetown University, and Yasmine El Rashidi, Hodder Fellow, Lewis Center for the Arts, Princeton University

Michael Curtis, Distinguished Professor Emeritus, Political Science, Rutgers University
Lecture on politics and gender in the Middle East
East Brunswick Public Library

The Fertile Crescent: Gender, Art, and Society in the Middle East Diaspora
Symposium
Jane Voorhees Zimmerli Art Museum, Rutgers University
Moderator: Alison Bernstein, Director, Institute for Women's Leadership, Rutgers University
Presenters: Negar Ahkami, artist; Margot Badran, Woodrow Wilson International Center for Scholars and Prince Alwaleed ibn Talal Center for Muslim-Christian Understanding, Georgetown University; Zeina Barakeh, artist; Kelly Baum, Princeton University Art Museum; Ayana Friedman, artist; Fakhri Haghani, Center for Middle Eastern Studies, Rutgers University; Fatimah Tuggar, artist

Israel in Fiction
Lecture
Leora Skolkin-Smith
Princeton Public Library

Lucette Lagnado, Novelist and senior special writer and investigative reporter, *The Wall Street Journal*
Lecture
Princeton Public Library

Sigalit Landau, Artist
Ruth Ellen Steinman Bloustein and Edward J. Bloustein Memorial Lecture
Edward J. Bloustein School of Planning and Public Policy, Rutgers University

Ariane Littman
Lebowitz Visiting Artist-in-Residence Public Lecture
Rutgers University

Middle East Gender, Art, and Politics
Panel
Woodrow Wilson School of Public and International Affairs, Princeton University
Moderator: Stanley N. Katz, Director, Center for Arts and Cultural Policy Studies, Woodrow Wilson School of Public and International Affairs, Princeton University

Middle East Women Artists: Books on the Edge
Annual Book Arts Symposium
Arts Council of Princeton / Paul Robeson Center for the Arts
Organizer: Michael Joseph
Presenters included Patricia Sarrafian Ward, book artist and writer, and other artists

Gilane Tawadros
Laurie Chair in Women's Studies Public Lecture
Rutgers University

Themes in the Works of Middle East Women Writers
Panel with readings by Middle East Women writers
Lewis Center for the Arts, Princeton University
Participants included Ronit Matalon and others

Women and Documentary Film: Celebrating the Fortieth Anniversary of Women Make Movies **(focusing on Middle East and Muslim women artists)**
Symposium
Rutgers University
Participants included Debra Zimmerman, Executive Director, Women Make Movies, and others

SPECIAL EVENTS

Fashioning the Cultural Impact of the Islamic Diaspora: An Afternoon of Events
Rutgers University
Panel
Moderator: Ousseina Alidou, Associate Professor, Department of African, Middle Eastern, and South Asian Languages and Literatures, and Director, Center for African Studies, Rutgers University
Panelists: Fawzia Afzal-Khan, Montclair State University; Heather Marie Akou, Indiana University; Pallabi Chakraborty, Swarthmore College; Sylviane Diouf, Schomburg Center for Research in Black Culture; Fakhri Haghani, Rutgers University; Meheli Sen, Rutgers University

Musical and dance performances
Mandinka traditional music, performed by Senegal Dance Performance, and Kathak dance, performed by Courtyard Dancers Company

Exhibitions
Everyday Islam: Photographs by Annanya Dasgupta
Out of the Closet (clothes and textiles from the Middle East)

The Fertile Crescent: Gender, Art, and Society
Art Walk in Princeton
Walk included The Fertile Crescent exhibits at the Arts Council of Princeton, Bernstein Gallery, and Princeton University Art Museum; and Lifting a Secret, performance by artist Nezaket Ekici at the Lewis Center for the Arts, Princeton University

The Fertile Crescent: A New York Public Library Book Event
Stephen A. Schwarzman Building, New York Public Library

PERFORMANCES

The Alter-Ego of an Arab-American Assimilationist
Crossroads Theatre, New Brunswick
Performance by Betty Shamieh, introduced by Andreia Pinto-Correia

Lifting a Secret
Lewis Center for the Arts, Princeton University
Performance by artist Nezaket Ekici

Najla Said
Lewis Center for the Arts, Princeton University
Performance

Scheherazade Goes West
Lewis Center for the Arts, Princeton University
Performance by Fawzia Afzal-Khan, Montclair State University. Following the performance, conversation between Afzal-Kahn and Jill Dolan, Princeton University

Songs of the Fertile Crescent
Wolfensohn Hall, Institute for Advanced Study, Princeton
World premiere of suite of arias from the new opera *Territories* (music by Andreia Pinto-Correia and libretto by Betty Shamieh), sung by Haleh Abghari. Concert featuring women composers from the Middle East and Iberia, followed by an onstage discussion

Tabla
The College of New Jersey
Performance by Abhijit Banerjee and Tarang

Tales of Transformation
Richardson Auditorium, Princeton University
Nikolai Rimsky-Korsakov's *Scheherazade*, performed by the Princeton Symphony Orchestra, with Susan Babini on cello

FILM SCREENINGS

COMMUNITY EDUCATIONAL ACTIVITIES

Amreeka, by Cherien Dabis
Rutgers University
Hosted by the New Jersey Film Festival

Caramel, by Nadine Labiki
Rutgers University
Hosted by the New Jersey Film Festival

Films by and about Iranian Women
Rutgers University

Films by Israeli Women Directors
Regal Theater, South Brunswick
Hosted by the Rutgers Jewish Film Festival

Lady Kul el-Arab, by Ibtisam Salh Mara'ana
Princeton Public Library and New Brunswick Public Library

Miss Representation, by Jennifer Siebel Newsom
New Brunswick Public Library

Persepolis, written and directed by Marjane Satrapi
and Vincent Paronnaud
Arts Council of Princeton / Paul Robeson Center for
the Arts

Women Without Men, by Shirin Neshat and
Faridoun Farrokh
Rutgers University
Hosted by the New Jersey Film Festival

Community Read
Princeton Public Library
Beirut Nightmares, by Ghada Samman
Once in a Promised Land, by Laila Halaby
Women Without Men, by Shahrnush Parsipur

Women, Film, and Storytelling in the Middle East
Hands-on filmmaking program for high school students
New Brunswick Public Library

Contributors to the Project

Contributors to the Project

SAMIRA ABBASSY (born 1965, Ahwaz), who moved to London as a child, is a painter whose work addresses women, war, and identity. After graduating from Canterbury College of Art, she began showing her work in London. In 1998, she moved to New York to help establish the Elizabeth Foundation for the Arts Studio Center, where she currently has a studio and is a board member. She had a solo exhibition in New York in 2007, and her work is shown internationally. Her paintings are included in many private and public collections, including the British Government Art Collection; British Museum, London; Burger Collection, Hong Kong; Devi Foundation, New Delhi; Farjam Collection, Dubai; and Rubin Museum of Art, New York. She received a Yaddo residency in 2006, a grant from the New York Foundation for the Arts in 2007, and a Joan Mitchell Painting/Sculpture Award in 2010. In 2012, she was an artist-in-residence at the University of Virginia. Abbassy was one of the artists in the exhibition *Memory of Here, Memory of There,* at the West Windsor Arts Council Galleries.

HALEH ABGHARI (born 1970), a native of Iran who makes her home in New York City, is a singer-activist who has performed in the United States, Canada, and Europe to critical acclaim. Abghari pursued her studies in music at the University of California at Davis, Mannes College of Music, the Peabody Conservatory, and the Banff Centre for the Arts. Abghari is the only woman to have portrayed the title role of Peter Maxwell Davies's *Eight Songs for a Mad King.* In addition to working with numerous living composers, Abghari has collaborated on a number of projects and site-specific installation-performances with visual and performance artists. She appeared in the title role of *L'Enfant et les sortilèges,* and as the Old Lady in *Candide,* two productions staged at the Peabody Opera Theatre, where she also served as stage director for a full production of *The Telephone.* Her awards include the Presidential Undergraduate Fellowship from the University of California at Davis, two Career Development Grants from the Peabody Conservatory, and a Fulbright Scholar Grant to study the vocal music of György Kurtág in Budapest. Abghari was the soloist in the concert at Wolfensohn Hall, Institute for Advanced Study, which featured the debut of arias from the new opera *Territories,* the libretto for which was written by Betty Shamieh, based on her play of the same name, and the music by Andreia Pinto-Correia.

MOHAMED ABOU EL NAGA (born 1960, Tanta), a multidisciplinary visual artist, art professor, curator, and developer, studied art and received his PhD in art philosophy from Alexandria University in 1997. He was the first Middle East artist to receive a grant from the Japan Foundation to study the art of papermaking. El Naga represented Egypt in the Venice Biennale of 2002, and received the First Prize at the Alexandria Biennale of 2001. As a curator, he founded *Imagining the Book,* the Artist Book Biennial in the Alexandria Bibliotheca, which he directed in 2002 and 2005. In 2009, he was appointed curator of the Alexandria Biennale. El Naga established the El Nafeza Foundation for Contemporary Art and Development, where he practices environmentally-friendly papermaking from raw agricultural refuse material. He is a Fellow of Ashoka, the global association of the world's leading social entrepreneurs. In 2007, *Newsweek* listed El Naga among the one hundred entrepreneurs who can change the world. He was named a Goodwill Cultural Ambassador for Africa by the President of Senegal. Paper made at the El Nafeza Foundation was shown in an exhibition at the East Brunswick Public Library.

EVELYN KIM ADAMS studied at Parsons School of Design before matriculating at Shimer College, Oxford University, where she received a BA. She later completed her MA at Alliant University, and is ABD in anthropology at Rutgers University. Entitled "A Preliminary Study of Enculturation and Acculturation among the Toba Batak of North Sumatra, Indonesia," her master's thesis included fieldwork in North Sumatra on Samosir Island on Lake Toba (Danau Toba). Following the completion of her first master's degree, she began working toward a doctorate at Rutgers University; her degree work was interspersed with consulting work in Southeast Asia, while concurrently working on Wall Street for an international commodity brokerage house. She subsequently pursued a degree in library science, and went on to work in archives and preservation at the New Brunswick Free Public Library and in the Special Collections and University

Archives Department of the Rutgers University Libraries. Adams organized the *Fertile Crescent* program for New Brunswick high school students and was a member of the planning team.

FAWZIA AFZAL-KHAN is a University Distinguished Scholar, Professor of English, and Director of the Women and Gender Studies Program at Montclair State University, New Jersey. She holds a BA in English, French, and music from Kinnaird College; a Diplôme Supérieure in French from the Alliance Française; an MA in English from Government College, all three in Lahore; and a PhD in English literature from Tufts University. She co-edited *The Pre-Occupation of Postcolonial Studies* (Duke University Press, 2000) with Kalpana Seshadri-Crooks and edited *Shattering the Stereotypes: Muslim Women Speak Out* (Interlink Books, 2005). She has also authored *A Critical Stage: The Role of Secular Alternative Theatre in Pakistan* (Seagull Press, 2005); *Lahore with Love: Growing Up With Girlfriends, Pakistani-Style; A Memoir* (Syracuse University Press, 2010; reprint, Insanity Ink Publications, 2011). Since 2001, Afzal-Khan has published over thirty journal articles and essays in the United States and Pakistan. Fourteen of her poems have appeared over the last decade, including the publication of "Amazing Grace" in Tina Chang, Nathalie Handal, and Ravi Shankar, eds., *The Norton Anthology: Language for a New Century* (W. W. Norton, 2008). In 2011, she received a National Endowment for the Humanities grant to make a trailer for *Bridging Cultures Through Film*, a documentary film on Pakistani women singers. Her performance *Scheherazade Goes West* was performed at the Lewis Center for the Arts, Princeton University, as part of the *Fertile Crescent* programming, and she was also a member of the planning team.

KAREN ALEXANDER (born Louisville) received master's degrees in English and philosophy from the University of Louisville in 1997 and 1999, and earned a PhD in English from the University of London in 2005. She is Dean of Junior and Senior Year Programs at Douglass Residential College and an affiliate faculty member of the Women's and Gender Studies Department, both at Rutgers University. She is responsible for developing programs to involve students in collaborative, project-based, experiential learning that encompasses local and global awareness.

Student engagement with leadership, social justice, media and technology, and environmental stewardship are also priorities for her office. For seven years prior to joining Douglass, she served as Senior Editor of *Signs: Journal of Women in Culture and Society,* in which capacity she worked with scholars in a variety of disciplines from around the world. She is a co-founder of *Films for the Feminist Classroom,* an online, open-access resource that strives to enhance the use of media texts in teaching. Her interests include the technology-driven changes taking place in higher education and academic publishing, as well as experimental writing, documentary film, and feminist art. She co-edited *War and Terror: Feminist Perspectives* (University of Chicago Press, 2008) with Mary Hawkesworth. Alexander was a member of the planning team, facilitated involvement in *Fertile Crescent* of undergraduates enrolled in Douglass Residential College, and also facilitated the inclusion of the *Women Make Movies* symposium as a *Fertile Crescent* event.

OUSSEINA ALIDOU is Associate Professor, Department of African, Middle Eastern, and South Asian Languages and Literatures, and Director of the Center for African Studies at Rutgers University. Her research focuses on the study of women's discourses and literacy practices in Afro-Islamic societies; African women's agency; African women's literatures; and the politics of cultural production in Francophone Muslim African countries. Her book *Engaging Modernity: Muslim Women and the Politics of Agency in Postcolonial Niger* (University of Wisconsin Press, 2005), exploring women's agency through the contributions of women to religious and secular education, public politics, and the performing arts, was a runner-up for the ASA 2007 Women's Caucus Aidoo-Snyder Book Prize. Her other publications include *A Thousand Flowers: Social Struggles Against Structural Adjustment in African Universities,* co-edited with Silvia Federici and George Caffentzis (Africa World Press, 2000), and *Post-Conflict Reconstruction in Africa,* co-edited with Ahmed Sikainga (Africa World Press, 2006). In 2006, Professor Alidou was awarded the Rutgers University Board of Trustees Fellowship for Scholarly Excellence "in recognition of her significant contributions in the areas of linguistics, literature and culture and gender studies, particularly her highly innovative interpretations of Islam

relating to women and of new individual and collective social practices in Africa." Professor Alidou was a member of the *Fertile Crescent* planning team and facilitated the organization of the session on the Middle East diaspora, which included a panel that she moderated, two exhibitions, and a performance.

NADIA AYARI (born 1981) is an artist who lives and works in New York. She received a BA in art history from Boston University in 2004, a Certificate of Fine Arts from Brandeis University in 2005, and an MFA in painting from the Rhode Island School of Design in 2007. She has had solo exhibitions in New York at Mehr Gallery in 2008 and Monya Rowe Gallery in 2011, as well as at Luce Gallery, Turin, 2009, and ArtSTRAND, Provincetown, 2010. She has participated in group exhibitions at the Monica De Cardenas Gallery, Zuoz, Switzerland; the Saatchi Gallery, London, 2009; and was included in the United States Pavilion, International Cairo Biennale, 2010. She received a Summer Residency and Scholarship, Skowhegan School of Painting and Sculpture, 2006, and a Visual Arts Fellowship, Fine Arts Work Center, Provincetown, 2009–10. Ayari was one of the artists in the exhibition *Memory of Here, Memory of There,* at the West Windsor Arts Council Galleries.

MARGOT BADRAN is a Senior Scholar at the Woodrow Wilson International Center for Scholars, Washington, D.C., and Senior Fellow at the Prince Alwaleed ibn Talal Center for Muslim-Christian Understanding at Georgetown University. She holds a diploma from Al Azhar University, an MA from Harvard, and a DPhil from Oxford. She was the Edith Kreeger Wolf Distinguished Visiting Professor in the Department of Religion and Preceptor at the Institute for the Study of Islamic Thought at Northwestern University in 2003–04, and held the Georgianna Clifford and Reza Khatib Visiting Chair in Comparative Religion at St. Joseph's College, Brooklyn, in 2010. A co-editor of the Brill series on Women and Gender in the Middle East and Islamic World, she is on the boards of several publications. Her books include: (as editor) *Feminists, Islam, and Nation: Gender and the Making of Modern Egypt* (Princeton University Press, 1995); *Feminism beyond East and West: New Gender Talk and Practice in Global Islam* (Global

Media Publications, 2007); *Feminism in Islam: Secular and Religious Convergences* (Oneworld Publications, 2009); and *Gender and Islam in Africa: Rights, Sexuality, and Law* (Woodrow Wilson Center Press, 2011); and (as co-editor) *Opening the Gates: An Anthology of Arab Feminist Writing* (Indiana University Press, 2004). Her work, which also includes numerous scholarly articles as well as essays in newspapers and popular journals, has been translated into many languages. Among her awards are the Fulbright New Century Scholars Award; ISIM (Institute for the Study of Islam in the Modern World) fellowship, Leiden; Rockefeller Foundation fellowship, Bellagio; Social Science Research Council grant, New York; United States Institute of Peace grant; and Woodrow Wilson International Center for Scholars fellowship. Badran wrote an essay for the *Fertile Crescent* catalogue based on her research and interviews with Egyptian women artists to learn how the events of the Arab Spring had affected them. She also spoke at the inaugural symposium and again in conversation with Yasmine El Rashidi at Princeton University.

SHEETAL BAGEWADI (born 1973, Kolhapur) received her bachelor's degree in 1994 and her fine arts degree from Dalvi's Arts Institute in 1995, both in Maharashtra, India. She has always been fascinated by the sculptural art of Indian temples. Using embossed metalwork, she has represented this ancient art form through modern techniques. She also works in acrylic, painting female figures with added textures to create three-dimensional effects. Her work was shown in a number of exhibitions in India during the 1990s, including *Nature*, a show for the World Wildlife Fund, Shahu Smarak Hall, Kolhapur, 1993; *Mural Art*, also at Shahu Smarak Hall, Kolhapur, 1994; and *The Summer Show*, Jehangir Art Gallery, Mumbai, 1995. Most recently, she took part in the Eighth Annual Fine Arts Festival, East Brunswick, New Jersey, 2010. Bagewadi's work was included in the exhibition at the New Brunswick Public Library.

ABHIJIT BANERJEE is considered one of the foremost *tabla* players in the world, and is one of the most sought-after creative artists in the realm of Indian classical music, accompanying nearly all the top-ranking luminaries of this genre. As a *tabla* soloist, he has also made his mark in numerous performances

and recordings both in India and abroad. His international performances of note include Carnegie Hall, Gewandt Haus in Leipzig, Lincoln Center, the Paleis in Brussels, Radio France and Théâtre de la Ville in Paris, and the South Bank cultural complex, United Kingdom. Banerjee represented India in the Granada Festival of Music in Spain. He has also left his mark in the diverse field of crossover music as both a performer and composer. His crossover work includes collaborations with musicians such as Ry Cooder, Larry Coryell, and Trilok Gurtu. Banerjee founded his own touring ensemble, Tarang, which performs his original compositions and releases CD's of the same titles. He is also a member of the Arohi Ensemble, a Raga Jazz group. Banerjee has scored music for Indian television; he won the National Award for Documentary Music for *The Trail*, a film about Calcutta screened at the Munich and Amsterdam Film Festivals. He founded and established the Dhwani Academy of Percussion Music in Los Angeles, New York, Singapore, and Calcutta, attracting talented students from around the world. The Academy works to promote Indian music and has initiated needy blind children into the art of music. Banerjee performed at The College of New Jersey.

GOLBARG BASHI is an Iranian Swedish feminist scholar. She holds a First Class (Honors) BA in Middle Eastern studies from Manchester University, an MS in women's studies from Bristol University, and a PhD in Middle Eastern studies from Columbia University. She is a faculty member in the School of Arts and Sciences, Rutgers University, and the Rutgers Center for Middle Eastern Studies. The courses that Dr. Bashi offers provide a panoramic perspective on medieval and modern Middle Eastern history in the geographical, political, and cultural contexts of the Arab and Muslim world, viewed through postcolonial theory. She also teaches courses on various aspects of gender in the Middle East and representations of race, gender, and ethnicity in Western media and popular culture (including cinema and art). Selected publications include a chapter in Nader Hashemi and Danny Postel, eds., *The People Reloaded: The Green Movement and the Struggle for Iran's Future* (Melville House, 2011) and "Reflections on a Photograph of a Mother and Child," in *IDÉE: A Magazine about Ideas* (February 7, 2012). Dr. Bashi is also a visual artist and a member of Professional Women Photographers,

Inc. Her photographs have appeared in *Aljazeera English, The New York Times, Amnesty International, Jadaliyya,* and *Electronic Intifada,* and on *CNN* and *BBC News,* among others. Bashi led the discussion after the screening of *Women Without Men.*

MILCAH BASSEL (born 1981, Boston) was raised in Jerusalem. She studied drawing and painting at the Jerusalem Studio School, alternative medicine at Lev Hamaga College, Tel Aviv, received her post-baccalaureate in studio art from Brandeis University in 2011, and her MFA from the Mason Gross School of the Arts, Rutgers University, in 2012. Her drawings and installations explore the complex and constantly shifting relationship between bodies and framed spaces. She was one of the artists included in the exhibition *Memory of Here, Memory of There,* at the West Windsor Arts Council Galleries.

KELLY BAUM (born Norfolk) received a BA in art history from the University of North Carolina at Chapel Hill, and an MA and PhD from the University of Delaware in 2005. She is the Haskell Curator of Modern and Contemporary Art, Princeton University Art Museum. From 2002 to 2007, she was Assistant Curator of Contemporary Art at the Blanton Museum of Art, University of Texas at Austin; from 2008 to 2010, she was the Locks Curatorial Fellow for Contemporary Art at the Princeton University Art Museum. Her exhibitions include *Carol Bove,* 2006; *Jedediah Caesar,* 2007; *The Sirens' Song,* 2007; *Transactions,* 2007, all at the Blanton Museum; *Nobody's Property: Art, Land, Space, 2000–2010* and *Doug Aitken: migration (empire),* both at the Princeton University Art Museum, 2010. She has published essays in *October, Art Journal, The Drama Review,* and PUAM's *Record.* She manages the Sarah Lee Elson, Class of 1984, International Artist in Residence Program, and serves as curatorial advisor to the University's campus art committee. Baum received a Curatorial Research Fellowship from the Andy Warhol Foundation for the Visual Arts in support of her 2013 exhibition *New Jersey as Nonsite.* Baum was a member of the planning team, wrote an essay for the catalogue, and spoke at the *Fertile Crescent* inaugural symposium.

ANONDA BELL, the Director and Curator of the Paul Robeson Galleries at Rutgers University, Newark, was born and educated in Australia. She holds a BA from the University of Melbourne in psychology and English, a postgraduate diploma from that same institution, a BFA in painting and printmaking from RMIT University (a global university of technology and design based in Australia), and an MFA from Monash University. For more than a decade, Bell has worked in the not-for-profit arts sector as a curator at institutions that include the Bendigo Art Gallery and the National Gallery of Victoria in Australia. Bell is a multimedia artist as well as a curator. She has had solo shows in Australia and has participated in numerous group exhibitions in both Australia and the United States. Bell curated the Farah Ossouli exhibition in the Paul Robeson Galleries.

MICHELE BENJAMIN (born 1964, Middletown) is a New York–based web designer, working with educational and community-based partnerships that promote women artists. Benjamin received her BA in art history from Arizona State University, 1988, followed by web design studies at Parsons School of Design, New York, 2001. Her company, gothamdiner.com, was launched in 2011. Her inspiration comes from New York City arts and cultural institutions, travel, and modern and contemporary design. Benjamin has created web sites and related printed materials in collaboration with Arizona State University, 2001–present; the Whitney Museum of American Art, 2003–present; and the Rutgers University Institute for Women and Art (IWA), for which she designed the *Fertile Crescent* web site, 2011–12.

DOROTHEA BERKHOUT is Associate Dean at the Edward J. Bloustein School of Planning and Public Policy at Rutgers University. She holds a PhD in comparative literature from Ohio University. Berkhout has been a member of the Rutgers administration in various capacities for many years. She serves on a number of civic boards in New Jersey, including the Transition Team Task Force for the consolidation of Princeton Borough and Princeton Township. Berkhout facilitated the visit to Rutgers University by Sigalit Landau, who gave the Ruth Ellen Steinman Bloustein and Edward J. Bloustein Memorial Lecture at the Bloustein School.

DEREK BERMEL (born 1967, New York) is an American composer, clarinetist, and conductor whose music blends various facets of world music, funk, and jazz with the classical musical vocabulary. Bermel earned his BA at Yale University and later studied at the University of Michigan, Ann Arbor, with William Bolcom and William Albright. His interest in a wide range of musical cultures sent him to Jerusalem to study ethnomusicology with André Hajdu, Bulgaria to investigate Thracian folk style with Nikola Iliev, Brazil to learn caxixi with Julio Góes, and Ghana to study Lobi xylophone with Ngmen Baaru. He first came into the national spotlight with works like *Natural Selection,* a series of animal portraits for baritone and ensemble, and *Voices,* a concerto for clarinet and orchestra that he wrote for himself to perform. He is the recipient of major awards, including a Guggenheim Fellowship and the prestigious Rome Prize, awarded to American artists for a year-long residency in Rome. Bermel completed a three-year residency with the American Composers Orchestra in 2006–09, and currently serves on the ACO board. He also served as composer-in-residence with the Los Angeles Chamber Orchestra in 2009–12. He is artist-in-residence at the Institute for Advanced Study in Princeton, New Jersey, where he currently lives and works. Bermel arranged the Institute for Advanced Study concert organized by Andreia Pinto-Correia.

ALISON R. BERNSTEIN received her BA from Vassar College, and her MA and PhD from Columbia University in 1985. She assumed the position of Director, Institute for Women's Leadership, and Professor of History at Rutgers University in 2011. She formerly served as a Vice President for the Ford Foundation's Program on Knowledge, Creativity, and Free Expression. Bernstein joined the Foundation in 1982 as a Program Officer and subsequently served as Director of the Education and Culture Program in 1992–96. A former Associate Dean of Faculty at Princeton University, Bernstein is the author of three books: *The Impersonal Campus* (Jossey-Bass, 1979), with Virginia B. Smith; *American Indians and World War II: Towards a New Era in Indian Affairs* (University of Oklahoma Press, 1991; paperback, 1999); and *Melting Pots and Rainbow Nations: Conversations about Difference in the United states and South Africa* (University

of Illinois Press, 2002), with Jacklyn Cock. Bernstein has taught at Princeton University; Sangamon State University (now the University of Illinois, Springfield); Staten Island Community College (now the College of Staten Island, City University of New York); and Teachers' College, Columbia University. She is currently a Trustee of Bates College and serves on the Board of the Samuel Rubin Foundation and the News Literacy Project. Bernstein moderated the *Fertile Crescent* inaugural symposium.

LINDA BOCK-HINGER's photographs chronicle her global travels from Australia to Zanzibar. She has photographed the Masai tribes in East Africa, villages in the Middle East and China, ancient ruins in Cambodia, temples in India, labyrinth souks in Morocco, wild animal safaris on the Serengeti, dancers in Bali, pyramids in Egypt, fishermen on the Amazon River, and Native Americans at PowWow. Bock-Hinger's avocation as a photographer became her profession after her retirement in 2000 from a career in education. Her work has been shown in solo exhibitions, juried art and photography shows, public buildings and museums, private homes, corporate offices, and several publications in this country and others. Her international photographs have won many awards and prizes. Bock-Hinger was one of the artists in the exhibition at the New Brunswick Public Library.

JUDITH K. BRODSKY (born 1933, Providence) received her BA from Harvard University in 1954, and her MFA from the Tyler School of Art, Temple University, in 1967. She is Distinguished Professor Emerita, Visual Arts Department, Mason Gross School of the Arts, Rutgers University; founding Director of the Rutgers Center for Innovative Print and Paper, renamed the Brodsky Center for Innovative Editions in her honor; and Co-founder and Co-director with Ferris Olin of the Rutgers University Institute for Women and Art, a member institution of the Rutgers University Institute for Women's Leadership, and The Feminist Art Project, a national program to promote women artists in the cultural milieu. Brodsky was the Chair of *Philagrafika 2010*, an international contemporary visual arts festival focusing on the printed image; National President of the Women's Caucus for Art, 1976–78, the College Art Association, 1992–94, and ArtTable, 2002–04; Chair of the Art Department, 1978–81, former

Dean, 1981–82; and Associate Provost, 1982–86, at Rutgers University's Newark campus. She was a contributor to the first history of the American women's movement in art, *The Power of Feminist Art* (Harry N. Abrams, 1993). Brodsky has organized and curated many exhibitions, among them *100 New Jersey Artists Make Prints*, which traveled throughout the United States and internationally to venues in the Middle East and Africa, 2002–07. Her prints are in over one hundred public collections worldwide, including the Grunwald Center for the Graphic Arts, University of California at Los Angeles; Harvard University Art Museums; Library of Congress; Rhode Island School of Design Museum; Stadtsmuseum, Berlin; and Victoria and Albert Museum, among others. She is on the boards of the New York Foundation for the Arts (NYFA) and the International Print Center New York (IPCNY). She has received many awards and holds honorary degrees from several universities.

LESLIE BURGER earned her undergraduate degree at Southern Connecticut State University, an MLS from the University of Maryland, College Park, and a master's degree in organizational behavior from the University of Hartford. She is Executive Director of the Princeton Public Library. Burger is firmly committed to the critical role libraries play in furthering democracy and fostering civic engagement, and has been instrumental in forming community collaborations with other non-profits in the Princeton area that have brought hundreds of artists, musicians, authors, filmmakers, and others to the library and other community venues for public programs. She was a member of the committee that selected artworks for permanent installation in the new Princeton Public Library. Her honors and awards include the *New York Times* Librarian of the Year Award, Outstanding Alumna Awards from the University of Maryland and Southern Connecticut State University, Princeton Area Chamber of Commerce Community Leader of the Year Award, Princeton Rotary Community Service Award, and YWCA Princeton Tribute to Women Award. Burger served as President of the American Library Association, the oldest and largest library association in the world, in 2006–07, as well as President of the Connecticut and New Jersey Library Associations. She was a member of the *Fertile Crescent* planning team.

ABENA BUSIA (born Accra) spent her childhood in Ghana, the Netherlands, and Mexico, before her family settled in Oxford. She received a BA in English language and literature from St. Anne's College, Oxford, in 1976, and a DPhil in social anthropology (race relations) at St. Antony's College, Oxford, in 1984. Chair of Women's and Gender Studies and Associate Professor of English and Comparative Literature as well as the Associate Director of the Center for African Studies at Rutgers University, where she has taught since 1981, Busia is the past President of the African Literature Association; a founding board member and past Director of the Association for the Study of the Worldwide African Diaspora; a founding board member and past Programs Committee Chair of the African Women's Development Fund; and the current Interim President of AWDF-USA. She co-directed and co-edited, with Tuzyline Jita Allan and Florence Howe of the Feminist Press, *Women Writing Africa,* a multi-volume, continent-wide, twenty-year project of cultural reconstruction that aims to illuminate for a broad public the long-neglected history and culture of African women. Busia was Associate Editor of the West Africa, Sahel, and North African volumes, in which she helped translate the poetry from a range of African languages, including Berber and Arabic, into English. She is the author of two volumes of poetry, *Testimonies of Exile* (Africa World Press, 1990) and *Traces of a Life* (Ayebia Books, 2008). Busia was a member of the planning team for the *Fertile Crescent* project.

ILANA CLOUD (born Ottawa, 1989) graduated from the Mason Gross School of the Arts at Rutgers University with a BFA in 2011, concentrating in painting and printmaking. Her work has been shown in Frenchtown and New Brunswick, New Jersey. Cloud has worked for the Center for Contemporary Art in Bedminster, New Jersey, and the Brodsky Center for Innovative Editions, Rutgers University. In January 2011, she assisted master printmaker Ron Pokrasso in a "Monoprintathon," in which twenty New Jersey artists each created forty monoprints for the new Capital Health Hospital in Hopewell, New Jersey. Last year, one of her prints was selected for the print collection of the Department of Visual Arts at Rutgers; and her work was also selected for the annual *Window Art for Highland Park* event

in Highland Park, New Jersey. Cloud worked as a personal/artist assistant for Judith K. Brodsky and Ferris Olin and as a part-time employee for the Rutgers University Institute for Women and Art, where she kept the *Fertile Crescent* web site updated and helped with other projects.

EMILY CROLL was named Director of the College of New Jersey Art Gallery and the Sarnoff Museum in 2011. Since then, she has curated exhibitions on contemporary Chinese art, data visualization, the drawings of Raymond Pettibon, and modern and contemporary Indian painting. Croll has more than twenty-five years of museum experience, including serving as Senior Administrative Officer of the Barnes Foundation, Director of the Morven Museum & Garden, and Director of the Historical Society of Princeton. In 2008–11, she was Curator and Academic Liaison for Art and Artifacts at Bryn Mawr College, where she curated a collection of more than fifty thousand art, archaeological, and anthropological artifacts and taught a graduate museum studies course. Croll mounted the exhibition *Goddess, Lion, Peasant, Priest: Modern and Contemporary Indian Art from the Shelley and Donald Rubin Private Collection* at The College of New Jersey Galleries as a complementary exhibition for the *Fertile Crescent* project.

MARY CROSS is a distinguished photographer who has exhibited widely and is the author of many books of the photographs that she has taken throughout the Middle East, Africa, and Asia. Cross studied philosophy and literature at the Sorbonne and later studied photography under the late Philippe Halsman. She has had numerous solo exhibitions in this country, including at Harvard University; University of California, Berkeley; University of Pennsylvania; and the Los Angeles County Museum of Natural History, as well as in New Jersey at the Bernstein Gallery, Woodrow Wilson School of Public and International Affairs, Princeton University; the Brodsky Center Gallery at the Heldrich Hotel and Conference Center, New Brunswick; and the Art History Department Gallery, Princeton University. Her books include *Behind the Great Wall: A Photographic Essay on China; Egypt,* with text by

Ted Cross; *Morocco: Sahara to the Sea,* with an introduction by Paul Bowles; and *Vietnam: Spirits of the Earth,* with text by Frances Fitzgerald. Her photographs were shown at the Princeton Public Library during the *Fertile Crescent* project.

MICHAEL CURTIS (born 1923, London) received a First Class degree at the London School of Economics in 1951, and his PhD from Cornell University in 1956. Distinguished Professor Emeritus in political science at Rutgers University, Curtis is an authority on politics in the Middle East. His book *Should Israel Exist? A Sovereign Nation under Attack by the International Community* was published in 2012. Other books on the Middle East include *Israel: Social Structure and Change* (Transaction Publishers, 1973); *Israel in the Third World* (Transaction Publishers, 1976); *Religion and Politics in the Middle East* (Westview Press, 1981); and *Orientalism and Islam* (Cambridge University Press, 2009). His scholarship extends to the fields of political theory, comparative government, and European politics. His analysis of the rise of anti-democratic and anti-Semitic ideology in France after the Dreyfus Affair in *Three Against the Third Republic* (Princeton University Press, 1959; reprint, 2011) is considered the definitive study of early-twentieth-century French politics. *Totalitarianism* (Transaction Publishers, 1979) is a study of twentieth-century European totalitarian regimes. *Antisemitism in the Contemporary World* (Westview Press, 1986) is a collection based on the papers delivered at a conference that Professor Curtis organized that same year. In 1970–78, he served as the President of American Professors for Peace in the Middle East and Editor of the *Middle East Review.* In addition to Rutgers, he has taught at Hebrew University, Tel Aviv University, the University of Bologna, and Yale University. Curtis gave a lecture on politics and gender in the Middle East at the East Brunswick Public Library.

CHERIEN DABIS (born 1976) is a Palestinian American director, producer, and screenwriter. She was named one of *Variety* magazine's *10 Directors to Watch* in 2009. Dabis was born in Omaha, Nebraska, to a Palestinian father and a mother from a Jordanian family whose history is associated with Salt, Jordan.

She grew up in Ohio and Jordan. Dabis received her BA with honors in creative writing and communications from the University of Cincinnati and her MFA in film from the Columbia University School of the Arts in 2004. Her first short film, *Make a Wish,* premiered at the 2007 Sundance Film Festival and received awards at other festivals. She was a writer for the television series *The L Word* from 2006 to 2008. Dabis made her feature film debut with *Amreeka,* which premiered at the 2009 Sundance Film Festival. *Amreeka* has received many awards, among them Best Arabic Film and Best Arabic Screenplay, Cairo International Film Festival, and the Firpesci Prize, Cannes Film Festival, both 2009. Dabis received a Guggenheim Fellowship in 2012. *Amreeka* was shown in the *Fertile Crescent* film series.

ELIN DIAMOND received her BA from Brandeis University and her MA and PhD from the University of California, Davis. She is a Professor of English, Director of the Graduate Program in Comparative Literature, and a faculty member in the Women's and Gender Studies Department at Rutgers University. Her research focuses on drama and dramatic theory as well as feminist and literary theory. Her books include *Pinter's Comic Play* (Bucknell University, 1985); *Performance and Cultural Politics* (Routledge, 1996); and *Unmaking Mimesis: Essays on Feminism and Theater* (Routledge, 1998). Her many journal publications include essays on seventeenth- and twentieth-century drama, and Freudian, Brechtian, and feminist theory. Her work continually explores the connection between performance and feminist or critical theory, using texts from early modernism through postmodern art. Through Diamond's efforts, the Graduate Program in Comparative Literature was a sponsor of the performance by Betty Shamieh.

JILL DOLAN (born Pittsburgh) received her bachelor's degree in communications from Boston University and her PhD in performance studies from New York University. She is the Annan Professor in English and Theater at Princeton University, where she also directs the Program in Gender and Sexuality Studies. She is the author of many books and essays, among them, *The Feminist Spectator as Critic* (University of Michigan Press, 1989, reissued in a 2012 anniversary edition with a new introduction);

Utopia in Performance (University of Michigan Press, 2005), and *Theatre and Sexuality* (Palgrave Macmillan, 2010). She is the editor of *A Menopausal Gentleman: The Solo Performances of Peggy Shaw* (University of Michigan Press, 2011). She won the 2011 Outstanding Teacher Award from the Association for Theatre in Higher Education, and a lifetime achievement award from the Women and Theatre Program, 2011. Dolan is a member of the College of Fellows of the American Theatre and of the National Theatre Conference in the United States. She writes *The Feminist Spectator* blog at www.thefeministspectator.com, for which she won the 2010–11 George Jean Nathan Award for Dramatic Criticism. Her research addresses feminist, lesbian, and Jewish women's performance, theater, and film. Dolan was in conversation with Fawzia Afzal-Khan after Khan's performance of *Scheherazade Goes West*, and was also a member of the *Fertile Crescent* planning team.

ILENE DUBE (born 1954) received her bachelor's degree in psychology and media studies at SUNY Buffalo, 1975, and her master's degree in human resources counseling at the University of Bridgeport, Connecticut, in 1988. Known as "The Artful Blogger," she writes about art for Princeton area publications. *The Artful Blogger* is a weekly feature of WHYY's newsworks.org. In nearly two decades at *The Princeton Packet* (1993–2010), first as *Lifestyle*, then as *TIMEOFF* editor, Dube consistently won first place awards for best section and writing from the New Jersey Press Association and Suburban Newspapers of America. She continues to freelance for *U.S. 1 Newspaper* and other publications, works in public relations at the Michener Art Museum, and as communications consultant for D&R Greenway. Dube has curated exhibitions at the Arts Council of Princeton, Gallery Verde, Historical Society of Princeton, Roosevelt Arts Project, and West Windsor Arts Council, where she was founding Chair of the Exhibitions Committee and past President of the Board of Directors. As an artist, she has exhibited at the Monmouth Museum; the *Ellarslie Open* at Ellarslie, The Trenton City Museum; in the *Mercer County Artists Juried Exhibitions*, Grounds For Sculpture, Plainsboro Library, and Arts Council of Princeton. Dube initiated the exhibition *Memory of Here, Memory of There*, held at the West Windsor Arts Council Galleries.

EL NAFEZA FOUNDATION FOR CONTEMPORARY ART AND DEVELOPMENT, founded by Mohamed Abou El Naga, is an Egyptian foundation working in the areas of art and development. It was legally registered in 2007, although it has informally been in operation since 2002. El Nafeza seeks to revive and promote the papermaking industry, contributing to the protection of the environment through the disposal of agricultural refuse such as rice straw, Nile water lilies, and paper refuse in an environmentally friendly way. It tries to provide an untraditional source of income for many residents of the countryside and poor areas, especially girls and people with special needs, by teaching them the art of papermaking. Its papermaking center is located in the El Fustat district, in Masr El Qadima (Old Cairo, the ancient Coptic area). El Nafeza organizes local and international exhibitions and workshops in the field of artist's books. Through El Nafeza's web site, www.elnafeza.com, the organization also provides a database and news for artists and others interested in learning about this field. An exhibition of El Nafeza's papermaking project was shown at the East Brunswick Public Library.

YASMINE EL RASHIDI (born Cairo) still lives in Cairo. She is a frequent contributor to the *New York Review of Books* and a contributing editor to the Middle East arts and culture journal *Bidoun*. Her writing has appeared in publications including *Aperture*, *The Guardian*, *Index on Censorship*, *London Review of Books*, *The Wall Street Journal*, and the Arabic literary journal *Weghat Nazar*. A collection of her writings on the Egyptian revolution, *The Battle for Egypt*, was published by New York Review of Books/Random House in 2011. She was named a Mary MacKall Gwinn Hodder Fellow for the 2012–13 academic year at the Lewis Center for the Arts, Princeton University. During her fellowship, El Rashidi worked on a literary nonfiction book, *The Successors*, a portrait and memoir of Egypt's youth generation. El Rashidi spoke about present-day Egypt in conversation with Margot Badran at the Lewis Center for the Arts, Princeton University.

DAHLIA ELSAYED (born 1969, New York) graduated from Barnard College in 1992, received her MFA from Columbia University in 1994, and lives and works in New Jersey. She is an artist whose practice focuses on the relationship between image and text, specifically how language shapes landscape. Her paintings, installations, and prints synthesize an internal and external experience of place, connecting the psychological with the topographical. She pulls ideas from conceptual art, comics, cartography, and landscape painting, and employs symbols of hard data—text, geologic forms, geographic borders, sign/markers, coastlines, and tidal schedules—to frame the ephemeral. Her work has been exhibited at galleries and art institutions throughout the United States and internationally, including the Cairo Biennale, 2010, and solo exhibitions at the Jersey City Museum, 2003, and Aljira Center for Contemporary Art, 2010. Her work is in the public collections of the Johnson & Johnson Corporation, New Jersey State Museum, The Newark Museum, and Jane Voorhees Zimmerli Art Museum. She has received awards from the Edward Albee Foundation, 1999; Visual Studies Workshop, 2003; New Jersey State Council on the Arts, 2004; Women's Studio Workshop, 2004; Headlands Center for the Arts, 2005; and the Joan Mitchell Foundation, 2007. Elsayed's work was displayed in the exhibition *Memory of Here, Memory of There*, at the West Windsor Arts Council Galleries.

SUSAN E. FALCIANI (born 1978, Camden) received her BA in history from the College of William and Mary in 2000, and her master's in library and information science from Rutgers University in 2011. Prior to beginning a career in librarianship, she spent ten years in the antiquarian book and auction gallery world. Her appreciation for history, art, and rare objects has led to a strong interest in the exhibition aspects of libraries, not just their capacity to showcase their own treasures, but also as venues for cultural and educational interaction in their communities. Falciani curated the exhibition *Borderlands*, at the New Brunswick Public Library.

FARIDOUN FARROKH (born Mashhad) was educated in Iran, where he embarked on a teaching career, initially in schools and later at the universities in Shiraz and Mashhad, after completing graduate studies in the United States. Currently, he is Professor of English at Texas A&M International University, where he has taught since 1986. His academic specialty and research interests are eighteenth-century English literature, contemporary Iranian fiction, and literary translation. He was Shirin Neshat's collaborator on the film *Women Without Men,* which was screened as part of the *Fertile Crescent* film series.

JANE FRIEDMAN (born Woodbury, 1967) is a Chicago-based freelance art history editor, indexer, and independent scholar. She holds undergraduate and graduate degrees in art history, receiving her BA from the University of Pennsylvania and MA from Hunter College. She is also ABD from Northwestern University, where she focused on modern European art with a concentration in Russian art. For roughly the last ten years, she has edited a wide range of art-related materials—books, journals, exhibition catalogues, articles, and museum didactics—for public institutions and individuals including the Carnegie Museum of Art, Guggenheim Museum, and Jane Voorhees Zimmerli Art Museum. Recent projects include Alla Rosenfeld, ed., *Moscow Conceptualism in Context* (Jane Voorhees Zimmerli Art Museum and Prestel, 2011) and Amy Bryzgel, *Performing the East: Performance Art in Russia, Latvia, and Poland since 1980* (I.B. Tauris, 2012), for both of which she served as editor and indexer. In addition to her work as an editor, Friedman has published articles on Russian art in publications that include *Studies in the Decorative Arts*, the *Zimmerli Journal*, and *Russian Life* magazine, and worked on various Russian art exhibitions organized by such institutions as the Chicago Cultural Center, Guggenheim Museum, and The Museum of Russian Art, Minneapolis. She served as copy editor and indexer of the *Fertile Crescent* catalogue.

DANIELLE GOUGON is the Dean of First- and Second-Year Programs at Douglass Residential College, one of the largest public institutions for women, located within Rutgers University. She has a PhD in political science from Rutgers University and

specializes in women in politics, social movements, and reproductive politics. Gougon also oversees Global Village, a series of living-learning communities dedicated to advancing students' global awareness and intercultural appreciation. In 2006, she launched the Middle East Coexistence House, which was developed as a hands-on experiment in coexistence for Jewish and Muslim students. Gougon participated in the planning of *Fertile Crescent* and helped with student involvement.

FAKHRI HAGHANI holds an advanced degree in art history from Facolta di Magistero, University of Rome (Sapienza), an MA in women's studies, and a PhD in history from Georgia State University. Haghani has been a faculty member at the Center for Middle Eastern Studies at Rutgers University since 2009. She is an interdisciplinary scholar interested in exploring the intersections of gender and women's rights movements, political art, and social and intellectual history in Iran, Egypt, and in a regional and global comparative and transnational context. Her field research in Egypt and Iran has been funded by the American Research Center in Egypt and the Council of American Overseas Research Centers. Recent publications include "Women, Gender, and Identity Politics in Iran and Afghanistan," in Suad Joseph and Afsaneh Najmabadi, eds., *Encyclopedia of Women and Islamic Cultures (EWIC)*, Volume II (Brill, 2005); "The 'New Woman' of the Interwar Period: Gender, Identity, and Performance in Egypt and Iran," *Al-Raida, The Journal of the Institute for Women's Studies in the Arab World at the Lebanese American University* (special issue on women in the performing arts) (Summer/Fall 2008); and "Shahr Ray (City of Ray) and the Holy Shrine of Shah/Hazrat (King/Holiness) Abdol Azim: History of the Sacred and the Secular in Iran through the Dialectics of Space," in Soheila Shahshahani, ed., *Cities of Pilgrimage* (Lit-Verlag Publishers, 2009). Haghani spoke at the *Fertile Crescent* inaugural symposium on the Middle East diaspora, mounted courses related to the subject, was a member of the planning committee, and organized an Iranian film festival.

LAILA HALABY, who now lives in Tucson, Arizona, was born in Beirut to a Jordanian father and an American mother. She speaks four languages, won a Fulbright Scholarship to study folklore in Jordan, and holds a master's degree in Arabic literature. Her first novel, *West of the Jordan* (Beacon Press, 2003), won the prestigious PEN Beyond Margins Award. She is also the author of *Once in a Promised Land* (Beacon Press, 2007), read and discussed in the community read sponsored by the Princeton Public Library in conjunction with the *Fertile Crescent* project.

RUBAB HASSAN (born 1991, Karachi) will graduate from Rutgers University in 2013 as a member of the School of Arts and Sciences Honors Program. She is a double major in Middle Eastern studies and English, with an emphasis on postcolonial literature of the Middle East and its diaspora. She worked as a docent at the Jane Voorhees Zimmerli Art Museum and served as research assistant for the Aresty Research Center, where she worked on a project pertaining to United States foreign policy, political Islam, and media representations, with a particular focus on Iran and Saudi Arabia. Hassan has received several awards, including the Rodkin Scholarship, the Rutgers 2011 Academic Excellence Award, and the Simon and Schuster Diversity Scholarship. Hassan is president of Oxfam Rutgers, a local chapter of the non-profit humanitarian organization Oxfam International. She was an assistant to the curators of the *Fertile Crescent* project and helped develop the bibliography.

JANIE HERMANN received her undergraduate degree from Queen's University in 1989 and her MLIS degree from the University of Western Ontario in 1996. She is a librarian with a focus on public service and events that contribute to lifelong learning. Since 2007, she has been the Public Programming Librarian at the Princeton Public Library. Hermann oversees the library's fifteen-member cross-departmental programming team, which implements more than 1,500 programs per year for people of all ages, from birth to retirement years. From 1998 to 2007, she was the Technology Training Librarian at the library; during that time, she planned and coordinated technology for the community of Princeton. Before coming to Princeton,

she was the Reference/Interlibrary Loan Librarian at Hobart and William Smith Colleges and the Children's Literature Web Strategist at the National Library of Canada. Since 2003, she has also had her own consulting firm, JH Library Consulting. She leads focus groups, assists with strategic planning, and conducts staff training on a variety of topics. Hermann was a member of the *Fertile Crescent* planning team and organized the community read and other literary programs.

REEM HUSSEIN (born Bayonne), who currently lives and works in New York, received her BFA from the Fashion Institute of Technology in 2000 and her MFA from Long Island University in 2011. Hussein is a visual artist who has exhibited her work throughout the United States as well as abroad, in venues that include the Muslim-Jewish Art Collaborative Project, Bronfman Center Gallery, 2007, and *A Book about Death*, SLA Gallery, Brookville, 2010. She has lectured at many colleges and universities including Columbia, Hofstra, Rutgers, the University of Pennsylvania, and Yale. Hussein introduces the art of Middle East and Islamic cultures through workshops for students and teachers sponsored by Long Island Traditions and the Huntington Arts Council. Her paintings have been selected by the Art in Embassies Program and were exhibited in American embassies in Egypt and Malaysia, 2006–10. Her work was included in the exhibition *Borderlands*, at the New Brunswick Public Library.

DEBORAH HUTTON received her BA from Penn State University and her MA and PhD from the University of Minnesota. She has been Associate Professor of Asian and Islamic Art History at The College of New Jersey since 2004. Her area of focus is Indo-Islamic art; she also teaches a range of courses covering the arts of Central, South, and East Asia, from the Bronze Age to the present. These courses include *Arts of South Asia, Arts of East Asia, Arts of the Islamic World*, and upper-level seminars on subjects such as the history of photography in India. In her scholarship, she examines the relationships between art, identity formation, and intercultural exchange at the princely courts that ruled over the Deccan region of India between the sixteenth and early twentieth centuries. Her

current research examines the images that the celebrated late-nineteenth-century Indian photographer Raja Deen Dayal took for the Nizam of Hyderabad. Hutton's first book, *Art of the Court of Bijapur* (Indiana University Press, 2006), which traces the development of painting and architecture at Adil Shahi Bijapur during the sixteenth and seventeenth centuries, won the American Institute of Indian Studies Edward Cameron Dimock Jr. Prize in the Indian Humanities. Hutton also co-edited *Asian Art: An Anthology* (Wiley-Blackwell, 2006), the first anthology of important primary documents and contemporary scholarship on Asian art. She is currently co-editing a follow-up companion volume to that work. Hutton was co-curator of *Goddess, Lion, Peasant, Priest: Modern and Contemporary Indian Art from the Shelley and Donald Rubin Private Collection*, The College of New Jersey Galleries.

NICOLE IANUZELLI (born 1981, Somerville) earned her AA in visual arts at Middlesex County College in 2003 and her BFA in studio art with a concentration in painting in 2006 from the Mason Gross School of the Arts, Rutgers University. She received the Excellence in Art Award at Middlesex County College in 2003 and the Ben and Evelyn Wilson Foundation Award for Outstanding Achievement in Painting at Rutgers University in 2006. Since 2007, she has been a member of the staff at the Rutgers University Institute for Women and Art and manager of the Mary H. Dana Women Artists Series, mounting exhibitions, designing publicity materials, and working on projects including *Fertile Crescent*. She was a member of the planning team.

AMANEY JAMAL (born 1970, Oakland) earned her bachelor's degree in politics at the University of California, Los Angeles, in 1993 and her PhD in political science from the University of Michigan. She is Associate Professor of Politics at Princeton University, and directs the Workshop on Arab Political Development. Jamal's research focuses on democratization and the politics of civic engagement in the Arab world, including Muslim and Arab Americans. Jamal's first book, *Barriers to Democracy* (Princeton University Press, 2007), exploring the role of civic associations in promoting democratic effects in the Arab World, won the Best Book Award in Comparative

Democratization at the American Political Science Association in 2008. Other publications include *Race and Arab Americans before and after 9/11* (Syracuse University Press, 2007), a volume edited with Nadine Naber, which looks at the patterns and influences of Arab American racialization processes; *Citizenship and Crisis: Arab Detroit after 9/11* (Russell Sage Foundation, 2009); and *Of Empires and Citizens: Authoritarian Durability in the Arab World* (Princeton University Press, 2012). Jamal is a principal investigator of the "Arab Barometer Project"; winner of the Best Dataset in the field of Comparative Politics: Lijphart/ Przeworski/Verba Dataset Award, 2010; and Senior Advisor on the Pew Research Center Projects focusing on Islam in America, 2006, and Global Islam, 2010. In 2005, Jamal was named a Carnegie Scholar. Jamal served on the planning committee for *The Fertile Crescent*.

MICHAEL JOSEPH (born 1952, Brooklyn) received a BA in 1973, an MA in 1975 in English literature from the University of Hartford, and an MLS from Columbia University in 1985. Joseph has been a rare book librarian at the Rutgers University Libraries since 1991. Since 1995, he has been the Director of the New Jersey Book Arts Symposium, one of the earliest North American conferences committed to the study and significance of artist's books. Among the many exhibitions he has curated are *Suellen Glashausser and Her Circles,* Special Collections and University Archives, Rutgers University Libraries, 2007; *Material Translations,* Arts Council of Princeton, 2010; and *A Portable, Constant Obsession: The Book Art of Karen Guancione,* Special Collections and University Archives, Rutgers University Libraries, 2012. He has also collaborated with many artists on the creation of books of poetry and fiction, including *For Constance* (a collaboration with the artist/printer Alberto Casiraghy) (2004); *Contes de Fees* (a collaboration with the artist Valerie Hammond) (2008); *The Real Story of Puss in Boots* (a collaboration with artists Henry Charles and Sarah Stengle) (2009); *Lost Light* (a collaboration with the artist/printer Barbara Henry and composer Herb Rothgarber) (2011); and *Useless Tools: For Every Anxious Occasion* (collaboration with the artist Sarah Stengle) (2011). Michael Joseph organized the book arts conference and exhibition for *The Fertile Crescent*.

NATALIA KADISH (born 1984) received her BA in illustration at the School of Visual Arts, New York, 2007. She considers herself a Surrealist artist inspired by the Torah. While incorporating the realism of her father, Laszlo Kubinyi, in her work, Kadish also explores mystical concepts stimulated by her visit to the artist colony in Tzfat, Israel. Exhibitions in which she has participated include musical events such as the Gathering of the Tribes concert, New York, 2008, and the Battle of the Bands, New York, 2008. Her shows include the solo exhibition *Natalie Kadish: Spiritual Surrealism,* Aish, New York, 2010; and *Water Vessels: Artists for Israel,* New York. 2011. Her work was included in the exhibition *Borderlands,* at the New Brunswick Public Library.

STANLEY KATZ (born 1934, Chicago) graduated from Harvard University in 1955, received his PhD in British and American history from Harvard in 1961, and attended Harvard Law School in 1969–70. Katz is the Director of the Center for Arts and Cultural Policy Studies at the Woodrow Wilson School of Public and International Affairs, Princeton University. He was President of the American Council of Learned Societies in 1986–97. Formerly Class of 1921 Bicentennial Professor of the History of American Law and Liberty at Princeton University, Katz is a specialist in American legal and constitutional history, and on philanthropy and non-profit institutions. His recent research focuses on the relationship of civil society and constitutionalism to democracy, and on the relationship of the United States to the international human rights movement. He is a prolific author and scholar. Among recent major projects, he was the editor-in-chief of the *Oxford International Encyclopedia of Legal History* (Oxford University Press, 2009); and the editor of the *Oliver Wendell Holmes Devise History of the United States Supreme Court* (Cambridge University Press, 2010). He has served as President of the Organization of American Historians and the American Society for Legal History, as Vice President of the Research Division of the American Historical Association, a member of the Board of Trustees of the Newberry Library, and Chair of the American Council of Learned Societies/Social Science Research Council Working Group on Cuba. Katz is a member of the American Academy of Arts and Sciences. He received the annual Fellows Award from Phi Beta Kappa in 2010 and the National

Humanities Medal (awarded by President Obama) in 2011. He holds honorary degrees from several universities. Katz was a member of the *Fertile Crescent* planning team and moderated the panel at the Woodrow Wilson School of Public and International Affairs, Princeton University.

DEEPA KUMAR (born 1968, India) received a BS from St. Joseph's College in 1991, a BS from Bangalore University, an MA from Bowling Green State University in 1994, and PhD from the University of Pittsburgh in 2001. Kumar is Associate Professor, Journalism and Media Studies, and Center for Middle East Studies at Rutgers University. Kumar's research concerns are neoliberalism and imperialism. Her books include *Outside the Box: Corporate Media, Globalization, and the UPS Strike* (University of Illinois, 2007) and *Islamophobia and the Politics of Empire* (Haymarket Books, 2012). She has written numerous articles in both scholarly journals and alternative media. Recent publications include "Heroes, Victims, and Veils: Women's Liberation and the Rhetoric of Empire Post 9/11," *Forum on Public Policy* (journal of the Oxford Roundtable) (2008); "Jihad Jane: Constructing the New Muslim Enemy," *Fifth Estate Online: International Journal of Radical Mass Media Criticism* (April 2010); "Framing Islam: The Resurgence of Orientalism during the Bush II Era," *Journal of Communication Inquiry* (2010); and "Terrorizing Muslims: The Bipartisan Logic of Empire," *The Nation* (2012). Her honors include the Leader in Diversity Award, Rutgers University, 2007; Young Scholar Leader Award, National Communication Association, CCS division, 2007; Top Paper Award, Race and Ethnicity Division, International Communication Association (ICA), 2008; and Research Council Grant, Rutgers University, 2010. She led the discussion after the screening of the Lebanese film *Caramel*.

NADINE LABAKI is a Lebanese director and actress. She received a degree in audiovisual studies at Saint Joseph University in Beirut (IESAV). Her first feature, *Caramel,* revolves around the taboos that women face in Arab society. In her second feature, *Where Do We Go Now?,* she tackles a subject related to the conflicts in the Arab world. Her features have received awards in many film festivals around the world, among

them the Abu Dhabi, Cairo, Cannes, Doha, Namur, San Sebastian, and Toronto Film Festivals. In 2008, Labaki received the Chevalier de l'Ordre des Arts et des Lettres from the French Ministry of Culture and Communication. Labaki's film *Caramel* was shown during the *Fertile Crescent* film series.

LUCETTE LAGNADO (born 1956, Cairo) received her BA from Vassar College in 1977. Lagnado resides in New York. She and her family left Egypt as refugees when she was a small child, an experience that helped shape and inform her recently published memoirs, *The Man in the White Sharkskin Suit* (Ecco/ HarperCollins, 2007), for which she was awarded the 2008 Sami Rohr Prize for Jewish Literature, and *The Arrogant Years* (Ecco/ HarperCollins, 2011). She is also the co-author of *Children of the Flames: Dr. Josef Mengele and the Untold Story of the Twins of Auschwitz* (William Morrow and Company, 1991), which has been translated into nearly a dozen languages. She is a senior special writer and investigative reporter for *The Wall Street Journal* and has received numerous prizes for her work at the *Journal*, among them the New York Press Club Award in the Feature Category and the Exceptional Merit Media Award for Exceptional Feature Story; New York Press Club's Heart of New York Award; Columbia University Graduate School of Journalism's Mike Berger Award for outstanding reporting on the lives of ordinary citizens, 2002; and the *Columbia Journalism Review's* Laurel Award in 2003. Lagnado spoke about her work at the Princeton Public Library.

JACKIE LITT is the Dean of Douglass Residential College, Rutgers University. She received her PhD in sociology from the University of Pennsylvania. She has taught at Allegheny College and Iowa State University, and before coming to Rutgers was Chair of the Department of Women's and Gender Studies at the University of Missouri. For her first book, *Medicalized Motherhood: Perspectives from the Lives of African-American and Jewish Women* (Rutgers University Press, 2000), she won an award for outstanding scholarship on race, class, and gender from the American Sociological Association. Her second book, *Global Dimensions of Gender and Carework* (Stanford University Press, 2000), co-authored with Mary Zimmerman and Christine

Bose, is used widely in classes in sociology and women's studies. Litt was a recipient of a Social Science Research Council (SSRC) grant for her work on African American Women's networks in the aftermath of Hurricane Katrina. At Missouri, Litt was principal investigator for *Mizzou ADVANCE*, a $499,000 University of Missouri grant to increase the representation and advancement of women in science, technology, engineering, and math. Litt also received the Distinguished Faculty Award for exemplary contribution toward gender equity in education from the American Association of University Women (Iowa chapter), and the Early Excellence in Teaching and Master Teacher in Multicultural Education awards, both from Iowa State University. Litt was a member of the *Fertile Crescent* planning team.

NANCY MAGUIRE received her bachelor's degree from Florida State University. She is Associate Director of Exhibitions at the Stedman Gallery, Rutgers–Camden Center for the Arts, where she has curated many exhibitions and organized many community outreach projects. With Cyril Reade, she organized the *Fertile Crescent* exhibition at the Stedman Gallery.

IBTISAM SALH MARA'ANA (born 1975, Faradis) founded Ibtisam Films, a documentary film factory, ten years ago. It produces films that explore the borders and boundaries of Palestinian and Israeli society with a focus on women and minorities, exploring gender, class, racism, collective and individual identity, history, the present, and people's dreams for the future. Ibtisam Films confronts taboos and examines and deconstructs structures of oppression. The film factory is committed to its workers, to their unique voices and their progress, and to an increasingly equal, free, and creative society. Mara'ana grew up in Faradis, a Muslim Arab, working-class village in the north of Israel. Without ever having seen a film in a cinema, at the age of eighteen she was accepted to film school, where she began to create films with the themes Ibtisam Films is still exploring today. Her first commercial release, *Paradise Lost*, is considered the first film to be made from the perspective of a Palestinian woman. Mara'ana was the director of *Lady Kul el-Arab*, screened at the New Brunswick and Princeton Public Libraries.

ALAMIN MAZRUI (born 1948, Lamu) holds a BS and MA from Rutgers University and received a PhD in linguistics from Stanford University in 1980. He is a Swahili poet and playwright and Professor of Sociolinguistics and Literature and Chair of the Department of African, Middle Eastern, and South Asian Languages and Literatures at Rutgers University. In the 1980s, Mazrui was imprisoned, as were a number of intellectuals regarded as critical of the government of Kenya's second president, Daniel Arap Moi. After his 1984 release, Mazrui went into exile in the United States. His books include *Debating the African Condition: Volume 1; Race, Gender, and Culture Conflict* (Africa World Press, 1983) and *Debating the African Condition: Volume 2; Governance and Leadership* (Africa World Press, 2003) (both with Willy Mutunga); *The Power of Babel: Language and Governance in the African Experience* (with Ali Mazrui) (University of Chicago Press, 1998); and *Swahili beyond the Boundaries: Literature, Language, and Identity* (Ohio University Press, 2007). His play *Kilio cha Haki* (Cry for Justice), has been staged in East Africa, including at the Kenya National Theater. His 1988 collection of poems, *Chembe cha Moyo* (Arrow in My Heart), composed while he was a political prisoner at Kamiti Maximum Security Prison, and his recent award-winning play, *Sudana* (co-authored with Kimani Njogu), which explores the theme of pan-Africanism in a neocolonial context, have received wide critical acclaim. Mazrui was on the planning committee and led the participation of the members of his department in *Fertile Crescent*.

ANNE MCKEOWN (born 1950, New York) holds a BS from Skidmore College, 1992, and an MFA in painting and printmaking, Yale University School of Art, 1995. Master papermaker, Brodsky Center for Innovative Editions, Mason Gross School of the Arts, Rutgers University, McKeown has worked in collaboration with nationally and internationally recognized artists as well as local New Jersey artists to create multiples of work in handmade paper. McKeown has had three solo exhibitions of her paintings, prints, and paper art at SOHO 20 Chelsea Gallery, New York, 2008, 2009, 2011; with other solo exhibitions at Gallerie 141, Nagoya, 2003; 55 Mercer Gallery, 2003; Johnson & Johnson Headquarters, New

Brunswick, 2007; and the University of Dallas, Irving, Texas, 2010. She has exhibited in group shows nationally from New York to Hawaii, and internationally in Japan, Belgium, Sweden, Canada, and Cuba. McKeown has researched papermaking in Egypt, Turkey, and Syria and was a Fulbright Alternate for a Research Grant in Turkey, 2012. She is on the Board of Directors of *Hand Papermaking Magazine*. She has given many lectures including at the University of Johannesburg, South Africa, 2007, and had residencies at the Burren College of Art, Ballyvaughan, Ireland, 2003; the Awagami Paper Factory, Shikoku, Japan, 2007; and the BAU Institute, Otranto, Italy, 2010. McKeown curated the exhibition *Memory of Here, Memory of There,* at the West Windor Arts Council Galleries, and the El Nafeza papermaking exhibition at the East Brunswick Public Library.

JEFF NATHANSON (born 1955, Los Angeles) received a BA from the University of California, Santa Cruz, in 1977 and a graduate certificate in non-profit administration and fundraising at the Indiana University School of Philanthropy in 1990. Nathanson is an arts management professional who has balanced his career among visual arts, curatorial practice, non-profit arts management, and music. He became Executive Director of the Arts Council of Princeton in 2005. Nathanson was previously Executive Director of the Richmond Art Center in Richmond, California, 1991–2000; and President/Executive Director of the International Sculpture Center (publisher of *Sculpture Magazine*), 2000–03. Nathanson has organized exhibitions, served as a consultant and an exhibition juror, given lectures, and contributed catalogue essays for a number of institutions and public entities including the town of Princeton, Princeton Public Library, Princeton University Art Museum, Rhode Island School of Design, the Oakland Museum, and the San Francisco Art Institute, among others. The Arts Council of Princeton, under Nathanson's leadership, has been recognized by the New Jersey State Council on the Arts with its Citation of Excellence, and was designated a Major Arts Organization for the state. Nathanson has received the New Jersey Governor's Award for Leadership in Arts Education, the New Jersey Art Educators' John Pappas Award, and the Contra Costa County Award for Outstanding Achievement in the Arts. Nathanson was a member of the *Fertile Crescent* planning committee.

ISABEL NAZARIO has been Associate Vice President for Academic and Public Partnerships in the Arts and Humanities at Rutgers University since 2004. She came to Rutgers in 1992 as founder of the Rutgers Center for Latino Arts and Culture. After serving as Director of the Center for ten years, she was appointed Executive Director of the Office for Intercultural Initiatives. Before coming to Rutgers in 1992, she held positions at the New York State Council on the Arts, Queens College, and Hunter College. At Queens College, she developed the first courses on Latin American and Caribbean art history for the Art History and Puerto Rican Studies Departments, courses she subsequently taught at Hunter College. At Rutgers, she has taught a course on Latin American art history through the Latin American Studies Program, and co-created and co-taught a course in the Visual Arts Department of the Mason Gross School of the Arts entitled "The Response of the Creative Mind to Gender, Race, Class, and Identity," funded through a Rutgers Dialogues grant. Over the course of her career at Rutgers, Nazario has raised support for exhibitions, public programs, and student scholarships from such sources as the Geraldine R. Dodge Foundation, Johnson & Johnson, JP Morgan Chase, New Jersey State Council on the Arts, Merrill Lynch, the Rockefeller Foundation, the Mid Atlantic Arts Foundation, Hitachi, America Limited, and Rutgers University Hispanic/Latino Alumni. In 1997, she was one of seven Hispanic women in the nation to be awarded *Hispanic Magazine*'s Women's Health and Science Award for developing an innovative arts and health education program for black and Latino youth. In 2002, she was recognized as a national leader for advancing the Hispanic arts by *El Diario La Prensa,* a daily newspaper for Hispanics in the United States. The Rutgers University Institute for Women and Art is one of the units under the umbrella of her office.

ALBERT GABRIEL NIGRIN (born 1958, Charlottesville) holds a BA from the State University of New York at Binghamton, 1976; an MA in French literature, Rutgers University, 1983; and an MFA in visual arts/film, Rutgers University, 1986. He is the Executive Director of the Rutgers Film Co-op/New Jersey Media Arts Center, Inc., which presents the biannual New Jersey Film Festival and the New Jersey International Film Festival. He is also a Cinema Studies Lecturer at Rutgers University. In addition,

Nigrin is an award-winning experimental media artist. His films/videos were screened as part of *Big as Life: An American History of 8mm Filmmaking Retrospective,* Museum of Modern Art, New York, 2001; *Enter The Screen: Experimental Film Program,* Changzhou, China, 2004; *Floating Images: Experimental Film Program,* Shanghai, China, 2005; and *Toronto Images Film Festival,* 2006. Nigrin was a 1986 and 2002 New Jersey State Council on the Arts Media Arts Fellowship winner, and has also received fellowships from the National Endowment for the Arts/American Film Institute Mid-Atlantic Media Arts Fellowship Program, 1988 and 1989, and the Ford Foundation, 1990. Nigrin worked with Brodsky and Olin to organize the *Fertile Crescent* film series.

FERRIS OLIN (born 1948, Trenton) holds a BA from Douglass College, 1970, an MLS, 1972, an MA, 1975, and PhD in art history, 1998, as well as a graduate certificate in Women's and Gender Studies, 1988, all from Rutgers University. She is Professor Emerita at Rutgers University and the Co-founder and Co-director (with Judith K. Brodsky) of the Rutgers University Institute for Women and Art and The Feminist Art Project, an international effort to make visible the impact of women on culture. She also established the Miriam Schapiro Archives on Women Artists as well as the Margery Somers Foster Center, a resource center focused on documenting women's leadership in the public arena, and served as Associate Director of the Institute for Research on Women and, earlier, as Director of the Art Library. She is curator with Judith K. Brodsky of the Mary H. Dana Women Artists Series at Rutgers, founded in 1971 by Joan Snyder. Recent publications include *Eccentric Bodies: The Body as Site for the Imprint of Age, Race, and Identity* (Rutgers University, 2007); and "Stepping out of the Beaten Path: Feminism and the Visual Arts," *Signs: A Journal of Women in Culture and Society* (2008), both co-authored by Brodsky. With Brodsky, Olin created the Women Artists Archive National Directory (WAAND), a digital directory to archives of the papers of women artists active in the United States since 1945, funded by the Getty Foundation. Among the exhibitions she and Brodsky have curated in recent years are *How American Women Artists Invented Postmodernism, 1970–1975,* 2005, and a fifty-year retrospective of Faith Ringgold's work, 2009. Olin was Vice President of the College Art Association, 2004–05.

Recent awards include the College Art Association Committee on Women's Annual Recognition Award (now known as the Distinguished Feminist Award), 2008; the Women's Caucus for Art Lifetime Achievement Award, 2012; and the YWCA Princeton Tribute to Women Award, also 2012. Olin's research focuses on gender and cultural history, art collecting, art documentation, and regional women's history. With Brodsky, Olin is the originator and director of the *Fertile Crescent* project.

FARAH OSSOULI (born 1953, Zanjan), who lives in Brooklyn and Iran, completed her bachelor's degree in graphic design at Tehran University. She has taught in Tehran at the Design Studio, 1972–77, and the Moaser Studio, 1981–87. She now works only on her own art. Her works are multifaceted in their formal, historical, and symbolic complexity, drawing on numerous sources for inspiration, including iconic Western or Persian art, decorative arts (including book illuminations, carpets, and fabrics), and handwritten quotations from contemporary Persian poetry. Her work is in the collections of the Imam Ali Religious Arts Museum, Tehran; Tehran Museum of Contemporary Art; Tropen Museum, Amsterdam; Ludwig Museum, Koblenz; and the Koran Museum, Tehran. Ossouli's art was the focus of a solo exhibition at the Paul Robeson Galleries.

ISABELLA DUICU PALOWITCH (born Brasov) is Hungarian/Romanian in origin. She earned her BFA from the Institutul Nicolae Grigorescu, Bucharest, 1978, and received her MFA from the Mason Gross School of the Arts, Rutgers University, 1984. Palowitch has exhibited her paintings and drawings in New York, Philadelphia, Paris, Madrid, Vienna, and Bucharest; her work has also appeared in several art publications, and is in private and public collections including the Museum of the American Hungarian Foundation, New Brunswick. She is the founder and owner of ARTISA LLC, a graphic design firm located in Princeton, New Jersey, and Bryn Mawr, Pennsylvania. She has designed art books and catalogues that sell in major museum bookstores including the National Gallery of Art, Washington, D.C.; Museum of Modern Art, New York; and in Europe. Palowitch has received awards for design and printing excellence from Graphic Design:

USA, Neographics, Benjamin Franklin Premier Print, Astra, and *Art Direction Magazine;* she has also received CASE Gold Awards. Selected clients include Princeton University (numerous departments, including Art and Archaeology; the Cotsen Children's Library; Office of Information Technology, where she worked on the design of the university's first web site in 1996–98; Princeton University Press; and the 250th Anniversary Celebration Committee; the Princeton Symphony Orchestra (since 1997); the Historical Society of Princeton; and Rutgers University (numerous departments including the Institute for Women and Art, Rare Books Collection, Rutgers University Press, and Jane Voorhees Zimmerli Art Museum). Palowitch designed and managed the production of the *Fertile Crescent* catalogue, whose publication month of September 2012 auspiciously marked thirty years to the month that she met Judith K. Brodsky, her cherished advisor in the MFA program, and was warmly welcomed in Romanian by Ferris Olin, then the Director of the Rutgers Art Library.

SHAHRNUSH PARSIPUR (born 1946, Tehran) received a bachelor's degree from the University of Tehran in sociology in 1973. She has written eighty-nine novels, a memoir, hundreds of articles, and has been a radio producer. She started her literary career when she was sixteen. In 1974, she wrote *Sag va Zememstaneh Boland* (The Dog and the Long Winter), translated into Russian. That same year, while serving as the producer of *Rural Women*, a weekly program for National Iranian TV, she resigned in protest against the meaninglessly cruel torture and execution of two journalist-poet activists by SAVAK. She was subsequently imprisoned for several months. Upon her release, she moved to France to study Chinese philosophy and language. There, she wrote her second novel, *Majerahayeh Sadeh va Kuchake Ruheh Derakht* (Plain and Small Adventures of the Spirit of the Tree), published in 1977. Due to problems associated with the Iranian Revolution of 1979, she had to return to the country. Because of a misunderstanding, she wound up in the Islamic Republic of Iran's political prison, where she remained for four years and seven months. Following her release, she published the novel *Touba va Maanayeh Shab* (Touba and the Meaning of Night). She subsequently ended up in jail again on two different occasions. Her book *Women without Men*, on which Shirin Neshat and

Faridoun Farrokh based their film of the same name, was one of the selections for the community read sponsored by the Princeton Public Library in conjunction with *The Fertile Crescent.*

LEIGH-AYNA J. PASSAMANO (born 1987, Livingston) completed her undergraduate studies at Pace University as a double major in art history and theater arts with a concentration in costuming in 2009. She received a master's degree in the Cultural Heritage and Preservation Studies Program, Art History Department, Rutgers University, in 2011. Her thesis research focused on the preservation of memories and the experiences of survivors of atrocities, such as the Holocaust and 9/11. She has worked at the Rutgers University Institute for Women and Art since 2009. Her research has been published in the exhibition catalogue *Passion in Venice: Crivelli to Tintoretto and Veronese*, edited by Catherine Puglisi and William Barcham (Giles Ltd., 2011). At Pace University, she won several awards, including the Writing Enhanced Course Program Writing Achievement Award, 2008; and the Fine Arts Department Award for the Highest Academic Achievement in Art History, 2009. She was inducted into the Alpha Chi National Honors Society, 2008, and the Dyson Society of Fellows at Pace University, 2009. Passamano was the Curatorial Assistant for *The Fertile Crescent* and Assistant Production Manager of the catalogue.

ANDREIA PINTO-CORREIA (born 1971, Lisbon) studied first at the Academia de Amadores de Música, Lisbon, and then at the New England Conservatory, Boston, where she is currently a Teaching Fellow. Her music includes influences from Iberian folk traditions, in particular Arab Andalusian poetic forms. Described by *The New York Times* as an "aural fabric," her music was profiled in the *Jornal de Letras*, where it was described thus: "the music of Andreia Pinto-Correia has been a major contribution to the dissemination of Portugal's culture and language, perhaps a contribution larger than could ever be imagined." Recent performances include the premiere of a work commissioned by the American Composers Orchestra at Carnegie Hall, 2011; a European premiere with the Orquestra Metropolitana de Lisboa, 2011; a composer residency with the chamber orchestra

Orchestr Utópica, Centro Cultural de Belém, 2011; and a premiere by the Minnesota Symphony Orchestra and Maestro Osmo Vänskä, 2012. She has received numerous commissions, among them the European Union Presidency Commission, 2008; Companhia Ópera do Castelo/ Drumming GP for an opera with libretto by the acclaimed West African writer Ondjaki, 2013. She is also the recipient of various honors and awards: the Toru Takemitsu Award, Japan Society, 2009; Tanglewood Music Center Fellowship, 2010; Susan and Ford Schumann Center for Composition Studies-Aspen Music Festival Fellowship, 2011, a MacDowell Colony Residency, 2011; and several ASCAPLUS and NEC Merit Awards, 2006–12. She collaborates with her father at the Centro de Tradições Populares Portuguesas, University of Lisbon, on a catalogue of ethnomusicology fieldwork. Pinto-Correia organized the concert held at the Institute for Advanced Study that included the debut of arias from her new opera *Territories*, the libretto for which was written by the Palestinian American playwright Betty Shamieh, based on her play of the same name.

BARRY V. QUALLS received his BA from Florida State University and his MA and PhD from Northwestern University. He is Vice President for Undergraduate Education at Rutgers University. He began as an Assistant Professor in 1971, specializing in Victorian literature. His popularity earned him the prestigious Warren I. Susman Award for Excellence in Teaching in 1985, the first year it was created. He served as Director of the Graduate English Program, Chair of the Rutgers English Department, and Dean of Humanities in the Faculty of Arts and Sciences (FAS), Rutgers's largest academic unit, before his appointment as Vice President. Professor Qualls is the author of *The Secular Pilgrims of Victorian Fiction: The Novel as Book of Life* (Cambridge University Press, 1982), of articles and reviews on nineteenth-century English literature, and essays on the Bible and its literary impact. In 2004–05, he chaired the Task Force on Undergraduate Education, a group of faculty, staff, and students appointed by Rutgers President Richard L. McCormick to examine and reorganize undergraduate education at Rutgers's New Brunswick/Piscataway campus. Professor Qualls was named the 2006 New Jersey Professor of the Year by the Carnegie

Foundation for the Advancement of Teaching and the Council for Advancement and Support of Education. Vice President Qualls provided the funds to hire buses to enable Rutgers students to attend *Fertile Crescent* events at Princeton University and also helped to fund several programs including Betty Shamieh's performance.

ARMITA RAAFAT received her BFA from Al-Zahra University, Tehran, and completed her MFA at the School of the Art Institute of Chicago, 2008. Her installations and sculptures weave together intricate structures, patterns, and motifs of Islamic and pre-Islamic Iranian architecture. She introduces an ornamental form transformed by the culture, history, and politics that produced it, and translates it through the lens of her personal experience. Many of her recent works reference *muqarnas*, an architectural ornament comprised of three-dimensional parts arranged into tiers. Her work has been displayed in exhibitions in Tehran, Chicago, and New York. Her solo shows include *12 x 12: New Artists / New Work*, Museum of Contemporary Art, Chicago, 2009. Group exhibitions in which she has participated include *Ah-Decadence*, Sullivan Galleries, Chicago, 2008; and *Left*, part of the South Asian Women's Creative Collective annual exhibition in New York, 2010. She was featured in Susanne Slavick and Holly Edwards, *Out of Rubble* (Charta, 2011). Raafat was a 2009 recipient of a Swing Space Residency, Lower Manhattan Cultural Council; and she is currently doing a studio residency with the Elizabeth Foundations for the Arts in New York. Raafat's work was included in the exhibition *Memory of Here, Memory of There*, West Windsor Arts Council Galleries.

CYRIL READE earned a PhD in visual and cultural studies from the University of Rochester. He is Associate Professor of Art History in the Fine Arts Department at Rutgers–Camden and is Director of the Rutgers–Camden Center for the Arts. He published *Mendelssohn to Mendelsohn: Visual Case Studies of Jewish Life in Berlin* with Peter Lang in 2007. His historical interests focus on German Jewish cultural life in the nineteenth century, including its identification with its Middle East origins. His interests in modern and contemporary culture

include monuments and memorials, gender and sexual identity, museums, and the shaping of cultural values. A recent curatorial work is *Reversing the Catastrophe of Fixed Meaning*, an exhibition of the artist's books of Scott McCarney that explore the relation between the manipulation of the book and its homoerotic content. Other curatorial projects include *How Good Are Your Dwelling Places*, for the Koffler Gallery, Toronto, which presented the work of Rita Bakacs, Susan Lakin, Ross Racine, and Allen Topolski, investigating the relation between the notion of home and the construction of identity. With Nancy Maguire, Reade organized the *Fertile Crescent* exhibition at the Stedman Gallery, Rutgers–Camden Center for the Arts.

NIDA SAJID (born New Delhi) received a BA in Spanish language and literature in 2000, an MA/MPhil in linguistics and English at Jawaharlal Nehru University, New Delhi, in 2004, and a PhD in comparative literature from Western University, Canada, in 2011. She is a Lecturer/Assistant Professor in the Department of African, Middle Eastern, and South Asian Languages and Literatures at Rutgers University. She previously taught in the Global Asia Studies Program, University of Toronto. Her areas of research comprise postcolonial theory, gender studies, South Asian history, Hindi and Urdu literatures, and South Asian popular culture, including research on minor literary traditions in postcolonial locations and revisionist readings of canonical European texts. She has published in journals like *The Feminist Review* and *The Journal of Hindu Studies*. At present, she is editing an anthology on the representations of *Zenana* fashion in film and literature. This volume traces the historical trajectory of the production, circulation, and consumption of Muslim femininity and fashion from the early modern period to the era of postnational globalization, revealing the heterogeneities of Muslim women's lives and the hegemonic impulses behind the construction of their identity as "invisible" women in patriarchal societies. Sajid was a member of the *Fertile Crescent* planning team and facilitated the organization of the session on the Middle East diaspora, which included a panel, two exhibitions, and a performance.

GHADA SAMMAN (born 1942, al-Shamiya) spent her childhood in Syria and in 1964 moved to Beirut, where she studied and graduated from the American University of Beirut. She attended the University of London for a period, and received her doctorate from Cairo University. Her first language was French, followed by Arabic and the learning of the Koran. In 1966, she was sentenced to prison for three months for antiauthoritarian expression, and left Syria without the state's permission. Her writing focuses on issues concerning Arab women and Arab nationalism. Among her many writings, beginning in 1962 with her first collection of short stories, are: *Ainak Qadari* (Your Eyes Are My Destiny), *Night of Strangers, No Sea in Beirut, The Other Time of Love,* and *The Sea Prosecutes a Fish. Beirut 75, Beirut Nightmares,* and *The Night of the First* form a trilogy based on the experience of the civil war in Lebanon, immigration, nationalism, and exile during the Israeli invasion of 1982. She founded her own publishing company in order to continue to write her opinions uncensored. In her essay "Our Constitution: We the Liberated Women," Samman describes a liberated woman as someone who "believes that she is as human as a man," and who recognizes that the difference between a man and a woman is "how, not how much." Samman's book *Beirut Nightmares* was selected for the community read by the Princeton Public Library.

MEDIHA SANDHU holds a BFA in digital media from Rutgers University and an MFA in computer arts from New Jersey City University. She says of her work: "My art is a reflection of the drama and tension faced by second-generation Pakistani immigrants." Sandhu, who wants her work to be "not only a window in for non-Muslims, but a reflection of themselves for Muslims," explains that through use of the comic book and graphic-novel formats, she can express the complexities of her life. Her animations can be found on ninjabi.com. Sandhu has been profiled in *Azizah, USA Today,* and *Jersey Journal Magazine.* She won the LinkTV OneNation Animation Award in 2007, and received Honorable Mention at Lunafest, Muslimfest, and Box[ur]shorts. Her animations were featured in the New Brunswick Public Library exhibition.

NICOLE SARDONE (born 1987, Edison) has a BFA in visual arts from the Mason Gross School of the Arts, Rutgers University. She is a painter who has exhibited her work in New Brunswick and Woodbridge, New Jersey. Sardone was an assistant on the *Fertile Crescent* project, working with Judith K. Brodsky and Ferris Olin. In addition, she works with a fine art appraiser as a research assistant, and formerly interned with Knoedler & Company in New York.

MARJANE SATRAPI (born 1969, Rasht) is an Iranian-born French contemporary graphic novelist, illustrator, animated film director, and children's book author. In 1983, at the age of fourteen, Satrapi was sent to Vienna by her parents to flee the Iranian regime. There, she attended the Lycée Français de Vienne. She later returned to Iran. She studied visual communication, eventually obtaining a master's degree from Islamic Azad University in Tehran. Satrapi became famous worldwide because of her critically acclaimed autobiographical graphic novels, originally published in French in four parts in 2000–03 and in English translation in two parts in 2003 and 2004, respectively, as *Persepolis* and *Persepolis 2*, which describe her childhood in Iran and her adolescence in Europe. *Persepolis* won the Angoulême Coup de Coeur Award at the Angoulême International Comics Festival. Her later publication, *Broderies* (Embroideries), was nominated for the Angoulême Album of the Year Award in 2003, an award that was won by her most recent novel, *Poulet aux prunes* (Chicken with Plums). *Persepolis* was adapted into an animated film of the same name that debuted at the 2007 Cannes Film Festival and shared a Special Jury Prize. Co-written and co-directed by Satrapi and the director Vincent Paronnaud, the French-language picture stars the voices of Chiara Mastroianni, Catherine Deneuve, Danielle Darrieux, and Simon Abkarian. The English version, featuring the voices of Gena Rowlands, Sean Penn, and Iggy Pop, was nominated for an Academy Award for Best Animated Feature in 2008. *Persepolis* was shown at the Arts Council of Princeton.

JOAN WALLACH SCOTT (born 1941, Brooklyn) graduated from Brandeis University in 1962 and received a PhD in history from the University of Wisconsin in 1969. She is Harold F. Linder Professor of Social Science at the Institute for Advanced Study in Princeton. Scott works on issues related to the treatment of Muslim minority populations in Western Europe, especially France. Her book on this subject is *The Politics of the Veil* (Princeton University Press, 2007). In addition to her work in French history, she has published a number of books and articles on the history and theory of feminism. The classic work is *Gender and the Politics of History* (Columbia University Press, 1988, 1999) and the most recent is *The Fantasy of Feminist History* (Duke University Press, 2011). Professor Scott has been awarded honorary degrees from Harvard University, the University of Wisconsin, SUNY Stony Brook, the University of Bergen (Norway), and Brown University. Scott was on the *Fertile Crescent* planning team and instrumental in securing the participation of the Institute for Advanced Study.

ELA SHAH (born Mumbai) received a BA in psychology, SNDT University, Mumbai, and a Diploma in Fine Arts, CN College of Fine Arts, Ahmedabad. After moving to the United States, she received her MA in sculpture at Montclair State University. Although an American citizen, she has held on to her Indian heritage, incorporating it into her artwork along with Western influences. Her work has been exhibited in many group shows, including *Diversity and Democracy in South Asian Art*, William Benton Museum, 2004; *International Perspectives in Contemporary Art*, Hunterdon Art Museum, 2004; *Fatal Desire*, Queens Museum of Art, 2005; *Sultana's Dream*, Exit Art, New York, 2007; and *Contemporary India*, Gallery Projects, Ann Arbor, 2009. She has received numerous awards and fellowships including the Amelia Peabody Memorial Award and Elizabeth Morse Genius Foundation Award from the National Association of Women Artists, 1994; a New Jersey Print and Paper Fellowship, Rutgers University, 1995; a Dodge Foundation residency award, 1999; and two New Jersey State Council on the Arts fellowships, one for sculpture in 1999 and another for painting in 2006. Her work is in many public collections, including the Jain Centre, Leicester, United Kingdom (mural); the New Jersey State Museum; The Newark Museum; and the Jane Voorhees Zimmerli Art Museum, Rutgers University. Shah's work was included in the exhibition *Borderlands*, at the New Brunswick Public Library.

BETTY SHAMIEH (born San Francisco) is a graduate of Harvard College and the Yale School of Drama. She is the first Palestinian American to have a play premiere Off-Broadway with the 2004 production of *Roar*, a drama about a Palestinian family, selected as a *New York Times* Critics Pick for four weeks. *The Black Eyed* premiered Off-Broadway at the New York Theatre Workshop in 2007. *Territories* had its world premiere at the Magic Theatre in 2008 and its European premiere in German translation at the European Union Capital of Culture Festival in 2009. Other works include *Chocolate in Heat*, 2001; *Again and Against*, which had its world premiere at the Playhouse Theatre of Sweden, 2007; and *The Machine*, directed by Marisa Tomei, 2007. She has received many honors, including the Clifton Artist in Residence, Harvard University, 2004; a Playwriting Fellowship, Harvard/Radcliffe Institute for Advanced Studies, 2005; a New York Foundation for the Arts Playwriting Grant, 2005; a Bellagio Center Residency, 2005; a playwriting residency at the Sundance Institute Theater Lab, 2006; an NEA playwriting grant, 2008; playwright residency at the Magic Theatre, San Francisco, 2008; New Dramatists Van Lier Fellowship Playwriting Grant, 2010; UNESCO Young Artist for Intercultural Dialogue, 2011; the United States/Russia Bilateral Presidential Commission award to translate her play *Again and Against*, 2011; and a playwriting residency, Yaddo, 2011. Her plays have been translated into seven languages. Shamieh wrote the libretto for the opera *Territories*, based on her play of the same name, arias from which debuted at the Institute for Advanced Study during *The Fertile Crescent*. Shamieh also performed at the Crossroads Theatre in New Brunswick.

LYNN SHANKO is the Executive Director of the Rutgers Center for Historical Analysis (RCHA), which brings together internationally distinguished scholars, the university community, and the New Jersey public to engage in research, education, and public service on historical topics of broad community relevance. The RCHA's programs are designed to put current social trends and issues in historical perspective and overcome the fragmentation of knowledge that keeps individuals from seeing the wider dimensions of problems. In addition to weekly seminars, the Center hosts a variety of public conferences and related cultural events, sponsors an institute for high school teachers, and houses the *Journal of the History of Ideas*. A seminar for high school teachers on the *Fertile Crescent* project was held at the RCHA.

IFAT SHATZKY (born 1966), who resides in Princeton, New Jersey, was raised on a kibbutz, where she absorbed the complicated meanings of territory, conflict, pain, and war in Israel. She received a BFA in art and education at the Ramat Hasharon School for the Arts, Tel Aviv, in 1991. Her work has been included in group exhibitions at Ellarslie, The Trenton City Museum; Mercer County Artists juried exhibitions; and Arts Council of Princeton exhibitions. Shatzky explains that she addresses the ideological issues surrounding nature and land. She was featured in a solo exhibition at the Princeton Public Library.

JANE SLOAN holds a BA from Loyola University, 1969, an MA from the University of Wisconsin, and an MA in film studies from San Francisco State University, 1982. She is the Media Librarian at Rutgers University Libraries. Sloan has published widely in the field of film studies, including the reference works *Robert Bresson: A Guide to References and Resources* (G. K. Hall, 1983) and *Alfred Hitchcock: A Filmography and Bibliography* (University of California Press, 1995), and is the Media Editor for *The Encyclopedia of Women in Today's World*. Her recent guide to international films about women, *Reel Women* (Scarecrow Press, 2007), includes sections on the countries of the Middle East and North Africa. She is currently working on a project documenting the life and work of Mai Zetterling, who figured in the development of 1960s iconic imagery depicting women's response to their lesser status, and the dynamic relationship of the women's movement to peace, war, and the environment. She received awards from the American Library Association for Achievement in Women's Studies Librarianship in 2008 and the New Media Consortium in 2011. Sloan was the presenter for the screenings in the *Fertile Crescent* film series.

KAREN SMALL received her bachelor's degree from Indiana University and her master's degree in social work from the Wurzweiler School of Social Work, Yeshiva University. She is the Associate Director of the Allen and Joan Bildner Center for the Study of Jewish Life at Rutgers University. She oversees community outreach programs that link Rutgers with the community through public lectures, cultural events, conferences, and symposia. Small is the Director of the annual Rutgers Jewish Film Festival, now entering its thirteenth year. She oversees the Herbert and Leonard Littman Families Holocaust Resource Center, cultivating community partnerships and organizing leadership development programs, such as the New Jersey Jewish Leadership Forum. Before coming to Rutgers in 1998, Karen Small was a Program Director at the JCC of Greater Philadelphia, and had previously worked as a Planning Associate for the Jewish Federation of Greater Philadelphia. She has received many grants and awards for her work in the area of Jewish education and Holocaust education. Small currently serves on the board of Rutgers Hillel, and was appointed by Governor Jon Corzine to the New Jersey Israel Commission. Small was a member of the planning team and developed the program of films by Israeli women directors for the Rutgers Jewish Film Festival.

ANDREA SMITH is a veteran publicist who for twenty-five years has implemented strategic publicity and marketing campaigns to raise the visibility of organizations and individuals in the arts, entertainment, and publishing. She has a BA in media studies from Fordham University. In 2011, she started her own publicity firm, Andrea Smith Public Relations, serving clients that range from emerging artists to leading publishers of art books, to non-profit organizations in the arts. Previously, she served for nine years as Director of Communications at Aperture Foundation, a leading non-profit arts institution dedicated to advancing photography, where she worked in close collaboration with Aperture's renowned roster of artists to create customized media campaigns to publicize their work through artist monographs published by Aperture, and supporting exhibitions and events. Before that, she worked for thirteen years at MTV, where she was a member of the publicity team that helped make MTV a brand name. Ms. Smith is also a board member

and Marketing Director for L.E.A.D. Uganda, an educational leadership program that locates vulnerable youth in Africa with innate talents and trains them to be leaders. Smith was the publicist for *The Fertile Crescent*.

KATHERINE A. SOMERS (born 1952, Doylestown) received her BA from George Washington University in 1981 and her MA in art history from Rutgers University in 1994. She has been an independent consultant in the fine arts since 1995, and since 2003 has been Curator of the Bernstein Gallery at the Woodrow Wilson School of Public and International Affairs at Princeton University. She has also been a consultant to the Princeton University Art Museum, and since 2008, has served as consultant for the Borough of Princeton on public art. Somers was the Director of the Sculpture Project and Fine Art Exhibition Program at the gallery at Bristol-Myers Squibb's corporate headquarters in Lawrenceville, New Jersey, in 2000–06. She has also been a consultant to other corporate and public collections and has acted as a consultant to artists' estates. Her work has included art-historical research, cataloguing, restoration, and development for exhibitions, Internet auctions, and book publications. Her writing has included an essay in *Daily Bread*, an artist's book by Lisa Salamandra, published by Cheminements Editions, 2009, as well as numerous exhibition catalogue introductions for artists and art groups including Amy Oliver, Hetty Baiz, Jim Perry, and MOVIS, an artists' collective in Princeton. Somers was a member of the *Fertile Crescent* planning team.

GILANE A. TAWADROS (born 1965, Cairo) is a writer and curator based in London. She studied art history and film at the University of Sussex and Université de Paris IV (Sorbonne-Nouvelle), receiving her BA in 1987 and her MA from the University of Sussex in 1989. She was the founding Director of the Institute of International Visual Arts (InIVA), London, which achieved widespread recognition as a groundbreaking cultural agency at the leading edge of artistic and cultural debates nationally and internationally through its program of exhibitions, education and multimedia projects, publications,

and research. She has curated numerous exhibitions, including: *Veil*, New Art Gallery, Walsall, Bluecoat Art Gallery and Open Eye Gallery, Liverpool, and Modern Art, Oxford, 2003, and Kulturhuset, Stockholm, 2004; *Fault Lines: Contemporary African Art and Shifting Landscapes*, Venice Biennale, 2003; *The Real Me*, Institute of Contemporary Arts, London, 2005; Brighton Photo Biennial, 2006; *Alien Nation*, Institute of Contemporary Arts, London, and tour, 2006–07; and *Transmission Interrupted*, Modern Art, Oxford, 2009. She has written extensively on contemporary art. Her books include *Changing States: Contemporary Art and Ideas in an Era of Globalisation* (InIVA, 2004) and *Life Is More Important than Art* (Ostrich, 2007). She was a Board Director and then President of the International Foundation of Manifesta, Amsterdam, and serves on the Boards of the Camden Arts Centre, London; Photoworks, Brighton; and the Editorial Board of Whitechapel Art Gallery. Tawadros wrote an essay for the catalogue and held the Laurie Chair in Women's Studies at Rutgers University during the *Fertile Crescent* project.

FARIDEH TEHRANI (born 1940, Shiraz) received a BA in history from Pahlavi University, Shiraz, in 1968; her MLIS degree from the Pratt Institute in 1976, and a Doctor of Library Science from Columbia University in 1986. She is the Middle East Studies librarian at the Rutgers University Libraries. Tehrani is President of the Shiraz University Association (SUA) in North America. She is the project advisor for the *Bridging Cultures: Poetry of the Muslim World* project, funded by an NEH Grant awarded to City Lore in collaboration with Poets' House, New York. It is a three-year long (2012–14) national initiative across six states to develop and implement the publication *Poetic Voices of the Muslim World*. Tehrani also published *Library Space and Market Place: Library Messages beyond the Border* (K. G. Sur, 2006) co-authored by Myoung Wilson and edited by Trine Kolderup Flaten. Tehrani was a member of the planning team.

CONNIE TELL received her BFA from the University of Massachusetts and her MFA from the San Francisco Art Institute. She is the Deputy Director for the Rutgers University Institute for Women and Art. Tell has been an arts administrator for over twenty-five years, working with private and non-profit arts organizations and institutions. Tell is also a working artist who makes conceptually driven artwork in a variety of mediums on topics of gender and identity, DNA, and personal and cultural history. Her work has been exhibited in the United States and Mexico, garnering reviews and awards. Tell was a member of the planning team.

MEREDETH TURSHEN received a BA from Oberlin College, 1959, an MA from New York University, 1961, and a DPhil, University of Sussex, England, 1975. She is a Professor in the Edward J. Bloustein School of Planning and Public Policy at Rutgers University. Her research interests include women, armed conflict, and international health, and she specializes in public health policy. She has written four books and edited six others. Since 2000, the following have appeared: *African Women's Health* (Africa World Press, 2000); *Ce que font les femmes en temps de guerre* (L'Harmattan, 2001); *The Aftermath: Women in Postconflict Transformation* (Zed Books, 2002); *Women's Health Movements: A Global Force for Change* (Palgrave Macmillan, 2007); and *African Women: A Political Economy* (Palgrave Macmillan, 2011). She has served as Chair of the Association of Concerned Africa Scholars, as Treasurer of the Committee for Health in Southern Africa, as Contributing Editor of the *Review of African Political Economy*, and is on the editorial board of the *Journal of Public Health Policy*. She received the Leadership in Diversity Award from Rutgers in 2007 and a Fulbright Award to the University of Ottawa in 2011. Meredeth Turshen is also a painter whose work can be seen at Viridian Gallery, New York. Turshen was a discussant for the screening of the film *Amreeka*.

PATRICIA SARRAFIAN WARD (born 1969, Beirut) moved to the United States at the age of eighteen. Ward holds a BA from Sarah Lawrence College, 1991, and an MFA from the University of Michigan, 1995. Her work focuses on the civilian experience of war and issues of identity and belonging. Her novel *The Bullet Collection* (Graywolf Press, 2003), about two sisters growing up in wartime Beirut, received the Great Lakes College Association (GLCA) New Writers Award, the Anahid Literary Award, and the Hala Maksoud Award for Outstanding Emerging Writers. Her

short stories, poems, essays, and reviews have appeared in a number of journals and anthologies, most recently in *Banipal*, *Guernica*, and *The Electronic Intifada*. In recent years, Ward has been exploring the field of book arts. She is an artist member of the Center for Book Arts, New York, where her installation *Re/Vision* was on exhibit in 2012. Three of her books were on tour in *Correspondence*, the International Book Festival based in Lodz, Poland, 2012–14. She is also a member of *al-Mutanabbi Street Starts Here*, an international collective of artists responding to the 2007 bombing of al-Mutanabbi Street in Baghdad. Ward was a speaker and her artist's books were on exhibit for the book arts symposium held at the Arts Council of Princeton.

CAROLYN WILLIAMS received her BA from Wellesley College and her MA and PhD from the University of Virginia. She is the Chair of the English Department at Rutgers University. Until 2010, she was Director of Undergraduate Studies and Director of the reading series *Writers at Rutgers* and *Writers from Rutgers*. She was the founding Director of Writers' House. The author of *Transfigured World: Walter Pater's Aesthetic Historicism* (Cornell University Press, 1989), she co-edited *Walter Pater: The Transparencies of Desire* (ELT Press, 2002) with Laurel Brake and Lesley Higgins; and edited a special issue of *Victorian Literature and Culture* on Victorian studies and cultural studies (1999), and an issue of the *Pater Newsletter* devoted to queer Pater studies (2007). Williams has also published a study of the comic operas of Gilbert and Sullivan, entitled *Gilbert and Sullivan: Gender, Genre, Parody* (Columbia University Press, 2011). Her current research focuses on Victorian melodrama, under the working title "The Aesthetics of Melodramatic Form." She has served on the Supervisory Board of the English Institute and the Executive Board of the Dickens Project, and she now serves on the PMLA Advisory Committee, as well as the editorial boards of *Victorian Literature and Culture* and *English Literature in Transition*. She was awarded the Warren I. Susman Award for Excellence in Teaching, Rutgers University, in 1999; a Guggenheim Fellowship in 2004–05; and the Scholar-Teacher Award, Rutgers University, in 2010. Williams facilitated Betty Shamieh's performance at the Crossroads Theatre.

TAMARA WORONCZUK received her BA in art/art education from Glassboro State College and her MA in art education and painting from New York University. She served as an art teacher in New Jersey for many years, educating hundreds of young children in design, the use of color and various media, and the history of art, until her recent retirement. "Twelve years ago my life underwent a drastic change and my relationship with my art shifted. I took out my brushes, paints, and canvas and began to put my feelings on canvas. Instead of isolation and sadness, mystical, colorful landscapes danced across the canvas. As a youngster, I was very intrigued by the colors and textures of the insides of Russian Orthodox churches. I can remember thinking that heaven must be decorated with gold, gilding, and icons. As I grew up, the shapes of domes and arches played a significant role in my paintings and drawings. As a young adult I spent some time in Spain, visiting the Alhambra and the Generalife in Granada and the mosque in Cordova. The forms of these places—the domes, archways, paths, walls and promenades—found their way into my art, coupled with the other Eastern images… I always seem to return to the mystical and graceful shapes of domes and arches. They seem to be images I cannot escape." Woronczuk was one of the artists in the exhibition at the New Brunswick Public Library.

YAEL ZERUBAVEL received her BA from Tel Aviv University and PhD from the University of Pennsylvania. She is Professor of Jewish Studies and History, and the founding Director of the Allen and Joan Bildner Center for the Study of Jewish Life at Rutgers University. A leading expert on the study of Israeli memory and national culture, Zerubavel is the author of *Recovered Roots: Collective Memory and the Making of Israeli National Tradition* (University of Chicago Press, 1995), which won the 1996 Salo Baron Prize of the American Academy for Jewish Research, and numerous articles on memory and identity, Israeli culture, war and trauma, Israeli literature and film, and the Jewish immigrant experience. Recent publications include "Memory, the Rebirth of the Native, and the 'Hebrew Bedouin' Identity," *Social Research* 75, no. 1 (Spring 2008); and "The Desert and the Settlement as Symbolic Landscapes in Modern Israeli

Culture," in Julia Brauch, Anna Lipphardt, and Alexandra Nocke, eds., *Jewish Topographies Visions of Space, Traditions of Place* (Heritage, Culture and, Identity Series) (Ashgate Press, 2008). Since 2000, Zerubavel has been a Visiting Fellow at the École Pratique des Hautes Études, Paris; the Institute for Advanced Study; the Hebrew University, Jerusalem; the Ben-Gurion Research Center at Ben-Gurion University; and the Katz Center for Advanced Judaic Studies, University of Pennsylvania. Zerubavel was a member of the planning team and, with Karen Small, the selector of the films by Israeli women directors for the Jewish Film Festival.

EMNA ZGHAL (born 1970, Sfax) lives in New York. She received her BA at the Ecole Des Beaux Arts, Tunis, in 1992, and her MFA from the Pennsylvania Academy of the Fine Arts in 1999. She also studied at the Skowhegan School of Painting and Sculpture in 2004. Her solo shows since 2000 include *The Scene Gallery,* New York, 2002; *The Prophet Of Black Folk,* Alwan for the Arts, New York, 2003; *Oeuvres Récentes*, Galerie El Marsa, Tunis, 2004; *The Tree Of My Mind,* 2007; *Against Reason,* 2008; *Plato/ Pineappple*, 2012, all at Miyako Yoshinaga Art Projects, New York; and *Interflow*, Ogilvy, New York, organized by the Museum for African Art, New York, 2009. Among her group exhibitions are *Contemporary Art From the Ancient World*, Cathedral of Saint John the Divine, New York, 2003; *Nostalgie: Sfaxian Artists Living Abroad*, Galerie La Kasbah, Sfax, Tunisia, 2004; *BookBlast,* Lönnström Art Museum, Rauma, Finland, 2006; *Invitational Exhibition of Visual Arts*, American Academy of Arts and Letters, New York, 2007; *Marked Differences: Selections from the Kentler Flatfiles,* Kentler International Drawing Space, Brooklyn, 2011, as well as featured in exhibitions in France, Germany, Japan, Kuwait, India, and Italy. She has received many awards and fellowships including a MacDowell Colony Fellowship, 2002; Purchase Award, Academy of Arts and Letters, 2007; and a Creative Capital Award, 2008. Her works are in the Schomburg Collection, New York Public Library; Yale University; the Museum for African Art, New York; and Grinnell College. She has been artist-in-residence at the MacDowell Colony; The Newark Art Museum; the Weir Farm Trust; and the Cité Internationale des Arts, Paris. She has collaborated with the Women's Studio Workshop and the Lower East Side Printshop in New York. Zghal was one of the artists in the exhibition *Memory of Here, Memory of There,* at the West Windsor Arts Council Galleries.

DEBRA ZIMMERMAN has been the Executive Director since 1983 of Women Make Movies, a non-profit New York–based film organization that supports women filmmakers. During her tenure, it has grown into the world's largest distributor of films by and about women, and its internationally recognized Production Assistance Program has helped hundreds of women get their films made. Films from WMM have won prizes at the last three Sundance Film Festivals, including *El General,* by Natalia Almada, recipient of the Documentary Directing Award; *The Oath,* by Laura Poitras, which received the Excellence in Cinematography Award for a U.S. Documentary; and *Rough Aunties,* by Kim Longinotto, awarded the World Cinema Jury Prize in Documentary. She has consulted for foundations and non-profit arts organizations, most recently as a member of the Gender Montage Advisory Board project for the Soros Foundation's Open Society Institute. She is also a member of numerous advisory boards for media and film organizations, including the Australian International Documentary Conference (AIDC); the Banff World Television Conference; The Center for Social Media at American University; Cinema Tropical, New York; Cine-Arts Afrika, Kenya; and the Black Lily Film Festival, Philadelphia. She has also been a jury member for many international film festivals, and regularly sits on foundation and government funding panels. Most recently she served on the New Jersey State Council on the Arts media panel and the Pew Charitable Trust's Media Fellowship panel as well as on the jury for the Leipzig Documentary Film Festival and the Cleveland International Film Festival. Zimmerman spoke at a conference honoring the fortieth anniversary of Women Make Movies, which focused on films about and from the Middle East.

Bibliography

Bibliography

Please note that this is a selected bibliography. To view a more complete bibliography for each of the artists and general books on women's cultural production in the Middle East, please go to the Fertile Crescent web site, www.fertile-crescent.org, or visit the individual artists' web sites.

NEGAR AHKAMI

negarahkami.com

Ahkami, Negar, and Leila Heller Gallery. *Negar Ahkami: Pride and Fall*. New York: Leila Heller Gallery, 2009.

Buckberrough, Sherry A. *Womenartists@NewBritainMuseum*. New Britain: New Britain Museum of American Art, 2010–11.

"Close Reading: Negar Ahkami," *New York Times Online*, June 4, 2009, nytimes.com/interactive/2009/06/04/arts/20090607-closereading.html.

Cotter, Holland. "Do You Think I'm Disco." *The New York Times*, February 3, 2006.

———. "*Iran Inside Out.*" *The New York Times*, July 23, 2009.

Davis, Ben. "Iranian Art Now." artnet.com, July 20, 2009, artnet.com/magazineus/reviews/davis/iran-contemporary-art7-20-09.asp.

Ebstein, Alex. "Her Stories: Group Show Presents and Examines Women's Voice and Identity." *Baltimore City Paper*, February 18, 2009, citypaper.com/eat/story.asp?id=17537.

Esman, Abigail R. "The Art of War: Why Today's Iranian Art Is One of Your Best Investments Now." Forbes.com, January 10, 2011, forbes.com/sites/abigailesman/2011/01/10/the-art-of-war-why-todays-iranian-art-is-one-of-your-best-investments-now/.

Flandrin, Antoine. "Le Voile dévoilé." *Le Courrier de l'atlas* (March 2010).

Genocchio, Benjamin. "Exploring the Effects of Disco's Beat." *The New York Times*, February 19, 2006, nytimes.com/gst/fullpage.html?res=950CE5D7133EF93AA25751C0A9609C8B63.

Gold, Sylviane. "A Female, but not Mainly Feminine, Eye." *The New York Times*, January 7, 2011, nytimes.com/2011/01/09/nyregion/09artct.html.

Jigsawnovich, Julie. "*Iran Inside Out* at the Chelsea Art Museum." persianesque.com, July 26, 2009.

Kino, Carol. "Iranians Shine, Assisted by Expatriate." *The New York Times*, August 12, 2009, nytimes.com/2009/08/16/arts/design/16kino.html?pagewanted=all.

Neuschler, Chris. "Iran Inside Out inside Chelsea Art Museum, New York." *premierartscene.com*, premierartscene.com/magazine/iran-inside-out.

Passariello, Micol. "News: Arte Da Mille E Una Notte." *Cosmopolitan (Italia)* (September 2009).

Richardson, Denise. "Exhibit Mixes Politics and Art." *The Daily Star*, September 15, 2005, old.thedailystar.com/news/stories/2005/09/15/exhib2.html.

Riley-Lopez, Erin. "How Soon Is Now?" *AIM 28*. Bronx: Bronx Museum of the Arts, 2008.

Smith, Kyle Thomas. "The Seen and the Hidden: [Dis]covering the Veil." *whitehotmagazine.com* (July 2009), whitehotmagazine.com/articles/covering-veil-austrian-cultural-forum/1907.

Smith, Roberta. "Artists Leap into the Moment." *The New York Times*, July 25, 2008, nytimes.com/2008/07/25/arts/design/25now.html.

———. "Painting in the 21st Century: It's Not Dry Yet (Image)." *The New York Times*, March 26, 2010, nytimes.com/2010/03/28/arts/design/28painting.html.

Sontag, Deborah. "The Intersection of Islam, America, and Identity." *The New York Times*, June 7, 2009.

Torres, Eddie. "Iconoclasmic: Answering to a Higher Calling." *South Bronx Contemporary: A Catalogue of Essays, Interviews and Images Celebrating Longwood Arts Project's 25th Anniversary*. Bronx: Bronx Council on the Arts, 2007.

Walker, Carolee. "Artists Use Images of the Veil to Explore Identity, Culture." payvand.com, August 27, 2009, payvand.com/news/09/aug/1243.html.

Wei, Lilly. "Selseleh / Zelzeleh at Leila Taghinia-Milani Heller Gallery," *ARTnews* (October 2009).

SHIVA AHMADI

ltmhgallery.com/artists/shiva-ahmadi

Abd Allah, Alikhani, Husayn Farahbakhsh, et al. *Tarzana*. Calif.: Bita Film, 2005.

Arus-i Farari (Runaway Bride). Videodisc (84 min.): sd., col.; 4 3/4 in. Directed by Bahram Kazimi.

Biro, Mathew. "Contemporary Developments in Drawing." *Contemporary* 83 (August 2006): 20–23.

Bolleber, Luise. "Gallery Welcomes 'Detroit Now.' " *The Oakland Post*, June 11, 2003, 1.

Cynar, John, and Dick Goody. *Detroit Now*. Rochester: Meadow Brook Art Gallery, Oakland University, 2003.

Dumont, Shana. *Merging Influences: Eastern Elements in New American Art*. Beverly: Montserrat College of Art, 2007.

Gioni, Massimiliano, and Jarrett Gregory. *2008 Altoids Award*. New York: New Museum, 2008.

Haddad, Natalie. "Displaced." *Real Detroit Weekly*, April 21, 2004.

———. "Room for Interpretation," *Real Detroit Weekly*, December 2002, 61.

Khorrami, Mohammad Mehdi, and Shouleh Vatanabadi. *A Feast in the Mirror: Stories by Contemporary Iranian Women*. Boulder: Lynne Rienner Publishers, 2000.

Leila Heller Gallery. *Shiva Ahmadi: Reinventing the Poetics of Myth*. New York: Leila Heller Gallery, 2010.

Naghmah. viewing copy. 1 videodisc of 1 (videodisc PAL) (121 min.): sd., col.; 4 3/4 in. Directed by Abu al-Qasim Talibi, `Ali'raza Sabt Ahmadi, Husayn Yari, Faqihah Sultani, and Muassasah-i Farhangi-i Hunari. Tehran: Muassasah-i Farhangi-i Hunari Qarn-i 21, 2007.

Naghmah. 2 videodiscs (VCD) (98 min.): sd., col. ; 4 3/4 in. Directed by Abu al-Qasim Talibi, `Ali'raza Sabt Ahmadi, Husayn Yari, Faqihah Sultani, Humayra Riyazi, and Muassasah-i Farhangi-i Hunari. Tehran: Muassasah-i Farhangi-i Hunari Qarn-i 21, 2004.

Pilgian, Ellen. "Expats on Show." *Metro Times*, April 28, 2004, metrotimes.com/editorial/story.asp?id=6159.

"Review of *On the Wall* at Tangent Gallery." *Real Detroit Weekly*, June 2003, 24.

Rutter, Ben. "It's pronounced nu-cle-ar: Atomica review." *New York Arts* 10 (September–October 2005).

Tysh, George. "Wild at Heart." *Metro Times*, June 11, 2003, metrotimes.com/editorial/story.asp?id=5013.

JANANNE AL-ANI

janannealani.net

Al-Ani, Jananne, Steven Bode, and Nina Ernst. *Jananne Al-Ani*. London: Film and Video Umbrella, 2005.

———, and Claire Fitzsimmons. *Around the World in Eighty Days*. Frankfurt: Archiv für Aktuelle Kunst, 2006.

———, and Jules Verne. *Tour du monde en quatre-vingts jours* (Around the World in Eighty Days). London: Institute of Contemporary Arts and the South London Gallery, 2006, *HathiTrust Digital Library*: http://catalog.hathitrust.org/api/volumes/oclc/75712973.html.

Amodeo, Fabio. "Arles: Il vestito nuovo del festival piu blasonato." *Arte* 347 (July 2002): 119.

Arts Council of England. *Strangerthanfiction: Arts Council Collection, Hayward Gallery*. London: Hayward Gallery, 2004.

Back Matter. *Afterall: A Journal of Art, Context, and Enquiry* 10 (Autumn–Winter 2004).

Bailey, David A., and Gilane Tawadros, eds. *Veil: Veiling, Representation, and Contemporary Art*. London: Institute of International Visual Arts in association with Modern Art, Oxford, 2003.

Barrett, David, Jananne Al-Ani, and Frances Kearney. *Fair Play*. London: Danielle Arnaud, 2001.

"Calendar: Italian Art." *The Burlington Magazine* 147, no. 1232 (November 2005): 781–86.

Connor, Valerie. *EV + A 2001 Expanded*. Limerick: Paul M O'Reilly Gandon Editions, 2001.

Daftari, Fereshteh, ed. *Without Boundary: Seventeen Ways of Looking*. New York: Museum of Modern Art, 2006.

Deepwell, Katy. "Ecbatana? Artists from the Middle East: Ghazel, Zineb Sedira, Mona Hatoum, Jananne Al-Ani." *Paradoxa* 7 (2001): 63–67

Delin, Elisabeth. *Ekbatana?* Copenhagen: Hansen Nikolaj Contemporary Art Centre, 2001.

Dietrich, Linnea S. "Untitled." *Woman's Art Journal* 26, no. 1 (Spring–Summer 2005): 56–57.

Faraj, Maysaloun. *Strokes of Genius: Contemporary Iraqi Art*. London: Saqi Books, 2001.

Farhad, Massumeh. "Arts of the Islamic World." *Arts of Asia* 36 (2006): 118–23.

Fortnum, Rebecca. *Contemporary British Women Artists: In their Own Words*. London: I.B. Tauris, 2007.

Galford, Hugh S. "Three Exhibits at Sackler Gallery on Modern Mideast." *Washington Report on Middle East Affairs* 19, no. 1 (January 2000): 85.

Green, Tyler. "Without a Prayer." *Modern Painters* 23, no. 3 (April 2011): 28–30.

Hylton, Richard, Jananne Al-Ani, and JorellaAndrews. *Landscape Trauma in the Age of Scopophilia: Annabel Howland, Henna Nadeem, Ingrid Pollard, Camila Sposati; The Search for Terrestrial Intelligence (S. T. I. Consortium)*. London: Autograph, 2001.

Issa, Rose. *Harem Fantasies and the New Scheherazades*. Barcelona: Centre de Cultura Contemporània de Barcelona, 2003.

Keep on Onnin': Contemporary Art at Tate Britain; Art Now 2004–7. London: Tate Publishing, 2007.

Kivland, Sharon, and Lesley Sanderson. *Transmission: Speaking & Listening*, Vol. 3. Sheffield: Sheffield Hallam University/Site Gallery, 2004.

Kravagna, Christian. "Ein Kompliziertes Stück Tuch." *Springerin* 10, no. 1 (March 2004): 54–57.

Lenz, Iris, Chant Avedissian, and Selma Gürbüz et al. *Love Affairs*. Stuttgart: Institut für Auslandsbeziehungen, 2003.

Lunn, Felicity, Jane Rendell, and Jananne Al-Ani. *(Hi)Story: Al-Ani–Moffatt–Varejão*. Thun: Kunstmuseum, 2005.

Mattar, Philip. *Encyclopedia of the Modern Middle East and North Africa*. New York: Macmillan Reference USA, 2004.

Moaven, Dariush. *Alethia: The Real of Concealment*. Göteborg: Göteborgs konstmuseum, 2003.

New Art Gallery, Walsall. *In Memoriam: Jananne Al-Ani, Nick Crowe, Echolalia, Darryl Joe Georgioi, Felix Gonzalez-Torres, Susan Hiller, Kenny Hunter, Alastair MacLennan, Gavin Turk, Andrew Tiftl*. Walsall: New Art Gallery, 2000.

O'Brien, David, and David Prochaska. *Beyond East and West: Seven Transnational Artists*. Champagne-Urbana: Krannert Art Museum, 2004.

Okon, Rohini Malik. *Performing Difference*. London: Artsadmin, 2004.

O'Reilly, Paul. *EV+A 2001: Expanded*. Kinsale, Ireland: Gandon Editions, 2001.

Pethick, Emily. *Jananne Al-Ani: Artnow at Tate Britain*. London: Tate, 2005.

Pironneau, Amelie. *Fair Play: De Nouvelles Règles du jeu*. Paris: Fondation d'Art Contemporain Daniel & Florence Guerlain, 2002.

Puff, Melanie. "Without Boundary: Seventeen Ways of Looking." *Kunstforum International* 180 (May–June 2006): 397–99.

Sandhu, Sukhdev. *Stranger than Fiction*. London: Hayward Gallery Publishing, 2004.

Stein, Judith E. "Untitled." *Woman's Art Journal* 26, no. 1 (Spring–Summer 2005): 54–56.

Tohme, Christine, Mona Abu Rayyan, and Ashkal Alwan. *Home Works: The Lebanese Association for Plastic Arts Disorientation*. Berlin: Haus der Kulturen der Welt, 2003.

Withers, Rachel. "EAST International 2000." *Artforum* 39, no. 2 (October 2000): 155.

Women by Women: 8 Fotografinnen aus der arabischen Welt. Frankfurt: Fotografie Forum International, 2004.

FATIMA AL QADIRI

fatimaalqadiri.com

Al Qadiri, Fatima, "*AbraK48dabra*," *K48* (New York) 8 (2011).

———. "The Bed Thief." *Bidoun Magazine* 21 (Summer 2010): 28–29.

———. "Boy Talk." *Bidoun Magazine* 19 (Winter 2009–10): 125–127.

———. *Dazed and Confused* 2 no. 93 (January 2011): 122.

———. "Excavating the Egyptians." *Bidoun Magazine* 25 (Fall 2011): 032C.

———. *How can I Resist U*, video, XLR8R, xlr8r.com/news/2012/01/video-fatima-al-qadiri-how-can-i.

———. *How can I Resist U*, video: Fatima Al Qadiri, the FADER, thefader.com/2012/01/19/video-fatima-al-qadiri-how-can-i-resist-u/.

———. "Kuwaiti Arabic Slang." *Bidoun Magazine* 19 (Fall 2008): 199.

———. "Mahma Kan Althaman 'Whatever the Price,'" *Bidoun Magazine* 20.

———. *No Soul for Sale* (part of K48 Kontiuum). London: Charley Independents, 2010.

———. *Resurrection,* compiled by Jon Santos, New York: Common Space, 2006.

———. "*Starship Counterforce*." *K48 Magazine* (2009).

———. *The Times Literary Supplement*, 5528, March 13 2009, 3.

———. "Wolves that Do Not Eat Meat." *Bidoun Magazine* 17 (Spring 2009):130–133.

Al Qadiri, Fatima, and Lauren Boyle. *Pâté*. New York: Common Space, 2011.

ALTERED ZONES - Posts Tagged Fatima Al Qadiri, alteredzones.com/tags/fatima-al-qadiri.

"Arabian-American Bonafide Sorceress: Q&A with Fatima Al Qadiri I the Creators Project," thecreatorsproject.com/blog/arabian-american-bonafide-sorceress-qa-with-fatima-al-qadiri.

ARTPULSE MAGAZINE » Editor's Picks » Collective Utopia: Zenana as the Public Sphere, artpulsemagazine.com/collective-utopia-zenana-as-the-public-sphere.

Ayshay: WARN-U EP I Album Reviews I Pitchfork, pitchfork.com/reviews/albums/15902-warn-u-ep/.

Bazaar Magazine - Kuwait, bazaar-magazine.com/baz/bazaar/index.php? show=eIndex&show filter=view&action=article&art_id=ART00000000395.

Bartley, Christopher. *The Last Magazine* 2 (Spring 2009).

Busby, Kate. *J Magazine* (Jazeera Airways) 20 (February–March 2011).

"Children of War: Kuwait," by Fatima Al Qadiri and Khalid Al Gharaballi I Bidoun Projects, bidoun.org/magazine/16-kids/children-of-war-kuwait-by-fatima-al-qadiri-khalid-al-gharaballi/.

"Corpcore (2010): Fatima Al Qadiri," *Rhizome,* rhizome.org/editorial/2010/oct/1/corpcore-2010-fatima-al-qadiri.

"Culture: Art: A New Take on Body, Sex and Gender," *The Daily Star,* dailystar.com.lb/Culture/Art/2011/Aug-09/A-new-take-on-body-sex-and-gender.ashx#axzz1sb7ecqdt.

"Dubstep before it Wobbled"; eidemagazine.com/index.php?option=com_k2&view=item&id=225&Itemid=17.

"Electric Selection: The Forecast," Clash Music Exclusive Interview, clashmusic.com/feature/electric-selection-the-forecast.

"Fatima Al Qadiri: How Can I Resist U." *File Magazine,* file-magazine.com/tv/fatima-al-qadiri-how-can-i-resist-u.

Friedemann. "De: BugMagazin." *De:Bug Magazin*, April 12, 2012.

"Genre Bender: Fatima Al Qadiri." *Interview Magazine,* interviewmagazine.com/art/fatima-al-qadiri/#_.

Hromack, Sarah. "NSFS: A Video Interview with K48," *Art in America* (June 23, 2009), artinamericamagazine.com/features/nsfs-a-video-interview-with-k48.

"Jamming at Telfar Clemens." *Papermag,* papermag.com/2008/09/jamming_at_telfar_clemens.php.

Flood, Kathleen. "Through the Internet and inside Fatima Al Qadiri's Genre-Specific Xperience." *The Creators Project,* November 4, 2011, thecreatorsproject.com/blog/through-the-internet-and-inside-fatima-al-qadiris-igenre-specific-xperiencei.

Lord, Christopher, "A New Art Exhibit Explores the Influence of Music in the Middle East." *The National,* June 23, 2011, thenational.ae/arts-culture/art/a-new-art-exhibit-explores-the-influence-of-music-in-the-middle-east.

"Post-Irony and Fatima Al Qadiri's Genre Specific Xperience." *Cluster Mag,* theclustermag.com/blog/2011/11/fatima-al-qadiris-genre-realness-a-critical-proximity.

Sandberg, Patrick. *V Magazine* 70 (Spring 2011): 123.

"A Slice of Pâté." *V Magazine,* vmagazine.com/2011/03/a-slice-of-pate.

"Snail Fever." *ArtAsiaPacific,* artasiapacific.com/Magazine/WebExclusives/SnailFever.

Wallace-Thompson, Anna. "Shows: *Snail Fever*." *Frieze Magazine,* July 26, 2011, frieze.com/shows/print_review/snail-fever.

MONIRA AL QADIRI

Chamas, Sophie. "Bodies Moving to Memory." *Jadaliyya,* August 4, 2011, jadaliyya.com/pages/index/2307/bodies-moving-to-memory.

Farhat, Maymanah. "New York: Sultan's Dream." *ArtAsiaPacific* 56 (2007): 166–67, artasiapacific.com/Magazine/56/NewYorkSultanaSDream.

GHADA AMER (since 2006)

ghadaamer.com

Amer, Ghada, and Martine Antlee. *Ghada Amer and Reza Farkhondeh: A New Collaboration on Paper.* Singapore: Singapore Tyler Print Institute, 2008.

———, and Maria Elena Buszek. *Ghada Amer: Breathe into Me.* New York: Gagosian Gallery, 2006.

———, and Danilo Eccher. *Ghada Amer.* Milan: Museo d'Arte Contemporanea Roma and Electa, 2007.

———, and Laurie Ann Farrell. *Ghada Amer: Le Salon Courbé.* Milan: Francesca Minini, 2007.

———, and Karen Moss. *Ghada Amer.* San Francisco: San Francisco Art Institute, 2002.

———, and Maura Reilly. *Ghada Amer.* New York: Gregory R. Miller & Co., 2010.

———, Reza Farkhondeh, Laurie Ann Farrell, et al. *Ghada Amer & Reza Farkhondeh: Collaborative Drawings.* Seoul: Kukje Gallery, 2007.

———, Reza Farkhondeh, and Nadine Rubin. *No Romance: Ghada Amer, Reza Farkhondeh & Collaborative Work.* Cape Town / Johannesburg: Goodman Gallery, 2011.

———, Vincent Katz, and Reza Farkhondeh. *Ghada Amer, Reza Farkhondeh: Roses Off Limits.* New York: Pace Prints, 2009.

———, Simon Njami, and Kukche Hwarang. *Ghada Amer: Another Spring.* Seoul: Kukje Gallery, 2007.

Bardouil, Sam, and T. Fellrath. *Told, Untold, Retold: 23 Stories of Journeys Through Time and Space.* Milan: Skira; Doha: Mathaf: Arab Museum of Modern Art, 2010.

Buszek, Maria Elena. *Extra/ordinary: Craft and Contemporary Art.* Durham: Duke University Press, 2011.

Cayne, Naomi. *Sex, Power, and the Stitch: The Contemporary Feminist Embroidery of Ghada Amer.* Philadelphia: Temple University, 2007.

Clemente, Chiara. *Our City Dreams: Five Artists, Their Dreams, One City*. Milan / New York: Charta, 2009.

Daftari, Fereshteh. *Without Boundary: Seventeen Ways of Looking*. New York: Museum of Modern Art, 2006.

Dent-Brocklehurst, Mollie, Elliot McDonald, and Sudeley Castle (Winchcombe). *Reconstruction #1*. London: Spear Media, 2006.

Domene-Danés, Maria. *Ghada Amer: Embroidering a Hybrid Work*. Bloomington: Indiana University, 2010.

Enwezor, Okwui, and Chika Okeke-Agulu. *Contemporary African Art since 1980*. Bologna: Damiani, 2009.

Fahrer, Wan Ling. *The Fine Art of Threading*. New York: Hunter College, 2009.

"Ghada Amer." In Simon Njami, ed. *Africa Remix: Contemporary Art of a Continent*. Ostfildern: Hatje Cantz, 2005; Johannesburg: Jacana Media, 2007.

"Ghada Amer." In Paul Sloman, ed. *Contemporary Art in the Middle East*. London: Black Dog, 2009.

"Ghada Amer: Painter, Sculptor, Installation Artist." In Dele Jegede, ed. *Encyclopedia of African American Artists*. Westport: Greenwood Press, 2009.

Hericks-Bares, Eva Susanne. *Creating Art within Boundaries Without: Ghada Amer and Zineb Sedira*. New York: Stony Brook University, 2006.

Kaphetse, Anna. *O Megalos Peripatos* (The Grand Promenade). Athens: Ethniko Museio Synchrones Technes, 2006.

Loring Wallace, Isabelle, and Jennie Hirsh. *Contemporary Art and Classical Myth*. Farnham / Burlington: Ashgate, 2011.

Monem, Nadine Käthe. *Contemporary Textiles: The Fabric of Fine Art*. London: Black Dog, 2008.

Nabil, Youssef, and Octavio Zaya. *Youssef Nabil: I Won't Let You Die*. New York: D.A.P. / Distributed Art Publishers, Inc., 2009.

Oweis, Fayeq. *Encyclopedia of Arab American Artists*. Westport: Greenwood Press, 2008.

Sharp, Christopher, and Sarah Kent. *Demons, Yarns & Tales: Tapestries by Contemporary Artists*. Bologna / London: Damiani, in association with Banners of Persuasion, 2008.

Sloman, Paul. *Contemporary Art in the Middle East*. London: Black Dog, 2009.

St. Gelais, Thérèse. *Ghada Amer*. ABC Art Books Canada Distribution, 2012.

ZEINA BARAKEH

zeinabarakeh.com

Al-Taki, Yakzan. "Faces that Do Not Rest." *Al-Mustaqbal* (2005): 13.

G. D. "Facettes de Zeina Barakeh: La Femme aux grands yeux." *L'Orient-Le Jour* (2005).

Ghanem, Zuheir. "The Adventure of Expression and Illuminated Mirrors." *Al-Liwaa* (2005): 23.

Ghannam, Jess. Interview with Zeina Barakeh. *Arab Talk*, KPOO 89.5 FM, San Francisco, 2007.

Ghorayeb, Laure. "Interlaced Pathways Between Abstraction, Examination, and Self-Portraiture." *An-Nahar* (2005): 10.

Harfouche, Nicole Malhamé. "Des Oeuvres nées d'une vision intérieure." *La Revue du Liban* (2005): 51.

Interview with Zeina Barakeh, Alam Al Sabah (Future TV), Beirut, 2005.

Osseiran, Sawsan. Interview with Zeina Barakeh. Heya TV (Arab Woman Channel), Beirut, 2005.

Wilson-Goldie, Kaelen. "Twenty-One Ways of Looking at the Face of Zeina Barakeh." *The Daily Star/International Herald Tribune*, May 5, 2005, 12.

"Zeina Barakeh Searches for Her Inner Self and for Her Different Faces." *Al-Ousbou' Al-Arabi* (2005): 47.

OFRI CNAANI

ofricnaani.com

Art in General. *5th Annual Video-Marathon Catalogue*. New York: Art in General, 2003.

Aviv, Naomi. *The Kiss: Yehiel Hemi, Yael Cnaani, and Ofri Cnaani*. Tel Aviv: Kalisher Gallery, 2002.

Ben-Ner, Guy. *Waiting Room*. Tel Aviv: Peer Gallery, 2000.

Casati, Martha. "Ofri Cnaani." *EspoArte* 39 (February–March 2006).

Castello e Parco dell'Acciaolo, *Storytellers*. Scandicci, 2007.

"Catalog." *Art Focus* 4 (December 2003).

Ciu, Carmela. "Slippery Cabaret Art." *The Forward*, February 4, 2009.

Cohen, David, ed. "Ofri Cnaani: The Colonel and I," *artcritical.com* (April 2005).

"Colonel Collection," *New York Sun*, March 16, 2005.

Dana, Shuepi. "Decreation," *Time Out TLV*, January 2007.

Director, Ruty. "The Understanding of the Ceiling." *Ha-Eir* (April 2003).

"Dungeon," *Block Magazine* (Tel Aviv) (June 2006).

Eisenberg, Adam. "Ofri Cnaani: A Tale of Ends," *Flavorpill* (February 2009).

"[Female torso next to bearded man's head] [art reproduction]." *Artforum International* 43, no. 7 (March 2005): 146.

Gal-Azmon, Neta, and Muzeon Bat Yam le-omanut. *16 Matok: `al na`arut Ve-Gil Hitbagrut : Hilah Ben Ari, Tali Ben-Basat, Sharon Bareket, Uri Gershuni, Anah Yam, Ronah Yefman, `Ofri Kena`a`ni, Hilah Lulu Lin, Sashah Serber, Eden `Ofrat, Ayal Frid, Keren Shpilsher*. Bat Yam: Bat Yam Museum, 2007.

Garwood, Deborah. "A Multi-Media Artist's Taut Reporting," *Gay City News* 14, 204.2.109.187/gcn_415/multimediaartist.html.

———, "Visionaries," *NYArts* (August 2005).

Gat, Orit. "Artist Profile: Ofri Cnaani," *Rhizome*, December 14, 2011.

Gilerman, Dana. "A Game with Secret Rules." *Haaretz* (January 2002).

———. "Harmony of Negatives." *Haaretz* (July 2001).

———. "It's from Home." *Haaretz* (July 2002).

Glinter, Ezra. "Forward Fives Mark Best in Arts." *The Forward* (December 2011).

Goldfine, Gil. "Under the Plastic Tree," *The Jerusalem Post* (May 2003).

Herschthal, Eric. "The Art of 'Sisterhood.'" *The Jewish Week*, March 1, 2011, thejewishweek.com/arts/theater/art_sisterhood.

———. "Israeli Artists Caught Between Here and Home." *The New York Jewish Week*, March 21, 2008.

Jablon, Samuel. "Exhibition Review." *Bomblog*, March 16, 2011.

Kaplan, Cheryl. "Dangerous Liaisons." *The Jewish Daily Forward*, February 23, 2011.

Lipman, Steve. "(Gen) X Plus Y Equals 10 (Commandments)." *The New York Jewish Week*, June 10, 2005.

Maine, Stephen. "Space Is the Place." *Artnet Magazine* (June 2006).

Margit, Eszter. "Moving Talmudic Murals." *Jewish Art Now*, February 17, 2011.

Meltzer, Gilad. "Twilight Zone." *Yediot Ahronoth* (April 2003).

"Occasional Cities," *Block Magazine* (Tel Aviv) (April 2007).

Ofri Cnaani. Milan: Galleria Pack, 2006.

Ofri Cnaani: Death Bed. Haifa: Haifa Museum of Art, 2006.

Sanderson, Naomi. "Everything Is in Order: Ofri Cnaani's Video-Art Trilogy" (August 2011), *comme-il-fault.com*.

Segal, Noam. "A Viewer in Search of Meaning," *Programma* (September 2009).

"Self-Portrait," *Tema Celeste* (July 2005).

Sheffi, Smadar. "Creation from the End to the Beginning." *Haaretz* (February 2007).

———. "Directly to the Central Circle." *Haaretz* (July 2001).

———. "Ofri Cnaani: The Black & White Theater." *Haaretz* (January, 2005).

———. "A Playground Full of Surprises." *Haaretz* (July 2002).

The Sota Project. Montreal: Sternthal Books, 2010.

The Space Between. Yedioth Achronot: Petach tikva Museum, n.d.

Sutton, Benjamin. "Top 10 Exhibitions in Brooklyn in 2011." *The L Magazine,* December 21, 2011.

Tsur, Uzi. "Ofri Cnaani: The Black & White Theater," *Haaretz* (January 2005).

———. "The Possible Revolving of the Young Artist." *Haaretz* (August 2001).

———. "Reverberating Between Spaces and Senses." *Haaretz* (January 2002).

———. "Summer in the Winter." *Haaretz* (February 2007).

Two Dimensional Days. New York: Andrea Meislin Gallery, 2007.

Young, Stephenie. "Ofri Cnaani." *Vellum Magazin* (December 2006).

Zanfi, Claudia. "Atlanta Mediterraneo." *Going Public* 6 (2006).

———. *Going Public '04: Mappe, Confini, Nuove Geografie* (Maps, Confines, and New Geographies). Milan: Silvana, 2004.

———. *Ofri Cnaani.* Milan: Galleria Pack, 2007.

———. "The Sun Still Shines: One Journey, One Hope," *Milan* (March 2005).

"1998–2008: Real Time," *Eretz Magazine* (June–July 2000).

NEZAKET EKICI

ekici-art.de

Belasco, Daniel. "Nezaket Ekici at Elgiz Museum and Karsi Sanat." *Art in America* 94, no. 8 (September 2006): 183.

Biesenbach, Klaus. "Into Me / Out of Me." *Flash Art* 39, no. 249 (September 2006): 78–81.

Claus, Elisabeth. *Das Kritische Auge : Nezaket Ekici–Türkei, Parastou Forouhar–Iran, Amirali Ghasemi–Iran, Mohammed Shoukry–Ägypten, Keun-Byung Yook–Korea.* Aschaffenburg: Neuer Kunstverein Aschaffenburg, 2006.

Denaro, Dolores, and Caroline Nicod. *Seriously Ironic: Positions in Turkish Contemporary Art Scene.* Nuremberg / Biel: Verlag für moderne Kunst / CentrePasquArt, 2009.

Ekici, Nezaket. *Nezaket Ekici: Mimesis Performance, Freitag 2. September 2005: Kirche St. Martin, Martinsplatz : Kantonsbibliothek/Staatsarchiv, Karlihofplatz: Capellerhof, Kornplatz* s.n., 2005.

Ekici, Nezaket, and Friederike Fast. *Personal Map: To be Continued...* Bielefeld: Kerber, 2011.

———, Özlem Günyol, Barbara Heinrich, et al. *Türkisch Delight : Nezaket Ekici ; Özlem Günyol Und Mustafa Kunt ; Gülsün Karamustafa : Ebru Özseçen Anny Und Sibel Öztürk ; Iskender Yediler.* Nordhorn: Der Städtischen Galerie Nordhorn, 2007.

Hatry, Heide. *Meat after Meat Joy.* Cambridge: Pierre Menard Gallery, 2009.

Liveartwork DVD. Issue 4, Nov 06 Showcasing Contemporary Live Art. 1 videodisc (100 min.): sd., col.; 4 3/4 in. Directed by B. Catling, Nezaket Ekici, Julie Andrée T., et al. Berlin, Germany: Liveartwork.com, 2006.

Lungu, Florentina. "Chefs-d'Oeuvre privés temporairement publics." *Vie des Arts* 210 (March 2008): 69–71.

Meyer, Helge. "Une Transformation de la durée et du temps." *INTER* 86 (Winter 2003–2004): 20–21.

Nachtigäller, Roland. *Turkish Delight.* Nordhorn: Städtische Galerie Nordhorn, 2007.

Nezaket Ekici: GASAG-Kunstpreis 2004. Berlin: Kunstfabrik am Flutgraben, 2004.

Pfütze, Hermann. "Mahrem: Anmerkungen zum Verschleiern." *Verhüllungsdiktat und Geschlechterspannung* 193 (2008): 280–82.

Selen, E. "The Work of Sacrifice: Gender Performativity, Modernity, and Islam in Contemporary Turkish Performance (1980s–2000s)." PhD diss., New York University, 2010.

Tannert, Chistoph. "Nezaket Ekici." *European Photography* 28, no. 2 (December 2007): 24–25.

Tragatschnig, Ulrich. "Das Eigene im Fremden und Vice Versa." *Kunst und Kirche* 3 (2008): 56–58.

Westcott, James. "Silence Is Golden." *Art Review* 54 (September 2004): 74–77.

DIANA EL JEIROUDI

Atakav, Eylem. "Representations and/or Interpretations: Women in Middle Eastern Film." *Near East Quarterly,* June 19, 2012, neareastquarterly.com/?p=268.

Dolls: A Woman from Damascus. Twenty-Fifth International Documentary Film Festival, Amsterdam (IFDA), idfa.nl/industry/tags/project.aspx?id=03723143-f3a3-4f9b-bc09-e45e7de6ec00.

Jackson, Tabitha. "Dolls: A Woman from Damascus." First Hand Films, firsthandfilms.com/index.php?film=1000251.

Jandaghian, Shohreh. "Diana El Jeiroudi talks about 'Veiled Barbie dolls.'" *Cinema Without Borders,* July 24, 2007, cinemawithoutborders.com/conversations/1327-diana-el-jeiroudi-talks-about-veiled-barbie-dolls.html.

Junko, Tsukamoto. "An Interview with Diana El Jeiroudi (Director): Individuality Is Diverse." *New Asian Currents,* yidff.jp/interviews/2005/05i056-e.html.

Portis, Larry. "Diana El Jeiroudi's *Dolls: A Woman From Damascus*: Syria and the Arab Barbie Doll–Before the Deluge." *CounterPunch,* January 2–4, 2009, counterpunch.org/2009/01/02/syria-and-the-arab-barbie-doll-before-the-deluge.

"Wide Field of Vision: Independent Film Documentary in Syria." *The Majala,* November 16, 2010, majalla.com/eng/2010/11/article55192713.

"2009 Asian Art Biennial." E-flux, November 29, 2009, e-flux.com/announcements/2009-asian-art-biennial/.

PARASTOU FOROUHAR (since 2006)

parastou-forouhar.de

Afsarian, Iman, Parastou Forouhar, and Susann Wintsch. *Analysing While Waiting (for Time to Pass): Contemporary Art in Tehran.* Zürich: S. Wintsch, 2007.

Claus, Elisabeth. *Das Kritische Auge : Nezaket Ekici– Türkei, Parastou Forouhar–Iran, Amirali Ghasemi–Iran, Mohammed Shoukry–Ägypten, Keun-Byung Yook–Korea.* Aschaffenburg: Neuer Kunstverein Aschaffenburg, 2006.

Forouhar, Parastou. *Black is My Name, White is My Name Series [Art Reproduction]* (2010).

———. *Das Land, in dem Meine Eltern Umgebracht Wurden: Liebeserklärung an Den Iran.* Freiburg / Basel / Vienna: Herder, 2011.

———. *Yakhbandan Butterfly [Art Reproduction]* 98 (2010).

Forouhar, Parastou, and Susann Wintsch. *Treibsand: DVD Magazine on Contemporary Art* (Zurich) 1, 2007.

Glanville, Jo. *Index on Censorship* ("Art Issue") 40, no. 3 (2011).

Harris, Gareth. ". . . and Contemporary Is nearly as Bad." *Art Newspaper* (November 2011), no. 229: 97.

Herda, Isabel, and Jochen Ludwig. *Iran.Com: Iranische Kunst Heute* (Iranian Art Today). Freiburg: Modo, 2006.

Hoffmann, Jakob. *Eastern Expressway Kunst im Zeichen der Krise: Mohamed Abdulla, Mahmoud Bakshi-Moakhar, Parastou Forouhar, Amirali Ghasemi, Marc Petzoldt, Talal Refit, Jinoos Taghizadeh.* Frankfurt am Main: Gutleut-Verl, 2006.

Issa, Rose. *Iranian Photography Now.* Ostfildern: Hatje Cantz, 2008.

———. "Nowhere to Go." *Art in Exile* (2010), no. 17: 36–47.

————. *Parastou Forouhar: Art, Life, and Death in Iran.* London: Saqi Books, 2010.

Kirkpatrick, Gail B., Susanne Düchting, and Julia Wirxel. *Krieg/Individuum: 20.* Berlin: Revolver, 2010.

Mascheroni, Loredana. *Identità Negate / Denied Identities.* 2010.

Mühleis. *Ein Kind lässt einen Stein ubers Wasser Springen. Zu Entstehungsweisen Von Kunst.* Paderborn: Verlag Wilhelm Fink, 2011.

Nouri, Miriam, "In Violence: Aesthetics & Politics in Iran." MA thesis, California Institute of the Arts, 2011.

"Nuevos modos de la ornamentación." *Lapiz* 28, no. 250–251 (March 2009): 42–42.

Nungesser, Michael. "Heimat Kunst." *Kunstforum International* 151 (July–September 2000): 305–307.

Pellinghelli di Monticello, Giovanni. "Donna iraniana ovunque in esilio." *Giornale dell'Arte* 28, no. 297 (April 2010).

Pfütze, Hermann. "Hannah Arendt Denkraum." *Kunstforum International* 183 (February 2006): 308–310.

————. "Mahrem: Anmerkungen zum Verschleiern Verhüllungsdiktat und Geschlechterspannung." *Kunstforum International* 193 (October 2008): 280–282.

————. "Re-Imagining Asia: Kampfabsage der Kulturen." *Kunstforum International* 191 (July 2008): 286–289.

Reckitt, Helena. "Unusual Suspects: 'Global Feminisms' and 'WACK! Art and the Feminist Revolution.' " *n.paradoxa* 18 (2006): 34–42.

Rouhani, Omid. "Women Artists: The Big Issues." *Art Press* 17 (*L'Iran dévoilé par ses artistes*) (July 2010): 48–54.

Wallace, Miranda. *21st Century: Art in the First Decade.* South Brisbane: Queensland Art Gallery, 2010.

Wintsch, Susann. "Eine Strategie der Vieldeutigkeit." *Kunst-Bulletin* 1–2 (February 2010): 38–39.

Wolinski, Natacha. "Regards Persans." *Beaux Arts Magazine* 297 (March, 2009): 86–91.

AYANA FRIEDMAN

ayanafriedman.info

Abrams, Carol K. "From Family Violence to Healing: Powerful New Art Exhibit by American and Israeli women at HUC." *The Jewish Cleveland News,* December 26, 1997.

Auerbach, Aliza, Ayana Friedman, and Gila Svirsky. *Golden Aging.* Jerusalem: Artists' House, 2000.

Blustain, Sarah. "Battered Images Reflect Rough Realities: American and Israeli Women Artists Address Family Violence in Their Work," *Forward,* October 17, 1997.

Cassouto, Nella. *Long Memory / Short Memory: Daniel Sack, Elisha Dagan, Moshe Gershuni, Ariane Littman-Cohen, Yocheved (Juki) Weinfeld, Moshe Kupferman, Mani Salama, Ayana Friedman, Micha Ullman.* Raleigh: City Gallery of Contemporary Art, 1997.

Dugan, Cory. "Beasts of Burden." *Memphis Flyer,* October 19, 1998.

Friedman Ben-David, Miriam Friedman, and Ayana Friedman. *A Holokauszt Árnyékában Izraeli Muvészej "Második Generáció* [In the Shadow of the Holocaust: "Second Generation" Israeli Artists]. Budapest: Peter Wilhelm Art Projects, 2008.

Friedman, Ayana. "Artist and Teacher: Julia Keiner-Forchheimer." *Weaving and Collages* (Jerusalem) (Fall–Winter 1993): 9–12.

————. *A Choice of Alternatives.* Mishkenot Sha'ananim, Jerusalem: Fischer Gallery; Haim Zippori Community Education Center; and Kol Ha-Isha, 1996.

————. "Dancing is Sculpture, Too: The Dance of Rina Schoenfeld is like Sculpture." *Mishkafayim* 11 (1990): 56–57.

————. "Entrance Women Only: American Artist Judy Chicago Makes Dinner for 39 Women who Left Their Mark on History." *Mishkafayim* 31 (1997): 24–27.

————. "The Geisha, the Hamburger, and AIDs," *Studio Art Journal* 6 (1989): 44–45.

———. *Ha-Tseva` Ha-Shlishi.* Jerusalem: Bet ha-omanim: 2000.

———. "Heavy as a Feather: On Stone in the Art of Ilan Auerbach, an Israeli Artist who Lives and Aworks in the U.S. and Europe." *Mishkafayim* 37 (1999) 67–69.

———. *Here and Now: First Work by Immigrant Artists from the Soviet Union.* Jerusalem: Van Leer Institute, 1992.

———. "Interview with Martin Weyl." *Studio Art Journal* 14 (1990): 4–5.

———. "Knitted Sculpture: On the Work of Contemporary German Artist Rosemarie Trockel." *Mishkafayim* 33 (1998): 32–34.

———. "Locations of Ra: On the Art of Dov Or-Ner," *Studio Art Journal* 5 (1989): 26.

———. "Munch: The Drama on the Bridge," *Studio Art Journal* 15 (1990): 28–29.

———. "The Rope and the Hanging," *Studio Art Journal* 5 (1989): 28–29.

———. "Sculptural Garments: Clothing as Packaging and Sculpture in the Work of Six Artists." *Mishkafayim* 9 (1990): 17–19.

———. "Soft Sculpture: The Season of Fiber." *Studio Art Journal* 32 (1992): 24–25.

———. *A Swing for Every Age: The Third Color.* Jerusalem: Artists' House.

———. "Tracks of Time: On an Installation of Adina Bar-On and Daniel Davis." *Mishkafayim* 20 (1994): 34.

———. "The Trick is to Love on a Philosophical Level: The Art of Jeff Koons and Ciccioline." *Mishkafayim* 18 (1993): 78.

———. "Ya'akov Pins: Artist, Collector, Teacher." *Studio Art Journal* 24 (1991): 48–49.

———. *Yarok `ad* (Evergreen). Jerusalem: Bet avi hai, 2011.

Friedman, Ayana, Y. Kuris, and Haim Maor. *Kolo Shel Ha-`ets : Pisul 1980–1994.* Jerusalem: h. mo. l, 1994.

Gordon, Ayala, Ayana Friedman, and Gila Svirsky. *By Way of Flour.* Beer Sheva: Kaye College of Education, Art Gallery, 2001.

Ilan, Neve. *Passages: Artfocus 1994.* Israel: Navon Gallery, 1994.

Kruger, Laura, Ayana Friedman, Yitzhak Brick, et al. *The Art of Aging.* New York: Hebrew Union College / Jewish Institute of Religion Museum, 2003.

Linker, Jane. "Images of Life: Israeli Artist Salutes Women and Their Struggles in Photo Exhibit at Mamaroneck Gallery." *The New York Jewish Week* (Manhattan edition), September 18, 1998.

Mann, Bruría, and Ayana Friedman. *Beruryah Man.* Israel: Kav Graph, 2002.

Ossman, Tova. *"Le-Marit `ayin"* ("It Seems as if"). Yavneh: Iriyat Yavneh, Agaf hinukh ve-tanus, ha-Mahlakah le-tarbut, 2000.

Pardes, Hannah. "Not by Portrait Alone… Introduction and Analysis of the Work of Sixteen Artists." *The Golden Brush: Self Portrait.* Shoham Geriatric Center, 2003.

Wilhelm, Peter, and Peter Wilhelm Art Projects. *In the Shadow of the Holocaust: "Second Generation" Israeli Artists.* Budapest: Peter Wilhelm Art Projects, 2008.

SHADI GHADIRIAN (since 2006)

shadighadirian.com

Azimi, Roxana. "Le Moyen-Orient, Mirage ou Véritable Oasis?" *Oeil* 599 (February 2008): 98–99.

Bush, Samar Mohammad. *Complicating the Veiled Iranian Woman: The Work of Shirin Neshat and Shadi Ghadirian.* 2008.

Carver, Antonia. "Christie's Second Sale Makes $9.4m." *Art Newspaper* 16, no. 178 (March 2007): 56–56.

Corty, Axelle. "L'Art iranien en première ligne." *Connaissance des Arts* 675 (October 2009): 122–123.

Crenn, Julie. "Sous le voile, la lutte: Les Photographies de Shadi Ghadirian." *Les Éditions Intervention Érudit*, id.erudit.org/iderudit/65837ac; id.erudit.org/iderudit/65837ac.

Downey, Anthony. "Children of the Revolution: Contemporary Iranian Photography." *Aperture* 197 (December 2009): 38–45.

Etehadieh, Anahita Ghabaian. "La Photographie iranienne et ses enjeux / Iranian Photography: Issues and Developments." *Art Press* 361 (November 2009): 63–71.

Genocchio, Benjamin. "In the Heat of the Moment." *Art in America* 97, no. 10 (November 2009): 121–129.

—— "The Insanity of Iran." *Artinfo* 23, no. 4 (2011): 48–56.

Ghadirian, Shadi, and Ruchira Gupta. *Qajar: Out of Focus; West by East; Like Everyday; My Press Photo; be Colorful; Ctrl+Alt+Del.* Bangalore: Tasveer, 2008.

Hattori, Cordélia, Jean-Marie Dautel, and Régis Cotentin. *Miroirs d'Orients: Dessins, Photographies, Autochromes, Vidéo.* Paris / Lille: Somogy éditions d'art; Palais des Beaux-Arts, 2009.

Issa, Rose. *Iranian Photography Now.* Ostfildern: Hatje Cantz, 2008.

—— "Shadi Ghadirian." *Art Press* 17 (*L'Iran dévoilé par ses artistes*) (July 2010): 75–77.

Lam, Melissa. "Letter from London." *Vie des Arts* no. 215 (June 2009): 13–13.

Mascheroni, Loredana. *Identità Negate / Denied Identities.* 2010.

Maulmin, Valérie de. "Les Artistes arabes en pleine ascension." *Connaissance des Arts* no. 659 (April 2008): 144–145.

Merali, Shaheen. *The Promise of Loss: A Contemporary Index of Iran.* Vienna: ÖIP/EIKON, 2009.

Moisdon, Stéphanie. "Provocateur, spéculateur ou visionnaire?" *Beaux Arts Magazine* 317 (November 2010): 120–125.

Nouri, Miriam, "In Violence: Aesthetics and Politics in Iran." MA thesis, California Institute of the Arts, 2011.

Pellinghelli di Monticello, Giovanni. "Donna iraniana ovunque in esilio." *Giornale dell'Arte* 28, no. 297 (April 2010).

Porter, Venetia, and Isabelle Caussé. *Word into Art: Artists of the Modern Middle East.* London: British Museum Press, 2006.

Rouhani, Omid. "Women Artists: The Big Issues." *Art Press* no. 17 (*L'Iran dévoilé par ses artistes*) (July 2010): 48–54.

Sausset, Damien. "Charles Saatchi, Le (dé)Faiseur De Stars." *Connaissance des Arts* 687 (November 2010): 74–77.

Severi, Hamid, and Mandana Mapar. *Ey! Iran: Contemporary Iranian Photography.* Surfers Paradise, Qld: Gold Coast City Art Gallery, 2006.

Sloman, Paul. *Contemporary Art in the Middle East.* London: Black Dog, 2009.

Tavakoli, Shahriar. "Iranian Photography: Snapshots over the Years." *Art Press* 17 (*L'Iran dévoilé par ses artistes*) (July 2010): 86–95.

They Call Me Muslim: A Documentary. 1 videodisc (27 min.): sd., col.; 4 3/4 in. Directed by Diana Ferrero and Women Make Movies. New York: Women Make Movies, 2006.

Thomson, Jonathan. "A Fair to Remember." *Asian Art News* 19, no. 3 (June 2009): 78–83.

Unveiled: New Art from the Middle East. London: Booth-Clibborn Editions, 2009.

Weisbrich, Christian, Fr Welschen, and Gerd Borkelmann. *Different Places, Different Stories 09.* Cologne: Salon, 2009.

Wolinski, Natacha. "Grand Angle sur l'Iran et les pays Arabes." *Beaux Arts Magazine* 305 (November 2009): 160–165.

—— "Regards Persans." *Beaux Arts Magazine* 297 (March 2009): 86–91.

MONA HATOUM (since 2007)

Adolphs, Volker, and Philip Norten. *Gehen, Bleiben: Bewegung, Körper, Ort in der Kunst der Gegenwart* (Going, Staying: Movement, Body, Space in Contemporary Art). Bonn: Kunstmuseum Bonn; Ostfildern: Hatje Cantz, 2007.

Alphant, Marianne, Nathalie Léger. *Objet Beckett: Ouvrage réalisé à l'occasion de l'exposition Samuel Beckett présentée Au Centre Pompidou*. Paris: Centre Pompidou and Institut Mémoires de l'édition Contemporaine, 2007.

Amirsadeghi, Hossein, Salwa Mikdadi, and Nada M. Shabout. *New Vision: Arab Contemporary Art in the 21st Century*. London: Thames & Hudson, 2009.

Ankori, Gannit. *Palestinian Art*. London: Reaktion, 2006.

Antoni, Janine, and Mona Hatoum. *Mona Hatoum*. Amman: Darat al Funun, Khalid Shoman Foundation, 2008.

Archer, Michael, Guy Brett, Catherine de Zegher, et al. *Mona Hatoum*. London / New York: Phaidon Press, 2010.

Aydemir, Murat, and Alex Rotas. *Migratory Settings*. Amsterdam / New York: Rodopi, 2008.

Bailer, Juli Cho. *Mining Glass*. Tacoma: Museum of Glass, 2007.

Bell, Kirsty. *Mona Hatoum: Unhomely*. Berlin: Holzwarth Publications, 2008.

Berengo, Adriano. *Glasstress. Biennale Di Venezia*. Milan / New York: Charta, 2009.

Bertola, Chiara, ed. *Mona Hatoum: Interior Landscape*. Milan: Charta: 2009.

Biddle-Perry, Geraldine, and Sarah Cheang. *Hair: Styling, Culture and Fashion*. English-language edition. Oxford / New York: Berg, 2008.

Bonora, Lola G. *Mona Hatoum: Undercurrents*. Ferrara: Gallerie d'arte moderna contemporanea, 2008.

Boullata, Kamal, and John Berger. *Palestinian Art, 1850–2005*. 1st edition. London / Berkeley: Saqi Books, 2009.

Bühler, Kathleen. *Ego Documents: Das Autobiographische in der Gegenwartskunst* (The Autobiographical in Contemporary Art). Heidelberg: Kehrer, 2008.

Eigner, Saeb, and Isabelle Caussé. *L'Art Du Moyen-Orient: L'Art moderne et contemporain du monde arabe et de l'Iran*. Paris: Ed. du Toucan, 2010.

Finger, Brad, and Christiane Weidemann. *50 Contemporary Artists You Should Know*. Munich / New York: Prestel, 2011.

Furlong, William, and Mel Gooding. *Speaking of Art: Four Decades of Art in Conversation*. London / New York: Phaidon, 2010.

Goetz, Ingvild, and Rainald Schumacher. *Mona Hatoum*. Munich: Sammlung Goetz, 2011.

Hapkemeyer, Andreas. *Magic Line*. Milan / New York: Charta, 2007.

Hatoum, Mona. *Mona Hatoum*. Milan: Charta, 2009.

Hatoum, Mona, and Chiara Bertola. *Mona Hatoum: Interior Landscape*. Milan: Charta, 2009.

———, Ingvild Goetz, Leo Lencsés, et al. *Mona Hatoum*. Ostfildern: Hatje Cantz, 2011.

———, and Catherine Grenier. *Mona Hatoum*. Vancouver: Rennie Collection, 2010.

———, and Chus Martínez. *Le Grand Monde: Mona Hatoum*. Santander: Fundación Marcelino Botín, 2010.

Hervol, Anke, and Mona Hatoum. *Mona Hatoum*. Berlin: Akademie der Künste: 2010.

Holzwarth, Hans Werner. *Art Now, Vol. 3: A Cutting-Edge Selection of Today's Most Exciting Artists*. Cologne / London: Taschen, 2008.

Husslein-Arco, Agnes Vogel, and Sabine B. Vogel. *Die Macht des Ornaments*. Vienna: Belvedere, 2009.

Kiefer, Carol Solomon, Janet Yoon, Fariba Alam, et al. *Mapping Identity*. Haverford: Haverford College, 2010.

Laïdi-Hanieh, Adila. *Palestine: Rien ne nous manque ici*. Brussels: University of Brussels. 2008.

Lebanese Artists: Michel Elefteriades, Sami Makarem, Mona Hatoum, Jalal Toufic, Chaouki Chamoun; List of Lebanese Artists. Memphis: Books LLC, 2010.

Mathur, Saloni. *The Migrant's Time: Rethinking Art History and Diaspora*. Williamstown / New Haven: Sterling and Francine Clark Art Institute, 2011.

May, Susan. *Kupferstichkabinett: Between Thought and Action.* London: White Cube, 2010.

McFadden, David Revere, and Holly Hotchner. *Slash: Paper under the Knife.* Milan / New York: 5 Continents, 2009.

Mouakhar, Nizar. *"Le 'Faire-Oeuvre': Poïésis de l'altération, du grattage et du barbouillage dans la peinture."* Thesis, University of Provence, 2007.

Palestinian Peoples : Nabil Shaath, Abdel-Razak Al-Yehiyeh, George Bisharat, Farouk Shami, Afif Safieh, Juliano Mer-Khamis, Nadia Hijab, Morad Fareed, Omar Jarun, Abu Obeida, Faisal Husseini, Ali Abunimah, Kawther Salam, Mona Hatoum, Naseer Aruri, Fadwa Touqan, Nasser Al-Shaer, Mahmoud Tawalbe, Roberto Kettlun. Memphis: Books LLC, 2010.

Prinz, Ursula. *Neue Heima: Berlin Contemporary.* Bielefeld: Kerber, 2007.

Post-War & Contemporary Art: Afternoon Session. London: Christie's, 2008.

Pot Luck: Bobby Baker, Han Bing, Helen Chadwick, Gayle Chong Kwan, Anya Gallaccio, Antony Gormley, Subodh Gupta, Mona Hatoum, Aaron Head, Lia Anna Hennig, Damien Hirst, Anthony Key, Lucy + Jorge Orta, Rainer Prohaska, Manuel Saiz, Jana Sterbak, Karen Tam. London: Art Circuit Touring Exhibitions, 2009.

Rattemeyer, Christian. *Kompass: Zeichnungen aus dem Museum of Modern Art.* Ostfildern: Hatje Cantz, 2011.

Roman, Mathilde. *Art vidéo et mise en scène de soi: Essai.* Paris: L'Harmattan, 2008.

Rosen, Rhoda. *Imaginary Coordinates.* Chicago: Spertus Institute of Jewish Studies, 2008.

Rugoff, Ralph. *The New Décor.* London / New York: Hayward, 2010.

Schjeldahl, Peter. *Let's See: Writings on Art from the New Yorker.* New York: Thames & Hudson, 2008.

Sloman, Paul. *Contemporary Art in the Middle East.* London: Black Dog, 2009.

Turbulence: 3rd Auckland Triennial 2007. Auckland Art Gallery and N. Z. Artspace. Auckland: Auckland Art Gallery, 2007.

Van Assche, Christine. *Vidéo Vintage, 1963–1983: Une Sélection de vidéos fondatrices des collections nouveaux médias du Musée National d'Art Moderne Centre Pompidou.* Paris: Centre Pompidou Editions, 2012.

Wanås 2008: Förlust. Knislinge: Wanås Foundation, 2008.

Watteau, Diane, and Yann Beauvais. *Vivre l'intime.* Paris: Thalia, 2010.

Weidemann, Christiane, Petra Larass, and Melanie Klier. *50 Women Artists You Should Know.* Munich / London / New York: Prestel, 2008.

Wu, Haien, Guangdong mei shu guan, Shou du bo wu guan (Beijing, China), Zhong yang mei shu xue yuan (China), Great Britain, Embassy (China), Culture and Education Section, and British Council. *Yu Zhen: Yingguo Dang Dai Yi Shu Zhan 1990–2006* (Aftershock: Contemporary British art, 1990–2006). Di 1 ban ed. Changsha Shi: Hunan mei shi chu ban she, 2007.

HAYV KAHRAMAN

hayvkahraman.com

Ailyn, Agonia. "Hayv Kahraman Exhibition." *Qatar Tribune* (May 2009), qatar-tribune.com.

El Baroni, Bassa. *Life Drawing: Approaches to Figurative Practices by Neda Hadizadeh, Ghadah Al Kandari, Hayv Kahraman, and Lamya Gargash.* Dubai: Third Line Gallery, 2007.

Gavin, Francesca. *100 New Artists.* London: Laurence King, 2011.

"Hayv Kahraman." *Sleek* (Winter 2009).

Honigman, Ana Finel. "Interview with Hayv Kahraman." *ARTslant* (2009).

"Iraqi Artist to Exhibit Works on Women," *The Peninsula*, thepeninsulaqatar.com.

Mohsini, Yasmine. "Inner Travels." *Canvas Magazine* (November 2009).

Moon, Timur. "Cruelty in the Pursuit of Beauty." *The National*, November 3, 2010.

Paynter, November. "Interview with Hayv Kahraman." *RES* (September 2009), no. 4.

"Pins and Needles / Model Poise." *NY Arts* 16, no. 1 (January 2011): 88–90.

Shabout, Nada. *New Vision: Arab Art and the Twenty-First Century*. London: Transglobe Publishing, 2009.

Unveiled: New Art from the Middle East. London: Booth-Clibborn Editions, 2009.

Vali, Murtaza. "Islamic Inspiration." *V&A Magazine* 25 (June 2011): 46–53.

Wallace-Thompson, Anna. "Smile, You're in Sharjah." *Canvas* (May 2009): 57–62.

EFRAT KEDEM

efratkedem.com

"A Collection of Films." *Classes of 2006/07*. 1 videodisc: sd., col.; 4 3/4 in. Directed by Hagar Ben Asher, Pathways, Genady Kuchuk, et al. Israel: Minshar for Art School and Center, 2007.

Ofrat, Gideon, and Daria Kassovsky. *Ha-Nimrodim Ha-Hadashim*. Jerusalem: Bet ha- omanim, 2011.

Va`adat Peniyot Ha-Tsibur. 1 videodisc (DVD PAL) (162 min.): col.; 4 3/4 in. Directed by Ilan Gilon, Mosheh Matalon, Efrat Gafni, et al., 2010.

SIGALIT LANDAU (since 2006)

sigalitlandau.com

Adolphs, Volker, and Philip Norten. *Gehen, Bleiben: Bewegung, Körper, Ort in Der Kunst Der Gegenwart* (Going, Staying: Movement, Body, Space in Contemporary Art). Bonn: Kunstmuseum Bonn; Ostfildern / New York: Hatje Cantz, 2007.

Bailey, Stephanie. "The Politics of Sustenance." *Aesthetica* 42 (September 2011): 30–35.

Bouruet-Aubertot, Véronique. "Les Dix Artistes israéliens à connaître." *Connaissance des Arts* 678 (January 2010): 80–89.

Bousteau, Fabrice, Emmanuelle Lequeux, and Natacha Nataf. "54e Biennale de Venise: Le Meilleur et le pire." *Beaux Arts Magazine* 325 (July 2011): 112–119.

Broersen, Persijn, Uwe-Jens Gellner, and Annegret Laabs. *Everyday Ideologies*. Nuremberg / Manchester: Verlag für moderne Kunst, 2010.

Bürgi, Brigitt, and Peter Fischer. *Lebenszeichen: Altes Wissen in der zeitgenössischen Kunst* (Signs of Life: Ancient Knowledge in Contemporary Art). Heidelberg / London: Kehrer, 2011.

Coetzee, Mark, and Luisa Lagos. *Memorials of Identity: New Media from the Rubell Family Collection; William Kentridge, Sigalit Landau, Jun Nguyen-Hatsushiba*. Miami: Rubell Family Collection, 2006.

Del Revés: Artistas contemporáneous de Israel (Inside Out: Contemporary Artists from Israel). Vigo: Museo de Arte Contemporánea de Vigo, 2006.

Diez, Renato. "Scelti per voi." *Arte* 454 (June 2011): 100–107.

Fogh, Annemette. "Illuminating the World of Photographic and Video Art." *Katalog* 23, no. 3 (2011): 46–51.

Gether, Christian. *Mad Love: Ung Kunst i Danske Privatsamlinger*. Ishøj: Arken Museum for Moderne Kunst, 2007.

Goldfine, Gil. "The History of Violence." *Asian Art News* 19, no. 2 (April 2009): 54–59.

Heartney, Eleanor. "Worldwide Women." *Art in America* 6 (July 2007): 154–165.

Horn, Gabriele, and Ruth Ronen. *Sigalit Landau*. Ostfildern: Hatje Cantz, 2008.

Hübl, Michael. "Viele Tote und ein kleiner Tod." *Kunstforum International* 210 (September 2011): 28–43.

Jones, Simone. *Figuratively Speaking: The Figure in Contemporary Video Art*. Brisbane: QUT Creative Industries Precinct, 2007.

Kaumkötter, Jürgen, Peter Theissen, et al. *Francisco De Goya: Visionen von Schrecken und Hoffnung: Franciso De Goya und Maja Bajevic, Jacques Callot, Conrad Felixmüller,*

George Grosz, Willibald Krain, Sigalit Landau, Otto Pankok, Daniel Pesta, Wilhelm Schnarrenberger, Horst Strempel, Eugenio Lucas y Velazquez, Tina Winkhaus, Yongbo Zhao. Merzig: Gollenstein, 2010.

Kirkpatrick, Gail B., Susanne Düchting, and Julia Wirxel. *Krieg/Individuum.* Berlin: Revolver, 2010.

Kistler, Ashley, and Dinah Ryan. *The Nameless Hour: Places of Reverie, Paths of Reflection.* Richmond: Anderson Gallery, Virginia Commonweath University School of the Arts, 2010.

Kleebatt, Norman L. "Israel's Traumas and Dreams." *Art in America* (May 2006): 106–115.

Landau, Sigalit, Gabriele Horn, and Tali Tamir. *Sigalit Landau.* Ostfildern: Hatje Cantz, 2008.

———, Jean de Loisy, Ilan Wizgan, et al. *Sigalit Landau: One Man's Floor Is Another Man's Feelings.* Venice Biennale (2011). Paris / Dijon: Kamel Mennour, Les presses du réel, 2011.

Lavi, Tali. "Tales of Ash: Phantom Bodies as Testimony in Artistic Representations of Terrorism." MA thesis, RMIT University. 2007.

Lequeux, Emmanuelle. "Israël: L'Art sans frontières." *Beaux Arts Magazine* 293 (November 2008): 110–117.

Levine, Angela. "Surviving in a Hostile Environment: Sigalit Landau." *Sculpture* 28, no. 1 (February 2009): 30–35.

Masters, H. G. "Sugar-Rich Cannibalism." *ArtAsiaPacific* 69 (August 2010): 88–95.

Mendelsohn, Amitai. *Real Time: Art in Israel, 1998–2008.* Jerusalem: Israel Museum, 2008.

Moss, Karen, "Mediating Sand and Sea: Video Landscapes by Israeli Women Artists." MA thesis, University of Southern California, 2010.

Rossi, Mariella. "Una Plaza internacional / An International Plaza." *Lapiz* 30, no. 267 (August 2011): 28–41.

Sausset, Damien, Jérôme Cotinet-Alphaize, and Dominique Polad-Hardouin. "Vers un nouvel expressionnisme?" *Connaissance des Arts* 696 (September 2011): 52–57.

Schmidt, Sabine Maria. *Designing Truth: Daniele Buetti, Jimmie Durham, Jochen Gerz, Knowbotic Research.* Freiburg: Modo, 2006.

Van Assche, Christine, Mark Nash, Chantal Pontbriand, et al. *Une Vision du monde: La Collection Vidéo d'Isabelle Et Jean-Conrad Lemaître.* Lyon / Paris: Fage éditions / La Maison Rouge, 2006.

Wei, Lilly. "Israel Report: The Homeland within." *Art in America* 98, no. 3 (March 2010): 71–77.

Zaya, Octavio. *Del Revés: Artistas contemporáneos de Israel.* Vigo / Pontevedra: Marco, 2006.

ARIANE LITTMAN (since 2000)

ariane-littman.com

Arieli-Horowitz, Dana. *Nocturnal Stillness: Reuven Zahavi, Ariane Littman-Cohen, Niv Ben-David.* Jerusalem: New Gallery Teddy Stadium, 2008.

Art: Das Kunstmagazin (November 2010): 15.

Braverman, Irus. *Planted Flags, Trees, Land, and Law in Israel/Palestine.* Cambridge: Cambridge University Press, 2009.

Harper, Cheryl, and Tami Katz Freiman. *LandEscapes: A Multi-Site Exhibition of Contemporary Israeli Art.* Philadelphia: Gershman Y, The Center for Arts and Culture, 2002.

Hazan, Jenny. "Hazira Makes Everything Possible." *The Jerusalem Post* (June 2004).

Hussein, Hannan Abu, Ariane Littman-Cohen, and Khen Shish. *Scar.* Jerusalem: New Gallery, 2003.

Kaufman, Leslie. "Land Escapes: A Multi-Site Exhibition of Contemporary Israeli Art." *Sculpture* 22, no. 4 (May 2003), 81–82.

Lagerlof, Hannah. "Att dela Varandras Berattelser." *Trott Allt* 4–5 (2004).

Maor, Haim. "T.N.T. or A.R.T? Terror or Art." *Arts and Literature, Kibbutz Trends* (Winter 2001), no. 43–44: 31–35.

Mishori, Alic. *Visual Israeliness: Exhibition in the Framework of the 23rd Annual Conference of the Association for Israel Studies.* Raanana: Dorothy de Rothschild Open, 2007.

Offering Reconciliation: Catalog of the Exhibition at the Ramat Gan Museum, Organized by The Bereaved Families Forum for Peace. Ramat Gan: Ramat Gan Museum, 2006.

Ofrat, Gideon. *Lights in Literature, Art, and Jewish Thoughts.* 2005.

Porzgen, Gemma. "Vom Starken Gefuhl, Zeuge sein zu wollen." *Der Stuttgarter Zeitung,* June 3, 2006, 46.

Religion, Art, and War. London: Salon des Arts, 2003.

Rettberg, Felix. "Was war da los Frau Littman." *Der Spiegel (Szene),* September 6, 2010, no. 36, 60.

Ronnen, Meir. "Uses of Romance," *The Jerusalem Post,* February 23, 2001.

Sela, Rona. *White Land.* Jerusalem: Artists' House, 2001.

Shefi, Smadar. "Manipulated Landscapes," *Ha'aretz* (September 3, 2001).

Sozanski, Edward J. "Symbolic Israeli Landscapes." *The Philadelphia Inquirer,* February 1, 2002, 34.

Vine, Richard. "Report from Israel: Wider Focus." *Art in America* (May 2000), no. 5: 65–75.

SHIRIN NESHAT (since 2007)

gladstonegallery.com/neshat.asp

Adams, Laurie. *Art across Time.* 4th ed. New York: McGraw-Hill, 2011.

Amirsadeghi, Hossein, Hamid Keshmirshekan, Mark Irving et al. *Different Same Upsidedown and Backwards Letterers: New Perspectives in Contemporary Iranian Art.* London: Thames & Hudson, 2009.

Arakistain, Xabier, and Silvia García Lusa. *Kiss Kiss, Bang Bang: Arte Eta Feminismoaren 45 Urte = 45 Años De Arte y Feminismo* (45 Years of Art and Feminism). Bilbao: Museo de Bellas Artes de Bilbao, 2007.

Big Picture: Provisions for the Arts of Social Change. Washington, D.C.: Provisions Library, 2007.

Cao, Marián. *Shirin Neshat: Transformar el Deseo en el Cuerpo.* Madrid: Eneida, 2009.

Connolly, Maeve. *The Place of Artist's Cinema: Space, Site and Screen.* Bristol / Chicago: Intellect, 2009.

Danto, Arthur Coleman. *Shirin Neshat.* New York: Rizzoli, 2010.

de Weck Ardalan, Ziba, ed. *I Know Something about Love (On the Occasion of the Exhibition: I Know Something about Love: Shirin Neshat, Christodoulos Panayiotou, Yinka Shonibare, MBE, and Yang Fudong).* Cologne: König, 2011.

Expressing the Inexpressible Shirin Neshat. Films for the Humanities & Sciences, Films Media Group and German United Distributors.

Ferydoni, Pegah, and Martin Darst. *Women Without Men.* Berlin: NFP, 2011.

Finger, Brad, and Christiane Weidemann. *50 Contemporary Artists You Should Know.* Munich / New York: Prestel, 2011.

Finkelpearl, Tom, Valérie Smith, Jennifer Liese, et al. *Generation 1.5.* Queens: Queens Museum of Art, 2009.

Furlong, William, and Mel Gooding. *Speaking of Art: Four Decades of Art in Conversation.* London / New York: Phaidon, 2010.

Grosenick, Uta, and Ilka Becker. *Women Artists in the 20th and 21st Century.* Cologne / New York: Taschen, 2011.

Grosenick, Uta. *Art Now 2: The New Directory to 81 International Contemporary Artists = Der Neue Wegweiser Zu 81 Internationalen Zeitgenössischen Künstlern.* Hong Kong / Los Angeles: Taschen, 2008.

Halasa, Malu, and Maziar Bahari. *Transit Tehran: Young Iran and its Inspirations.* 1st ed. Reading: Garnet Publishing, 2009.

Hapkemeyer, Andreas. *Magic Line.* Milan / New York: Charta, 2007.

Husslein-Arco, Agnes, and Sabine B. Vogel. *Die Macht des Ornaments*. Vienna: Belvedere, 2009.

Issa, Rose. *Iranian Photography Now*. Ostfildern: Hatje Cantz, 2008.

Jeffery, Celina, and Gregory Minissale. *Global and Local Art Histories*. Newcastle: Cambridge Scholars Publishing, 2007.

Jung, Jörg, Ralf Raimo Jung, Jörg Jung, et al. *Shirin Neshat: Der Frau eine Stimme Film und Gespräch zu Iranischer Kunst im Exil und in Teheran*. Sternstunde Kunst. s.n., 2008.

Madoff, Steven Henry. *Art School: (Propositions for the 21st Century)*. Cambridge: MIT Press, 2009.

Martínez, Noemí, and Marián Cao. *Shirin Neshat: Posibilidades de Ser a Través del Arte; Creación y Equidad. El Arte Como Expresión*. Madrid: Eneida, 2009.

Mathur, Saloni. *The Migrant's Time: Rethinking Art History and Diaspora; Clark Studies in the Visual Arts*. Willamstown: Sterling and Francine Clark Art Institute in association with Yale University Press, 2011.

Morin, France, and John Alan Farmer. *The Quiet in the Land: Luang Prabang, Laos; A Project by France Morin*. New York: Distributed by D.A.P. / Distributed Art Publishers, 2009.

Nahidi, Katrin. *Shirin Neshat: Women Without Men; Ein Beispiel Iranischer Exilkunst*. Munich, 2010.

Neef, Sonja, José van Dijck, and F. C. J. Ketelaar. *Sign Here! Handwriting in the Age of New Media*. Amsterdam University Press, 2006.

Neshat, Shirin. *Shirin Neshat: Games of Desire*. Milan: Charta, 2009.

Neshat, Shirin, Dan Cameron, and Brigitte Schenk. *Shahram Karimi: In Between*. Milan / Brighton: Charta, 2011.

————, Pegah Ferydoni, Arita Shahrzad, and Shabnam Toloui. *Women Without Men*. Berlin Eurovideo, 2009.

————, and Mona Jensen. *Shirin Neshat: Women Without Men*. Aarhus: ARoS Aarhus Kunstmuseum, 2008.

————, France Morin, Catherine Choron-Baix, et al. *Games of Desire*. Milan: Charta, 2009.

————, and Nikzad Nojoomi. *Ardeshir Mohassess: Art and Satire in Iran*. New York / Woodbridge: Asia Society / Antique Collectors' Club, 2008.

————, Christodoulos Panayiotou, Yinka Shonibare, et al. *I Know Something about Love*. London: Parasol Unit Foundation for Contemporary Art / Koenig Books, 2011.

————, Shahrnush Parsipur, Eleanor Heartney, et al. *Shirin Neshat: Women Without Men*. Milan / New York: Charta, 2011.

Parsipur, Shahrnush, and Faridoun Farrokh. *Women Without Men: A Novel of Modern Iran*. New York: Feminist Press, 2011.

Robertson, Jean, and Craig McDaniel. *Themes of Contemporary Art: Visual Art after 1980*. 2nd ed. New York: Oxford University Press, 2010.

Schilling, Wilber H., Sean Scully, Shirin Neshat, et al. *A+B: Arthur & Barbara*. Minneapolis: Indulgence Press, 2011.

Sloman, Paul. *Contemporary Art in the Middle East*. London: Black Dog, 2009.

Teerlinck, Hilde, and Irene Aristizábal. *You Are Not Alone*. Barcelona: Fundació Joan Miró; Vigo: Fundació Artaids; Marco: Museo de Arte Contemporánea de Vigo, 2011.

Wawryniuk, Alicja. *Vom Kinosaal in die Galerie Formen der Verwandlung der Kinoästhetik in die Kunstästhetik in den Installationen von Shirin Neshat*. Hamburg: Diplomica-Verlag, 2011.

Weidemann, Christiane, Petra Larass, and Melanie Klier. *50 Women Artists You Should Know*. Munich / London / New York: Prestel, 2008.

Weintraub, Linda. *Making Contemporary Art: How Today's Artists Think and Work*. London: Thames & Hudson, 2007.

Women without Men: Ein Film von Shirin Neshat und Shoja Azari (Österreich/Deutschland/Frankreich/Schweiz 2009). @Filmindex-Programm; 1988; Variation: @ Filmindex-Programm; 1988. Vienna: Filmprogramm- & Kunstverl. Odlas: 2010.

Women Without Men. 1 videodisc (96 min.): sd., col.; 4 3/4 in. Directed by Shirin Neshat, Pegah Ferydoni, Arita Shahrzad, et al. Artificial Eye, 2010.

Zaya, Octavio, and Shirin Neshat. *Shirin Neshat: The Last Word.* Ostfildern: Hatje Cantz, 2008.

Zaman, Şimdiki. *Gecmis Zaman: 20 Yilda Uluslararasi Istanbul Bienali'Nden Iz Birakanlar* (Highlights from Twenty Years of the International Istanbul Biennial). Istanbul: Istanbul Modern, 2007.

EBRU ÖZSEÇEN

ebruozsecen.com

Altindere, H., and S. Evren. *User's Manual of Contemporary Art in Turkey, 1986–2006.* Istanbul, 2007.

Amirsadeghi. H. *Unleashed Contemporary Art from Turkey.* London: Transglobe Publishing, 2010.

Bafra, C. *Dream and Reality / Ebru Özseçen.* Istanbul: Istanbul Modern Publications, 2011.

Balogh, Istvan, Sabina Baumann, Selim Birsel, et al. *Arguments: Istvan Balogh, Sabina Baumann, Selim Birsel, Mauricio Dias & Walter Riedweg, Ebru Özseçen, Bülent Sangar, Hale.* Istanbul: Istanbul Kültür ve Sanat Vakfı, 2000.

Baykal, E., and F. Erdemci. *Istanbul Pedestrian Exhibitions 2: Tünel Karaköy, Istanbul: Guide.* 2004.

Block, René, and Vakfı Vehbi Koç. *Starter: Vehbi Koç Vakfı Çagdas Sanat Koleksiyonun'Ndan Isler.* Istanbul: Arter, 2010.

———, Barbara Heinrich, Alexandra Bootz, et al. *The Song of the Earth.* Kassel: Museum Fridericianum, 2000.

Burton, P. "Decorative and Burnt Façades: The Engaging Art of Ebru Özseçen." Radio Nederland Wereldomroep, December 1, 2004.

Candela, E. "Paradise Revealed: Reanimation of Place." *Interfac*e (2008).

Cingöz, A. "Sanatçi Berlin'e gitmis, Ya Kısmet demiş." *Sabah,* June 22, 2010.

Dogtas, G. "Ebru Özseçen: Kismet." *Matt Magazine 7* (October 2010): 38–44.

"Ebru Özseçen: Skulptur und Video." *Der Tagesspigel,* July 7, 2010.

"Ebru Özseçen in Tanas Galerie." *Art in Berlin,* June 18, 2010.

Ekici, Nezaket, Özlem Günyol, Barbara Heinrich. *Türkisch Delight: Nezaket Ekici; Özlem Günyol Und Mustafa Kun ; Gülsün Karamustafa: Ebru Özseçen: Anny Und Sibel Öztürk.* Nordhorn: Städtischen Galerie Nordhorn, 2007.

Emirdag, P. *At Home, wherever / Ebru Özseçen.* Istanbul: Kosova, E., Yapi Kredi Publications, 2011.

Erdemci, F. *Iconografias Metropolitanas.* São Paulo: São Paulo Biennial Publications, 2002.

———. "Istanbul Biennial." *Arco* 22 (October 2001).

———. *Pismanliklar, Hayaller, Degisen Gökler* (Regrets, Reveries, Changing Skies). Istanbul: Atelye Alaturka, 2001.

Erkmen, A. "Artist's Favorites." *Spike Magazine,* December 10, 2009.

"Food For Thought." *U-Turn Satellite Exhibition.* Stege Sukkerfabrik, 2008.

Heinrich, B. *Turkish Delight.* Nordhorn, 2008.

Herbert, M. *Paradise Revealed: Reanimation of Place.* Kent / London: Dover, 2008.

Hoekendijk, C. "17th World Wide Video Festival." Amsterdam: interview, 1999.

Les Intérieurs du Monde. Haarlem: Zaanstad Museum Publication, 2001.

Kalkreuth, C. "Turkische Kunstausstellung Kismet in Berlin: Verschmelzung der Gestalten." *Zenith Online,* July 26, 2010.

Korgül, R. "Ebru Özseçen." *Hillsider,* 31, 2002.

Krueger, A. *Passion and Wave: The 6th International Istanbul Biennial.* Istanbul: 1999.

Love it or Leave it. Cetinje: Cetinje Biennial, 2004.

Martinez, R. "Ebru Özseçen's Harem." *Flash Art* (October 2000).

Motzer, M., *Erinnern an die NS-Opfer im Stadtraum des 21. Jahrhunderts: Neue Formen des Gedenkens in München* (Remembering the NS-Victims in the Public Space of the 21st Century. New Forms of Commemoration in Munich). Thesis, University of Heidelberg, 2009.

Nachtigäller, Roland, and Martin Schick. *Türkisch Delight.* Nordhorn: Städtische Galerie, 2009.

Özseçen, Ebru. *In den Schluchten des Balkan: Eine Reportage.* Kassel: Kunsthalle Fridericianum, 2003.

———. *Istanbul Pedestrian Exhibitions 1: Nişantaşi Personal Geographies, Global Maps.* Istanbul, 2002.

———. *Meisterwerke der Medienkunst aus der ZKM Sammlung.* Karlsruhe: Mediagra, 2005.

———. *Metropolis Now.* Madrid: Museo Reina Sofía, 2002.

———. *Slow Space, Fast Pace.* Cork, 2007.

Pitz, H. *Out of Nowhere.* Dordecht: CBK, 1999.

Pupat, H. "City Cinema." *Leipziger Volkszeitung,* May 27, 2005.

Quin, J. "Ebru Özseçen: Kismet." *October* 44 (2010).

Roelstrade, D. *Sonsbeek 9.* Arnhem, 2001.

Senova, B. *Arguments, Geneve.* Istanbul, 2000.

———. "Ebru Özseçen." *Bilkent News,* 1996.

———. "Ebru Özseçen's Translucent Lucidity." *Domus M* (October 2001).

———. *Das Lied von der Erde.* Kassel, 2000.

———. *Metropolis Now.* Istanbul: Borusan Art Center, 2001.

———. *Springtime.* Copenhagen: Nikolaj Art Center.

———. "Trans Express Barcelona 2001: A Classic For The Third Millenium." *Domus M* (September 2001).

———. *Trans Sexual Express.* Barcelona: Santa Monica Art Center, 2001.

———. *Unlimited nl-4.* Amsterdam: De Appel Foundation, 2001.

"Sensüchte und Träume." *Der Tagesspiegel,* July 9, 2010.

Starter: Works from the Vehbi Koç Foundation Contemporary Art Collection. Istanbul: Arter, 2010.

Tee, M. "Limerick Biennial." *Rieze* (December 2000).

Who Killed The Painting. Nuremburg: Neues Museum, 2008.

Yayintas, A. *Modern and Beyond.* Istanbul: Santralistanbul, 2007.

LAILA SHAWA

lailashawa.com

Collier, Caroline. *Arab Print: Volume 1.* Abu Dhabi: ADMAF, 2008.

Eigner, Saeb. *Art of the Middle East: Modern and Contemporary Art of the Arab World and Islam.* London / New York: Merrell, 2010.

Farhat, Maymanah. "Imagining the Arab World: The Fashioning of the 'War on Terror' Through Art." *Callaloo* 32, no. 4 (Winter 2009): 1223–1231.

Hamanaka, Sheila. *On the Wings of Peace.* New York: Clarion Books, 1995.

Highet, Juliet. "MidEast Cool." *Saudi Aramco World* 62, no. 3 (May–June 2011), saudiaramcoworld.com/issue/201103/mideast.cool.htm.

Joffe, Lawrence. "Laila Shawa: Still Shaking People Up; Lawrence Joffe Talks to the Palestine-Born Artist Whose Work Forms Part of the British Museum's Collection, Laila Shawa." *The Middle East,* February 1, 2002, reprinted on Highbeam web site: business.highbeam.com/4356/article-1G1-83078369/laila-shawa-still-shaking-people-up-lawrence-joffe.

Laila Shawa: Works, 1965–1994. London: Al-Hani Books, 1994.

Lloyd, Fran, ed. *Contemporary Arab Women's Art: Dialogues of the Present.* London: WAL, 1999.

Macnab, E. "Passages Between Cultures: Exhibition Rhetoric, Cultural Transmission, and Contemporaneity

in Two Exhibitions of Contemporary Middle Eastern Art." MA Thesis, Carleton University, n.d.

October Gallery, octobergallery.co.uk/artists/shawa/index. shtml.

Porter, Venetia, and Isabelle Caussé. *Word into Art: Artists of the Modern Middle East*. London: British Museum Press, 2006.

Riding, Alan. "The British Museum's Mission: Cultural Ambassador to the World." *The New York Times,* July 1, 2006, nytimes.com/2006/07/01/arts/design/01ridi. html?_r=1.

Roads Were Open, Roads Were Closed: Tarek Al Ghoussein, Fouad Elkoury, Joana Hadjithomas & Khalil Joreige and Laila Shawa. Dubai: Third Line Gallery, 2008.

Sloman, Paul. *Contemporary Art in the Middle East*. London: Black Dog, 2009.

"Text Messages: Five Contemporary Artists and the Art of the Word." *ArteNews,* (October 2006), arteeast.org/ artenews/artenews-articles2006/text-messsges/artenews-text-message.html.

SHAHZIA SIKANDER (since 2000)

shahziasikander.com

Ahmady, Leeza. "Shahzia Sikander: Aldrich Contemporary Art Museum." *Flash Art* 239 (November–December 2004).

Akhtar, Aasim. "Acts of Balance." *Libas International* 15 no. 2 (June 2002).

Anderson, Maxwell. *American Visionaries: Selections from the Whitney Museum of American Art*. New York: Harry N. Abrams, Inc., 2001.

Antelo-Suarez, Sandra, et al. *Urgent Painting*. Paris: ARC, Musée d'Art moderne de la Ville de Paris, 2002.

Arditi, Fiamma. "La Rinascita de New York, vista dalle gallerie." *Panorama*, October 11, 2001.

Arnason, H. H. *History of Modern Art*. 5th ed. Upper Saddle River: Prentice Hall, 2004.

Augaitis, Daina. *For the Record: Drawing Contemporary Life*. Vancouver: Vancouver Art Gallery, 2003.

Brown, Kathan. *Shahzia Sikander: No Parking Anytime*. San Francisco: Crown Point Press, Spring 2002.

Cameron, Dan. *Poetic Justice*. Istanbul: Istanbul Biennial / Istanbul Foundation for Culture and Arts, 2003.

Chambers, Kristin. *Loose Threads, Threads of Vision: Toward a New Feminine Poetics*.Cleveland: Cleveland Center for Contemporary Art, 2001.

Contemporary Art Commissions at the Asia Society and Museum. Introduction by Vishaka Desai. New York: Asia Society, 2002.

Daftari, Fereshteh. *ARS 01*. Helsinki: Museum of Contemporary Art, Kiasma, 2001.

———. "Beyond Islamic Roots: Beyond Modernism," *RES* 43 (Spring 2003).

———. *Projects 70*. New York: Museum of Modern Art, 2001.

Dailey, Meghan. "Preview: Shahzia Sikander at the Aldrich." *Artforum* (September 2004).

Desai, Vishakha N. *Conversations with Traditions: Nilima Sheikh and Shahzia Sikander*. New York: Asia Society, 2001.

Falguieres, Patricia. *134 Views of the World: Urgent Painting*. Paris: ARC, Musee d'art Moderne de la Ville de Paris, 2002.

Fletcher, Valerie. *Art Worlds in Dialogue*. Cologne: Museum Ludwig; Dumont Publishers, 20 Press, 2001.

Gupta, Somini. *Unveiling the Visible: Lives and Works of Women Artists of Pakistan*. Pakistan: Actionaid, 2002.

Hecker, Judith, and Shahzia Sikander. *Artists and Prints: Masterworks from The Museum of Modern Art*. New York: Museum of Modern Art, 2004.

Heller, Nancy G. *Women Artists*. New York: Abbeville Press, 2003.

Herbert, Lynn, "Sikander, Turrell, Hamilton, Feodorov." *Art: 21, Art in the 21st Century*. New York: Harry N. Abrams, Inc., 2001.

Hertz, Betti-Sue. *Shahzia Sikander: Flip Flop* (Contemporary Links 2). San Diego: San Diego Museum of Art, 2004.

Hoptman, Laura. *Drawing Now: Eight Propositions*. New York: Museum of Modern Art, 2002.

Kim, Elaine H., Margo Machida, and Sharon Mizoto. *Fresh Talk/Daring Gazes*. Berkeley: University of California Press, 2003.

Kortun, Vasif. *Fresh Cream*. London: Phaidon Press, 2000.

Kunitz, Daniel. "An Evolving and Appealing Excellence," *The New York Sun*, March 31, 2005.

Marcoci, Roxana. *Threads of Vision: Toward a New Feminine Poetics*. Cleveland: Cleveland Center for Contemporary Art, 2001.

Marquardt, Janet, and Stephen Eskilson. *Frames of Reference: Art History and the World*. New York: McGraw-Hill, 2005.

Nemiroff, Diana. *After Arcadia, Elusive Paradise: The Millenium Prize*. Ottawa: National Gallery of Canada, 2001.

O'Brian, David, and David Prochaska. *Beyond East and West: Seven Transnational Artists*. Champaign: Krannert Museum of Art, 2004.

Platform Year Report 2003: Packaged Paradise; Shahzia Sikander, Istanbul Biennial Exhibition. Istanbul: Istanbul Foundation for Culture and Arts, 2003.

Pollack, Barbara. "The New Look of Feminism." *ARTnews* 100, no. 8 (2001): 132–136.

Reckit, Helena, and Peggy Phelan. *Art and Feminism*. London: Phaidon Press, 2001.

Saltz, Jerry. "Good on Paper." *The Village Voice* 57, October 30, 2002.

Sand, J. Olivia. "Interview." *Asian Art Newspaper* (January 2002, March 2005).

Sawhney, Hirsh. "Small Things Considered." *Time Out, NY*, March 25–April 1, 2004.

Scherr, Apollinaire. "Small Wonders: Miniature Paintings with Big Ideas about Gender and Tradition." *Elle* 194 (2001).

Self, Dana. "Trame orientale et hybridité picturale." *L'Homme* 156 (October–December 2000).

Sikander, Shahzia. "Charting a New Discourse." *Gallerie International, Biannual* 3, no. 2 (2000).

———. "Land-Escapes." *The Subcontinental: The Journal of South Asian American Public Affairs* 2 no. 2 (2004): 85–90.

Singer, Debra. *Shahzia Sikander: Acts of Balance*. New York: Whitney Museum of American Art at Philip Morris, 2000.

Szeemann, Harald. *The Joy of My Dreams*. Seville: First International Biennial of Contemporary Art, 2004.

Thon, Ute. "In Glanzender Form." *Art: Das Kunstmagazin* 12 (December 2002).

Weiss, Rachel. *From Place to Place, As Long As it Lasts*. Renaissance Society, 2004.

Wye, Deborah. *Artists and Prints in Context, Artists and Prints: Masterworks from The Museum of Modern Art*. New York: Museum of Modern Art, 2004.

FATIMAH TUGGAR

Alonso, Rodrigo, and T. J. Demos. *Vitamin Ph: New Perspectives in Photography*. London / New York: Phaidon, 2006.

Barliant, Claire. *Africaine*. New York: Studio Museum in Harlem, 2002.

Bourriaud, Nicolas. *Post Production*. Prato / San Gimignano: Gli ori / Galleria Continua, 2003.

Chambers, Kristin. *Threads of Vision: Toward a New Feminine Poetics*. Cleveland: Cleveland Center for Contemporary Art, 2008.

Cream 3: Contemporary Art in Culture: 100 Artists, 10 Curators, 10 Source Artists. London: Phaidon, 2003.

"Fatimah Tuggar (b. 1967): Media and Installation Artist." In Dele Jegede, ed. *Encyclopedia of African American Artists*. Westport: Greenwood Press, 2009.

"Fatimah Tuggar: Fusion Cuisine." *Transferts*. Brussels: Palais des Beaux-Arts, 2003.

Fleetwood, Nicole R. *Troubling Vision: Performance, Visuality, and Blackness*. Chicago: University of Chicago Press, 2011.

Fleetwood, Nicole R. "Visible Seams: Gender, Race, Technology, and the Media Art of Fatimah Tuggar." *Signs: Journal of Women in Culture & Society* 30, no. 1 (September 2004): 1429–1454.

Jocks, Heinz-Norbert. "Afrika Remix: Erkundigungen auf dem Kontinent der Anderen Bilder." *Kunstforum International* 172 (September–October 2004): 324–327.

Kovalev, Andrei, Ekaterina Lazareva, Elena Panteleeva, et al. "Dialectics of Hope: Non-Entities Without Discourse and Visuality." *Art Chronika* (2005): 46–123.

McKee, Yates. "The Politics of the Plane: On Fatimah Tuggar's Working Woman." *Visual Anthropology* 19, no. 5 (2006): 417–422.

Murray, Soraya. "Africaine: Candice Breitz, Wangechi Mutu, Tracy Rose, Fatimah Tuggar." *Nka: Journal of Contemporary African Art* 16–17 (Fall–Winter 2002): 88–93.

Nelson, Alondra. *Afrofuturism: Social Text*. Durham: Duke University Press, 2002.

Pollack, Barbara. "The Newest Avant-Garde: African Art Goes Global." *ARTnews* 100, no. 4 (April 2001): 124–129.

"Recommended Viewing: Beyond the Gaze; Recent Approaches to Film, Feminisms." *Signs: Journal of Women in Culture & Society* 30, no. 1 (Autumn 2004): 1473–1476.

Riley, Terence, Kynaston McShine, and Anne Umland. *MoMA QNS Boxed Set*. New York: Museum of Modern Art, distributed in the U.K. by Thames & Hudson, 2002.

Rollefson, J. Griffith. "The Robot Voodoo Power: Afrofuturism and Anti-Anti- Essentialism from Sun Ra to Kool Keith." *Black Music Research Journal* 28, no.1 (Spring 2008): 83–109.

St-Laurent, Stefan, Tam-Ca Vo-Van, and Galerie SAW Gallery. *International Geographic*. Ottawa: Galerie Saw Gallery; Toronto: YYZ Books, 2006.

Thea, Carolee. "Globalization's Undertow: An Interview with Paolo Colombo in Istanbul." *Sculpture* 19, no. 3 (April 2000): 32–37.

"Tuggar, Fatimah." In Simon Njami, ed. *Africa Remix: Contemporary Art of a Continent*. Ostfildern: Hatje Cantz, 2005; Johannesburg: Jacana Media, 2007.

Tuggar, Fatimah. *Jahresring* 49 (2002): 149–154.

———. *Kitchen Center for Video, Music, Dance, Performance, Film, and Literature* (New York) and BintaZarah Studios. New York: Fatima Tuggar, 2000.

———. "Ohne Titel." In Clara Himmelheber, *Der Hund is Für Die Hyä. neineKolanuss: Zeitgenössische Kunst und Kultur aus Afrika*. Cologne: Oktagon, 2002.

Vine, Richard. "The Luminous Continent." *Art in America* (2004): 68–73.

Zabel, Igor, and Valerie Cassel. "Beyond Boundaries: Rethinking Contemporary Art Exhibitions." *Art Journal* 59, no. 1 (Spring 2000): 4–21.

NIL YALTER

nilyalter.com

Alev Ebüzziya & Nil Yalter. Istanbul: Galeri Nev, 2006.

Allen, Jennifer. "Nil Yalter." *Frieze Magazine* 2 (2012).

Altug, Evrim. *Seramigin etiyle, resmin tirnagi*. Istanbul, 2006.

Atakan, Nancy. "Nil Yalter, Galerist Tepebasi." *Flash Art* 14 (2012).

Bozkurt, Muammer. *Istanbul, Mardin, Diyarbakir*. Istanbul: Cumhuriyet, 2006.

Contemporary Artists. 5th ed. St. James Press, 2002.

de Mèredieu, Florence. *Arts et Nouvelles Technologies*. France: Editions Larousse, 2003.

Dumont, Fabienne. *Femmes à l'oeuvre*. France: Edition Histoire de l'Art, 2008.

———. *Nil Yalter's Work on Memory, Migrants, and Workers in 1970s–1980s*. France, 2010.

Garaudet, Marie-Françoise. Réalisateur / Metteur en scène / Directeur artistique, Vera Molnar, Participant, Yalter, Richard Serra, and Participant. *Médiatisation De l Art Contemporain Par La Vidéo*. Saint-Denis: Laboratoire VAO, UFR Arts de l'Université Paris 8th ed, 2008.

Gonnard, Catherine, and Elizabeth Lebovici. *Femmes artistes / artistes femmes*. France: Edition Hazan, 2007.

Nil Yalter Videosu. Istanbul: Melis Tezkan. rh+ sanart , 2009.

Schor, Gabriel. *Donna: Avanguardia femminista negli anni '70: Dalla Sammlung Verbund Di Vienna*. Milan: Electa, 2010.

Sonmez, Aysegul. *Goçmenlik dedigin, zor 'zanaat.'* Istanbul: Bir Gun, 2007.

———. *Haksiz Tahrik: Bir Sergi Kitabi* (Unjust Provocation: An Exhibition Book). Istanbul: Amargi, 2009.

Turkish Realities: Positions in Contemporary Photography and Video from Turkey ; Photographic Artists: Merih Akogul, Murat Germen, Zeki Faik Izer, Hüseyin Karakaya, Korhan Karaoysal, Ilker Maga, Yildiz Moran, Ferhat Özgür, Ahmet Polat, Pinar Yolacan ; Video Artists: Aksel Zeydan Göz, Sinasi Günes, Burcak Kaygun, Özlem Sulak, Nil Yalter. (Türkiye Gercekligi : Türkiye'den Cagdas Fotograf ve Video Sanati). Heidelberg: Kehrer, 2008.

Yalter, Nil. *Abdal Pir Sultan, 15.-1590, Ashik Nesimi Cimen, Latife Baci, Kaygusuz Abdal, Bernard Dupaigne, and Achik Nesimi Cimen. Le Chant Des Troubadours De Turquie.* Anonymous 1977. Société française de productions phonographiques. 761690423 (1 disque : 33 t, stéréo compat. ; 30 cm.).

———. *Nil Yalter: Su Gurbetlik Zor Zanaat Zor* 2, (1974-1992) ["C'est un dur métier que l'exil * 2, (1974-1992)].* Istanbul: Istanbul Fransiz Kültür Merkezi, 2006.

Yildiz, Esra, and Sanat Dunyamiz. "Nil Yalter ile soylesi." *n.paradoxa* 26 (2011).

Index

Index

George, Lloyd, 51
Germany. *See* Ekici, Nezaket; Forouhar, Parastou; Özseçen, Ebru
Ghadirian, Shadi, 112; butterfly in the work of, *3, 5,* 112, *113–115.* Works: *Miss Butterfly* series, *3, 5,* 112, *113–115*
globalization, and Middle East women artists, 13, 36. *See also* Al Qadiri, Fatima; Sikander, Shahzia
graffiti, and the Egyptian revolution, 18–20. *See also* Tarek, Aya
Gregory, Derek, 50–51, 53

H

Haifa. *See* Friedman, Ayana
Hall, Stuart, 54–55, 56
Hammam, Nadine, 34; gender (sexuality) in the work of, 28, 32. Works: *Got Love,* 23; *Tank Girl, 22,* 32
harem, as Orientalist trope, 4, 12, 44. *See also* Ahkami, Negar; Delacroix, Eugene; Ingres, Jean-Auguste-Dominique; Yalter, Nil
Hatoum, Mona, 116; maps in the work of, *13, 50, 51,* 52, 57; and Middle East diaspora, 12–13, 56–57; and Palestine, 12–13, 56–57; precarity in the work of, 42–44. Works: *Entrails (Carpet),* 42; *Hair and there, 13, 118; Interior Landscape; Light Sentence,* 42; *Map,* 57; *Prayer Mat,* 44; *Projection, 13, 50, 51,* 52, 57, *117; Round and round, 10, 13, 37,* 42–44, *119; Slicer,* 42; *3-D Cities,* 52
healing, as theme. *See* Littman, Ariane
Helwan University, 16, 32, 33, 34, 35
Higher Institute for Art Education for Girls, Cairo, 16, 28, 35
hijab. *See* veil (burka, chador, hijab)
hybridity. *See* Bhabha, Homi; Breasted, James Henry

I

identities (fixed or unfixed), 3, 36, 38, 46n3, 56–57. *See also* Al Qadiri, Monira
immigration, as theme. *See* Kahraman, Hayv
imperialism, Western, and the Middle East, 2, 38–42, 47n17, 48n29, 54. *See also* European colonialism; Sikander, Shahzia
Ingres, Jean-Auguste-Dominique, odalisques of, 4, 12
installation. *See* Ahkami, Negar; Al-Ani, Jananne; Barakeh, Zeina; Cnaani, Ofri; Ekici, Nezaket; El Ansari, Nermine; Friedman, Ayana; Hammam, Nadine; Hatoum, Mona; Kedem, Efrat; Kenawy, Amal; Landau, Sigalit; Özseçen, Ebru; Shawa, Laila; Yalter, Nil
Institute of International Visual Arts (InIVA). *See Veil: Veiling, Representation, and Contemporary Art*
Iran: revolution in, 45, 49n53, 49n55; women in, 45, 49n53, 49n55. *See also* Ahkami, Negar; Ahmadi, Shiva; Amer, Ghada and Reza Farkhondeh; Forouhar, Parastou; Ghadirian, Shadi; Neshat, Shirin
Iraq, 40, 42; Iran-Iraq War, 64; Iraq War (Second Gulf War), 47n5, 51, 53. *See also* Al-Ani, Jananne; Barakeh, Zeina; Kahraman, Hayv
Islam, 14, 48n24; artistic legacy of, 60, 144; and fundamentalism, 45, 49n50; and Orientalism, 47n9, 48n20. *See also* Egypt; Islamophobia; Muslims; Neshat, Shirin; political Islam; Shawa, Laila; veil
Islamophobia, 42, 60
Israel: Six-Day War (1967 War), 46. *See also*

Cnaani, Ofri; Friedman, Ayana; Israeli-Palestinian conflict; Kedem, Efrat; Landau, Sigalit
Israeli-Palestinian conflict, 44, 46, 47n5, 51, 52. *See also* Barakeh, Zeina; Landau, Sigalit; Littman, Ariane; Oslo Process; Shawa, Laila

J

Jerusalem. *See* Kedem, Efrat; Landau, Sigalit; Littman, Ariane
Jews, 36

K

Kabul. *See* Hatoum, Mona
Kahraman, Hayv, 120; gender (sexuality) in the work of, 4, 45, 49n51, 120; and Persian miniaturist painting, 4, 120. Works: *I Love My Pink Comb,* 45, *121; Leveled Leisure, 13,* 45, *121; Mass Assembly (Sliding Puzzle), 38, 121; Migrant 3,* 45; *String Figures,* 45
Kalthum, Umm, 32
Kamel, Shayma, *30,* 32, 34
Kandivoti, Deniz, 12
Kedem, Efrat, 122; surveillance in the work of, 10–11. Works: *The Reality Show,* 10–11, *11,* 122, *123–125*
Kenawy, Abd El, 34
Kenawy, Amal, 25, 34. Works: *Fighter Fish,* 34; *My Lord Is Eating His Tail,* 34; *The Room,* 34; *The Silent Multitudes,* 25; *Transformation,* 34
Khomeini, Ayatollah Rouhollah, regime of, women under, 45
Kuwait. *See* Al Qadiri, Fatima; Al Qadiri, Monira

L

Landau, Sigalit, 42–44, 46, 126. Works: *Barbed Hula,* 44; *Dancing for Maya, 9, 12,* 42, 49n60, *126–129; Dead Sea,*

Madkour, Nazli; Persian miniaturist painting, legacy of; Rasoul, Souad Abdel; Shawa, Laila; Sirry, Gazbia; Tarek, Aya

Pakistan. *See* Sikander, Shahzia

Palestine, 42; mandatory rule of, 40, 48n29, 48n31. *See also* Balfour Declaration; Barakeh, Zeina; Cnaani, Ofri; Hatoum, Mona; Israeli-Palestinian conflict; Littman, Ariane; Shawa, Laila

Palestinian intifadas. *See* Israeli-Palestinian conflict

paper, papermaking. *See* Hatoum, Mona

papier maché. *See* Littman, Ariane

Paris, 11. *See also* Sedira, Zineb; Yalter, Nil

passport, as theme. *See* Barakeh, Zeina

patriarchy, 8, 28, 31–32, 46, 166

performance. *See* Al Qadiri, Fatima; Al Qadiri, Monira; Cnaani, Ofri; Ekici, Nezaket; Friedman, Ayana; Landau, Sigalit; Littman, Ariane; Özseçen, Ebru; Yalter, Nil

Persian miniaturist painting, legacy of. *See* Ahkami, Negar; Ahmadi, Shiva; Kahraman, Hayv; Sikander, Shahzia

photography. *See* Al-Ani, Jananne; Al Qadiri, Fatima; Barakeh, Zeina; El Ansari, Nermine; El Hossamy, May; Elkoussy, Hala; Forouhar, Parastou; Ghadirian, Shadi; Littman, Ariane; Lutfi, Huda; Madkour, Nazli; Tuggar, Fatimah; Yalter, Nil

photomontage. *See* Lutfi, Huda; Tuggar, Fatimah

political Islam, 54

portraiture, approaches to, in the work of Egyptian women artists, 30–31

postcolonialism, 11–12, 56. *See also* Sikander, Shahzia

Proaction Film, 98

R

Rasoul, Souad Abdel, *26, 27,* 31, 35

Rockefeller, John D., and James Henry Breasted, 48n28

S

Sadat, Anwar, regime of, women under, 16–17

Saffarzadeh, Tahereh, 45

Said, Edward, 50, 55–56; *Culture and Imperialism,* 52; on Hatoum, 56–57; *Orientalism,* 39–41, 47n9, 47n19, 48n20, 48n35

Schmitt, Carl, 47n5

sculpture. *See* Ahmadi, Shiva; Hatoum, Mona; Lutfi, Huda; Shawa, Laila

Sedira, Zineb, 56; and *Veil: Veiling, Representation, and Contemporary Art,* 52–54

self-portraiture. *See* Al Qadiri, Monira

Senegal. *See* Al Qadiri, Fatima; Al Qadiri, Monira

September 11, 2011, 2; Middle East in the aftermath of, 51, 53, 54; and *Veil: Veiling, Representation, and Contemporary Art,* 53–54. *See also* Shawa, Laila

shahida (female suicide bombers). *See* al-Biss, Samir Ibrahim; Shawa, Laila

Sha'rawi, Huda, 33n18

Shawa, Laila, 144; Dubai in the work of, *6, 9, 145, 146–147, 149;* Israeli-Palestinian conflict in the work of, *44, 46,* 144; *shahida* (female suicide bombers) in the work of, *44, 46,* 144, *150, 151.* Works: *Cast Lead* series, 144; *Clash,* 144;

Crucifixion 2000: In the Name of God, 144; *Day and Night, Night and Day,* 148–149; *Disposable Bodies No. 3: Point of Honor, 150; Disposable Bodies No. 4: Scheherazade, 151; Gaza Fashion Week,* 44, 46, 144; *Gaza III* series, 144; *Gaza Sky,* 46; *The Hands of Fatima,* 144; *Night and the City, 146–147; The Other Side of Paradise, 6, 44, 46,* 144, *150, 151; Refraction of Paradise, 6; Sarab* series, 6, 144, *145, 146–147, 148–149; Trapped,* 44, 46; *Unchain My Heart,* 145; *The Walls of Gaza* series, 144; *Women and Magic* series, 144; *Women and the Veil* series, 144

Sikander, Shahzia, 11, 46, 152; and Persian miniaturist painting, 11, 152. Works: *The Last Post,* 11, 152, *156–157, 158–159; SpiNN,* 152, *152–153; Unseen Series,* 152, *154–155*

Sirry, Gazbia, 14, 16, 28, 30, 35. Works: *About the January 25, 2011, Revolution, Egypt,* 15

Six-Day War (1967 War), 46. *See also* Littman, Ariane

sofa, as theme. *See* Abdou, Eman; Ahkami, Negar

sound art. *See* Barakeh, Zeina; El Ansari, Nermine

Stuttgart. *See* Ekici, Nezaket

surveillance, as theme, 10–11. *See also* Kedem, Efrat

Syria, 40. *See also* El Jeiroudi, Diana

T

Tarek, Aya, 20, *21,* 35

Tehran. *See* Forouhar, Parastou; Ghadirian, Shadi; Neshat, Shirin

Tel Aviv. *See* Landau, Sigalit

Published by the Rutgers University Institute for Women and Art in conjunction with the exhibition *The Fertile Crescent: Gender, Art, and Society*
(www.fertile-crescent.org)
The artists were presented at each of the five venues as follows:

Jananne Al-Ani, Fatima Al Qadiri, Monira Al Qadiri, Ofri Cnaani, Diana El Jeiroudi, Ayana Friedman, Ariane Littman, Ebru Özseçen, Laila Shawa, Nil Yalter
Mason Gross Galleries, Rutgers University, 33 Livingston Avenue, New Brunswick, New Jersey
August 13–September 9, 2012

Parastou Forouhar, Mona Hatoum, Sigalit Landau, Shirin Neshat, Laila Shawa
Princeton University Art Museum, Princeton, New Jersey
August 18, 2012–January 13, 2013

Negar Ahkami, Ghada Amer and Reza Farkhondeh, Zeina Barakeh, Ofri Cnaani, Parastou Forouhar, Shadi Ghadirian
Bernstein Gallery, Woodrow Wilson School of Public and International Affairs, Princeton University
Prospect Avenue at Washington Road, Princeton, New Jersey
August 20–October 19, 2012

Fatimah Tuggar; Ariane Littman, *Lebowitz Visiting Artist-in-Residence;* Shahzia Sikander
Mary H. Dana Women Artists Series Galleries, Rutgers University
Mabel Smith Douglass Library, 8 Chapel Drive, New Brunswick, New Jersey
Sponsors: Associate Alumnae of Douglass College, Center for African Studies, Institute for Women and Art,
Rutgers University Libraries, South Asian Studies Program, and The Feminist Art Project
August 29–September 28; October 4–November 1; November 9–December 17, 2012

Shiva Ahmadi, Monira Al Qadiri, Nezaket Ekici, Hayv Kahraman, Efrat Kedem
Arts Council of Princeton / Paul Robeson Center for the Arts
102 Witherspoon Street, Princeton, New Jersey
October 4– November 21, 2012

Sponsors
The Fertile Crescent: Gender, Art, and Society has been supported in part by funds from the National Endowment for the Arts, grant 10-4100-7033;
the Andy Warhol Foundation for the Visual Arts; the Violet Jabara Charitable Trust; the Artis Foundation, which helped fund the participation of the five Israeli
artists in the exhibition, Ofri Cnaani, Ayana Friedman, Efrat Kedem, Sigalit Landau, and Ariane Littman; and the Harris Finch Foundation. Several programs were
made possible by a grant from the New Jersey Council for the Humanities, a state partner of the National Endowment for the Humanities. Any views, findings,
conclusions, or recommendations in these programs do not necessarily represent those of the National Endowment for the Humanities or the New Jersey Council
for the Humanities. In addition, *Fertile Crescent* partner institutions provided both financial and in-kind contributions, as did
Basem and Muna Hishmeh, along with other individuals. The Rutgers University Institute for Women and Art
receives General Program Support from the New Jersey State Council on the Arts.

Rutgers University Institute for Women and Art
191 College Avenue, New Brunswick, New Jersey 08901
womenart@rci.rutgers.edu iwa.rutgers.edu

Judith K. Brodsky and Ferris Olin
The Fertile Crescent: Gender, Art, and Society
Includes bibliographic references and an index

Library of Congress Control Number: 2012940221

ISBN 978-0-9790497-9-8

Individual essays © in the names of their authors, 2012
Reproduction permissions received from all artists and essayists

Cover
Parastou Forouhar, *Freitag* (Friday) (detail), 2003, Aludobond, Four panels,
Each 66 7/8 x 33 7/8 in. (170 x 86 cm), Courtesy of the RH Gallery, New York, and the artist

Production
Catalogue designer and production manager: Isabella Duicu Palowitch, ARTISA LLC
Assistant production manager: Leigh-Ayna Passamano
Copy editor and indexer: Jane Friedman
Typeset in ITC Stone Serif and the Sans type families by Margaret Trejo
Printing: Capital Offset, Concord, New Hampshire
Paper: 100 lb Garda Silk

Distributed by
D.A.P. / Distributed Art Publishers, Inc.
155 Sixth Avenue, 2nd floor, New York, New York 10013
Tel.: 212-627-1999 Fax: 212-627-9484 www.artbook.com

Printed and bound in the USA